Images of Power

Remapping Cultural History

General Editor: Jo Labanyi, University of Southampton

Published in association with the Institute of Romance Studies, School of Advanced Study, University of London

The theoretical paradigms dominant in much of cultural history published in English tend to be derived from northern European or North American models. This series will propose alternative mappings by focusing partly or wholly on those parts of the world that speak, or have spoken, French, Italian, Spanish or Portuguese. Both monographs and collective volumes will be published. Preference will be given to volumes that cross national boundaries, that explore areas of culture that have previously received little attention, or that make a significant contribution to rethinking the ways in which cultural history is theorized and narrated.

Cultural Encounters: European Travel Writing in the 1930s
Edited by Charles Burdett and Derek Duncan

Images of Power: Iconography, Culture and the State in Latin America
Edited by Jens Andermann and William Rowe

Images of Power

Iconography, Culture and the State in Latin America

Edited by
Jens Andermann and William Rowe

Berghahn Books
New York • Oxford

First published in 2005 by
Berghahn Books

www.berghahnbooks.com

© 2005 Jens Andermann and William Rowe
First paperback edition published in 2006

Library of Congress Cataloging-in-Publication Data
Images of power : iconography, culture and the state in Latin America/editors,
Jens Andermann and William Rowe.
 p.cm.
Includes bibliographical references.
ISBN 1-57181-533-3 (alk. paper)
 1. Arts and society–Latin America. 2. Nationalism and art–Latin America.
3. Visual communication–Latin America. 4. Communication and the
arts–Latin America. 4.Communication and the arts–Latin America.
I. Andermann, Jens. II. Rowe, William.

NX180.S6I448 2004
306.4'7'098–dc22

British Library Cataloguing in Publication Data
A catalogue record for this book is available from the British Library.

Printed in Canada on acid-free paper

ISBN 1-57181-533-3 (hardback)
ISBN 1-84545-212-7 (paperback)

Contents

Part IV: Spaces of Flight and Capture

List of Illustrations

Introduction

The Power of Images

Jens Andermann and William Rowe

To suggest that images have a privileged purchase on power is hardly an original proposition. In fact, that representation and the artifact which sustains it exercise some kind of dominion both over the beholder and the referent they command into their domain, is indeed the fundamental, if sometimes unadmitted, assumption of all theories of mimesis, most notoriously in the case of their more obsessive cousins such as fetishism and sympathetic magic. As W. J. T. Mitchell (1986: 5–6) has argued, a deep mistrust and even fear of visual representation underlies a tradition in Western philosophical thought that has come down to us from the Platonic distinction between *eidolon* – that which provides a mere likeness (*eikon*) or semblance (*phantasma*) – and *eidos*, or idea, as that in which the true, spiritual essence of the (only apparently) material universe is crystallized. Yet it is in this spectral insubstantiality, precisely, that the image tends to return as the repressed other of language – and of written language in particular – which has supposedly exorcised it but in whose very substance it re-emerges in manifold forms of tropes, figures of speech, calligraphies and cryptographies. As in all antagonisms, then, in the contest between images and ideas, each of the contenders is from the very outset affected and contaminated by that which it constitutes as its other, and just as no writing is exempt from the stigma of idolatry, all images in one way or the other bear the mark, or indeed the inscription, of the verbal. Mitchell has gone so far as to suggest – borrowing an expression from Michel de Certeau – that all representation is therefore by nature 'heterological', or indeed that 'the interaction of pictures and texts is constitutive of representations as such: all media are mixed media, and all representations are heterogeneous; there are no "purely" visual or verbal arts, though the impulse to purify media is one of the central utopian gestures of modernism' (Mitchell 1994: 4–5).

While, then, the power of images in this strand of thought is related to what might be called their irrepressible supplementarity, from a quite different angle (to use a cinematographic expression) the linkage between power, knowledge and visibility has been analysed by Michel Foucault in his investigations into modernity's techniques of domination qua surveillance: the 'making visible' of bodies both subjectified and serialized, from the vantage point of incorporeal networks of panoptic observation, becomes, in this account, constitutive of the shift from sovereignty to discipline out of which the modern state emerges (Foucault 1980, 1991). Representation entails in this sense the distinction between that which can be visualised and hence objectified – the realm of the physical, the bodily, the subaltern – and the immaterial, disembodied reason of the law to which it succumbs; yet, paradoxically, the power of the latter can confirm and reproduce itself only in the endless production and proliferation of images. Hence also the – again paradoxical – affinity between the image and *ideology* (which, we may recall here, has been described by Althusser (1971: 127–186) as an act of language that slides into the visual, as an interpellation which sets in motion a 'mirror structure' that is 'doubly speculary', as the interpellated subject contemplates 'its own image' in the Absolute Subject to which it is thus subjected).

If the problematic, even enigmatic, relationship between images and power has already occupied modern critiques of representation to a great extent, recent developments in information technology have added a new urge to the question. Yet do digital imaging, synthetic holography, virtual environment helmets and multispectral sensors indeed nullify, as Jonathan Crary has suggested, 'most of the culturally established meanings of the terms *observer* and *representation*', as they 'relocate vision to a plane severed from a human observer' (Crary 1990: 1)? Or is instead, as Mitchell argues, the 'pictorial turn' in contemporary human sciences due to the paradox that, while the attitudes of idolatry, iconoclasm, iconophilia and fetishism are as old as image-making itself, these now confront 'the fantasy of a pictorial turn, of a culture totally dominated by images, [which] has become a real technical possibility on a global scale'? And do we therefore, as Mitchell goes on to suggest, need an updated iconology in the form of 'a postlinguistic, postsemiotic rediscovery of the picture as a complex interplay between visuality, apparatus, institutions, discourse, bodies, and figurality' (Mitchell 1994: 14–16)?[1]

This book seeks to advance the hypothesis that the link between images and power – that is, the cultural status of visual and other images, and the ways in which they are forged, circulated and reified – has a local and historical specificity which, at the very least, calls for caution when forecasting a cultural predominance of the image on a global scale. More concretely, the chapters collected here discuss the idea that the image, in

Latin America, historically constitutes a contested site, one at which fig-urations of identity and alterity are constantly reproduced as well as re-assembled and re-signified. National iconographies, as they become hardened and stabilized, viabilise the State as the central instance of inter-pellation, yet they seem to retain, at the same time, part of the charge of otherness from which their iconicity derives, and which, at certain his-torical junctures, may suddenly be unleashed in counter-images and anti-icons (think, for instance, of the equivocal trajectory of the image – and indeed the body – of Eva Perón, or of the changing fate of the various indianisms and indigenisms across the continent). The notion of iconog-raphy, then, is used here not merely in the narrow sense of a visual philol-ogy aimed at the recovery of lost or forgotten narrative contents, as it has come to be understood through certain parochial and reductive readings of the conceptual writings of Erwin Panofsky (1939, 1955), among oth-ers. Even though the intellectual and disciplinary traditions out of which the contributors to this volume argue are much more manifold, perhaps it does make sense here to briefly sketch out two of modernity's key con-cepts of iconicity, which have been most influential for the reconceptual-ising of the status and impact of the image in recent cultural criticism, and which could thus be conceived as opposite, yet comple-mentary, ends of the critical endeavour proposed by this book. One of these conceptual strands might be identified with the Warburg school's project of iconography as part of a 'general science of culture' *(allge-meine Kulturwissenschaft)* – of which Panofsky and Ernst Cassirer were the theoretical protagonists – and particularly with Aby Warburg's own attempt to formulate a theory of visual memory; the other could be said to take its cues from Walter Benjamin's roughly contemporary notion of the 'dialectical image'. Both concepts, as well as the intellectual enter-prises from which they stem, are of course profoundly intertwined, and might have been even more so had Benjamin's application to Warburg's Institute of the General Science of Culture in the late 1920s been suc-cessful. Let us, then, look briefly at these approaches and map out some of the different theoretical and methodological conclusions they may entail. In both cases, there is a challenge, which this book takes up, to think about images not solely as representations of cultural history, but as depositories and instruments of power.

Warburg's notion of the image was in the first place intended as a challenge to earlier conceptions of an autonomous art history brought forward by some of Jakob Burckhardt's disciples (foremost among them Wölfflin and Riegl), as one of visual forms and styles embodying certain ideals and moods supposed to be of ontological status and thus removed from historical change. In contrast, Warburg opposed such normative formalism as much as a naïve, unreflected hermeneutic empathy, and

instead claimed that a work's content *(Gehalt)* and meaning could only be assessed in determining its particular, functional relation to wider symbolic chains, both those particular to its specific historical location and those which had been preserved and transmitted across the ages. Rather than towards a formal history of art, then, iconographic interrogation of the image would breach out into an attempt to understand the functioning of social memory through the ways in which images re-present fragments of past discourses and belief systems otherwise submerged by historical change. As Edgar Wind suggests in an early theoretical synthesis of the Warburg group's intellectual project, first published in 1931, this reconception of art criticism as a cultural theory of memory was principally informed by a 'bipolar theory of the symbol' inspired by the neokantian aesthetic of Friedrich Theodor Vischer: following Vischer, Warburg conceived the symbol initially as a juncture between the image (any kind of visual object) and meaning (a concept materialised in language). This juncture, however, is articulated in fundamentally antagonistic ways at different stages of the history of cultures. In his 'Lecture on Serpent Ritual', first published in 1939, Warburg describes the Hopi snake dance as a manifestation of the first, 'magically binding' conception of the symbolic, which characterizes the 'religious mind': the 'animal dance' is thus analysed as a 'self-loss to a strange being', as 'that which links man to the forces of nature' or, 'in other words, the magical act, which produces a bond that is experienced as real' (Warburg 1988: 24–5).[2] The controversy over the Eucharist marks the point of inflection or crisis of this religious, sympathetic notion of the symbol, as it is opposed by another, 'logically dividing', conception, which manifests itself in the 'just as' of comparison. There is thus a notion of the symbol which is not yet a sign, but the insoluble, magic unity of image and meaning, and a quite different conception that rests on the production of comparison, and which is most clearly realised in allegory. It is in the tension between these two notions, or in 'the critical phase, in which the symbol is understood as a sign and yet retains its liveliness as an image, where the excitation of the soul, held in a tense balance between these two poles, is neither concentrated by the binding force of metaphor to the extent of being released into action, nor dissolved by the dissembling order of thought to the point of being dematerialized into a mere concept,' that Warburg posits the iconic image. This means, at the same time, that the 'harmonious expression' of art is always nourished by its most radical opposite, that which Warburg calls the 'darkest energies of human life' (Wind 1994: 175). As for Warburg, therefore, there is no fundamental difference between artistic and gestual, or even motoric, expression, since art itself emerges from a region where expression is conceived as unmediated, while the body, on the other hand, is the bearer of a physiological memory that is always already metaphor-

ical; even the most discrete and minor gesture or detail can become endowed with iconic properties, or saturated with mnemonic energy. Iconography, then, rather than the study of the work as product, is a concern with its production at the nodal point of the transmission – of preservation as well as transformation – of cultural forms and contents on the borders, or in-between spaces, of discourses and disciplines, and of past and present.

For Benjamin, the 'dark energies' which endow the image with a power that reaches far beyond its 'form' or 'content', were not so much, as for Warburg, those emerging from the visual, gestual, or even physiological memory of an archaic phase prior to the split that constitutes the symbolic order. Rather, they were the product of the resurgent archaic within capitalist modernity itself, in its infinite proliferation of *wish images* projected onto the surface of the commodity, and which charge it with a desire as yet unconscious of itself. Commodity culture, Susan Buck-Morss (1989) has suggested, becomes in Benjamin's gaze a modern version of Baroque emblematic. Instead of merely denouncing the ideological delusion of modern capitalist idolatry, however, Benjamin's work sought to incorporate and develop the image into a critical strategy, one capable of opening up and rescuing the contingents of social desire locked up, as it were, in the wish image. As Theodor W. Adorno puts it, Benjamin's own *dialectical images*, creatively exploring the intellectual potential of surrealist montage, created 'picture puzzles which shock by way of their enigmatic form, and thereby set thinking in motion' (Adorno 1970: 53). In her brilliant experimental reconstruction of Benjamin's Arcades project, Buck-Morss has described this philosophical method as a 'dialectics of seeing', one that relies 'on the interpretative power of images that make conceptual points concretely, with reference to the world outside the text' (Buck-Morss 1989: 6).

Reference, of course, as a relay that inexorably slides down the metonymic chain of memory, had been precisely the point at which Warburg's critical revision of hermeneutics had set in. In a way, we could understand the different conceptions of iconicity and the critical use to which they are put in Benjamin and the Warburg school art historians, as a difference in the degree and purpose of suspicion towards the image. For Warburg, the image's source of power had been one that profoundly opposed the divisive, analytical regime of reason and language, even if it also secretly inhabited it: the mission of these latter, therefore, lay in the disentanglement of memory's intricate paths, of which the image was seen to be an enigmatic crossroads. Iconography, in other words, had to turn the attention of consciousness to the unconscious grip which the image exercises over us.[3] Meanwhile, Benjamin sought to wield the image into a strategy not only of unveiling the present condition, but of

making apparent its immanent desires for redemption, at the same time as it is only as an image that flashes up, unexpectedly, at a moment of danger, that historical memory can be saved from the threat that hangs over past and present (Benjamin 1969: 253–64). The image, in other words, has to be forged into an instrument of political struggle, rather than be tamed by the dissecting, analytical gaze of the specialised researcher.

It is in the double sense outlined here that this book attempts to advance the subject of iconography and the state, both as an object of study and as a means to re-politicise the practice of Latin American cultural studies. As such, it constitutes both an attempt to broaden cultural research beyond the limits of the lettered city – thanks to the encounter of different intellectual trajectories within disciplines as diverse as anthropology, literary criticism, art history and the history of science – and to conceive iconography as a key site of the cultural manufacture of the scene of politics in Latin America. The chapters of this book map out the question of iconography and the nation-state in an order that is thematic and, at the same time, roughly chronological. The first section discusses the ways in which, from the late colonial era to post-independence republicanism, images of the nation-state and the public sphere of their consumption emerge in a process of mutual implication. Section two further pursues the trajectory of the figurations of difference and locality in the modern languages of avant-garde art, literature and music, while section three looks at the ways in which modern state power had to be radically reconceptualised in the face of a new political and cultural subject, the mass or multitude, whose mobility and fugacity had to be captured by and in new images of collectivity. The fourth section, finally, analyses the construction of modern territorialities as providing the ground upon which these political iconographies were to be staged, as well as their dismantling in the new global order of porous spaces and transterritorial identities.

The chapters included in the first section discuss visual and mnemonic strategies of representing the colonial and national collectives of the eighteenth and nineteenth century. Magali Carrera, in 'From Royal Subject to Citizen', analyses the shift in visual representations of the body before and after Mexican independence, in their relation to the contemporary process of recharting the *colonial* as *national* territory: the space of the nation, she argues, is mapped onto the idealised body of the citizen, but at the same time this reterritorialisation of the state is a form of capture of the citizens' bodies, which submits them to new forms of behavioural control. Whereas the colonial human image (both as portrait and as *pintura de castas*) had focused less on individual than on typified, corporate bodies that made up the physical integrity of the colonial state (imagined precisely as a hierarchised, anthropomorphic body), the national image will, in contrast, draw upon an allegorical, individualised body that

nonetheless continues to take its inspiration from colonial forms of typification. Gordon Brotherston presents those longer continuities of transmission, which have often wilfully been obscured, between native Mexican texts *(tlacuilolli)* and literature, art, film, and practices of popular memory in Mexico. The endurance of non-Western signs, image-concepts, and formats has been closely linked with the failures of the state to invent an inclusive iconography, and in the postrevolutionary period became a vehicle for mobilising concepts of collective space and time for a critique of official versions of history. The mixing of native iconographic traditions with those brought from Europe allows a critical reading of the visual languages used to construct centralised power in Mexico.

Nineteenth-century public space, as Beatriz González Stephan shows in her chapter on Venezuela's first national exhibition, held in 1883, became a site of negotiations not only about ethnicised but also about the gendered images of power which emerge in the context of state consolidation. Antonio Guzmán Blanco's regime of authoritarian modernisation, she suggests, in the name and image of a Bolívar transformed into phallic founding father, created by means of architecture, the display of industrial machinery, and fine arts exhibitions (shows focusing on the 'male' materials of sculpted stone and oil on canvas), a patriarchal and phallocentric imagery of progress and citizenship. However, the spaces of performance of these images, such as the national exhibitions, also provided opportunities for alternative subjects (women, mestizos, etc.) to introduce minor, subaltern materials and themes, or to appropriate the state's signifiers. Thus, for instance, 'natural hair portraits' woven by female 'artisans' such as the one depicting Policarpa Salavarrieta, a heroine of the Independence struggle, show to what extent the gendered image of the state is always a contested one. These subalternised forms can be conceived, González suggests, as paradoxical objects that depict the 'hard' subject of 'the fatherland' using the 'bland' materials its official imagery seeks to suppress and marginalize. While the space of the exhibition – an event of limited duration – is thus not only one of the canonisation of dominant images of the nation-state, but also of the emergence of alternative, potentially subversive, counter-images, the foundation of museums – as Alvaro Fernández Bravo suggests in the following chapter on the creation of history and fine arts museums in Argentina – arises as an attempt to put an end to iconographic instability, and thus to confer an imaginary *longue durée* to the symbols of victory of one particular political faction. In the face of the 'threat' of cosmopolitism detected in the immigrant masses arriving from overseas, the Argentine elite of the late nineteenth century sought refuge in 'museumisation', granting public visibility to historical relics formerly in the possession of a handful of families, but now exposed to the citizenry as a 'shared her-

itage': the citizen, in other words, is supposed to be first of all a specta-
tor, one who gazes at, rather than acts on, the stage of history.

In contrast, the essays collected in the second section discuss the ways
in which the themes of alterity and locality have informed the production
and reception of Latin American art at different stages of twentieth-cen-
tury modernity. Trinidad Pérez, in 'Exoticism, Alterity, and the
Ecuadorean Elite', links Antonio Cornejo Polar's discussion of the
reader's position in indigenist literature to Panofsky's notion of perspec-
tive as a symbolic form: the encounter, in the work of Ecuadorean artist
Camilo Egas, between colonial iconographies of the Indian and a modern
painterly vocabulary and forms, she argues, results in a double detach-
ment, not only of the beholder's gaze from the image, but moreover of the
circuit of production and consumption of fine art from the 'subaltern'
subject matter that supposedly informs its meaning. Although the Indian,
in Egas's work as well as in contemporary ethnographic and political
writing in Ecuador, is rhetorically proclaimed as a symbol of the nation,
his artistic representation runs contrary to the shared cultural identity it
suggests. Florencia Garramuño, in the following chapter, analyses how
tango and samba music pervades narrative and the visual arts, to produce
'primitivist iconographies' of Argentina and Brazil. 'Primitivism', she
argues, in the avant-garde as well as in urban upper-class cultural con-
sumption in general, changes its location in early twentieth century from
a reason for exclusion into one for inclusion. At the same time, however,
writers involved with modernising projects rivalling those of the avant-
garde, such as social realism, take up tango and samba as narrative tropes
to denounce the 'corrupting' impact of modernisation. Primitivism,
rather than as a fashionable quote, becomes associated here with the
tragic pitfalls of modernity's promise of social mobility – the very phe-
nomenon that has made the trajectory of tango and samba from the out-
skirts to the city centres possible.

While modern artistic production as discussed by Pérez and Garra-
muño attempts to forge images that are both 'up to date', at the height of
universal modernity, and embedded in local memory and tradition, the art
of the Argentine avant-garde of the 1960s is shown by Andrea Giunta to
have been systematically stripped of any trace of locality. The 1965 exhi-
bition *Argentina in the World*, a key event of the cultural *movida* spon-
sored by the Instituto Torcuato di Tella as part of a concerted action to
refocus Argentine art after the fall of the first Peronist regime, attempted
nothing less than to merge local production completely with contempo-
rary 'international style'. In a strange recycling of an earlier Brazilian
avant-garde's slogan – 'art for export' – the national identity of Argentine
art was now to be established not by emphasizing its local distinctiveness,
but by seeking its *in-difference*, its lack of particularity, to be confirmed

on behalf of the leading lights of international art criticism. As Giunta points out, the notion of artistic freedom as, first and foremost, one from art's location within geographically and historically specific cultural and socioeconomic struggles, also played a key part in the U.S.-funded ideological counter-offensive against the Cuban revolution known as 'Alliance for Progress'. However, she suggests, over-insistence on the 'international style', rather than gaining Argentine artists a recognition of their contemporariness, provoked a new demand for a recognizably 'local' content on the part of the metropolitan art scene: the universal temporality of 'international style' had, in fact, never implied the possibility of a place for artists working on its margins.

The politics of locality proposed by the historical avant-garde, then, was turned upside down in Argentina following an experience of populism which, for many artists and intellectuals, had been a traumatic one. The third section analyses the representations that the emergence of masses and multitudes as political and cultural actors of Latin American modernity has generated from the late nineteenth century to this day. In chapter 8, Hendrik Kraay looks at the ways in which earlier, Imperial representations of the popular classes were refashioned, at the beginnings of the Brazilian Republic, into a new, monumental image of collective identity. Analysing the construction of a monument to independence at Salvador de Bahia, whose use of the popular image of the *caboclo* warrior sought to recall as well as replace by a new civic ritual the more performative, traditional celebrations of local identity, Kraay argues that monuments, while attempting to petrify the flow of memory, inexorably become ephemeral unless they succeed in integrating new ritual contexts, which regularly reclaim, indeed remonumentalise them. In Bahia, on the contrary, a bifurcation of mnemonic rituals occurred, as 'the nation' and 'the people' became two notions spatially and ritually separate from one another. At the same time, Kraay suggests, the failure of the 'Republican ritual' allows one to read its 'Imperial' predecessor in a new light, as one that had succeeded in theatricalising, and thus conferring a durable form to the tensions between these two antagonic notions.

A similar ambiguity is suggested in Andrea Noble's analysis of photographs of the Mexican Revolution, particularly the iconic image depicting Francisco 'Pancho' Villa in the presidential chair, flanked by Emiliano Zapata. Thanks to a synecdochal operation, this brief moment in December 1914 came to stand for the entire revolution, or rather, Noble suggests, imaginarily transformed a long, contradictory struggle for hegemony into a single moment of rupture. However, the iconic power of *Villa en la silla* derives not only from the appropriation of its national-popular visual rhetoric (the two *caudillos* surrounded by a male, multiracial 'sea of faces') on behalf of the triumphant conservative fac-

tion. Rather, the image's power lies in its ongoing ability to transform itself into counter-memory, one whose meaning turns on the disavowal of what might-have-been: iconicity, Noble proposes, is a form of compulsive repetition, here of the repressed of the revolution which is, precisely, popular power. In what could be read as an attempt to theorise the historical readings of the preceding chapters, but also as another case study contrasting photographs of mass gatherings in Argentina with literary texts by Arturo Cancela and Osvaldo Lamborghini, Graciela Montaldo in the final chapter of the section, characterises masses as a figuration of the internal aporias of the modern project of the nation. Masses are the illegitimate subjects of the *polis*, as they are devoid of speech and ratio: represented as pure physical presence – a mutable and de-individualised cluster of bodies – the masses are the antagonistic other of the figure of the intellectual who, as pure voice/ratio, dwells on the opposite limit of civic space. However, Montaldo reminds us, the performance of the masses and of mass violence, in the political arena of the Argentine cities, has been a contradictory one, not necessarily constrained by class divisions, ever since the pogroms committed by Creole upper-class mobs during the *Semana Trágica* of 1919. It also has gendered connotations, as to become a mass is to be stripped of the physical carcass of a civic identity modelled in the image of the masculine (insertive) body, and to become part of a feminised (receptive) collective body exposed to the penetrative and punishing actions of the state.

The final section comprises three very different approaches to one of the nation-state's paramount forms of visual capture, the territorialisation of space. Claudio Canaparo, in his chapter on the conquest of the Argentine south, makes the provocative point that, rather than purely on military violence, the production of national territory chiefly relied on the submission of space to new regimes of velocity, as generated by the railway and the telegraph, technologies that erased earlier forms of locality and produced a territory-in-movement, whose directionality and unified time pointed inevitably to the port-capital. Drawing on Paul Virilio's 'dromological' account of modernity, Canaparo shows military and audiovisual technologies (the new, long-range Remington rifles introduced into the Argentine army in the wake of General Roca's 'Desert Campaign', and the development of communication technology from 'marconigraphic' waves to cable television) to have been two complementary forms of territorial capture, thanks to which not only the ground itself but also the 'atmosphere' could become the object of striation on behalf of the state. Whereas Canaparo suggests that the notion of Patagonia as a 'desert' resulted from a symbolic emptying-out of space, to allow for its technological re-territorialisation, Gabriela Nouzeilles, in her reading of late nineteenth-century travel narratives to Patagonia, shows it to have been submitted to the

trope of desertification since its very 'discovery'. The Jungle and the Desert can be read, she argues, as the external effects of a narrative of self-fashioning on behalf of a particular masculine subject, the Explorer, who constructs spatial exteriors so as to distinguish himself from the Tourist and the Traveller, two 'lesser' representatives of the adventure of European colonial expansion. Instead of the rationalist dominion of savage space embodied by the colonial traveller, the explorer has to defect partially to the opposite pole of 'savagery', encountered in the 'extreme' landscapes of excess and of emptiness, so as to re-assert a masculinity that is imagined to be as much on the retreat as nature itself, in the face of the advance of tourism and the commodification of space it supposedly entails.

In the final chapter, Mary Louise Pratt takes the bifurcations of Mexico's second-most important religious icon, the Virgin of Zapopan, as the departure point for a meditation on space, place, and community under the sign of transnational capitalism. As early as in the eighteenth century, a second version of the Virgin had emerged, called *la peregrina*, which was to travel through the adjoining parishes and thus to link the colonial city with the surrounding *campo* as a shared, and centred, ritual community. Towards the end of the twentieth century, yet another incarnation of the Virgin surfaced among immigrant workers in California, called *la viajera*: the two travelling Virgins, then, could be seen to indicate the opposite ends of the historical cycle of the modern nation-state, and to propose alternative experiences of territoriality as a negotiation between mobility and dwelling. To analyse these new forms of movement of individuals, communities, and the narratives, memories and ritual practices they bring along and re-adapt to their new surroundings, Pratt reminds us, means in the first place to criticise the metaphor of 'flow' as one of the most perfidious ideological figures of neoliberal rhetoric, one that is routinely used to denounce the solidity and solidarity of the social as 'encrusted old structures'. In fact, Pratt tells us, the nomads of the twenty-first century do not flow but they sometimes drown, and their 'movement' significantly takes place, more often than not, while caged into the back of trucks or the underbelly of ships and planes. Against these rhetorics of flow, as a supposedly multidirectional fluidity of commodities, culture, living and dead labour, Pratt opposes a vision of dispossession and accumulation, processes which, rather than a transnational reciprocity, generate uncanny narrative 'returns' in the form of the new 'monsters of globalisation' (killer bees, *imbuches*, *chupacabras*, etc.).

However different in aspect, these popular counter-images of globalisation as well as the stigmatised figures of illegal migrants to which they respond, recall in a strange way the typifications of colonial bodies in

their allegorical relation to pre-national forms of territorialisation, which Magali Carrera analyses in the opening chapter of this book. It would seem, then, that the analytical juncture proposed in the subtitle of this volume – iconography, culture, and the state – as a means of approaching the aura-laden, affectively and fetishistically invested figurations of the state and its image, and the ways in which they command our reverence and submission, is only becoming visible at the present moment because the spell of the state-form in its modern, enlightened national version is vanishing into the thin air, which had probably been its true substance from the very outset. But rather than to release us into a less 'idolatric' future devoid of the worship of images of power, it seems this crepuscular moment will only prelude the dawning of new images, some of which already take shape on the horizon. If the magic of the state, to use Michael Taussig's (1997) expression, seems to be on the retreat, nevertheless the power of images and their proliferation appear to be as vivid today as they have been over the course of much of what we now subsume, in a retrospective or even nostalgic mood, as modernity. It is the need to find the instruments to deconstruct and criticise the new images of a postnational global order, then, rather than merely the historical interest in the interpretation of past constellations, which informs the intellectual quest the chapters of this volume are seeking to initiate.

Notes

1. Mitchell (1994: 4) distinguishes between 'picture' and 'image', the former indicating the 'constructed concrete object or ensemble (frame, support, materials, pigments, facture)', the latter 'the virtual, phenomenal appearance that it provides for a beholder'. More generally, then, a picture is the result of a historical process of production, the components and phases of which remain visible, while an image confronts us as a self-sufficient monad which has effaced (or 'contained', in a Hegelian sense of the term) the traces of its own making.

2. Warburg's 'Lecture on Serpent Ritual' was first published in English translation in the *Journal of the Warburg Institute* 2 (1939): 277–92. We are quoting from the reconstructed German version, translation J.A.

3. It is not a minor detail, in this regard, that one of Warburg's theoretically most ambitious renderings of the programme of iconography as a theory of human cultural memory, the 'Lecture on Serpent Ritual', was composed in 1923 during Warburg's internment at Ludwig Binswanger's – the founder of Gestalt therapy – psychiatrical clinic. The lecture, first given to a public of medical staff and fellow patients, was thus as much the expression of a programme of self-healing as an inquiry into the tense relationship between mythology and reason.

Bibliography

Adorno, Theodor W. 1970. *Über Walter Benjamin*. Frankfurt a. M.: Suhrkamp.

Althusser, Louis. 1971. 'Ideology and Ideological State Apparatuses (Notes Toward an Investigation)', *Lenin and Philosophy*, New York, Monthly Review Press.

Benjamin, Walter. 1969. 'Theses on the Philosophy of History', in: *Illuminations* (ed. Hannah Arendt). New York, Schocken.

Buck-Morss, Susan. 1989. *The Dialectics of Seeing: Walter Benjamin and the Arcades Project*. Cambridge, Mass.: The MIT Press.

Crary, Jonathan. 1990. *Techniques of the Observer: On Vision and Modernity in the Nineteenth Century*. Cambridge, Mass.: MIT Press.

Foucault, Michel. 1980. *Power/Knowledge: Selected Interviews and Other Writings, 1972–1977*, ed. Colin Gordon. New York: Pantheon Books.

———. 1991. *Discipline and Punish: The Birth of the Prison*. Harmondsworth: Penguin.

Gruzinski, Serge. 2001. *The Image at War: From Christopher Columbus to Blade Runner (1492–2019)*. Durham, NC: Duke University Press.

Mitchell, W. J. T. 1986. *Iconology: Image, Text, Ideology*. Chicago, London: The University of Chicago Press.

———. 1994. *Picture Theory*. Chicago, London: The University of Chicago Press.

Panofsky, Erwin. 1939. *Studies in Iconology*. New York: Oxford University Press.

———. 1955. *Meaning in the Visual Arts: Papers in and on Art History*. Garden City, NY: Doubleday Anchor.

Taussig, Michael. 1997. *The Magic of the State*. New York, London: Routledge.

Warburg, Aby. 1988. *Schlangenritual: ein Reisebericht*. Berlin: Verlag Klaus Wagenbach.

Wind, Edgar. 1994. 'Warburgs Begriff der Kulturwissenschaft und seine Bedeutung für die Ästhetik', in *Ikonographie und Ikonologie: Theorien, Entwicklung, Probleme*, Ekkehard Kämmerling (ed.), Köln, Dumont.

Part I

Memory and the Public Arena

Chapter 1

From Royal Subject to Citizen
The Territory of the Body in Eigtheenth- and Nineteenth-Century Mexican Visual Practices

Magali M. Carrera

> The present of the world, that appears through the breakdown of temporality, signifies a
> historical *intermediacy*,…whereby the past dissolves in the present, so that the future
> becomes (once again) an *open question*, instead of being specified by the fixity of the past.
> Homi Bhabha, *The Location of Culture*

Introduction

Colonialism attempts to essentialise or fix the colonial subject in deter-
minate forms, the colonised native or miscegenated body, and static time
to produce an inflexible present, justified by the events of the past and
structured to presume an unquestioned colonised future.[1] In eighteenth-
century New Spain, colonialism was given intense visual form across
secular art through imagery that disparagingly depicted indigenous peo-
ple, as well as those of mixed blood, who existed at the margins of the
contemporary metropolis of Mexico City. This imagery was historicised
through references to the Spanish conquest as religiously mandated and
politically ordained. Colonialism in New Spain was rendered visible
through corporeality and contemporaneity.[2]

In the nineteenth century, as New Spain confronted the protean possi-
bilities of political independence, the issues of the body and time would
continue to be enunciated visually. As a result, to regain agency, nation-
alist imagery would reclaim and redeem colonial bodies from colonial
time. Nineteenth-century imagery would reconstitute the colonial body,
negate its static, colonised present and place a new nationalist body into
an interstitial future – one that emerged from the claims of the colonial
past and the present hopes of independence. This paper explores these
broad issues of the body and time through an examination of the secular
art of eighteenth-century and nineteenth-century New Spain.

From Royal Subject to Citizen

One of the most well known paintings of nineteenth-century Mexico is José Obregón's *Discovery of Pulque* (figure 1.1). The 1860s image recounts the legend of the fermented maguey drink, *pulque*, discovered by a young Indian woman. Working in a neoclassic academic style, Obregón depicts noble Indians as a cultured, intellectually inquisitive people placed among their artistic and architectural achievements. A second important painting of the nineteenth century is Petronilo Monroy's *Allegory of the Constitution of 1857*, exhibited in 1869 (figure1.2). In this canvas, a life-size allegorical figure, a beautiful *mestiza*, a woman of mixed Spanish-Indian blood, hovers among the clouds carrying tablets inscribed with the words 'Constitución de 1857'. These paintings and others like them have been identified by scholars as seminal works in the development of a nationalist art of the nation-state that Mexico was striving to become during the 1800s.

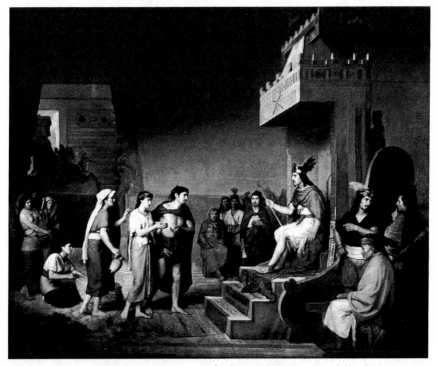

Figure 1.1 José Obregón, *The Discovery of Pulque*. Oil on canvas, exhibited 1869, approx. 186 x 231 cm, Museo Nacional de Arte, México (DF).

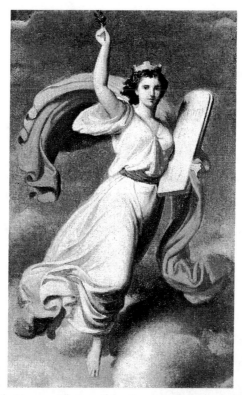

Figure 1.2 Petronilo Monroy, *Allegory of the Constitution of 1857*. Oil on canvas, exhibited 1869, approx. 170 x 90 cm, Museo Nacional de Arte, México (DF).

In her thought-provoking book on nineteenth-century painting, Stacie Widdifield concludes that history paintings like Obregón's *Discovery of Pulque* embody a search for an authentic and originating history, while Monroy's allegorical female can be seen to embody Mexico as a nation, a conclusion I subscribe to and wish to explore further (Widdifield 1996: 51–56, 91–93, 145). Specifically, I wish to examine how notions of 'the body' and embodiment may have become implicated in nineteenth-century nationalist painting. I will argue that certain eighteenth-century secular paintings laid out the static sociopolitical territory of the royal subject's body visually. At the same time, specific late-colonial writings proposed new ways of thinking about how time – past and future – was implicated in nation building. I conclude that, through these new frameworks of time, Obregón and Monroy revise and transform the eighteenth-century political and social construction of the body of the royal subject into that of the nationalist body.

While much of eighteenth-century painting in New Spain takes up religious themes, the secular painting may be seen to display and reference a vast array of *kinds* of bodies. These include political bodies, such as the

image of the late-century viceroy Revillagigedo in figure 1.3; elite social bodies such as those of the *peninsulares* (Spaniards born in Spain) or *criollos* (Spaniards born in New Spain and their descendants); and *caciques* (noble Indians) as shown in figure 1.4. Another genre of secular painting, *casta* paintings, emphasises non-elite social bodies. Typically produced in a series of twelve by sixteen panels, these paintings portray men, women, and their offspring classified in a hierarchy according to their proportion of Spanish blood; the lessening of Spanish blood denoted genealogical and, thus, social degeneration. For example, in figure 1.5, the first panel of such a series by an unknown painter, we see a Spanish man and an Indian woman with their offspring, a *mestizo,* as they stroll through the countryside. Continuing onto the fifth panel, we see a Spaniard with a *mulatto* woman and their son, a *morisco*, placed in their tobacco/cigarette store (figure 1.6). By panel twelve, we see vendors selling their goods on the streets of Mexico City (figure 1.7). The people in these serial images are placed in locales which vary from domestic interiors to city spaces, or open, lush landscapes; within these settings, material objects appropriate to *casta* life, such as clothing, foodstuffs, and vocational/trade items, are depicted according to their socio-economic status, that is their estate.

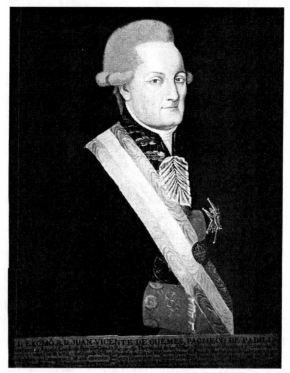

Figure 1.3 Anonymous (attributed to Felipe Fabres), *Juan Vicente de Güemes Pacheco de Padillo, conde de Revillagigedo.* Oil on canvas, late eighteenth century, 92 x 69 cm, Museo Nacional de Historia, México (DF).

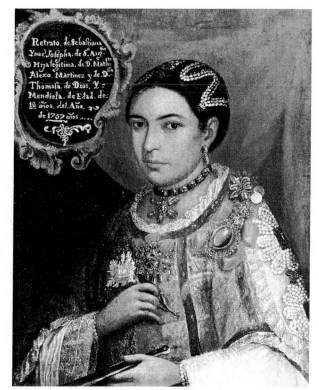

Figure 1.4 Anonymous, *Retrato de Doña Sebastiana Inés Josefa de San Agustín. Hija legítima de Don Mathias Alexo Martínez y Doña Thomasa de Dios y Mendiola. De edad de 16 años de año de 1757 años.* Oil on canvas, 1757, 58.2 x 47.7 cm, Museo Franz Mayer, México (DF).

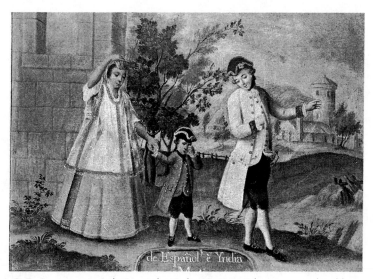

Figure 1.5 Anonymous, *1 de Español e Yndia Mestizo.* Oil on canvas, dated last quarter of the eighteenth century, 36 x 48 cm, Museo de América, Madrid.

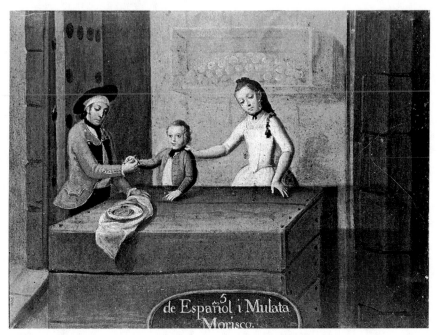

Figure 1.6 Anonymous, *5 de Español I Mulata Morisco*. Oil on canvas, dated last quarter of the eighteenth century, 36 x 48 cm, Museo de América, Madrid.

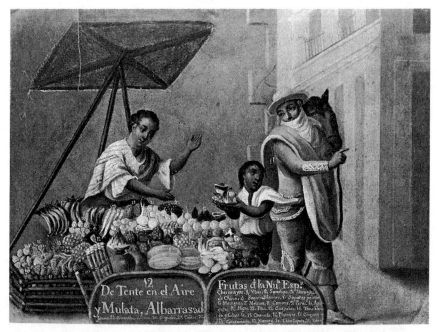

Figure 1.7 Anonymous, *12 de Tente en el Aire y Mulata, Albarrasado*. Oil on canvas, dated last quarter of the eighteenth century, 36 x 48 cm, Museo de América, Madrid.

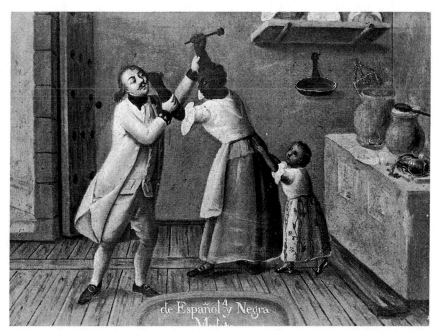

Figure 1.8 Anonymous, *4 de Español y Negra, Mulato.* Oil on canvas, dated last quarter of the eighteenth century, 36 x 48 cm, Museo de América, Madrid.

Casta painting and portrait painting have been treated by scholars as separate and distinct visual practices (Burke 1998; Vargaslugo 1994). While images of elites tend to derive from the portraiture traditions of Europe and Spain, the very limited documentation on *casta* paintings has thwarted scholarly understanding of their origin, meaning and function; current scholarship generally explains the images as depicting a taxonomy of race (Katzew 1996: 13–14).[3] In contrast, I believe portraiture and *casta* paintings to be closely related visual practices. Both are embedded in the broader discourse of the body and, specifically, the kinds or categories of bodies that constitute the disparate political and social territory of the royal subject of late-colonial New Spain.

Recent scholarly research in the fields of art history, history and literature has begun to explicate the fundamental importance of the trope of the 'body' in the thinking of seventeenth- and eighteenth-century Spain and New Spain. For example, scholars have shown that various parts of the human body were assigned to different classes and professions (Fee 2000: 89; Caro Baroja 1992: 91–102). Furthermore, in his recent dissertation study of viceregal power, Alejandro Cañeque (1999: 4–6), a historian of seventeenth-century New Spain, has argued convincingly that the metaphor of the body is critical for understanding the political discourse of much of the history of New Spain. In particular, this corporeal trope is

important in tracing the evolution of the early modern concept of the nation-state, which, as an essential concept that unifies and gives cohesion to a political community, did not enter the political imagination of Spain before, if not 1900, at least 1800. After a careful analysis of the rights, prerequisites and prerogatives of certain social estates of New Spain such as the guilds, nobles, etc., Cañeque writes,

> Early modern society was populated by 'imaginary persons' ... such as the estates or corporations of diverse rank ... *The 'individual' as an 'indivisible' person, as a unitary subject of rights, was nonexistent.* This way of conceiving the political community had one fundamental implication: *the multiplicity of estados (estates) and the absence of individuals made the existence of the Estado (state) as the only depository of the subjects' loyalties impossible.* (1999: 349, n. 79) (italics mine)

That is, in terms of the formation of the political structure of New Spain, the 'logic of the Spanish monarchy was not one of centralisation and uniformity but of a loose association of all its territories [and bodies], a logic very different from that of the centralised sovereign nation-state' (26–27).

As a result, political power was dispersed into an array of relatively autonomous centers, whose unity was maintained, more symbolically than in an effective way, by reference to a single head. Using sixteenth- and seventeenth-century political treatises and other primary documents, Cañeque asserts that:

> this dispersion corresponded to the dispersion and relative autonomy of the vital functions and organs of the human body, which ... served as the model for social and political organisation. This vision made impossible the existence of a completely centralised political government – a society in which all power was concentrated in the sovereign would be as monstrous as a body, which consisted only of a head. The function of the head of the body politic, that is, the king, was not, therefore, to destroy the autonomy of each of its members but to represent, on the one hand, the unity of the body politic and, on the other, to maintain harmony among all its members. (1999: 186)

Recurring visual public spectacles, processions and official events, asserted and affirmed the trope of the body as central to the political practices of New Spain. For example, in Mexico City, the 1666 funeral procession marking King Philip IV's death was organised to demonstrate that the community was a harmonious and hierarchised body. The procession began with the black and mulatto confraternities, followed by the Indian and Spanish confraternities. After these groups, came the elite Spaniards who were members of colleges and seminaries, the religious orders, the clergy and the ecclesiastical chapters. They were succeeded by the royal tribunals followed by the royal insignias of the sceptre, sword and crown and other important officials. Finally, the viceroy appeared with the senior judge at his right. This ordering of the procession made it clear that although the plebeians' role was not to rule the community, they were,

nevertheless, rightful members of the body politic; specifically, in the language of the period, they were not its head but its feet. That is, the physical space they occupied in the procession indicated the position they occupied in the political community: they were literally performing their place in the body politic (Cañeque 1999: 324–26).

In New Spain, Cañeque concludes, the Spanish Monarch did not so much try to impose a 'colonial state', as to reproduce the idea of kingship as based on the view of the political community as a political body, a corporation. New Spain was not conceived of as a totally subordinate, satellite territory tethered to a political center; it was, rather, considered a kingdom, based in the metaphor of a human body, constituted of disparate, independent yet intra-dependent members with a common head – the king/viceroy.

The notion of the body also structured the social discourse of New Spain. In her book, *Embodying Enlightenment*, Rebecca Haidt, a scholar of eighteenth-century Spanish literature, has explained how 'the body' functioned as one of the most basic tropes in eighteenth-century European cultures and how the outward appearance of the human body was perceived as 'discursive, a telltale transcript of the identity it housed' (Haidt 1998: 5). She argues that in late seventeenth- and early eighteenth-century Spain, numerous Enlightenment discussions by writers like the influential intellectual Benito Feijoo (1676–1764) and others structured ideas around expanding scientific knowledge of the human body. In part, they focused on renovating the nomenclature of human anatomy. These discussions, however, became intertwined with physiognomics, a concept traced back to Greek and Roman texts that diagnosed a person's interior disposition, fate or character though a visual examination of the body's external appearances (Haidt 1998: 125). Using physiognomic rationale and relying on a diagnostic gaze, the body (particularly the male body) was observed as legible through assessment of 'external bodily characteristics as a system of signs representing the invisible inner character' (107). Physiognomics did not identify specific persons but analyzed exterior human features and extrapolated the content of inner moral and ethical character (Haidt 1998: 108). In Spain this discourse on the body proved useful, furthermore, to promote better identification and maintenance of the king's subjects.

This same approach to the construction of the social body is evident in the culture of New Spain, as well. Identification, ordering, maintenance and control of the elite and non-elite body were the focal points of numerous edicts and laws promulgated in the eighteenth century. Thus, for example, in 1786, the king approved a plan which divided Mexico City into eight administrative units called *cuarteles mayoress* and subdivided each of these into four smaller units known as *cuarteles menores*,

for a total of thirty-two jurisdictional units. Each *cuartel mayor* had an *alcalde*, a chief magistrate, charged with supervision of his unit and each *cuartel menor* had a constable for further oversight. The *alcalde* was charged with preserving social order and required to watch over daily events in his assigned district. He was to keep detailed and accurate *cuartel* records, which included a list of residents, stating each person's Christian and surname, marital and social status, and occupation, and was also to record commercial establishments and artisans' workshops. In addition, this local overseer was responsible for the maintenance of municipal services and for communicating with other *alcaldes* to exchange information about changes in *cuartel* inhabitants' residences. This system promoted better coordination among law enforcement agencies, municipal authorities and the judicial system.[4]

Supplementary regulations in the *cuartel* system also made easier the constant surveillance of people. In 1762, a viceregal order was issued stipulating that residents should place a lamp at every door and balcony and keep it lit until eleven o'clock at night; the residents, however, refused to pay for the required oil. The order was reiterated in 1783 and again in 1785 and 1787, but for the most part, the streets remained dark. Night illumination was not reliable until 1790 when the viceroy ordered the installation of a thousand lamps and their upkeep by paid night watchmen. In addition, a signage system clearly marking streets and plazas was implemented in 1790. City spaces were now organised for daytime as well as nighttime surveillance.[5]

Alongside this comprehensive reorganisation and regulation of the city, specific problematic spaces or sites were also addressed. The *paseo*, a somewhat ritualised promenade through certain public spaces, often parks, was a common leisure activity of the elite. During the *paseo*, elite status was flaunted through the display of ostentatious clothing and coaches. In the 1770s, the Alameda, a city park and favorite site for a *paseo*, was renovated. Subsequently, however, the peace and tranquility of the Alameda were threatened by street smells and noise of vendors as well as the violence of thieves. In August 1791, in order to preserve the harmony of the *paseo*, the viceroy ordered sentinels to be placed at all the entrances to the park to keep out improperly dressed people and provide better security of the Alameda (Viqueira Albán 1999: 171–73; Croix 1771: 78).

The leisure sites of the *gente vulgar*, plebeians, were also part of this renovation campaign. Of intense interest to colonial administrators were *pulquerías*, street stands where *pulque* (the same drink celebrated in Obregón's painting), a popular beverage of fermented maguey, was sold to poor Indians and castas. *Pulque* caused intoxication, which often resulted in rowdiness and other criminal behavior. Although the drink was con-

stantly cited as another cause of plebeian depravity, the government refused to ban *pulque* because its production and sale were critical for the local economy and produced imperial tax revenue. Instead, the Ordinances of 1671 required that *pulquerías* be freestanding and have a roof and one wall allowing three sides open to public observation. Again, in 1724, the *pulquerías* were ordered to install a plaque with the name of the establishment clearly visible from the street (Viquera Albán 1999: 174).

In calling for a re-ordering of urban spaces, these and other documents also cited the polluted and unsanitary physical conditions of Mexico City's streets and plazas caused by unkempt street vendors, plebeian 'filthy habits', and such activities as maintaining livestock within the city limits. In 1763, city streets began to be repaired and cleaned. In 1790, the viceroy established a sanitation program. The *Bando de Limpieza*, or Cleanliness Edict, began with the affirmation that 'One of the most essential points in good civic order is the cleanliness of towns, which contributes not only to the comfort of the residents, but also improves public health, which represents an object of major concern' (*Gaceta* 1790: 158).

A related issue that was highlighted in these ordinances was plebeian nudity, which was seen not as the result of abject poverty, but as yet another indication of plebeian depravity. In 1791, a royal decree prohibited unseemly (lack of) clothing because such attire introduced dissolute and intolerable manners. It went on to require that factory workers wear a shirt, jacket or vest, short pants and shoes. Moreover, the decree mandated that Indians use their own traditional costume and not 'imitate people of other castas' (*Gaceta* 1791: 241; reiterated in *Gaceta* 1799: 333). One of the more extensive sumptuary ordinances began with Viceroy Revillagigedo's statement:

> Cleanliness or hygiene is one of the three principal objectives of social maintenance; and this does not only encompass the street and plazas of the cities, but also the persons who inhabit them whose decent and respectable dress much influences good manners, at the same time as adorning the bold, and contributing to the health of individuals. [Revillagigedo intends] to eradicate from the neighbourhoods of this beautiful capital the indecent and disgraceful nakedness in which a large part of its plebeians are presented, with no other clothing than a disgusting cloak or filthy tatters that does not cover them externally. (*Gaceta* 1799: 332. My translation)[6]

Thus, along with intense scrutiny, a concern with the maintenance of the diverse bodies that made up Mexico City was also evident.

Haidt's analysis offers further important and pertinent insight when she concludes that the practice of physiognomics was exemplified by two repeated figures of Spanish literature: the *hombre de bien*, the gentleman, and the *petimetre*, the fop. In these literary writings, the gentleman always dresses decorously, acts with great self-control and moral

rectitude. In contrast, the fop is extravagant in his dress and publicly shows little self-discipline or meritorious moral behavior. Within this dichotomy, the notion of *hombría de bien*, or gentlemanliness, that is, the virtuous ability to control the body, is shown as crucial to a larger, ethical scheme of masculine self-government (*Gaceta* 1799: 332).

Along with the kinds of bodies mentioned in the edicts and ordinances, the specific notions of the *hombre de bien* and the *petimetre* appear as characters in José Joaquín Fernández de Lizardi's (1776–1827) late-colonial novel *El periquillo sarniento* (The Itching Parrot), first published in 1816 and considered to be New Spain's first novel. The story begins with Pedro Sarmiento, a reformed *picáro* or delinquent, telling his children that he was born between 1771 and 1773 in the rich and opulent city of Mexico. Now ill and infirm, Pedro has sincere remorse for his earlier life of debauchery, and proceeds to tell his children his life story so that they may understand and avoid the moral calamity that marked much of his life. In the first three sections of the story, Pedro's body is transformed from that of a well-born *petimetre*-like character, who seeks fine clothing and an indolent lifestyle, to that of an unkempt, partially naked and debased plebeian, known pejoratively as Periquillo Sarniento. Moving through Mexico City and its environs, Periquillo's charlatan escapades allow him to experience the disparate social estates of New Spain. He pretends to be a pharmacist, doctor, and storekeeper and is reduced to the status of a beggar and thief. Concomitant with these divergent social identities, the story also narrates Periquillo's physical demise and attendant moral degradation. Well aware of the tenets of physiognomics, Lizardi, who cites the writings of Feijoo, verbally depicts Periquillo's body as legible and mappable for moral deterioration. Lizardi specifically refers to the character and characteristics of the *hombre de bien* when he contrasts Periquillo's dissolute moral character and physical appearance to that of his father who was a true *hombre de bien*.[7] Thus, Lizardi's writing further confirms and elucidates the awareness in New Spain of the notion of the body as a social construct and mirrors those eighteenth-century edicts and laws that sought to order and delimit the late-colonial body.

The imagery of portraits and *casta* paintings is embedded in, and reflective of, the same corporeal constructs that structured the political and social discourses of seventeenth- and eighteenth-century New Spain. Portraiture depicts elite members of New Spanish society as the metaphorical head and shoulders of the colony (figure 1.3), offering to the diagnostic gaze analyses of the sitter's *calidad*, social and moral quality, as mappable by their genteel appearance and restrained demeanor. The majority of the *casta* panels, on the other hand, emphasize those estates that are associated with social degeneration resulting from mixed-blood birth status, manifest through manual labor and poverty (figures 1.6 and

1.7). These people represent the metaphorical hands and feet of the body politic, providing the viewer with a similar diagnosis or mapping of such non-elite bodies. For example, in figure 1.8 we see the depiction of a violent encounter between a Black-African woman and Spanish male. The woman has grabbed the struggling man's hair and is about to strike him with some sort of kitchen implement. The couple's daughter pushes at her mother's leg. Within the system of honour in colonial Mexico, hair grabbing was used during arrests of criminals and was considered to be a desecration of an individual's personal honour (Lipsett-Rivera 1998: 511–39). In associating this gesture with the Black-African woman, the artist may be attempting to show not only the violent and depraved *calidad* or moral character of this kind of person, but also, with the presence of the mulatto child, the power of her blood to dishonor a respectable Spaniard.

As secular visual practices, portraiture and *casta* paintings trace the broad political and social territory of the body of the royal subject of New Spain found in contemporary discourses. This territory is projected both in terms of estates that constituted the corporate body of New Spain and mapped bodies that promoted a diagnostic reading of the *calidad* of people. This is to say, the elite and non-elite bodies of portraiture and *casta* painting articulate the static, normative categories and qualities of royal subjects who constituted the corporate body that *was* contemporary eighteenth-century New Spain.

At the beginning of the nineteenth century, the manufacture of portraits continued, while *casta* genre painting ceased. In addition, the establishment of the Academy of Fine Arts of San Carlos at the end of the eighteenth century institutionalised art production in a new way. The academy took over art production from guilds and artisans and subjected it to a controlling bureaucracy that established new, comprehensive iconographic programs for artistic production (Widdifield 1996: 14 ff; Acevedo 2001). The end of *casta* painting production and the establishment of an academic setting for visual practices did not mark, however, the end of the fascination with the body. On the contrary, I suggest that the bodies depicted in *The Discovery of Pulque* and *Allegory of the Constitution of 1857* prolong the eighteenth-century trope of the body, which has shifted and changed to reflect the new, unified and indivisible referential framework well analyzed by Widdifield and discussed by Cañeque – that of nation-state formation. A brief return to *El Periquillo Sarniento* and allied writings will serve to locate the mechanism of this shift.

In the fourth section of Lizardi's novel, Periquillo embarks on a trip to Manila and, when returning to New Spain, is shipwrecked on Saucheofú, an imaginary island. Islanders find Periquillo, naked and injured, sprawled out on a beach. He is nursed back to health, given fine clothing and taught the language of Saucheofú (358–60). Once he has recovered,

the *tután* -viceroy- of Saucheofú questions Periquillo about what he does for a living. Charlatan that he is, Periquillo explains that he is a count (the Count of Ruidiera [noise/chatter]), and in his country his noble status precludes any manual labor. Once the *tután* stops laughing at Pedro's statement, he explains that in Saucheofú nobles do manual labor and chides that 'if in your country the nobles cannot know how to value their hands [work] to obtain subsistence, neither can they understand anything else' (361). With the *tután* as his guide, Periquillo surveys this utopian society, one that has none of the social and economic defects of New Spain chronicled in the earlier sections of the book. He explores the conditions of this utopian state where social order is based not on a person's estate but on the individual's contribution to and maintenance of its order. Unlike Mexico City, here there are no filthy, idle or naked bodies; everyone is employed. Even the nobles and priests must work, and there are no lawyers, because everyone is equal before the law and laws are applied equitably without regard to social status. All citizens are required to wear insignias distinguishing nobles from plebeians and identifying marriage status and occupation. Thus, instead of disparate loyalty promulgated by the multiplicity of estates, Lizardi asserts emphatically that unified and indivisible visual identification is a critical part of Saucheofú citizenship because, here, all loyalty would be deposited in the utopian notion of the state (Alba-Koch 2000: 295–306).

The vision of Periquillo's naked and broken body lying on a desolate beach acts as a metaphor for the exposed and faulty hierarchical social system that marked New Spain's economic and political structure. The utopian experience of Saucheofú transforms Periquillo: he is clothed, made healthy and he learns a new language. As a result of the allegorical experience of Saucheofú, he understands a different kind of body politic. The head/body social metaphor, explored in earlier sections of the book, is dissembled in Saucheofú as nobles/heads are required to be hands and feet through the requirement of manual labor for all classes. Here, Lizardi sees independence in New Spain as bringing forth new ways of re-assembling or constructing the political body. As a result, upon his return to New Spain, the fourth and final manifestation of Periquillo's body appears: it is the body of Don Pedro. This name and physical change of Periquillo to Don Pedro, a true *hombre de bien*, denotes that Pedro is a decorous and morally meritorious individual who is a productive citizen. Here, in its unified and indivisible identity of the citizen, the reader is presented with an abstract and metaphorical body signifying an emerging ideal and independent nation. Thus, the concluding section of Lizardi's novel traces the shift of Pedro's body from a concrete example of the multiple estates, corporations and *calidades* of the royal subject – Periquillo – to that of unified and metaphorical abstraction – the citizen Don Pedro.

This shifting notion of the late-colonial body was evident in other aspects of the culture, for example, in 1790 a play originally titled *México rebelado* (Mexico in Rebellion) and retitled to the less offensive title, *México segunda vez conquistado* (Mexico Conquered Again), was performed in Mexico City. Opening to a full house, the drama told the story of the capture, torture and execution of the noble Aztec King Cuauhtémoc at the hands of the less-than-honorable Hernan Cortés. The historical Indian body, instead of being a topic of ridicule or depravity, now became a new theme in late-colonial theatre.[8] Importantly, the play locates the sociopolitical body of the Indian as a place to re-encounter the early history of New Spain.

Renovations near Mexico City's Plaza Mayor carried out at the end of the eighteenth century, meanwhile, resulted in the excavation of a number of significant monuments of the Indian past. For example, on 17 August 1790, a circular shaped monolith with a human face surrounded by concentric bands of relief elements carved on one side was discovered. Identified as the Calendar Stone or Sun Stone, the monument was left on display in the Plaza Mayor. Along with other discoveries, it spawned extended discussions about an originating past. Antonio de León y Gama, a well-regarded and erudite mathematician and astronomer with a scholarly interest in pre-conquest antiquity, began to measure, draw, and analyze the sculptures. His finished work was published in June 1792 (León y Gama 1978). In his introduction, León y Gama explained that the conquering Spaniards had demolished many indigenous monuments on the grounds that they supported Indian superstitions. In truth, the author argues, they represent Indian history. As further justification for the monuments' historical importance, León y Gama points out that such interest in antiquities was authorised, even fomented, by King Carlos III by his construction of an expensive museum in Portici displaying objects excavated from Herculaneum and Pompeii. He also claims to reveal the true meaning of the complex symbols and characters of Mexican culture. León y Gama then presents his extended study and concludes that, as a complex solar calendar, the Calendar Stone manifests the enlightenment of the Indian nation prior to its conquest (León y Gama 1978: 9).

León y Gama thus argues for an original and authentic Indian, and indigenous culture, and for the existence of an original and authentic pre-conquest (i.e., pre-Spanish) history. In fact, in a side discussion, he states that the authenticity of a true Indian is not found in appearances, but in an inherent, original culture emanating from the historical context (13–15). In this way, he postulates an authentic and unified indigenous identity based in history and at the same time anticipates nineteenth-century ideas of national identity as located in citizenship and as formulated

through indigenous origins and authenticity, rather than in estates, corporations or *calidad*.

The writings of Lizardi and León y Gama and the appearance of the play *México segunda vez,* exemplify late eighteenth-century attempts to discuss and explore questions of an original and national identity. A distinctive and new feature of all of these writings is their reference to 'kinds of time'. These writers transfer the reader out of the fixed present of New Spain into alternative realms of time: the non-chronological, allegorical and futuristic time of utopia for Lizardi and the legendary, idealised past of León y Gama and *México segunda vez*. It is in these alternative times that each writer opens questions about national origin, authenticity and citizenship. These types of imaginary time were also critically implicated in nineteenth-century visual arts. Obregón and Monroy made use of Lizardi and León y Gama's approach to time, in order to transmute late-colonial bodies, specifically those of the Indian and mestizo found in *casta* paintings, into mirrors of the nation-state.

Within the *casta* series, Indians and mestizos were identified in various ways in contemporary New Spain. Indians were visualised for example as the female mates of Spanish males who produce mestizo offspring, seen as unkempt vagrants or street vendors, or barbarous subsistence hunters. The mestizo, who could *only* signify miscegenation, was visually formulated in the paintings of *castas* in two ways: mestizo blood mixed with Spanish blood was perceived as able to be purified, but if mixed with Indian or Black African blood, it would be indelibly polluted. In the nineteenth century, however, Indian and mestizo bodies were revised and represented as national icons, just as Periquillo's body was transformed by his visit to utopia. In their new role, they embodied as well as claimed independence.

Nineteenth-century painting would take these representations of Indians and mestizos, remove them from the present and place them into an originating and allegorical time. While the Indians of *casta* paintings emphasize a social present, *Discovery of Pulque* (figure 1.1) narrates Indians of the legendary past. Instead of the Indians of the *pulquerías* and filthy streets of Mexico City, these are enlightened Indians, those placed among the antiquities discovered in the late eighteenth century, those whom León y Gama sought to discover in his exegesis on the Calendar Stone, and those who were idealised in *Mexico segunda vez*. Likewise, mestizo protean potential was visualised in *Allegory of the Constitution of 1857* (figure 1.2). Here, miscegenation becomes positively transformed through its displacement into the creative timelessness of allegory. As we saw in Lizardi's writings, it is through this legendary and allegorical or utopian time, not the present, that the abstraction of transformative citizenship would be best formulated.

In conclusion, the eighteenth-century corporeal discourse of estates, corporations and *calidad* was superceded by a nineteenth-century discourse of origins and authenticity. Historical and allegorical time, so critical to Lizardi and León y Gama's writings became the framing devices that transformed the eighteenth-century body into the new kinds of bodies presented by nineteenth-century painters such as Obregón and Monroy. As visualised only in the present, portraiture and *casta* paintings had depicted the knowable, tractable, corporate-defined body. Academic paintings, in contrast, looking towards both the imaginary past and imagined future so critical for nation building, took this disparate territory of the royal subject's body and produced the unified, metaphorical body originating nationalist history and the allegorical body of the nation.

Notes

1. I wish to express my gratitude to Dr Elizabeth Perry and Dr Michael Taylor for their careful reading of initial drafts of this paper. Their insightful comments were critical to the final form of this essay. I also wish to acknowledge and thank Jens Andermann and William Rowe for their judicious comments and editing. Portions of this article appear in my book, *Imagining Identity in New Spain: Race, Lineage, and the Colonial Body in Portraiture and Casta Paintings*, Austin: University of Texas Press, 2003. I thank the University of Texas Press for giving me permission to publish this material.

2. These arguments are found throughout the writings of Edward Said, Michel Foucault, and Homi Bhabha. An excellent overview of these writings is found in Prakash 1995.

3. Scholars have suggested, furthermore, that *casta* paintings were executed for Spaniards returning to their native land as souvenirs of their adopted country and they were used by the upper-level elite to assert their genealogical superiority. Still other researchers maintain that the images are simply taxonomic in nature and relate to an Enlightenment preference for classification.

4. 'Alcaldes de barrio. Policía. Ordenanza de la división de México en cuarteles, creación de alcaldes de barrio y reglas de su gobierno con un mapa de la ciudad', Archivo General de la Nación (hereafter, AGN), Bandos, Diciembre 4 de 1782, vol. 12, exp. 36 foja 101–22.

5. 'Alumbrado, Policía. Reglamento para el gobierno que ha de obervarse en el alumbrado de las calles de México', AGN, Bandos, Abril 7 de 1790, vol. 15, exp. 56, foja 158; 'Alumbrado, Policía. Adición al reglamento anterior', AGN, Bandos, n.d., vol. 15, exp. 57, foja 161; 'Alumbrado, policía. Bando que publica el alumbrado establecido en esta capital impone penas a los que robaren o quebraren los faroles y a los que hicieren armas contra los guardas', AGN, Bandos, Abril 15 de 1790, vol. 15, exp. 60, foja 175. An overview of these laws is provided by Viqueira Albán 1999: 178.

6. The original passage reads as follows: 'Limpieza y aseo es uno de los tres principales objetos de policía; y esta no sólo comprehende las calles y plazas de pobla-

ciones, sino también las personas que las habitan cuyo trage honesto y decente influye mucho en las buenas costumbres, al mismo tiempo que adorna la auda-dos,y contribuye a la salud de sus individuos...desterrar del vecindario de esta hermosa capital, la indecente y vergonjosa desnudes con que se presenta una gran parte de su plebe, sin otra ropa de un asqueroso manto o inmunda girga que no alcanza a cubirirla externamente.'

7. Lizardi inserts this verse into the text:

> El hombre de bien vivir
> y aquel que a ninguna daña,
> no ha menester el escudo
> ni flechas emponzoñadas.
> Por cualesquiera peligros
> pasa y no se sobresalta,
> seguro en que su defensa
> es un conciencia sana (Lizardi 1998: 263).

[The one who lives well and who harms no woman, has no need of shield or poi-sonous arrows. He goes through any danger and is not frightened, certain that his defense is a healthy conscience.] Here, Lizardi refers to the idea that exemplary internal moral qualities will defend the exterior body.

8. According to reports, while most of the audience enthusiastically applauded the performance, Spaniards were angered by the play. Subsequent performances were cancelled 'because the play presented untruths about events; these were uncertain and contrary to the character of the nation.' Censors, however, defended their original approval of the play by saying that, verisimilitude being a goal of the the-atre, *México segunda vez conquistado* re-created real events. The problem with the play, they added, was that it had been poorly performed by amateurs, and, as a result, realism was lost and anger was provoked instead. See Viqueria Albán 1999: 77–79.

Bibliography

Acevedo, Esther, ed. 2001. *Hacia otra historia del arte en México. De la estruc-turación colonial a la exigencia nacional (1780–1860)*, Tomo 1. México, D.F.: Consejo Nacional para la Cultura y las Artes.

Alba-Koch, Beatriz de. 2000. '"Enlightened Absolutism" and Utopian Thought: Fer-nández de Lizardi and Reform in New Spain', *Revista Canadiense de Estudios His-pánico* XXIV, 2: 295–306.

Bhabha, Homi. 1994. *The Location of Culture*. London: Routledge.

Burke, Marcus. 1998. *Treasures of Mexican Colonial Painting: The Davenport Museum of Art Collection*. Santa Fe: Museum of New Mexico Press.

Cañeque, Alejandro. 1999. *The King's Living Image: The Culture and Politics of Viceregal Power in Seventeenth-Century New Spain*. Ph.D. diss., New York Univer-sity.

Carrera, Magali. 2003. *Imagining Identity in New Spain: Race, Lineage, and the Colo-nial Body in Portraiture and Casta Paintings*. Austin: University of Texas Press.

Caro Baroja, Julio. 1992. 'Religion, World Views, Social Classes and Honor During the Sixteenth and Seventeenth Centuries in Spain', in *Honor and Grace in Anthro-*

pology, translated by Victoria Hughes and edited by J.G. Peristiany and Julian Pitt-Rivers. Cambridge: Cambridge University Press.

Croix, Carlos Francisco. 1771. *Instrucción del virrey marqués de Croix que deja a su sucesor Antonio María Bucareli*. Mexico, D.F.: Editorial Jus, 1960.

Fee, Nancy. 2000. *The Patronage of Juan de Palafox y Mendoza: Constructing the Cathedral and Civic Image of Puebla de los Angeles, Mexico*. Ph.D. diss., Columbia University.

Fernández de Lizardi, José Joaquín. 1816. *El periquillo sarniento*. Mexico, D. F.: Editorial Porrúa.

Gaceta de México, 7 de Septiembre de 1790, in *Gacetas de México*, Mexico, D. Felipe de Zuñiga y Ontiveras.

Gaceta de México, 6 de Septiembre de 1791, in *Gacetas de México*, Mexico: D. Felipe de Zuñiga y Ontiveras.

Gaceta de México, 29 de Mayo de 1799, in *Gacetas de México*, Mexico: D. Felipe de Zuñiga y Ontiveras.

Haidt, Rebecca. 1998. *Embodying Enlightenment: Knowing the Body in Eighteenth-Century Spanish Literature and Culture*. New York: St. Martin's Press.

Katzew, Ilona, ed. 1996. *New World Order: Casta Painting and Colonial Latin America*. New York: Americas Society.

León y Gama, Antonio de. [1792/1832] 1978. *Descripción histórica y cronológica de las dos piedras que con ocasion del nuevo empredado que esta formando en las plaza principal de México*. Reproducción facsimilar. México: Porrua.

Lipsett-Rivera, Sonya. 1998. '*De Obra y Palabra:* Patterns of Insults in Mexico, 1750–1846', in *The Americas* 54, 4: 511–39.

Prakash, Gyan, ed. 1995. *After Colonialism: Imperial Histories and Postcolonial Displacements*. Princeton, NJ: Princeton University Press.

Vargaslugo, Elisa. 1994. 'Autoridad del Alma', in *Artes de Mexico* 25, Julio-Agosto: 46–51.

Viqueira Albán, Juan Pedro. 1999. *Propriety and Permissiveness in Bourbon Mexico*, translated by Sonya Lipsett-Rivera and Sergio Rivera Ayala. Wilmington, Delaware: Scholarly Resources.

Widdifield, Stacie G. 1996. *The Embodiment of the National in Late Nineteenth-Century Mexican Painting*. Tucson: University of Arizona Press.

Chapter 2

The Mexican Codices and the Visual Language of Revolution

Gordon Brotherston

Much has been said about the Revolution in Mexico and the search for pre-European national roots that it provoked. Yet little of it actually touches on the intellectual precedent evinced in the books or codices painted and read in Mesoamerica before Cortés (Glass 1975), and kept alive in various formats and contexts long after the invasion he was responsible for, until the present day. Conversely, studies of the codices rarely invoke the Revolution and the importance it had for internalizing into the nation the visual language first used in those ancient texts, which before then had most often been viewed as something remote, alien, incomprehensible, even abhorrent.

It is fair to say that the foundations of colonizing Europe had been shaken a century before the Revolution, just prior to Independence, with the literal resurgence of a major example of a text written in the language of the codices. The momentous excavation of the Calendar Stone in 1790 from near the then still buried Templo Mayor in Mexico City, effectively promoted (via such figures as Ignacio Borunda and his disciple Fray Servando Teresa de Mier) an account of the Mesoamerican cosmogony of Suns or world ages, which already then was sensed to be both antithetical to and corrosive of the imported Biblical version of genesis, along with the model of world history authorized by the Bible (León-Portilla 1986; Vos 2000). However, only with the 1910–1920 Revolution do we see the beginnings of a national reading of the codices and a corresponding shift in historical perspective, thanks to the political and archaeological project epitomized by Manuel Gamio's excavation of Teotihuacan (1922) and, above all, Alfonso Caso's work on both Monte Alban and the corpus of pre-Cortesian Mixtec annals. Today, this project is perhaps more alive and diverse than ever, despite the relentless attempts of the

U.S. to attach the label 'prehistoric' to the whole of pre-contact America; and it critically involves the very notion of national iconography.

The kind of visual language found in the codices and other early Mesoamerican texts is called *tlacuilolli* in the Nahuatl or Aztec language (Nowotny 1961; Brotherston 1992, 1995; Boone & Mignolo 1994; Boone 2000). In this respect, the hieroglyphic codices of the lowland Maya constitute a group apart. It may be thought of as an example of representation or notation that is not easily defined in Western terms, since it may bring together into a holistic unit concepts which for us are separately understood as script, image, and arithmetic. Hence the ability to 'read' tlacuilolli need not in practice be equivalent to alphabetic literacy. Indeed, in Western scholarship this 'script' has most often appealed more to theoreticians and historians of art, mathematics, and even comics (Robertson 1959; Ades 1989; Harvey & Williams 1986; McCloud 1993), than to students of literature. As a result, scarcely any attention has been paid so far to such key literary concepts as reading principle and genre norms. In the cultural domain, the sign sets proper to toponymy, calendrics and other orders of knowledge within the tlacuilolli system may encode meanings that do not always or often find ready equivalents in non-Mesoamerican languages. Scholarship is still only beginning to reveal how far such image-concepts continue to inform native life in that part of America (Sandstrom & Effrein 1986; Loo 1987; Good 1988).

Found already in the earliest inscriptions, for example at Monte Alban, place-signs constitute nothing less than a small encyclopedia of Mesoamerican culture, for the way they coordinate features of landscape, and the activities of human and other species (Smith 1973). Their semantic resonance was brought home a decade or more ago in Enrique Escalona's film *Tlacuilo* (1989), which focuses in hypnotic detail on the title page of the Mendoza Codex and the celebrated toponym of Mexico-Tenochtitlan placed at its focal point: there, perching on the 'stone cactus' (te- noch-), the eagle signals the site of the future Mexica capital, an emblem that continues to be endlessly reproduced at all levels of national life. Examples of tlacuilolli toponyms taken from the codices feature on road signs in the Estado de México; and in Mexico City's metro system they help guide passengers who cannot read the alphabet. Hence, as in the Aztec screenfold annals, Chapultepec can still be seen as the place of the chapulin or grass-hopper, just as Coyoacan can be seen as the place of the coyote and Mixiuhcan as the place of childbirth. In this last case, the birth represented in the figure of the midwife clearly portends that of Tenochtitlan.

As for tlacuilolli iconography that characterizes time more than place, we may turn to the set of Twenty Signs, an encyclopedic concentration

of Mesoamerican knowledge. In measuring life-rhythms, these Twenty Signs are a main diagnostic of the Mesoamerican calendar and of tlacuilolli, and likewise bring its signification forward into the present from a millennial past. For present purposes, how this may be so may be noted with reference to three of the Signs in particular: Snake, Rabbit and Movement (Signs 5, 8 and 17), whose Nahuatl names are Coatl, Tochtli, and Ollin.

Snake or *coa-tl* simultaneously means, and in the codices is shown to mean, phallic energy, the intrusive power of the hissing gossip (*maquizcoatl*), poison and hence possible cure (precisely as in the Hippocratic image), yet also an architectural column (*coaquetzalli*, head downmost), or a planter's digging stick, and therefore notions of community and trust. Today, in colloquial Mexican, this last meaning of the snake Coatl is the direct origin of the much-used and resonant term for friend: *cuate*.

Rabbit or Tochtli invokes, amongst other possibilities, the orbit of the planet Venus, a guerrillero capacity to sally and vanish, and the new-moon orientation of pulque drinkers (the rabbit's twenty-nine night gestation period links it with the moon). In Tepoztlan, Morelos, the local bus company is called and visually announced as *Ome Tochtli*, the name of the pulque-drinking local hero whose epic is celebrated every 8 September in a Nahuatl drama and in spectacular murals made of more than seventy types of seeds, according to designs directly drawn from the codices tradition (Corona 1999; Brotherston 2000a). There can be no doubt whatsoever that the *Ome Tochtli* cult powerfully affected the capacity of Tepoztlan to withstand transnational assault on communal land during the mid 1990s blockade of the town. The seed mural of the year 2000 was crowned by a pair of figures who each in his own way resisted Cortes: Tepoztecatl, with his 'new-moon' shield, greeting the Aztec emperor Cuauhtemoc, with his name glyph 'plunging eagle'. In their tlacuilolli guise, these two could be simultaneously read as Tepoztlan's recognition of Cuauhtemoc Cárdenas's political party, the PRD, the only one in Mexico actively to support the cause of the town.

The seventeenth Sign denotes movement, tremor, rubber, elasticity. Its name, Ollin, survives in the everyday word for rubber in Mexico, *hule*, a product unknown outside the American tropics before Columbus, and which was indispensable to the philosophy of chance, or bounce, that determined and still determines the Mesoamerican ball-game *Ulama*. The sign Ollin itself is enshrined at the centre of the Calendar or Sunstone whose excavation heralded Mexico's overthrow of Spain; it announces the name of our 'sun' or world-age *Nauh* Ollin, which is expected to end in cataclysmic earthquakes. Today, the concentricities of the Sunstone itself have been ingeniously transposed into the centre-

pieces of the new peso coins. And in the official iconography of the Mexican state, the central sign Ollin serves as the logo of the foundation known as the Instituto Nacional de Antropología e Historia or INAH, all the while carrying with and in it a sense of instability so strong as to threaten, in the first place, the very notion of state institution or foundation. As many have noted, a similar counter-pull of concepts inheres in the name of the political party which succeeded in dominating the Estados Unidos de México, by fair means and foul, for six decades, the PRI that is at once 'revolutionary' and 'institutional'.

Reading tlacuilolli raises major theoretical questions in its own right. Here it is important simply to note its conceptual wealth and how, as a result, it may complicate standard Western ideas of icon and iconography, as it certainly has done in historical practice (López Austin 1984; Brotherston 2000; Florescano 2000).

At the most basic level, only after the Revolution was official sanction given to the idea that tlacuilolli could be understood as a visual langue in its own right, one which bore major witness to the nation's experience over time. In this, the Porfiriato had effectively prolonged Spanish colonial views, even though by then local archaeology and anthropology were starting to stir, in part under the impact of Franz Boas's 1910 visit, and Mexican codices were attracting ever more international attention, in the wake of colour reproductions and decipherments published by Humboldt, Kingsborough, Förstemann, Seler and Nuttall. To mark the 400th anniversary of Columbus's arrival, the Junta Colombina of Mexico produced a luxurious colour first edition of several codices (1892), yet the introduction and commentaries by Alfredo Chavero and others show little involvement, still less solidarity, with the worldview and perspective of these texts or their technical ingenuity as visible language. For showing just such an involvement and finding deeper meaning in a Mixtec Lienzo from Tlapiltepec, Abraham Castellanos, himself a Mixtec, was looked at askance by fellow Mexicans at the 1912 International Congress of Americanists.

By the 1920s, under Álvaro Obregón and his Minister of Education José Vasconcelos, indicators appear of how things were changing with the Revolution, in national programmes of recuperation and restitution of what had been silenced and degraded under Spanish rule. As champion of the new national archaeology, Manuel Gamio respected the testimony of the codices in his monumental work on Teotihuacan, texts that reveal the names of major pyramids and avenues in the city, and which detail how the surviving population regarded Spanish intrusion. Gamio's example was spectacularly followed by Alfonso Caso, for whom excavating the earth and reading the pages of pre-Cortesian codices became wholly

complementary activities. Meanwhile, in the schools tlacuilolli gave the impulse towards a system of sign writing, a kind of indigenous 'art alphabet' designed for pedagogical purposes (Best-Maugard 1923), in which the poet José Joan Tablada had a stake. Similar ideas of visual vocabulary were developed by Dr Atl, and by the team of muralists assembled by Vasconcelos (Charlot 1965). Indeed, in terms of sheer form, and certainly of image and ideology, it is possible to map a cluster of post-Revolutionary responses to the codices in Mexico, which cross-reference and foreground the whole question of iconography and nation-building, in both an affirmative and a critical spirit.

An obvious starting point is the codex-based style of mural painting pioneered by Diego Rivera, first in Cuernavaca (1929) in the narrative of Cortes's invasion of that city, then in the great celebratory works in the Palacio Nacional, the Hospital de la Raza (1950), the Teatro Insurgentes, and other sites in Mexico City. Catlin, Rochfort and others have shown how Rivera drew on the Florentine Codex and the Tlaxcala Lienzo for his angle on battle scenes, and the sordid oppression synonymous with the European import of herd animals. Quoted verbatim from the *Borbonicus Codex* (p. 30), the image of Tonantzin that overlooks the abundance on Gulf Coast agriculture in the Palacio Nacional sequence cunningly anticipates that of the Guadalupe with whom she came to be identified. Expressing a respect for native American medicine rare in his day, in the Hospital de la Raza mural, Rivera represents its achievements again through a quotation from *Borbonicus* (the midwife Tlazoteotl, p.13), together with pages from the exquisite *Libellus de medicinalibus indorum herbis*, in which sixteenth-century native scribes represented, in Latin-glossed tlacuilolli, the qualities, soil requirements and other facts pertaining to curative herbs.

An important complement to Rivera's statement on the wall, often overlooked, is his work on the page as a book illustrator, where he similarly turned to the codices to produce images that enrich or even redirect the argument of the alphabetic text into which they are set. Examples of these illustrations can be found in major literary texts, which include: Gregorio López y Fuentes's novel *El indio* (1935), where they much extend the bounds of the author's revolutionary yet rigidly socio-anthropological depiction of Nahua communities in Veracruz; Pablo Neruda's *Canto general* (Mexico 1950); and the *Popol vuh*, in an edition published in the heroic days of UNAM's *Cultura Popular* series, where they help to situate this major cosmogony in its Mesoamerican, indeed American, context (Edmonson 1971).

The first edition of Neruda's *Canto general* was in fact enhanced by paintings by both Rivera and Siqueiros. Each is identified by a quotation

from Neruda's text and between them they mark out its geo-historical span. Siqueiros's painting and energetic creed of liberation are linked to and corroborate lines from 'La arena traicionada', with its diatribes against the U.S. imperialism of Neruda's own day (Méndez-Ramírez 1999). Linked to lines from the first canto that speak of beginnings ('La lámpara en la tierra'), Rivera's painting relates more complexly to Neruda's text and in so doing draws heavily on the codices. Entitled 'Domingo prehispánico', Rivera's illustration condenses the massive latent power of the pre-Columbian world into a single map. With east uppermost, between the condor of the Andean peaks (right) and the eagle of Mexico's snow-capped volcanoes (left), it features the masonry of Neruda's own focal point Macchu Picchu; the Tupinamba, the Timehri and the petroglyphs of the lowland rainforest; the quetzal, snake and mammoth whose fossils inhere in the native American philosophy of evolution through the world-ages; Totonac wheeled toys, a trademark of Rivera's that undercuts the stupid notion 'they had no wheel'; canoes plying the length of the Ohio, and so on. The whole focuses on Mesoamerican twin temples, entirely through codex imagery and logic. Slightly to the left stands the temple of warfare, sacrifice and tribute. In the middle is the other temple, dedicated to culture of the maizefield and the codex page. It is occupied by a reclining Chac Mool – the figure that revolutionized the sculpture of Henry Moore and hence the West – and the blood running down its steps proves to be menstrual. Behind the figure are pages from the first chapter of the Borgia Codex, which deals with the nine moons of human gestation, and the evolutionary story of the Suns. One such Sun, from this source, dominates the upper centre of the design, as a striking conceptualization of time: a sun and a night sky each occupies its own half disk, thereby indicating the difference between their respective years, one which over the centuries produces the great spans and cycles of the world ages.

Hence, 'Domingo prehispánico' comes to stand in opposition to that version of America as preliterate, and therefore in need of Europe, which is defended by Neruda in his final comment on the European invasion, 'A pesar de la ira'. Celebrating the richness and intelligence of New World culture, Rivera's illustration is one of his most succinct and telling ideological statements, one which reveals the first settlers of America to be of and in a nature exemplarily different from that of the Western tradition, starting with the Sunday (Domingo) of the Biblical Genesis. And it could not have been made without the precedent of the codices.

A successor of Rivera's, comparable in stature as muralist, political activist, book illustrator and publisher, is Francisco Toledo, who as a Zapotec-speaker from Oaxaca enjoys on those grounds alone more direct

access to the world and logic of the codices. His techniques as a painter involve, however, a more fraught relationship with that source than is the case with Rivera; and the same may be said of his politics, with respect to the official indigenism with which Rivera (to a large degree unfairly) had come to be identified. As Dawn Ades puts it, 'Toledo belongs to the post-ruptura generation for whom the practice of art in the service of national identity held no interest' (2000: 33). Taking an intensely regional and sceptical view of 'national' culture, Toledo nonetheless finds the means of integrating the codices into his work as it were at a deeper semantic level, where programme and message are less immediately apparent, and certainly yet further from being nationally official. Once sensed, they are perhaps for that reason yet more persuasive.

Such is the case with Toledo's portrait of himself as an over-sexed rabbit in 'Conejo avispado' (Lampert 2000: 91), which draws intricately on the kind of codex page icon seen in *Vaticanus B* (p. 96). There the Twenty Signs are positioned on parts of the body, in this case a deer, and the duality anatomically proper to such features as eyes and ears is made to repeat in the tail/penis. Again, his 'En el terreno del lagarto' (Lampert 2000: 101) playfully celebrates, as do the codices and the *Popol vuh*, the phenomenon of the Caiman ('lagarto'), its monstrous strength, excessive appetite yet elegant fingernails. This creature belongs to what is a veritable bestiary in Toledo's work, which appeals to the zoology of the Twenty Signs (the Caiman being the first Sign, Deer and Rabbit the seventh and eighth – each a pair of prey as buck and doe) and at the same time contrives to include the human body of the artist, as in the 'rabbit' self-portrait, and as in the phallic image of him clad in the skin of a snake (Snake being the fifth Sign).

The calendar and philosophy of time in which these Signs function becomes the subtext of 'La mujer del calendario' (Lampert 2000: 95). Colloquially, the title means something like 'pin-up' and has that format, i.e., a naked female body above a grid of what could the dates of the month. On closer inspection, however, the body proves not to be entirely human (the head is both feline and bird-like), and the dates are hard to count because the whole surface has been deliberately 'aged' and obscured. This has the effect of inviting the reader of the painting to interpret the title more literally, as 'the woman of the calendar' (specifically, of a codex palimpsest), and hence to consider other (less consumerist) ways of understanding time, and the place of humans in an all-embracing nature.

Toledo's political statement is at its most direct in the paintings entitled *Títulos primordiales* ('land-deeds'), which update the format and logic of the sixteenth-century tlacuilolli maps known by the same name, that were created to defend land before the Spanish Colonial lawcourts. Toledo emphasises their sheer earthy materiality, in the spirit of the codex

toponyms, and so confirms loyalty to his own place Oaxaca, which for good reasons of its own has continually resisted the political ambitions of Mexico-Tenochtitlan, from times that long antedate the Cortes, let alone the Revolution. Benito Juárez, a fellow-Zapotec who left Oaxaca to become one of Mexico's most centralizing and anti-indigenist pre-revolutionary presidents is a motif Toledo has repeatedly returned to, setting the head made famous in nineteenth-century public statuary on to bodies and into environments which bring it back to earth and the nature that endures like the living Skull of tlacuilolli (Skull is one of the Twenty Signs). 'Juárez atraviesa el río de las calaveras rodantes' (Lampert 2000: 93) is a fine example of this kind of rehabilitation.

The style of indigenously-conscious muralism consecrated by the Mexican Revolution has found echoes and parallels all over America, salient examples being González Camarena in Chile (Universidad de Concepción, 1965), Aubrey Williams in Guyana (Timehri airport), Saint Omer in Guadeloupe, and whole schools of Mexican and Chicana/o painters working currently in California. These last draw in their own way on the codices, unearthing the history of Aztlan (Alurista 1971; Valdez 1972), and re-membering Mesoamerican philosophies of origin, vertebrate life, and agriculture. In this respect, Cherrie Moraga's brilliant response to the mural paintings provoked in Los Angeles by the contentious Quincentenary of 1992 (*The Last Generation*) serves as a guide to those that blossom now in the San Francisco Mission district, along a path marked on the pavement of 24th Street by the succession of the Twenty Signs. Among many other such examples stands José Antonio Burciaga's celebration of maize in the Casa Zapata dining hall at Stanford University, where what the *Popol vuh* teaches us about maize and our being what we eat is visually expressed through motifs from the *Borgia* and other codices.

Throughout America, the year 1992 proved to be a powerful prompt for the reaffirming of local culture, against the invasive ideology of Columbus's 'Discovery' (Brotherston 1992). In Mexico this coincided with outrage at Carlos Salinas de Gortari's wholesale rewriting of the constitution, in the cause of neo-liberalism and entry into the U.S.-dominated NAFTA. In all this, the codices provided an indispensable term of intellectual reference for a number of influential writers and artists, among them Eduardo del Río (RIUS), Carlos Monsiváis, Rafael Barajas (El Fisgón), Antonio Helguera, Ahumada, and Magú (figures 2.1–2.5). If 'La ruptura' of the late 1950s had meant a new sceptical look at official iconography and the ideology it was intended to propagate, including PRI-style indigenism, then this time it was a matter of that outright disgust which finally brought down the PRI, of radically rejecting a system that by now had abandoned even the rhetoric of indigenism.

Figures 2.1 and 2.2 Ahumada, *El Ahuizotl*, no. 1 (4 March 1992): 1; no.5 (27 May 1992): 9.

Figure 2.3 and 2.4 El Fisgón (Rafael Barajas), *Como sobrevivir al neoliberalismo*, Barajas 1996: 59, 186.

Figure 2.5 Rius (Eduardo del Río), *500 años fregados pero cristianos*, Del Río 1992: 74.

Nowhere was this more keenly the case than in the supplement published during 1992 by the newspaper *La Jornada*, then still under the directorship of Carlos Payan Velver. Entitled 'El Ahuizotl' – an Aztec emperor name with an exemplary pedigree in Mexican satire (as RIUS notes; 1998: 96), this supplement re-told the story of Mexico, in successive issues, from a point of view that was at once based in the codices and totally derisive of current state discourse. It is hard to exaggerate the ingenuity with which the visible language used in books half a millennium ago was made here to argue the case on such subjects as national progress and well-being, the economics of neo-liberalism, relations with the U.S. and NAFTA.

The native accounts of invasion given in such codices as the Lienzo de Tlaxcala and the Florentine Codex, sources which Diego Rivera had drawn on in his day and in his own way, are quoted only to have some inset indicator that this is a process of brutality and dispossession that continues right into the present, regardless of the intervening Revolution. The conquistador's blue-steel blade at the massacre of Cholula is replaced by a chainsaw made in U.S.A. (figure 2.4); the galleon at the coast becomes a fighter plane with royal Spanish markings but again of US design; engaged in diplomatic dialogue with local allies, Cortés has an American Express card tucked into his hatband.

The analysis does not stop, however, with foreign invasion. In setting the scene into which Cortés so violently intruded, El Ahuizotl takes a mixed view of the Mexica, who not long before had migrated from northern Aztlan and set up their capital in 'Chilangotitlan'. In Ahumada and Monsiváis's version of the migration, the Mexica follow the footprint trail from Aztlan that is traced out in the Boturini Codex and consecrated in stone in the Museo Nacional de Antropología; yet they do so as the Imeca, the great polluters who offer the lungs of their newborn to the god-turned-capitalist Huitzilopochtli. (The name Imeca is the acrostic of the Indice Metropolitano de la Calidad del Aire). This motif recurs when it comes to Moctezuma and the foreknowledge of Cortés's arrival attributed to him in the Florentine Codex: he cannot see the omens of doom because the sky is too polluted.

In his subsequent volume *Cómo sobrevivir al neoliberalismo* (to which RIUS appended the warmest of recommendations), Barajas offers further examples of these techniques. As an icon of mindless destruction, Cortés appears amid dismembered native bodies and felled trees, just as he does in the Lienzo de Tlaxcala; only here he is driving over the bodies in a bulldozer that is identified by the letters FMI (i.e., the International Monetary Fund; figure 2.2). In Barajas's book and El Ahuizotl alike, repeated play is made with that prime emblem of nationality taken from the pages of the codices: the eagle perched on the cactus. The cactus falls apart, or becomes a TV aerial in the poorest part of town (figure 2.5), the eagle eats junk food or loses its feathers.

The sparse but pungent recourse to codex logic in Barajas's *Cómo sobrevivir al neoliberalismo* is extraordinarily compelling. As well as the examples of Tenochtitlan's foundational cactus and Cortés on his bulldozer, there is a reworking of the Coyoxauhqui stone disk from the Templo Mayor. As Huitzilopochtli's sister, Coyolxauhqui was brutally disabled and dismembered, yet not without the chance of her limbs becoming the stuff of world formation. In his version of the disk, Barajas substitutes Coyoxauhqui for a modern worker, reduced and disabled by neo-liberalism, yet, following the logic of his stone antecedent, never to be eliminated without trace (figure 2.3). As a predecessor and model for Barajas, Helguera and others, RIUS has produced two books (1987, 1992) which rework the codices throughout their whole considerable length. Each is overtly pedagogical and political in intent, as their titles suggest: *Quetzalcoatl no era del PRI* and *500 años fregados pero cristianos*. In this, far from being antiquarian, they contrive actually to bring particular codices to reperform the educative function they originally had, as records of Mexico's longer history. Hence in the former volume, the culture-hero Quetzalcoatl is built up from the codices as first sources; and our information about his successor Nezahualcoyotl is taken image by image from the Xolotl Codex (1987:

146–47), as it had been by the Texcocan historian Ixtlilxochitl four cen-
turies ago. Taking this one step further again in the later quincentenary vol-
ume, RIUS makes the codices into an effective comment on themselves.
Alongside examples of tlacuilolli, he puts the caption:

> Barbarians those who drew these marvels, or those who destroyed them?
> When not even creative modern graphic designers have achieved such an incredible syn-
> thesis of form.

The examples are of a Monkey (again, one of the Twenty Signs) that is
laughing, a design he had included in his history of the cartoon (1988:
6–7), and on the penultimate page of the Laud Codex (p. 45), an icon of
the rain god Tlaloc with the Twenty Signs disposed around his body (fig.
2.1). The Laud icon could hardly be an apter support for his message. For,
besides a visual sophistication that is evident even without colour (the
caiman below Tlaloc is of two blues, one of which Toledo took for his
caiman), it draws ingeniously on the conceptual and arithmetical
resources of tlacuilolli. By highlighting certain of the Twenty Signs, the
icon defines Tlaloc as the 'Jaguar Snake' (Signs 14 and 5), that is, his
thunder and his lightning whose numbers total that of his Rain mask or
persona (Sign 19).

As a long-standing and definitive element in Mesoamerican culture,
the codices and the special kind of visible language found in them
achieved a new and widespread recognition in post-revolutionary Mex-
ico. This has been the case from the 1920s until the present day, at many
levels and in many modes of national life, from the direct continuation of
indigenous practice to metropolitan programmes of cultural restitution.
Moreover, the conceptual richness of tlacuilolli as a resource has meant
its being used both to foster and to challenge the Mexican nation state (cf.
Gutiérrez 1999). On the one hand, the codices have helped those con-
structing an official and public lexicon, of institutional logos, pedagogic
murals, and road signs. On the other, they have enabled and sharpened
the keenest satire.

Bibliography

Ades, Dawn. 1989. *Art in Latin America.* New Haven: Yale University Press.
———— . 2000. 'Toledo' in *Francisco Toledo,* Catherine Lampert et. al. London,
 Whitechapel Art Gallery.
Alurista [Alberto H. Urista]. 1971. *Floricanto en Aztlan.* Los Angeles: University of
 California.
Barajas, Rafael. (El Fisgón). 1996. *Cómo sobrevivir al neoliberalismo sin dejar de ser
 mexicano.* Mexico: Grijalbo.

Best-Maugard, Adolfo. 1923. *Método de dibujo*. Mexico: Secretaría de Educación Pública.

Boone, Elizabeth. 2000. *The Red and the Black. Pictorial Histories of the Aztecs and the Mixtecs*. Austin: University of Texas Press.

Boone, Elizabeth & W.Mignolo. 1994. *Writing without Words*. Durham: Duke University Press.

Brotherston, Gordon. 1992. *Book of the Fourth World*. Cambridge University Press (*América indígena en su literatura*. México: Fondo de Cultura Económica, 1997 [revised edition].

————. 1995. *Painted Books from Mexico*. London: British Museum Press.

————. 2000. 'Indigenous Intelligence in Spain's American colony', *Forum for Modern Language Studies* XXVI: 241–53.

————. 2000a *El Códice de Tepoztlan*. San Francisco: Editorial Pacifica.

Caso, Alfonso.1942. 'El paraíso terrenal en Teotihuacan', *Cuadernos americanos* VI, 6.

————. 1977–9. *Reyes y reinos de la mixteca*. Mexico: Fondo de Cultura Económica.

Catlin, Stanton L. 1978. 'Political Iconography in the Diego Rivera Frescoes at Cuernavaca, Mexico', in *Art and Architecture in the Service of Politics*, H. Millon & L. Nochlin. Cambridge: MIT Press.

Charlot, Reed D. 1965. *The Mexican Mural Renaissance*. New Haven: Yale University Press.

Chavero, Alfredo. 1892. *Antigüedades mexicanas publicadas por la Junta Colombina de México*. Mexico: Secretaría de Fomento, 2 vols. and atlas of plates.

Corona, Yolanda. 1999. *Tepoztlan: pueblo de resistencia*. Cuernavaca: Universidad Autónoma del Estado de Morelos.

Edmonson, Munro. 1971. *The Book of Counsel. The Popol vuh*. New Orleans: Tulane University Press.

Escalona, Enrique. 1989. *Tlacuilo*. Mexico: UNAM.

Florescano, Enrique. 2000. *Memoria indígena*. Mexico: Grijalbo.

Gamio, Manuel. 1922. *La población del Valle de Teotihuacan,* 7 vols. México: Secretaría de Agricultura y Fomento.

Glass, John. 1975. 'A Census of Middle American Pictorial Mss.', in *Handbook of Middle American Indians*. Austin, University of Texas Press.

Good Eshelman, Catharine. 1988. *Haciendo la lucha. Arte y comercio nahuas de Guerrero*. Mexico: Fondo de Cultura Económica.

Gutiérrez, Natividad.1999. *Nationalist Myths and Ethnic Identities. Indigenous Intellectuals and the Mexican State*. Lincoln: University of Nebraska Press.

Harvey, Herbet R. & Barbara Williams. 1986. 'Decipherment and Some Implications of Aztec Numerical Glyphs', in *Native American Mathematics*, M.Closs. Austin: University Texas Press.

Lampert, Catherine et al. 2000. *Francisco Toledo*. London: Whitechapel Art Gallery.

León-Portilla, Miguel. 1986. *Coloquios y doctrina cristiana*. Mexico: UNAM.

Loo, Peter van der. 1987. *Códices, costumbres, continuidad. Un estudio de la religión mesoamericana*. Leiden: Archeologisch Centrum Rijksuniversiteit.

López Austin, Alfredo. 1984. *Cuerpo humano e ideología*. Mexico: UNAM.

McCloud, Scott. 1993. *Understanding Comics: The Invisible Art*. New York: Kitchen Sink Press.

Méndez-Ramírez, Hugo. 1999. *Neruda's Ekphrastic Experience*. Lewisburg: Bucknell University Press.

Monsiváis, Carlos, Rafael Barajas et al. *El Ahuizotl* (Supplement to *La Jornada* March–October 1992. Mexico.

Moraga, Cherrie. 1993. *The Last Generation*. Boston: South End Press.

Nowotny, Karl Anton. 1961. Tlacuilolli. Berlin: Mann.

RIUS (Del Río, Eduardo). 1987. *Quetzalcoatl no era del PRI*. Mexico: Grijalbo.

———. 1988. *El arte irrespetuoso*. Mexico: Grijalbo.

———. 1992. *Quinientos años fregados pero cristianos*. Mexico: Grijalbo.

Robertson, Donald. 1959. *Mexican Manuscript Painting*. Yale: Yale University Press.

Rochfort, Desmond. 1987. *The Murals of Diego Rivera*. London: South Back Centre.

Sandstrom, Alan E. & Pamela Effrein. 1986. *Traditional Papermaking and Paper Cult Figures of Mexico*. Norman: University of Oklahoma Press.

Smith, Mary Elizabeth. 1973. *Picture Writing from Ancient Southern Mexico*. Norman: University of Oklahoma Press.

Valdez, Luis. 1972. *Aztlan: An Anthology of Mexican American literature*. New York: Vintage Books.

Vos, Jan de. 2000. 'Teología india', *Ixtus* (Cuernavaca), 1.

Chapter 3

Subversive Needlework:
Gender, Class and History at Venezuela's National Exhibition, 1883

Beatriz González Stephan

The Needle that Tells a Tale

It is the art of knitting that allows the nameless female protagonist of *Soledad de la sangre* (*The Solitude of the Blood*) to accumulate the small amount of money that permits her, apart from regularly contributing to domestic expenses, to buy an old phonograph which fills her lonely hours with music (Brunet 1967). Selling her knitted pieces, while not providing her with the independence to rid herself of an exploiting and abusive husband, does enable her to create her own recreational space. The time thus spent is not only one of intense privacy, but also of contemplative self-fulfilment where art helps her to withdraw from an unpleasant reality. Indeed, the correlation between her needlework skills and the consumption of art is striking.

In her story, Marta Brunet relates the work with knitting needle and wool with the art of music in such a way as to condense the historico-cultural issues which have divided and gendered artistic practices into forms of high art and low art, art and handicraft, and objects of practical and those of symbolic value. The woman's knitting skills – she ends up with a long list of clients who place orders with her – allow her to manage the household by means of the money she earns. Though what she does is not art, it is a skill all the same, one that turns her into a productive subject: hence her husband's appreciation of her as a piece of property that earns him material values.

Knitting is a skill that has been acquired through long-standing traditions informally passed down, but it finds application in commercial exchange with the result that the house is looked after and things can be bought, among them the phonograph. Art is produced by others, by male musicians. The working woman only listens. Loaded down with the weight of her working body, she is transformed into a tradable object, and her relationship with art is merely a passive one. The proceeds from the sale of her handicraft allow her to consume art, but not to produce it. The distinction between knitting (as work, handicraft, feminine and reality) and music (as leisure, art, masculine and escapism) summarises a tension that surfaces in the last decades of the nineteenth century and which this story, already of the twentieth century, picks up by depicting the preconditions of a discrimination which it does not manage to resolve.

In any case, it is worth signalling an equation that has been the backbone of all cultural practice and according to which lower forms of art or handicraft – textiles, embroidery, sewing, pottery, cooking – have been assigned to women, and to men, those activities that society recognises as high art – painting, sculpture, architecture, music – a gendered distribution of materials, techniques, skills and places of acquiring knowledge which goes hand in hand with a separation between public and private spheres. It is therefore not without meaning that the protagonist of *Soledad de la sangre* produces her pieces in the house but steps out into the street to buy the phonograph. Ironically, it is also worth analysing how the goods produced within the family nucleus are productively channelled into the public sphere, and how the art that circulates there changes and contaminates the fictitious inviolability of the home.

Art forms related to the production and processing of textiles experienced a shift into the background of cultural activity, an attempt at obliteration that was not always accepted in an agreeable and complacent manner. At the same time, it is a fact that this historical unease – because there were indeed times when the production of tapestries, ornamentations and embroidery was a highly valued skill – was not expressed with sufficiently critical transparency: women embroidered and sewed without consciously competing with the high arts, though in a way they implicitly struggled with those categories of art that permanently excluded them. The major challenge was of course to directly start competing over the written word, over the printed letter, instead of giving in to the silence innate to needlework. Still, it was to be one of the most traditional ways of expression, namely the language of needle and thread, that skillfully started negotiating spaces and limits and conquered new terrains that made it possible to rethink modern subjectivity.

In 1883, under Antonio Guzmán Blanco (1870–1888) Venezuela organised its first National Exhibition to commemorate the birth of the Libera-

tor, Simón Bolívar. This event shook the still rather provincial foundations of a country that had only just exorcised the ghosts of a colonial past, while fervently attempting to garland itself with a cosmopolitanism of the most sophisticated sort. The occasion gave rise to a mix of cultural events that were nothing short of impressive, much more so than Adolfo Ernst, the chronicler who listed them in the style of catalogue entries, wants to make us believe.[1] In one of the halls of the Exhibition Palace, an unknown Miss J. Paz Guevara, who, almost like Marta Brunet's female protagonist, preferred to hide her real identity, unveiled a picture of the Colombian independence heroine Policarpa Salvarrieta (1793–1817) embroidered with human hair. But how should this gesture be understood, an act so affectionate towards the Colombian martyr, but so seemingly out of touch with a moment in history where everything was to allude to the *Padre de la Patria* (the Father of the Fatherland) or at least to the *Ilustre Americano* (the Illustrious American) who regenerated it? Naturally, nobody bothered to look at it and the work was removed. Guevara simply became one of the many women who had presented herself with the work of her hands, silently competing in the Exhibition with her modest portrait of a lady. It must be emphasised, though, that this was the only portrait of a woman that had been contributed by a woman, among hundreds of other works and objects by women demonstrating their needlework skills.

Before the eyes of the male population, J. Paz Guevara had done her utmost to lift her art of hair embroidery up to the level of oil painting; the portrait genre, widely cultivated by male painters, was much in *vogue* in those days during which a fast ascending bourgeoisie was keen on being represented in order to boost its prestige. Obviously, portraits made with perishable materials, such as hair, thread, feathers and scales, could not at all provide the illusion of eternity so much in demand.

The portrait of Policarpa Salavarrieta implied a lot without explicitly saying anything. For the time being, we are left with these implications: officially, Policarpa worked as a seamstress, offering her services to the aristocratic ladies of the Colombian viceroyalty. She sewed and embroidered. But she also fought with the patriotic army for her country's independence. This was her secret identity. As a seamstress, she was inoffensive; as a spy, she was dangerous; therefore she was executed by a firing squad. Which one of her two faces was it that had captured Paz Guevara's interest? Was it Policarpa as she was silently sewing in the houses, or rather Policarpa committed to the political cause?

Just as in the years leading up to the event, the very years that marked out Guzmán Blanco's government, all the gestures and details of the National Exhibition revolved around the lavish and hypertrophic cult of Simón Bolívar. Father figures and notables populated the collective imagination and swamped national historiography with male figures. At

this point in the century, it was difficult to even imagine women's participation in social life. The issue had been swiped off the table by the supremacy of patriarchs on display. Nevertheless, the possibly disturbing presence of Policarpa Salavarrieta in the aisles of the Exhibition was only a harbinger of other kinds of memory. The considerable contingent of women who took part in the Exhibition did not celebrate the Father of the Fatherland with their contributions. The face of Simón Bolívar was significantly absent from their works; in his place, the image of Policarpa Salavarrieta emerged.

There is still something disturbing about both the economic power of fabrics in the domestic sphere, i.e., the independence that the protagonist in *Soledad de la sangre* eventually gains, and the power of Policarpa Salavarrieta's embroidered countenance in the midst of representations of the nation's patriarchs: both underscore the productive meaning (productive in economic as well as symbolic terms) of the language that circumscribes, with needle and thread, the secrets of the fabric's texture.[2]

A Century for the Fatherland and for the World

On 2 August 1883, the first National Exhibition of Venezuela, the third of its kind on the Latin American continent,[3] opened its doors in celebration of the Centenary of the Liberator, under the auspices of the powerful and progressive government of 'the Illustrious American', Antonio Guzmán Blanco. The ancient campus of the University of Caracas, sumptuously rebuilt in a strictly neogothic style (the very style preferred by English exhibitions and at that time considered the most advanced expression of modern architecture) saw 62,841 visitors during those days. A considerable number had come from far away, not only to see for themselves how this once torrid zone had advanced and progressed, but also to catch a glimpse of the seemingly inexhaustible potential of the tropical rainforest, all of this under fourteen electrical spotlights.[4]

Everything was neatly arranged along the walls of the numerous Pompeian-style galleries; all manner of artistic styles had been revived and the *pastiche* was tastefully done. Had it not been for a magnificent watch donated by the Caracas guild of jewellers which marked the hours to the glorious tune of the national anthem, the distinguished audience might well have felt themselves transposed to the Crystal Palace in London, especially when considering that apart from a large number of richly dressed Caracas patrons, Prince Henry of Prussia as well as the consuls of Morocco, Macao, Brussels and Hamburg had come to pay their respects to the vanity of the *Regenerador de la Patria* (the Regenerator of the Fatherland).

The Centenary doubtlessly polished up the country's image both to the outside world (a vital step towards meeting the economic demands that arose from the progress in the Northern Hemisphere) as much as it crystallised its internal representation for those within its borders. The efforts of Guzmán's government had effectively transformed the image of a country in ruins – a legacy of the 1812 earthquake – into that of a country with at least some sectors of urban character where public buildings, squares, theatres, racecourses, seaside resorts, trains, trams and avenues imitated other metropolitan centres. In that respect, the Exhibition Palace, flanked by its *Santa Capilla*, or Holy Chapel, was an unambiguous attempt to elaborate on the traditions of both London and Paris (see figure 3.1).

Figure 3.1 'El Saludante'. Statue of Antonio Guzmán Blanco, Caracas, 1883.*

Thirteen years of intensive urban transformation, the redesigning of buildings, the renovation of squares and avenues, the creation of new spaces, the modernisation and rearrangement of infrastructure, on top of a compulsive as well as calculated introduction of national festivities around meaningful dates in the patriotic calendar (always accompanied by a myriad of histrionic and monumentalist gestures of symbolic importance), had prepared Venezuelan sensitivities for this magnificent celebration of the Centenary, the apex of long years of political energy devoted to strengthening the state apparatus.[5] The year 1883 spelled a high point of power for Guzmán's

* The *guzmanato* regime chose a neogothic style for the Palace of the National Exhibition. In this way, it would become the new cathedral of modernity, in charge of sacralizing the commodities that would be on display there. Although commemorations were supposedly dedicated to the centenary of Simón Bolívar's birth (1883), the Illustrious American's egolatry couldn't resist the temptation to have a statue on horseback of himself erected in the style of Napoleon III to welcome visitors to the Exhibition. Not by chance, then, the statue soon became known as 'El Saludante'.

autocracy. On the one hand, his government stood for the modern consol-
idation of the state apparatus as well as a coherent articulation of verbo-
symbolic imagery in civil society, but on the other hand and in an equally
exhibitionist manner, for a flaunting of all that manifested the country's
live force in the display cabinet of the international market.

After almost two decades, the national state under the aegis of Guzmán
Blanco had accumulated a patrimony of both structural and descriptive
works that were, by their sheer visual force, invaluable not only when it
came to consolidating the state's political development but also with
regard to articulating the imaginary of a society that had up to then been
fragmented and dispersed. At least, this patrimony helped establish a
strong relationship between the poetry of power and the aesthetic-sym-
bolic functions of politics, which opportunely served to pursue certain
people's personalist ambitions as well as those of the government and
state. Already since the beginning of the regime (1870), banalised forms
of patriotic culture had been promoted: the Rojas Hermanos department
store sold crystal paperweights bearing the image of Simón Bolívar; a few
years later, handkerchiefs framed with pictures not only of the national
hero but also of the Illustrious American, the Capitol and the Pantheon
were on offer. In the end, the popularisation of patriotic imagery became
inevitable after Guzmán Blanco had initiated a programme of embellish-
ing the whole of Caracas with statues of all the nation's great men.

In this sense and without giving much space to numerous other cultural
manifestations that marked Guzmán's reign (such as carnivals, parades,
patriotic festivities, glorifications, literary competitions and concerts), the
monumental character of public buildings and statues played an important
role both in the desire for constructing the nation's historical memory and in
the most prosaic of intentions: imposing public order and discipline. It is
interesting to note the symptomatic contiguity between the personalist cult
of Guzmán Blanco and the founding fathers of the Republic with their mutu-
ally contaminating reverence and sacralisation, as well as their objectifica-
tion in the form of sculptures and large-format paintings. The construction
of a national *patri*mony was closely linked to preserving the memory of the
Padre, the Father, a memory that emerged untouched through stone, iron,
bronze or oil paint, seeking, in an overpowering manner, to consolidate the
clearly androcentric character of the national agenda and to mark off the
heroic narrative of the nation's founding days as that of a strictly masculine
community.[6] It is therefore not coincidental that along with a concern for
modernising urban infrastructure, the construction of squares with their
respective sculptures was to play a decisive role in the new urban order.
However, it happened the other way round: in accordance with the rules of
narcissism, it was the erection of statues that took place – with or without
squares. The thus established semblance between the Illustrious American

and Simón Bolívar was a trifle matter: after all, if this one had been the Father, that one was 'regenerating' the Fatherland (see figure 3.2). Guzmán Blanco succeeded in harmonising both cults. While the year 1874 saw the unveiling of an equestrian monument to the Liberator (which was to survive through the times) on one of the Bolívar Squares mainly indented for hosting Sunday open-air concerts, the following year, Caracas citizens had to witness the erection of statues of Guzmán Blanco himself – Guzmán Blanco 'El Saludante' in 1875, and 'Manganzóu' in 1876 – in spots the citizenry could not avoid: one opposite the Exhibition Palace and one on the hill of Calvary. From there, the latter dominated the entire city with its excessive height. The stone it was set in emblematically combined cult and control, sugar-coated by an ornamental landscape of fountains, gardens and swans, in front of which, however, the iconoclastic rage of the opposition would not halt when it came to disposing of the president's statues.

Figure 3.2 Vicente Micolao Sierra and Felipe Esteves, 'Apoteosis del Libertador', living image, Caracas, 1883.*

* The culture of the *guzmanato*, within the fashionably grandiloquent and histrionic style, had a weakness for 'living images' and 'fantastic allegories'. So-called 'Apotheoses of the Liberator' were particularly well-received. In the year of the Centenary (1883), the most acclaimed of these was staged by Vicente Micolao Sierra and Felipe Esteves in the Guzmán Blanco Theatre (today's Municipal Theatre of Caracas). Living images were allegories of the nation, particularly suited for the public appearance of women on stage: it provided an 'intelligent' way of exhibiting them outside the home, yet transformed into symbolic objects, petrified in their Greco-Latin costumes, as satellite fetishes of the Father of the Fatherland. They were the ideal script in order to prevent women's movement and expression.

Still, Guzmán Blanco's personalist cult was not allowed to surpass the one of the Father of the Fatherland. In the year of the Centenary, he decreed the erection of a gigantic granite statue of Simón Bolívar, eighteen metres in height, to appease those hostile to the regime. In the end, the project was shelved because of its gargantuan proportions. This was not the case with other rather outsized statues that were cropping up in the urban panorama during this era: 1883 alone saw the erection of the monuments of Antonio Leocadio Guzmán in the San Jacinto square, likewise Francisco de Miranda's in the Pantheon, the one of José María Vargas in the University's cloister, another one of Simón Bolívar, this time on foot, on the University's façade, a statue of Juan Manuel Cajigal in the College of Engineers, a monument of George Washington in the poplar grove of St. Theresa's and, in exchange, a statue of the Liberator in New York's Central Park.[7]

The craving for effigies did not end here. However, we will leave it at those examples to show how much this monumentalism symptomised the state's real agenda, hinting, as it were, at a new pedagogical method to discipline the masses. It was assumed that they, on entering a given square, would be transubstantiated into a new civil body that would recognise the aesthetics of hero worship as well as follow the new *caudillos*. It was naively believed that stone, as if by magic, might exude order and progress.

It was, however, not only the marble or bronze of the statues, but the sheer size of certain public buildings that was to express the modernising powers of the state, of its agents and of a new form of creating historical memory. The Capitol (built in 1874), the Bolívar Square (rebuilt in 1874), the Pantheon (1875), the Calvary Parade (1873), the City Theatre (1881, built before Guzmán Blanco's reign), the South Cemetery (1876), the Masonic Temple (1876), the Palace of Justice (1877) and the University that was turned into the Exhibition Palace (between 1873 and 1883) remain politico-spatial points of reference and important to national life to this very day.

These sites of memory, which continue to invest physical space with the capacity to become sites of social ritual, were not only actively preserved; they also shaped, from that time onwards, a sense of national patrimony that was to be confirmed as time went by.[8] Up to this point, both historiographic writing and the dynamism of institutional practice itself have preserved the symbolic and material memory of the monument, whose meaning is inseparable from the 'hard' material of its making, in spite of it having been positioned in a society whose collective memory is so fragile and porous that even their most eminent sons cast in bronze and marble have found no firm hold in it. All in all, the work of engineers and architects, painters and sculptors, choreographers and designers,

poets and writers has been kept in the annals of the learned city that protected its virile creatures from being forgotten and falling into anonymity. Hurtado Manrique and Muñoz Tébar (responsible for the Capitol and the Exhibition Palace), Arturo Michelena, Cristóbal Rojas, Martín Tovar y Tovar (creators of the frescoes of the Battle of Carabobo' and the Signing of the Act of Independence), Felipe Tejera, Eduardo Blanco (author of *Venezuela heróica*), Adolfo Ernst (responsible for historically immortalising the National Exhibition) – a canon of men, not only because a tradition of patriarchal supremacy reproduced its markers of refinement both in and through them, but also because the relevant institutions (of family and education) hierarchically distributed the genres in which they would ultimately express themselves. Where, now, did the 'soft' objects end up, objects that had been made by other hands, or the forms of language spoken by less powerful voices?

The Great Illusion: The Democratisation of Space

The National Exhibition of 1883 was a founding moment in the creation of symbolic capital for the nation. Although it legitimised an imagery more geared towards dominant patriarchal tastes, it was also clear that it was to be remembered as an Exhibition more democratic towards the country's many diverse productive sectors. The formula of progress, at least outwardly, demanded the existence of a certain plurality and of social, ethnic and sexual diversity in the artificial space of the Exhibition. After all, it was a staging, a representation, a 'presentation for', which, just like all fiction, even if not exactly reflecting reality, did not fail to have an impact on the ensuing transformation of living conditions.

The official announcement of the previous year had unambiguously stated that no social group should be excluded. Special care was taken to particularly extend the invitation to the fairer sex, calling on them to participate in the Exhibition with their 'works and labours':

> Very successful was the idea of the Distinguished President of the Board of Directors to ask, in a circular dated the 31st January 1883, the Ladies-Principal of all national girls' schools to present at the Exhibition handicrafts produced by their pupils, not only in order to demonstrate their skill and diligence, but also as a sign of childlike innocence offered to the Father of the Fatherland. (Ernst 1983: III, 17)

Deciding whether or not to ask Venezuelan women to participate in the Exhibition could not have been a matter so easy to settle as discussions on this issue lasted for several months: women were the last group to be invited. They were only directly addressed in the year of the Exhibition, a few months before the event started. Their written responses to the Board

of Directors were indifferent; they hardly seemed to appreciate the gesture and, notably, no reference was made either to the Father or to the Regenerator of the Fatherland. They only agreed to organise themselves and assist.

It seems likely that the group of illustrious gentlemen of the Board of Directors who organised the event carefully tried to assess the impact of publicly exposing the 'sweet angel of home and hearth', which might compromise, to a certain degree and at a certain risk, the rigid distribution of roles and separation of space that affected both men and women, especially when taking into account the still provincial and conservative character of structures shaping Venezuela towards the end of the century, in particular those governing the male populace. Nevertheless, to the outside world the situation could only look progressive. It had been learned from other universal exhibitions to which Venezuelan delegates had contributed that women should be assigned one particular hall, just like other 'ethnic' groups such as *indios*, Africans and Asians (see figure 3.3).[9]

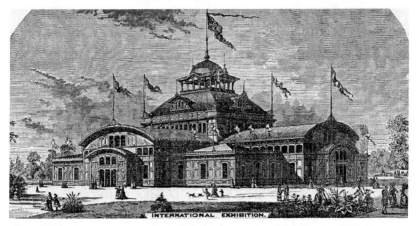

Figure 3.3 The Women's Pavillion, Philadelphia Universal Exhibition, 1876.*

On the planned date, women's participation in the Exhibition turned out to be overwhelming, not only with regard to the exhibits solicited by above-mentioned executive, but also with respect to other professions that were traditionally shunned by men: in the section 'Embroidery, laces and ornamentations' alone, Adolfo Ernst registered 173 pieces, more than half of those submitted by individuals, the remainder by professional bodies. Also to other sections did women contribute admirably: upholstery, carpet and mat-making, textiles, weaving, hammocks, rope mak-

* The Philadelphia world's fair was organised in order to commemorate the centenary of U.S. independence (1776–1876). All of the universal exhibitions took advantage of symbolic dates in order to construct, in the vertigo of the present, the nation's past, as well as to display its plural and multi-ethnic social spaces. North-American women, on this occasion – and perhaps for the very first time in the history of exhibitions –, were granted their proper pavillion. On subsequent occasions, such as the Chicago world's fair of 1893, their building would become much bigger.

ing, hat making, floristry, the production of clothes for both sexes, corsets, cocoa, coffee, candles, soap, pastries, preserves, and in particular 'Works of hair' and 'Artificial flowers and fruit, executed in silk, natural fibres, wool, feathers, wax etc.', where the organisers had grouped together examples of women's art which were obviously not considered quite 'artistic' enough.

The 'etc.' in the previous heading included, for example, a 'bouquet of flowers made of fish scales' by a certain Mrs Josefa Salias de Lugo, which perhaps seemed too much of a piece of handicraft to Adolfo Ernst to list it in his catalogue, although later and to his chagrin he found it among the award-winning entries, alongside many other 'pieces of work' by women that were recognised by the Exhibition's jury. Special mention, for example, was made of the satin card of Miss Natividad Rodríguez, a picture of a little bouquet of dried flowers made out of breadcrumbs by Miss María Isabel Cardoso, Venezuela's coat of arms made from feathers by Mercedes Meneses, Isabel González Guinán's handkerchief embroidered with scenes from the Battle of Carabobo, a cushion adorned with pieces of fabric imitating a mosaic by Felipa Geagan, a portrait of the Liberator with a frame of flowers made of leather by Juana Bello, and a portrait of the Illustrious American, embroidered with hair, by Mrs Josefa de Moreno Fernandez. The latter two received bronze medals as, in spite of having been made of materials that were neither considered very artistic nor noble, the jury wanted to recognise the fact that those were the only contributions by women that directly referred to the persons to be honoured. It took them much more to award a prize to Mrs Catalina Matute de Armas for her collection of insect-drawings, and to Dolores Ugarte (the only woman who was allowed to share a hall with the male sculptors) for her Group of Dogs made from potter's clay. Miss J. Paz Guevara with her portrait of human hair representing Policarpa Salavarrieta went unnoticed by the eyes of the jury.

Altogether, 249 women of known identity participated in the National Exhibition, signing their work on display with forename and surname. However, it can be assumed that actually more than twice that many took part since innumerable works were on display without their creators' identity revealed, simply as collective contributions made by delegations of some native locality (for example, the Barquisimeto Collection: woven cotton blankets, mats, articles made from *cocuiza* [a plant similar to sisal, traditionally used in the production of ropes, baskets and shoes (Translator's note)], and *alpargatas* [traditional rope-sole and canvas shoes (Translator's note)], hammocks...). The act of attaching a nameplate was not only about displaying a signature; it was the outward sign of a struggle for a stabilisation of identities that had been erased from the public sphere. Both the dissolution of individual identity into faceless commu-

nities or collective bodies and the overwhelming presence of works created by women revealed a repressed power which in one way or another just awaited its opportunity for taking to the streets. Indeed, a signature is the tangible expression of a chosen identity, of which the collegiate body represents a previous stage. These two modalities are but the two faces of the same coin.

The patriarchal culture of the Republic had taken away women's names, not only denying them their identity as citizens, but also their rights as authors and creators of produced goods and works of art.[10] But it is also true that bourgeois culture, in its endeavour to rearrange the arts in a hierarchical manner, had *dis-located* artistic identity from the things that women produced, reducing them, at best, to the status of 'handicraft', and at worst, to that of 'work', thereby devaluating the aesthetic competence of those who had made them. To leave the creators stand nameless had two effects: on the one hand, it removed them from the public sphere, thereby denying them an opportunity for public expression (which in turn stripped them of all access to written or 'high' culture) and, on the other hand, to belittle the sophisticated forms of art they practised (which implied diminishing the role and importance of textile works and embroidery). That is why the Exhibition was to become a very opportune moment for re-establishing, in the public eye, women's authority over what they produced. It was within this set-up that the virile subject, also in public, became confronted with what exactly it had displaced. This new situation, precisely because of its transitory nature, did not structurally modify the basic conditions, but it *re-placed* subjects and practices, albeit within irrelevant types of space. In other words, the male subject that had reduced women to pursuing their chores in and around the house was now obliged to address them and give them some space in his territory, even going so far as to recognise their talents.

The demands made by politics, including the cosmopolitan aspirations of Guzmán's government, accelerated (in a positive sense from women's point of view) democratisation of visual culture all throughout the Exhibition where women could effectively enter (or leave), even though they were subject to a rather harsh political economy that was full of contradictions. It was the moment when traditional conditions became more flexible. Women could now claim that in terms of numbers, in the country's economy and above all in the field of textiles and fabrics, they were a presence and even a workforce to be reckoned with.[11] In this sense, the Exhibition worked in two different aspects qualitatively opposed to each other in the way of two antagonistic forces: the one (centripetal) included and reinstated them, and the other one (centrifugal) excluded them again because it only credited them with the production of handicrafts and objects for domestic use.[12]

The dynamism of these exhibitions, insofar as they were examples of privileged types of space in a consumerist society, allowed and even obliged the spectator to acknowledge women as working subjects who produced things (but not art), guided by rules that simultaneously coded them as beacons of fragility and evanescence, with a precarious existence and a volatile history, just like any other merchandise that was on view in the display cabinet of the market. Therefore, the conditions of their exhibiting seemed doubly ephemeral, not only for the types of object through which they were represented, but also for the organic and perishable materials these objects consisted of. How were hair, fish scales, feathers, flowers, threads, worsted or bread crumbs to be preserved? It was nearly impossible for women to gain access to marble or bronze. They worked with types of material that were immediately available, either picked up from the kitchen floor, taken from nature or even from the ironmonger. Treated like objects of celebration on this occasion, they fulfilled the objective of passing on, through visual objects, signs of national 'progress' in the service of the superficial spectacle of modernisation; but on the other hand, they helped shape the paradoxical 'no-text' or emptiness innate to patrimonial history (because the history of the father generates, without fail, gaps when it comes to all that is seen as 'soft'), that means, a 'motherly' history without textual memory, or rather, without material props.

Within the visual culture produced by the Exhibition, the real and even novel event at the Palace was the unusually strong presence of women. Adolfo Ernst, rather taken aback by this unprecedented state of things, remarked in the first few pages of his catalogue:

> There was an outright invasion of ladies, young ladies and gentlemen, with the fairer sex being in a constant and absolute majority throughout the whole day. This did not change during the hours of the night when the entire Palace appeared splendidly illuminated by electrical light, just like the avenues of the Capitol as well as the Guzmán Blanco and Bolívar Squares. (Ernst 1983: III, 30)

So, while women had been excluded from the proceedings of official events, they had not, as we now know, from the panorama of social life. The Exhibition was their public mass debut, but again less so in terms of presenting themselves with their handiwork. In the country, there already existed a tradition whereby the same women organised trade fairs in marketplaces or schools to present their work. To see them at the Exhibition satisfied curiosity but also made the surprising normal: women had turned into their own exhibit. Just as for works of art (they were, after all, still the *fairer* sex), the gaze that met them refocused its mechanism of fetishisation away from their contributions towards their own subjectivity.

This complex process of democratising women helped to blunt the sharp lines of separation between house and street, between domestic regime and the marketplace. At this stage, it was of little importance whether their exhibits were works of art or not; women's gesture of transgression was to place themselves into the visual field, just like precious objects in the shop window of conspicuous consumption.

Neogothic Paradoxes: the Subversive Stitch

Turning once again back to the original text of the official announcement: women were indeed invited to present themselves, but only with their 'handiwork', and only to show their 'skill' and 'diligence'. The feminine subject as a historico-social reality remained fragmented (of the totality of the body, neither head nor tongue but only 'hands' remained); their economic power that was potentially gaining importance was devaluated (only 'skills', neither art nor genius). Their works were never more than 'handiwork', 'objects', 'articles', 'accessories', and in the worst case, when the historian's terminology of catalogue-writing had reached the end of its semantic tether, 'unclassifiable' objects. Very probably and on more than one occasion, Adolfo Ernst ran out of words in the face of feminine craftsmanship. This means that women's competence remained reduced to 'lower forms of art' which, as part of the politics of the weak, saw them explore the infinite expressive possibilities of materials that were either considered less important or just alternatives to the real thing and which shipwrecked the competence of institutional language.

The limited language that was used to write the Exhibition's history and of which Adolfo Ernst availed himself contained all the tension that emerges between the traditional act of naming and the de-centering of new subjects and situations. The ever more visible ascent of women in fields assigned to men produced feelings of threat and insecurity that took on a life of their own and grew ever more intense. On the other hand, it entailed a whole agenda of discourses that attempted to resolve these fears by either demonising or spiritualising women. During these last decades of the century, representations oscillated between women's abjection or their sublimation (Virgin versus Whore, Mother versus Slut, Flower versus Snake).[13] In the meantime, the number of literate women in Venezuela in the years of Guzmán's government exceeded the number of literate men by far: women not only read more, but perhaps played more music and very probably wrote much more, too.[14]

The misogynist reclusion of the lectured male rendered him unable to see the real feminine subject. Moreover, the event of the Exhibition worked just like a text that named women based on a range of parameters,

so that, once 'named', they had been disciplined back into the order of patriarchal discourse. In that sense, the neogothic design of the Exhibition Palace was not only a formality of modern architecture. On another level, it also expressed the contradictions of a modernity that juggled with processes of democratisation while closely guarding old feudal power structures. In the same way, the standardisation of women's participation that happened mainly in the form of 'handiwork' reinforced, to the eyes of the public, their place in the domestic sphere. The loom, the embroidery, and needlework: all those were things of the house and intrinsically constitutive of femininity. Even more: weaving and embroidering were activities that had grouped women together in orders ruled by monastic silence (see figure 3.4). The neogothic style of the Palace was without at doubt a fitting environment for women who reiterated a long medieval tradition through their activities. The rise of the middle classes, among them the humble little dressmaker who is appearing on the Exhibition's scene, did not necessarily bring about a massification of popular tastes. Within the walls of the Palace, nostalgia for certain aristocratic styles asserted itself: the embroidery laid out matched well with the courtly flair of the building's ogives.

Figure 3.4 Camille Pizarro, 'Two Women Stitching in a Chamber', charcoal on paper, 1853.*

* Many foreign travellers visited Venezuela during the nineteenth century. Their accounts and drawings constitute a valuable base of information. Among these was the French painter Camille Pizarro, who toured the country around mid-century. We have to assume that the profession of seamstress was one the most frequent among women, as there must have been many for the painter to have registered them as significant. Feminine labour found in textiles one of the most proficient sources of economic income, yet also a means of social organisation that allowed for the emergence of a new degree of self-consciousness.

Hence, patriarchal culture, and to a no lesser degree the Board of Directors who organised the Exhibition, appreciated women's contributions very much because appraising the fabrics and textiles meant controlling women's ways of expression. By assigning women a prominent space at the event, their place in the house was in fact being revalued, promoting the idea of a model woman who was confined in her expression to the language of fabrics and silence. Democratisation was a slippery and treacherous terrain. Putting themselves on display meant that women once again assumed the traits of obedience and submission embodied in the work of embroidery. To celebrate them for their work actually amounted to fencing them in and avoiding that they ever undermined 'high arts', in particular literature, from which they were elegantly excluded: in the section 'Scientific and literary works, works of music' the prize-winning contributors were the nation's men of letters. It was there that the foundational canon of literature had its roots: Eduardo Blanco with his *Venezuela heróica*; Felipe Tejera with *La Bolivíada, La Colombíada*, and *Triunfar con la patria*; Ramón de la Plaza with his *Ensayo sobre el arte en Venezuela*; Arístides Rojas with *Orígenes de la revolución venezolana*; and Hortensio with his two volumes of *Literatura venezolana*. The masters of the written word formed a special community: words were wielded as heroically as weapons. Writing was done in the eyes of the public and carried with it the power of fabricating history (see figure 3.5).

Figure 3.5 Martín Tovar y Tovar, 'Signing the Declaration of Independence', oil on canvas, 1883. Museo Nacional de Bellas Artes, Caracas.*

* This painting occupied a central spot in the National Exhibition. It also received the most important price. Not only did it group together in a fashion that satisfied contemporary beholders the body of illustrious men who had founded the Fatherland; it also spoke of the present pact public figures needed to sign as a virile community that presided over the matters of the state. Like a brotherhood, they would symbolically subscribe to a closing of their ranks, so as to impede the intrusion of non-white or non-masculine social subjects. Significantly, this oil painting passed on into the asset of the National Museum of Fine Arts, and is considered to be one of the hallmarks of the national patrimony.

However, the snares of democratisation did not always work in favour of those who pulled the strings of interpretative forms of language. The silence of the embroidering woman was set to be broken; she waited to be asked so she might speak out. But as she could not be interrupted, as her virtue depended on her rigorous diligence, she had to talk in the language of needle and thread. Women's needlework spoke for them. With threads of gold and silver and silk, satin, velvet, wool and cotton, as well as materials like hair, scales, wheat and breadcrumbs, women appeared at the Exhibition appropriating the patriotic agenda. By and large, politics was an arena that was closed to them. Nevertheless, the occasion gave them an opportunity to launch their own incursion into this sphere: after all, they could not suddenly stop being good citizens (see figure 3.6).

Figure 3.6 Faustino Padrón, 'Retrato del General Juan José Flores', natural hair portrait, 1883. Museo Bolivariano, Caracas.*

* None of the dozens of works submitted to the National Exhibition by women – some of them hair portraits such as this one – has been preserved, except the portrait of General Juan José Flores (1883) by Faustino Padrón, created using the Founding Father's own hair, which can still be admired in the Museo Bolivariano. We can assume that this is approximately how a hair portrait would have looked like and that the portrait of Policarpa Salavarrieta most probably looked similar to this one.

In the field of verbo-symbolic representation, which is in reality a reflection of existing hegemonies, all activities compulsively revolved around Simón Bolívar, the heroes of the independence and, as a consequence, Guzmán Blanco. There were plenty of patriotic motifs whenever artists had taken the opportunity to give a face to all past and present protagonists of the nation. At times, Guzmán Blanco's physiognomy mimicked that of the Liberator. In stark contrast to the flood of 'Bolívars' and 'Guzmáns', the women that had ventured to tackle patriotic themes with their embroidery and pictures of hair had decided, apart from two cases, to avoid representing the Fathers of the Fatherland. It seemed that in their eyes another male figure was more deserving: there were two works depicting the general Roberto Ibarra. In other pieces they opted for allegorical motifs that watered down their commitment to the political themes on offer, namely by some discreet abstraction that conveniently allowed them to enter the nationalist discourse without displaying too much attachment to Guzmán's autocracy or to the cult of Bolívar.

These works were mainly representations of the Venezuelan coat of arms, the allegorisation of the five republics liberated by Bolívar (providing an opportunity to work with female figures), the Battle of Carabobo and Masonic motifs. Free of grandiloquence and somewhat lacking in historical transcendence, these motifs decorated, for example, handkerchiefs, *mantillas*, pries-dieu; there was even a woman who submitted a collection of *alpargatas* of which each one had been embroidered with the coats of arms of the five republics. Quite apart from the fact that a certain dissonance, or kitsch, can usually be observed on occasion of such events where elements of 'high style' mingle with a 'popular style', of interest is where it permeated the central motifs of the Centenary. It is possible that the allegorical interpretation of the nation could express many things, such as an identification with virile patriotic imagery which was only partial and did by no means come naturally. Perhaps the impersonal character of the allegory gave women a margin to rework the nation in their own way. After all, they had always been at the epicentre of historical events, and not only as mere spectators. Women were of key importance in times of war and indispensable in times of peace – how else should their appropriation of the Masonic mitre be understood?[15] Their embroidery contained codes, hints to other types of knowledge that were anything but domestic, thus providing clues to their secret ways.

So there it was, the portrait of Policarpa Salavarrieta. It is necessary to come back to her troublesome presence, a destabilising feature in view of so many virile heroes. As a lone monolith among all the objects of a serialised patriotic masculinity, the portrait acquired a significant dimension that transgressed its innocuous borders. In the hands of J. Paz Guevara

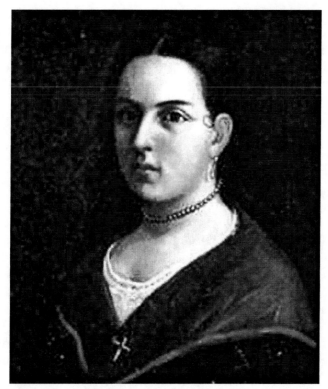

Figure 3.7 José María Espinosa, 'Retrato de Policarpa Salavarrieta', oil on canvas, ca. 1850.*

who might even have modelled Policarpa's head on her own features, Policarpa emerges in the space of the Exhibition in all the ambivalence of her double identity (see figure 3.7).

Symbolically speaking, she extended her gaze towards the women who worked, just like she herself had done, as seamstresses to make a living. In one way, she could thus be understood to show solidarity with the art of handiwork, with the threads, the fabric, the textiles, as well as with the work behind closed doors, bearing the attributes of silence, submission and utmost virtue. The same narrative, however, also described woman as earning a living with 'domestic' work that gives her a certain economic independence. Nevertheless, that particular way of reading the Colombian freedom fighter allowed a thousand seamstresses to identify their

* Policarpa Salavarrieta (1793–1817) was one of the many women who participated actively in the revolutionary process of independence, a political activity which would cost her her life. Perhaps because of the way in which she was executed by a shooting squadron, Policarpa´s memory survived in popular imagination through poems and songs. Some playwrights, such as the Venezuelan Heraclio Martín de la Guardia and the Colombian Lisandro Ruedas, based pieces on the Colombian woman´s biography. Yet her remembrance does not occupy any visible place within official memory. By contrast, the subaltern sectors – the people, women, second-rate writers – who would convert her into the reference point of a different kind of memory.

apparently insignificant work with that of the heroine, because it was exactly through her silent activity which dis-identified women and dissolved them into a pre-feudal mysticism that Policarpa Salavarrieta was able to act as a skilful spy for the patriotic cause: while she was sewing in the houses of the enemy, camouflaged as a simple seamstress, she obtained valuable information for her comrades in battle. In her double identity as seamstress and revolutionary, she appropriated a knowledge that was weaving a fine mesh of information. While her threads connected pieces of cloth of different textures, her frequent and stealthy travels through villages and towns created another structure that helped mobilise a nomadic liberation movement. Sewing had taught her that thousands of invisible stitches could transform the language of the fabric; in the same way, passing on small pieces of secret information created structures that in turn shaped different historical realities. Her knowledge and the risks she took became decisive for the freedom of the Fatherland.

Her silence, her false identity, her imperceptible and relentless work, her cautious coming and going that resembled the movement of the shuttle on a loom, produced, throughout most of the twenty-four years of her life, a text whose storyline was not written down but transmitted in the subdued and secret voices of oral memory. To remain silent did not necessarily mean not saying anything; it could spell the beginnings of a dangerous (in)subordination in which the house as prison could become the most unexpected site of a change in the public order. Policarpa Salavarrieta was executed in 1817. In the face of the uneasiness and disquiet of the vice kingdom's authorities, the last Communion she took turned into a revolutionary harangue and the people that were with her remembered those final words.

The hair that was used to embroider her countenance in the picture at the Exhibition was a sign of Venezuelan women's respect for other possible ways of representing them. Thus, Policarpa's complicity allowed them to create a little opening through which to redirect the dissatisfaction with the all-too-untainted site of the 'household' to which they had been consigned. Through her eyes, the women at the end of that century were able to behold, with nostalgia, a past where they were still allowed to step out of the house and into the streets to be protagonists in the political field. By then, it was evident that the Republic embellished its premises to the same degree it officially limited the movement of women: modern times where not necessarily more progressive. The portrait of Policarpa built a silent bridge between the women of 1883 and the founding days of the nation.

Like the two sides of an embroidered piece of fabric, it was a coded work providing two possible interpretations: it was a homage to the seamstress, to the one working with the secrets of 'low art', but at the same time it bore witness to a subversive type of labour, because with the thou-

sands of stitches other kinds of knowledge could be kept alive and other battles fought. Women's struggle for the interpretative power of signs had to be cloaked into a discreet form of art that did not cause scandal. Not for nothing had Isabel González Guinán embroidered one of her handkerchiefs with scenes of 'The Battle of Carabobo'. Even at the risk of over-interpretation, one could say that on a symbolic level the battle scenes with which Isabel had adorned her handkerchief could have allowed for other readings. Sadly, the thematic repertory on the basis of which women represented their world was culturally and historically pre-determined. Breaking out, if not unthinkable, meant risking one's reputation as a good citizen and to expose oneself to public disfiguration.

Nevertheless and as a complementary counterpoint to the inoffensive placidity of J. Paz Guevara's portrait, one corner of the room destined for plastic art held a clay sculpture by the Venezuelan Dolores Ugarte. We need to remember that it was a group of dogs. What business could a group of dogs, executed in potter's clay, possibly have next to an oil painting of six metres in height showing The Oath of the Independence by Martín Tovar y Tovar? The simultaneous existence of both works in the same space, apart from underlining how unfairly the female sculptor's piece had been positioned, cross-contaminated and redefined the symbolic content of both. Tovar y Tovar's painting approved of the supremacy of virile communities in intellectual and national issues, giving shape to a compact body of men who avoided feminine infiltration. In one way or another, Dolores Ugarte was being violently marginalized, not only with respect to the physical space she occupied, displaced from the symbolic space of representation (as a feminine subject both in the sense of *Vertretung* and in the sense of *Darstellung*), but also and finally from Adolfo Ernst's catalogue who simply did not consider her significant enough to list her name.

The violence of multiple ways of exclusion was reflected metaphorically through the mundane and almost dissonant motif of the dogs. Also in this case, the 'dogs' allowed for various readings: they actually represented these virile communities in quite a different light, as aggressive and warlike, assaulting each other with the sole aim of destruction, all that in the name of the Fatherland. Moreover, the prosaic motif, almost taken from life (well-known and everyday), reflected the real character of the feminine subject who had completed this work as that of a woman between real and disguised identity. This means that the dogs drew attention to the historico-material representation of women, away from their fetishisation as virgins or demons. The potter's clay they were made of invited a re-semanticisation of women's position in social life. The dogs' violence, too, points into different directions: Dolores Ugarte, less discreet, had decided to talk more frankly by means of a less pleasant lan-

guage. In the end, her distance and dissidence from all aesthetical codes robbed her of her place in memory.

The National Exhibition of 1883 created an historical space for negotiating not only the representation of women, but also their actual participation. It did nothing to substantially improve their conditions of social integration. It did not change their position in the home. Yet it did provide a starting point from which the issue of gender and gendering could be rethought in its entirety. For women, the Exhibition was a political act that allowed them to rethink the nation, as well as to think themselves part of it. In a certain way, it gave them a voice, if only a voice expressed through the chisel or through needle and thread. Outside the confines of the learned city, they used their own ways of expression. It is solely the cage of verbal language (and the extension it finds in literature) that makes and has made it impossible to recognise other signs and textures through which women have left inscriptions of their own history.

Translated by Heike Vogt

Notes

1. All of the period's Universal Exhibitions were widely reviewed. Every one of them had its own catalogue that meticulously described the works on display, as well as the pavilions in which the different countries exhibited. The register of the Venezuelan Exhibition was executed by the Venezuelan scientist Adolfo Ernst in two weighty volumes under the title of *The National Exhibition of Venezuela in 1883*, which was published in the following year. Both were re-edited on the occasion of the Liberator's second centenary and published in the *Complete Works* of Adolfo Ernst, Caracas, Fundación Venezolana para la Salud y la Educación, vols. III and IV, 1983. I quote from this edition.

2. See also the interesting book by Rozsika Parker, *The Subversive Stitch. Embroidery and the Making of the Feminine* (Parker 1984). It examines the crucial importance of identifying feminine identity consigned to home and hearth through the work of embroidery, which turned into more than an art or a skill and, as it evolved, came to embody the utmost virtue, chastity, purity and obedience of the ideal female as an exemplary wife. The 'artistic' quality was displaced, away from embroidery itself towards the aestheticisation of woman, who herself became an artistic object to the point where her mere presence replaced the work of art. To therefore believe that a living artistic entity reproduced itself in art is a redundancy. Such duplication would not have made sense.

3. The first Latin American Exhibition took place in Santiago de Chile in 1875, the second one in Buenos Aires in 1882, and the third one in Caracas. This indicates that Antonio Guzmán Blanco wanted to rapidly place Venezuela into the visual field of the international market. On a global scale, the Exhibition in Venezuela was the tenth after the great Universal Exhibition of London in 1851. Up to that date, Venezuela had contributed to a number of them: London (1862), Paris

(1867), Vienna (1873), Bremen (1874), Santiago de Chile (1875), Philadelphia (1876), Paris (1878) and Buenos Aires (1882), which allowed the country to reconstruct the cosmopolitan experience it had gained in the still provincial capital of the Republic.

4. Guzmán Blanco wanted to make Venezuela, which was in some way seen as the 'entrance gate' to South America, attractive to the whole world. This, however, presupposed foreign investment, an exchange of riches and of course a large-scale extraction of resources. The following consulates received an invitation to the Exhibition (the list given hereafter is by no means complete): Hamburg, Berlin, Bremen, Lubeck, Strasburg, Frankfurt, Leipzig, Vienna, Trieste, Brussels, Antwerp, Río de Janeiro, Rio Grande del Norte, San Luis, Santiago de Chile, Havana, Copenhagen, San Thomas, New York, Boston, Philadelphia, Baltimore, Chicago, Bogotá, Barranquilla, Panama, Veracruz, Tampico, Madrid, Barcelona, Malaga, Valencia, Bilbao, Tarragona, Nice, Algiers, Cape Town, Kingston, Antigua, Barbados, Gibraltar, Morocco, Omoa, Salerno, Callao, Lima, Casablanca, St. Petersburg etc. Of the countries that sent delegations and products, apart from the United States, we have to mention Belgium, which dutifully dispatched works of art to the Exhibition, even including a pen-and-ink portrait of the General Guzmán Blanco by a Belgian woman painter who also preferred to withhold her identity.

5. See also Paulette Silva Beauregard's (1993) interesting book *Una vasta morada de enmascarados*, which extensively discusses cultural practices that were used by Guzmán's government to prop up the state apparatus, as well as the unambiguous political function of all cultural manifestations that served to construct the imaginary of historical tradition so vital for the modern nation state.

6. In this sense, the historiographic revision with a view to recovering 'petite histoire' or 'microhistory' that has been taking place within the past few decades has proven extremely useful. For the purpose of my work, I am interested in the conceptual difference established by the historian Luis González who speaks about 'Motherland history' as that perspective of historiographic investigation that restores all that was marginalised by Fatherland history, which in turn is synonym with macrohistory, history that is official, manly, belonging to the 'world of the father'. In contrast, Motherland history (or *her-story*) takes note of a world that is small, everyday, familiar, modest, local, routine, well known and considered unimportant by great universal history.

7. The compulsive force of the cult of Bolívar went on to multiply itself into profane and sacralising versions: from allegories and *tableaux vivants*, where spectacular props set in motion a living scenery in worship of the national hero, to enormous frescoes and oil paintings that adorned the Capitol's Elliptical Hall and the galleries of the Exhibition Palace, respectively; from paperweights, handkerchiefs and fragrances to hymns, odes or waltzes all dedicated to both the Father and the Regenerator of the Fatherland. In this way, the audience could both see their Father in scenes from an epic past extolled by the artists as well as use the same Eau de Cologne that the Liberator had used. The epic traditions of national history were constructed for the consumption of the people and had nothing sacred about them. The banalised forms of history were short-lived; the ones that came in the shape of oil paintings and stone became part of the museological collective memory. The following example should suffice: even though the great pianist Teresa Carreño composed a hymn to the Liberator for the great day, audiences only ever

treasured her as an outstanding performer of the works of Beethoven, Chopin, Brahms and Mozart.

8. The process of constructing the country's national memory has suffered major blows and ruptures in the 200 years of the existence of the Republic. All the monuments, sculptures, buildings, squares and oil paintings have been subject to raids, displacement and destruction, which has turned the attempt to shape a tradition into an effort of almost paradoxical proportions. To take an obvious example, the end-of-century novel *Idolos rotos* (Broken Idols, 1901) by Manuel Díaz Rodríguez problematises the lack of consistency of national ventures. The people never saw their real needs represented in what the political elite was pursuing; therefore their sphinxes, the 'idols' of the oligarchy, are destroyed at the end of the novel. Even the Bolívar-on-horseback on the square appears covered in pigeon excrement. The marble sculptures desecrated by a collective rage cast doubt on the 'national' character of the modernising project. The patriarchal memory that was to be constructed has turned out to be doubly phallocratic: it summons up a father, but a castrating father who excises other memories and traditions.

9. In the first Universal Exhibitions (London, 1851 and 1862, Paris, 1855 and 1867, Vienna, 1873 and Philadelphia, 1876), women participated only to a very limited degree and there was more support from local women than from those invited from abroad. Women from Venezuela were conspicuously absent until well into the twentieth century. Nevertheless, it should be kept in mind that on the occasion of the Exhibition of Chicago in 1893 – which was attended by the Venezuelan writer Arístides Rojas as well as the aforementioned Adolfo Ernst, both of whom reviewed the event at length – women were given their own pavillion which had been designed by the American Sophia Hayden and which meant that they had a vast building at their disposal. In the same way, they succeeded in getting their own pavilion at the Exhibition of Philadelphia in 1876, albeit more modest in proportions than the one of Chicago. Both these achievements set important precedents for the process of a gendered redefinition of spaces and posts. The ample space provided by the two pavillions was an invitation to not only display the usual embroidery, but also sculptures, paintings and books.

10. Already in 1837 in Caracas, the well-known fashion department store Almacén de Modas owned by Mrs Flandín sold all kinds of fabric, dresses and accessories, not only imported from Paris, but produced in Venezuela; in the same way, Desiré Chillan, Anita Duprez and Alejandra Manhaviale, like many other women in similar positions, oversaw business on the El Comercio and Leyes Patrias streets where the most sophisticated attire, perfumes, shoes and wigs were on sale to satisfy the vanity of male and female Venezuelans alike. Not only did consumption and production of luxury articles, which was largely in the hands of female dressmakers and businesswomen, run at very high levels. This development was also indicative of an intense society life that boosted the arts of dancing and music as well as leading to a rise in society gatherings, which in turn produced a taste for reading, all in spite of the dire state of urban infrastructure. When in 1853 a minister from Lisbon arrived in Venezuela, he made special mention in his travelogue of an extraordinary woman pianist in Cumaná, as well revealing his surprise at the sheer opulence of goods in the Caracas department stores. In the same vein, the heads of the Colegio de Educandas girls' school, Teresa and Concepción de Luque, had the presumption to award eleven diamond rings and two studded with pearls to the most outstanding work of embroidery by their students. The award ceremony took place within the framework of a celebration not only complete

with ball and banquet but also an exhibition in the institute's galleries of the fine works of embroidery. Apparently, the audience was used to that type of event. An example is the Café del Avila, which in fact lay rather close to the buildings of the National Exhibition and in 1872 organised the first 'Picture Exhibition' of Caracas. It was there that Dolores Ugarte first exhibited her work. It could not have been such a rarity that women publicly appeared with their works of art. Around the year of 1877, the wife of Manuel María Zarzamendi was relatively successful in commercial terms with her 'chromophotographic miniatures in oil'; *La Opinión Nacional* even ran an advertisement on her. We can therefore assume that there were quite a few women who worked as painters, sculptors and musicians, offering their services on the market. About 1884 another woman, for example, advertised in the same *La Opinión Nacional* that she had to close her workshop and sell off her sculptures. Without doubt, art made a good profit and it seems likely that many women gained their economic independence thanks to selling their works.

11. What catches the eye in Adolfo Ernst's catalogue is the sheer number of small businesses – even though they might have been based in the home – that were in the hands of women and that produced carpets, hammocks, hats, gloves, foodstuffs, preserves, oils, soaps, candles, tobacco, cocoa, perfumery articles, medication and in particular, textiles and clothes. Adolfo Ernst himself could not help but praise women from the Isla de Margarita for 'producing a cotton of superior quality, though not in abundance. Only a little is for export, so what remains in the region is used for making hammocks, reins, fishing nets and other articles. All this is the work of women, and it is indeed rare to come across an idle woman there' (Ernst 1983: 560). This leaves us to assume that important enclaves of the national economy were headed by women, both in the sectors of agriculture and trade; they led financial businesses, hotels, typographical workshops, produced clothes and, as far as the service industry was concerned, worked as dressmakers, seamstresses, wigmakers, teachers and governesses. The wars of independence had left the labour market in disarray and women had to put themselves on the forefront of businesses, ensuring with their own hands that production continued. The case of the textile industry is a case in point: although in Ernst's catalogue, they were entered as either 'delegations' per zone or as businesses owned by a man, we would still not be mistaken to assume that the bulk of manual work was actually done by armies of women workers.

12. The 'hygienic corset' presented by Mrs Ana Aloe, who also received a prize for such a useful piece of clothing, can be seen as an example of how women's objects were passed around and circulated. On the one hand, the garment burdened women with all the weight of private intimacy. There, a woman's body was literally undressed. On the other hand, by being publicly exposed and potentially serialised for consumption, private joy was rendered meaningless. Thus, categories of public and private were distorted and redefined in a rapid shift of surfaces and borders.

13. A good number of oil paintings by Venezuelan painters were submitted to the National Exhibition, forming a gallery of pictures in the hall of the 'Fine Arts' depicting scenes of epic national history in celebration of the event. Among the *Oath of the Independence* by Martín Tovar y Tovar, the *Death of Guaicaipuro* by Manuel Cruz, the *Fire in the Park of San Mateo* by Antonio Herrera Toro, *The Death of Girardot* by Cristóbal Rojas, the *Encounter of Bolívar and Sucre on the Shores of the Desaguadero in the Andes* by Manuel Otero, the *Battle of Carabobo*

and *Bolívar, Disembarking in Ocumare* by Arturo Michelena, were also represen-
tations of female characters by the same painters. It is interesting to see how in
these cases women were represented in allegorical form (like the *Allegory of Bolí-
var and the Five Republics* by Manuel Cruz), in a spiritualised manner (like *Mar-
garita de Fausto* by Emilio Mauri, or the *Head of the Virgin* by Antonio Herrera
Toro), or reduced to pure body (like the *Female Nude* by Pedro Emilio Rodríguez
Flegel). The other woman, i.e., the real woman and her historical presence that
was unfolding right there, such as the sculptor Dolores Ugarte, the Belgian painter
Fany Laumans or the hundreds of women exhibiting in the adjoining rooms, van-
ished in the dead angle of men's vision.

14. In 1872, in the city of Caracas, Isabel Alderson embarked on a rather fulfilling
career as the head of the *Ensayo literario* journal, publishing more than seventy-
eight issues in two years of intense work. She wrote the articles, did translations,
administered finances as well as advertising, sales and subscriptions. And, under
the cover of some *nom de plume*, she even managed to publish novels in her own
journal.

15. Contemporary times are particularly responsive when it comes to denouncing tor-
ture and disappearances at the hands of dictatorships through witness reports.
Nevertheless, there were hundreds of women who were tortured, persecuted or
even publicly quartered during the wars of independence. We will only give a few
names of women in Venezuela: Josefa Joaquina Sánchez Bastidas (wife of José
María España), Josefa Palacios (wife of José Feliz Ribas), Nicolasa Briceño,
Josefa Camejo, Dominga Ortiz de Páez (a nurse in the patriotic army and wife of
Páez), Concepción Mariño, Luisa Cáceres de Arismendi or Mariquita Figueras, all
of them women whose husbands became part of history while they themselves
spent long years in prison, being subject to torture, and ultimately died.

Bibliography

Appadurai, Arjun, ed. 1991. *La vida social de las cosas: perspectiva cultural de las
mercancías*. Mexico: Grijalbo.
Auge, Marc. 1998. *Las formas del olvido*. Barcelona: Gedisa.
Barthes, Roland. 1999. *Image, Music, Text*. New York: Hill and Wang.
Bourdieu, Pierre. 1988. *La distinción: criterio y bases sociales del gusto*. Madrid:
Taurus.
Brunet, Marta. 1967. *Soledad de la sangre*. Montevideo: Arca.
Cao, Marián L.F., ed. 2000. *Creación artística y mujeres: recuperar la memoria*.
Madrid: Narcea.
Castiglione, Dario and Lesley Sharpe, eds. 1995. *Shifting the Boundaries: Transfor-
mation of the Languages of Public and Private in the Eighteenth Century*. Exeter:
The University of Exeter.
Cordato, Mary Frances. 1989. *Representing the Expansion of Woman's Sphere:
Women's Work and Culture at the World's Fair of 1876, 1893 and 1904*. PhD thesis,
New York, NY: New York University.
Cherry, Deborah. 2000. *Beyond the Frame: Feminism and Visual Culture, Britain
1850–1900*. London: Routledge.
De Diego, Estrella. 1987. *La Mujer y la Pintura del XIX Español*. Madrid: Cátedra.
Debord, Guy. 1994. *The Society of Spectacle*. New York: Zone Books.

Ernst, Adolfo. 1983. 'La Exposición Nacional de Venezuela en 1883', in *Obras Completas*. Caracas: Fundación Venezolana de la Salud y la Educación, vols. III and IV.

Esteva Grillet, Roldán. 1986. *Guzmán Blanco y el Arte venezolano*. Caracas: National Academy of History / El libro menor.

González, Luis. 1997. *Otra invitación a la microhistoria*. Mexico: Fondo de Cultura Económica.

Grant Darney, Virginia. 1982. *Women and World's Fairs: American International Expositions, 1876–1904*. PhD thesis, Atlanta: Emory University.

Greenhalgh, Paul. 1988. *Ephemeral Vistas: The Expositions Universelles, Great Exhibitions and World's Fairs, 1851–1939*. New York, Manchester: Manchester University Press.

Harris, Neil et al. 1993. *Grand Illusions: Chicago's World's Fair of 1893*. Chicago: Chicago Historical Society.

Hearman, E.A. 1999. *The Inglorious Arts of Peace: Exhibitions in Canadian Society During the Nineteenth Century*. Toronto: University of Toronto.

Hunt, Lynn. 1984. *Politics, Culture and Class in the French Revolution*. Berkeley: University of California.

Karp, Ivan and Steven D. Lavine, eds. 1991. *Exhibiting Cultures: The Poetics and Politics of Museum Display*. Washington: Smithsonian Institution.

Lamas, Marta, ed. 1995. *El género: La construcción cultural de la diferencia sexual*. México: UNAM-Porrúa.

Landes, Joan B. 1988. *Women and the Public Sphere in the Age of the French Revolution*. Ithaca, New York: Cornell University.

Lisboa, Miguel María. 1986. *Relación de un viaje a Venezuela, Nueva Granada y Ecuador*. Caracas: Fundación Venezolana para la Promoción de la Cultura.

Lowenthal, David. 1985. *The Past is a Foreign Country*. Cambridge: Cambridge University Press.

Majluf, Natalia. 1995. *Escultura y Espacio Público*. Lima: Instituto de Estudios Peruanos.

Nochlin, Linda. 1971. *Women, Art and Power and Other Essays*. New York: Harper & Row.

Parker, Rozsika. 1984. *The Subversive Stitch: Embroidery and the Making of the Feminine*. London: The Women's Press.

Plaza, Ramón de la. 1983. *Ensayos sobre el arte en Venezuela*. Caracas: La Opinión Nacional.

Pollock, Gisele. 1988. *Vision and Difference: Femininity, Feminism and the Histories of Art*. London, New York: Routledge.

Rojas, Arístides & Adolfo Ernst. 1893. *Exposición Universal Colombiana de Chicago*. Exhibition catalogue. Caracas, New York: Gobierno de Venezuela.

Salas, Horacio. 1996. *El centenario: la Argentina en su hora más gloriosa*. Buenos Aires: Planeta.

Silva Beauregard, Paulette. 1993. *Una vasta morada de enmascarados*. Caracas: Fundación Casa de Andrés Bello.

Stevens Carl, James. 1990. *Victorian Architecture*. London: David & Charles.

Various authors. 1983. *Venezuela 1883*. Caracas: Ediciones del Congreso de la República. 3 vols.

Various authors. 1995. *La mujer en la historia de América*. Caracas: Asociación Civil 'La Mujer y el V Centenario de América y Venezuela', Tomo Primero.

Weimann, Jeanne M. 1981. *The Fair Women*. Chicago: The Chicago Academy Press.

Chapter 4

Material Memories:

Tradition and Amnesia in Two Argentine Museums

Alvaro Fernández Bravo

Museums have been described, among many other things, as instruments for the enforcement of social order (García Canclini 1992; 1997). In Argentina, museums were established in significant numbers between the years 1880 and 1910 in the context of state organisation and played a pedagogic role in forging images of the nation to be imposed on the domestic population. My purpose is to offer some reflections on these creations of museums in late nineteenth-century Argentina, as a contribution to the study of the construction of cultural patrimonies. I will try to question, moreover, the assumption which regards museums as mere enforcers of hegemonic ideology, and rather study them as theatres of memory, that is, as spaces where conflicting versions of identity compete, struggle, and attempt to attach historical meaning to material culture. My central concern will be the foundation of two institutions, the National Historical Museum, inaugurated in 1889, and the National Museum of Fine Arts, of 1895, both located in the city of Buenos Aires. At the time of their foundation, these museums raised public debates involving intellectuals such as Rafael Obligado, Ernesto Quesada, Calixto Oyuela and Eduardo Schiaffino, who argued about national history and the nature of an 'Argentine' art. All of them belonged to a cultural coalition called the 'Ateneo', which functioned between 1892 and 1900, and in whose ranks the politics of cultural representation was a matter of discussion.[1]

Patrimony, Memory, History

Museum objects compose narratives orchestrated by memory. Much like narrative fictions, yet in entirely different forms and rhetorics of persuasion, museums exhibit versions of the past and contribute to the crystallisation of fables of collective identity. It is with regard to the narratives

of national identity which take shape in the museum display that I will consider museums as *theatres of memory*, spaces where fables of identity are enunciated by means of collections of objects, since, as Pierre Nora has remarked, 'memory takes root in the concrete, in spaces, gestures, images, and objects' (Nora 1989: 9). In the context of Argentine museums, I will suggest, objects take on the character of civic symbols.[2] The museum's emergence has been linked with the spread of written forms of memory and, hence, with the new logic proper to a civilisation of inscription.[3] The programme entrusted to museums, in other words, could be conceived as the inscription of a collective memory onto a surface, either by means of collecting and displaying objects – as in museums of science, anthropology, and history – or as the construction of visual representations of space – a political territory and a cultural landscape. These objects and landscapes, once they are placed in the museum, turn into constituent parts of a common national past. The image of General José de San Martín crossing the Andes to liberate Chile from Spanish rule, for instance, became part of Argentine national iconography by means of a painting exhibited at the National Historical Museum. Private possessions of those who had since become 'national heroes', including items of furniture and clothing, underwent a similar process. As relics, they were shown, in much the same way as the fossils which entered the museums of natural history at around the same time, against the backdrop of a natural landscape. Domestic interiors and natural landscapes operated as stages of national history.

As with written narratives of national history, museum displays attempted to colonise and appropriate external referents, changing their context (Clifford 1988; Mitchell 1991). By appropriating an object from the private realm and taking it into the public sphere, objects were endowed with new meanings. What, I shall ask, are the properties objects acquired in this displacement towards public visibility?[4] By travelling into the museal order, objects became inserted into a new dimension and acquired new layers of meaning, a process of transition and transformation in which the museum acted as a technology of inscription. It is in this way, precisely, that museums reveal their proximity to historical writing.[5] Composed by objects that can be 'read' in a narrative sequence, Clifford Geertz sustains, museums are 'cultural forms can be treated as texts, as imaginative works built out of social materials. [They] are not merely reflections of a pre-existing sensibility analogically represented; they are positive agents in the creation and maintenance of such a sensibility' (Geertz 1973: 449–51). Rather than being merely the metonymic extension of a concrete external referent, the exhibitionary order presupposes and thus forges one, as a 'duplicate' or a real-life copy of that which is displayed in the collection.[6] This procedure implies the creation of hierar-

chies (certain objects are endowed with more value than others) and a process of canonisation: heroes, historical events, works of art, authors, artists, or even entire collections are organised in a particular way which reflect the collector's or curator's position towards them. The referent 'Flemish painting', for example, is projected onto an imaginary 'outside' in the showroom of a fine arts museum dedicated to this particular historico-geographical unit; the referent 'British invasions' is produced in the showroom of a historical museum (the Argentine National Historical Museum, to be more precise), which alludes to that particular event, whose inclusion within the canon of national memory became, as we shall see, an immediate matter of controversy. Yet if all collections, as Krzysztof Pomian (1990: 24) has suggested, 'are involved in organizing an exchange between the fields of the visible and the invisible which they establish', the question that arises is which objects remain or became visible and which turn invisible on account of their having been included or excluded from the museum. How could the objects that would eventually became 'civic symbols' of a nation be defined? How was the nationality of the objects constructed and limited? Was the principle of classification their theme, their authors' nationality, the place or the way in which they had been produced? Which implicit narrative sequence underpinned the collecting of material culture? What were the symbolic effects of objects being accepted into the museum environment, both on themselves and on the collection as a whole? Finally, how did museums, as compared to written texts, design an imaginary audience, whose eventual emergence could be a matter of inquiry in its own right?

During the so-called 'museum period' between 1840 and 1890 the foundation of museums became an activity quickly spreading across the entire globe. (Stocking 1985; Sheets-Pyenson 1988). Argentina was no exception, and various museums were founded with the purpose of affirming national identity, particularly in the face of immigration and debates generated around the issue of cosmopolitism. As is well-known, Argentina received a massive influx of immigrants between 1870 and 1914. 'Cosmopolitism', therefore, was largely perceived as a threat to national identity, one that challenged the state to take an active role in the construction of cultural citizenship. Museums were to provide an answer to the question of national identity, appealing to objects and representations of cultural patrimony that had a tangible format, and where the nation could be observed as endowed with permanence and continuity. According to Andreas Huyssen, the museum's attempt to stabilize national memory can be described as a 'temporal anchoring' that works as a determination to contain the proliferation of historical interpretation and give objects a fixed meaning (Huyssen 1995: 7). The practice of 'temporal anchoring', at the end of the nineteenth century in Argentina,

attempted to separate history and its heroes from politics, sheltering them from symbolic vandalism inside the motionless environment of the museum.[7]

Before moving to a more detailed discussion of the museums under study here, it is important to consider the extreme instability of Argentina's national iconography during the nineteenth century. Key elements such as the country's very name, capital city, flag, coat of arms and even its Independence Day were deeply ambiguous and contested, only to become partially stabilised after 1880. It took[8] some time, in short, for Argentina's civic symbols to develop a *national* validity. An early example can be found in the May Pyramid, the first Argentine 'national monument' erected to commemorate independence. As early as in 1811, a proposal to include on one of the side panels of the pyramid an image commemorating the British invasions was rejected by representatives from the provinces at the *Junta Grande*. They considered the British invasions as merely a symbol of Buenos Aires, and by excluding them from the monument they were rejecting the 'local character which the Government wanted to give to the monument, alluding to the victories of 1806 and 1807, which belong exclusively to the city of Buenos Aires.' (Munilla Lacasa 1999: 108) The British invasions, then, became an ambiguous historical event, whose belonging to national tradition remained dubious. Even as the Historical Museum was founded, the debate about their inclusion within national history persisted: Adolfo P. Carranza, the institution's first director, opposed their inclusion on the grounds that they had taken place before the May Revolution and, hence, did not belong to national history proper (Klugg and Ruffo 1993: 155).

During most of the nineteenth century, other 'civic symbols' were also a matter of controversy. Independence Day even today continues to be celebrated on two different occasions: 25 May, usually considered a Buenos Aires tradition, which recalls the city's first public dispute of Spanish rule in 1810, and 9 July, a national celebration commemorating the formal declaration of independence at Tucumán in 1816. This duplication makes apparent the ongoing tension of national memory between Buenos Aires and the other provinces. (Quatrocchi-Woisson 1995: 36) The 'May Celebrations', which continued to be held over most of the nineteenth century in the city of Buenos Aires and eventually became part of the 'Centenary of Independence' in 1910, are witness to the extent to which the 25 May–9 July schism overshadowed nineteenth-century cultural politics in Argentina. The latter date only started to receive similar attention by the end of the 1900s, when national holidays, along with museums and monuments, were becoming part of a group of practices devised in order to ritualise nationality. Museums, too, were conceived as a means to put an end to iconographic instability, by helping to construct

a uniform national history, one that would replace and unify the conflicting regional memories which had dominated Argentina's cultural remembrance up to the 1880s. The stabilisation of national memory should be read not just as an effort to preserve the past, but as evidence, based on a collection of civic symbols, of the victory of one faction over another. The objects and symbols contained in the museum would make apparent the hegemony of Buenos Aires over the rest of the country, and the imposition of liberal ideas as the dominant narrative of identity.

What, however, makes 1880 a turning point for Argentine collective memory? Partly, that individual memory was beginning to fade due to the deaths of direct witnesses of the independence era. The need to capture images from a past in danger of extinction, characteristic of autobiography, was also at work in the cultural policies discussed at the end of the century, when the local elite attempted to construct a collective version of history beyond individual perspectives. The testimonies from history's main protagonists or, more specifically, the relics once in possession of the 'Founding Fathers' would serve to organise the past and objectify it in material collections. The freezing of memory in commodities and objects has been addressed as a form of amnesia which intends to detain the activity of remembrance and ossify its continuous productivity. Memory is not immobile but a practice of endless (re-) production and (re-) writing of the past. Memory, then, possesses its own temporality, which removes it from the immutable pastness of the document and approximates it to the aquatic metaphors that are so frequently evoked to describe it (Urry 1996: 48).

Whereas 'history' usually denotes a public and written form of speech, memory is regarded by most as a private and oral domain. It has to do with individual recall, but even where it is invoked for collective practices of remembrance these are conceived as far removed from documental discourse. In this sense, every historisation of collective memory intends to record the oral, fluid narrative of memory, capturing it under the firm, written surface of history. At the heart of history, Pierre Nora (1997: 25) has claimed, 'is a critical discourse that is antithetical to spontaneous memory. History is perpetually suspicious of memory, and its true mission is to suppress and destroy it. [...] History's goal and ambition is not to exalt but to annihilate what has in reality taken place.'

If museums, in this regard, can be compared to written texts for their ambition to record the past, as theatres of memory they are nonetheless also opposed to a specific kind of written production of the past, historiography. In fact, museums of a historical character were founded in Argentina in response to debates of that moment over issues such as the reconsideration of the Rosas period or the question of immigration.[9] The point here is that museums in the late nineteenth century rivalled written

historiography not so much for what they were saying – which did not seriously challenge the hegemonic liberal historiography of Mitre and López – but because the traces of the past (*milieux de mémoire*, in Nora's terms) had become endangered under the impact of the modernising process Argentina was undergoing and because museums, thanks to the monumentality and immediacy of their way of visualising material objects, could make a much more powerful claim to being capable of safeguarding and preserving these fading traces than even the most eloquent historical writing. If we agree with Andreas Huyssen's suggestion that memory opposes the archive (Huyssen 1997: 7), then the museum in turn-of-the-century Argentina was clearly located on the side of memory. Adolfo P. Carranza, the first director of the National Historical Museum, maintained heated arguments with the National Archive over the proper place for historical documents, a controversy which resulted in public quarrels regarding the jurisdiction of each institution. The war documents Carranza claimed for his museum, according to him had always been intended to be kept in glass cabinets, exposed to the gaze of the devoted spectator but locked away from the inquisitive eye of the historian anxious to alter their sense or question their value. Historiography and museums, then, each in their own way, attempted to inscribe memory given the rapid slipping-away of the present into historical past. Sites of memory (or, *lieux de mémoire*) were established as a form of re-assurance that allowed to exhibit material memories of the nation in a motionless way. It is in this ideological atmosphere that the debates surrounding the foundation of museums in Buenos Aires during the last decade of nineteenth century can be situated.

The Ateneo Controversy

The Ateneo was founded as the site of encounter of a cultural coalition comprising intellectuals and artists, who sought to provide answers to what was perceived as a spiritual crisis. Rafael Obligado, one of its founders and principal ideologues, in a text from 1894 depicted this crisis as follows: 'Eighty years of national life [...] have given us a national body, [but] haven't been enough to give us an Argentine soul' (Obligado 1974: 39). His intervention recommended employing cultural action to tackle the 'spiritual crisis'. As political parties already then suffered from a bad reputation, the Ateneo exerted its influence as a lobby, putting pressure on the government through the press and through public action. Its activities principally consisted in regular meetings, during which lectures were given, often to be subsequently published in newspapers. The institution also sponsored concerts and exhibitions, but of particular interest

is its impact on the creation and management of museums. Several of the group's members were museum directors or were to assume directorships at museums yet to be inaugurated: among others, Francisco P. Moreno, of the La Plata Museum, Dr. Carlos Berg, the future head of the Argentine Museum of Natural Sciences of Buenos Aires, Eduardo Schiaffino and Eduardo Sívori, both of whom would direct the National Museum of Fine Arts, and Juan Bautista Ambrosetti, future director of Buenos Aires University's Ethnographic Museum, belonged to the coalition and participated in its debates.

One of the central topics that appeared frequently in the Ateneo's discussions was the question of cosmopolitism. A closer look at these may serve to question a frequent assumption in Argentine cultural history that maintains, on the one hand, that the late-nineteenth century elite held a homogeneous position regarding the issue of cosmopolitism and on the other hand, that the citizenry accepted with passivity or indifference the narratives exhibited in the museums of the period. In the case of the Ateneo, the presence of Rubén Darío as a member of the group and the hectic activity the poet developed over the decade of the 1890s in Argentina, shows that there were people willing to see cosmopolitism as a refreshing renovation of Buenos Aires's provincial environment.[10] Whatever the evaluation, however, the debate over cosmopolitism provided a discursive framework for the foundation of museums of history and fine arts. The diagnosis of a spiritual crisis was shared by those who saw museums as an antidote to cosmopolitism, as well as by those who, without considering immigration a serious threat to the nation's identity, mourned over the weak support for the arts and culture provided by the State. This last position, represented by Eduardo Schiaffino and, to a certain degree, by Ernesto Quesada, took advantage of public sensitivity about the issue to push for the creation of museums.

The debates on the spiritual crisis of nationality accelerated a process of redistribution of the cultural roles and patterns of production and consumption of visual and material culture. On one side gathered the traditional elite which managed the symbolic capital and was immersed in debates over the best way to organise and magnify a cultural patrimony perceived as chaotic and in need of active policies on the part of the state. This group acted as a promoter of museums and cultural institutions, to forge a sense of nationality and, particularly at the end of the nineteenth century, confronted the task of reclassifying cultural patrimony and assigning specific spaces to it. In this manner, the National Historical Museum and the National Museum of Fine Arts were founded as part of a process of subdivision of the original patrimony held at the Public Museum of Buenos Aires, created in 1812 and reorganised by Rivadavia in 1823. Other museums, such as the La Plata Museum and the Ethno-

graphic Museum at the University of Buenos Aires, conceived their mission as a further distribution and disciplinary subdivision, of the Public Museum's original array and purpose. The creation of archival and pedagogical institutions and the assembly of a complex apparatus for the cultural control of identity can also be considered as part of this process. Each museum, in short, took upon itself a specific duty, field of research, and desired social impact.[11]

This process of disciplinary organisation also implied the fashioning of an audience. A public for the nation's new museums would be imagined in different ways, either as a subject in need of education – children, immigrants – , or as a devotee of the national iconography exhibited in museums. The exhibition of national memory should thus be read in the context of a programme of civic and aesthetic education. The cultural field was supposed to provide the ground for national reconciliation, while it actually represented a space of struggle over the control of the past. After a long period of national divisions and antagonisms, by the end of the century, '[a]esthetic culture becomes the ground or condition of possibility both for thinking and for forging the political subject' (Lloyd and Thomas 1998: 42). This means that not only foreigners would be targeted as a possible public for the museum, but that the elite itself was expropriated of its formerly private relics, separated from the objects on display and obliged to occupy the role of spectator. Locals and visitors, national and foreign observers would all be equals in facing the objects that 'captured' nationality.

The museum acquired as a result the features of a spectacle, conceived as a theatre where Buenos Aires's upper class exposed furniture and relics formerly kept at home, which were now being displayed for an audience supposedly eager to observe them with curiosity. Through visual consumption of material culture the subjects of the state would thus be turned into a cultural citizenry. Patrimony, as André Chastel recalls, owes its meaning to family heritage in Roman civilisation: *patrimonium* in Latin concerns a family legitimacy related to inheritance (Chastel 1997: 1433). National memory would thus be wrested from family objects, (dis-) appropriated and publicly displayed by museums (Andermann 2001: 154–60). Hannah Arendt, in discussing the re-accomodation of private and public sphere in the modern era, suggests that 'the rise of the public realm occurred at the expense of the private realm of family and household.' (Arendt 1969: 29) This is precisely the process that allowed the formation of collections at the Historical Museum: a *nationalisation* of family memories, in the economic sense of their appropriation and accumulation on behalf of the state. The same movement of concentration can also be seen at work in the inverse direction, as the identification of the entire national past with the heritage of a handful of families

which, nonetheless, to an extent also lost control of their memories as the objects on which these were hinged passed into the public domain. On entering the museum, objects had to be observed from a distance; citizenship was now being related to spectatorship. Once in the museum, material culture would no longer be under family control, and even those who used to own these objects would now have to see them from a distance and without any particular privileges: immigrants and elite would merge to become a single audience for national memory. But this iconography had previously to be established and it was over its composition and organisation that the debates surrounding the creation of the National Historical Museum and the Museum of Fine Arts took place.

The Nationalisation of the Past

The creation of the National Historical Museum in 1889 coincided with a peak in immigration to Argentina, as well as with a moment of scepticism about the future of the country, when the forgetting of the national past was seen as in urgent need to be tackled by the gathering of historical images. Sarmiento himself had asked with a sense of alarm for the possible impact of immigrant organisations on national cohesion. As Lilia Bertoni (2001) has demonstrated, the activism of immigrant communities in social life raised official concerns, and since 1887 the government had organised a nationwide campaign for the celebration of the past, including public ceremonies and a propaganda strategy. Bertoni indicates a rather pathetic episode, in which an octogenarian Independence warrior was 'exhibited' like a mummy during a parade, to the acclaim of school delegations and foreigners' organisations, an act that took place at the Buenos Aires Club for Gymnastics and Fencing.[12] Public acts such as this one allowed the formation of a national pantheon where some groups and regions were (over-) represented, in detriment of others, with a clear predominance of characters and families from Buenos Aires. This can be regarded as a process of internal imperialism in which institutions such as the National Historical Museum played a key role in imposing the values of the capital city on the nation and hegemonizing national representation.

By the end of the century, Buenos Aires's hegemony had been consolidated and the *porteño* elite was attempting to equate national history with their own class memories. At the same time, immigrant communities were starting to claim for narratives of identity capable of representing them in the country where they had settled. If the ruling class reacted with alarm to the 'Babel of flags' flooding the city on public holidays, the efficiency in neutralising immigrants' campaigns and organisations

through state-sponsored cultural activity was nonetheless remarkable. On September 1884, for instance, Italians marched through Rivadavia Avenue in Buenos Aires, waving torches and Argentine flags and singing patriotic anthems (Bertoni 2001: 86). Quite possibly, the proliferation of national iconography encountered such an eager response from the immigrant communities, because these had already been exposed to nationalist propaganda prior to their departure from Europe. The symbolic offensive of the Argentine state could thus be successful in infiltrating and neutralising immigrant communities, because their own nationalistic rhetoric had already made them accessible to the rhetorics and signs of patriotism. However, cultural appropriation is always a twofold process: a hegemonic strategy of the elite but also an eagerness on the part of subaltern sectors to appropriate on their own terms the narratives crystallised in collections of material culture and exhibited in museums. It would be interesting to analyse these strategies of appropriation on behalf of immigrant communities, who were rapidly replacing their own national iconographies with a vernacular Argentine cultural capital.[13]

Although the state's cultural strategy was capable of crafting a loose consensus, not everyone considered the nationalist pedagogic to be the adequate solution for promoting the cult of the past. Obligado warned against 'the museums of recent invention', a European fashion that would merely seize 'the flags conquered in battle that are still kept in our temples' (Obligado 1974 [1891]: 23). Flags and other relics from Independence wars had been kept, prior to the creation of the Historical Museum, in the Cathedral of Buenos Aires. Obligado distrusted museums because he saw them as a sign of secularism, which he held responsible for the crisis. Instead of a historical museum, Obligado advocated, in the face of 'cosmopolitism, the enemy of the fatherland' (Obligado 1974 [1894]:41), the creation of a national art based exclusively on the representation of local history and of landscape – which, furthermore, he restrained to the pampas and the coastal plains, in another symbolic triumph of Buenos Aires over the provinces –, in order to solve the spiritual crisis of the nation. Obligado's proposals, however, would remain a minority position among the intellectuals of the Ateneo, with little influence on the formation of the Historical Museum.

For Obligado's opponents, museums represented an apparatus capable of tackling the causes of the crisis rather than merely a sanctuary of the past. Their projected audience, supposedly possessing but a low level of education and therefore in need of visual representations of the nation, was conceived mainly as one of the future, a race not yet existing that would emerge from the 'cosmopolitan' invasion. In the nationalisation of this projective citizenry, the Historical Museum had to mediate as a productive instrument to craft an identity. It had to be capable of generating

its own object – the past – that had to be fabricated in the collections rather being already representable in images of 'deep nationality' as Obligado had wanted. Adolfo P. Carranza, first director and *alma mater* of the Historical Museum during its first twenty-five years of life, accumulated objects with the voracity of a collectionist and with no special concern regarding their classification. However, looking at the result of his gathering, he realised that there were blanks in the sequence of national history. The relics, objects, and portraits of the past he had assembled were not enough to cover the totality of national history. Therefore, among the numerous works of historical painting that compose the museum's collection, a significant share are works executed on commission during the institution's first two decades of existence. These paintings were mostly portraits of historical figures produced several years after their deaths, reproductions of which came to circulate in high numbers. Among these are some of the better known portraits of San Martín and Belgrano, canonical Founding Fathers of the nation, which were being fixed in the collective memory as some of the most popular representations of Argentine iconography. Ernesto Quesada in *El museo histórico nacional y su importancia patriótica* (1897) recalls the issue in this way:

> It must be said that the museum has not allowed a single patriotic opportunity to pass without contributing to its commemoration. On national holidays it has generously distributed prints with portraits of several heroes and of our national anthem among the people. In so doing, the museum has allowed the lower classes of the population to familiarise themselves with the memories of great Argentines, and it has encouraged the use of these prints to decorate even the humblest chamber. (Quesada 1897: 31; our translation)[14]

The museum was conceived, then, not just as a mirror of the unspoiled Argentina prior to immigration, as Obligado had wanted, but as an apparatus capable of creating its own audience. The museum not only selected the historical referents on which it would construct the nation's unalterable memory, but also forged an audience at the same time as the icons that supposedly represented it.

Although the collection of relics assembled in the museum only represented a homogeneous and limited layer of Argentine society, its historical narrative sought to address a broader subject than the one mirrored by the collection. In fact, we can see in this process the construction of an entirely new subjectivity: a cultural citizenry that would identify itself in the artefacts of material culture displayed at the museum. No matter how intensely the museum produces and affirms the symbolic order, there is always a surplus of meaning that exceeds set ideological boundaries, opening spaces for reflection and counter-hegemonic memories (Huyssen 1995: 15). Hence the very construction of a collective

memory assembled through the side-by-side display of commissioned paintings along with 'original' pieces (so as to bridge the gaps within a narrative sequence), allows us to see the museum more as a stage than as a loyal recording of 'what really happened'.

Environment and Landscape

The intellectuals of the Ateneo were attracted by the capacity of museums to generate an impact beyond themselves. They sought to create a cultural environment that would disseminate the spiritual and national values over a *milieu* they perceived as dominated by greed and materialism. Ironically, the cure for these ills supposedly lay in the display of material objects. Both the National Historical Museum and the National Museum of Fine Arts were conceived, then, as performative institutions capable of tackling the very roots of the spiritual crisis. While the pedagogic action of the former was destined to stabilize national iconography, the collecting and display practices of the latter aimed to build a cultural capital. These practices also included the promotion of new generations of artists who, in contrast with their predecessors, would be able to receive an education at home with no need to travel to Europe. Up to that moment, most Argentine artists had received their artistic education in Italy. However, through its educational activity, the new museum would also have a pedagogic impact on the population in general and not merely the artistic community. The museum, in short, would be both a producer of artists, painters, and sculptors educated in the country and the promotor of an emerging artistic environment capable of generating its own demand, a role the Ateneo had already attempted to play in sponsoring art salons. The emergence of a language proper to art criticism, centered around the debate on a national art, was a direct consequence of these activities.

The formal inauguration of the National Museum of Fine Arts took place in 1896, in the context of the fourth and last of the Ateneo's expositions. The show was located at the *Au Bon Marché* building on the lavish calle Florida, then a department store (today it is home to a shopping mall, the Galerías Pacífico), on whose premises the museum had provisionally been established (Glusberg 1996:16; Palomar 1962). Three years earlier, Ernesto Quesada had reviewed the first art exposition organised by the Ateneo, emphasizing that

> [t]he very fact that in a city of more than half a million souls, which distinguishes itself for its character of an offshore factory, it had been possible to organise an exclusively intellectual gathering such as the Ateneo, and that this group has felt itself called upon to create the annual Salon of Fine Arts, is a promising sign of progress, which should not be treated in a paltry way, but deserves our attention. (Quesada 1893: 374; our translation)[15]

Quesada's lengthy review verses over some foreseeable topics, such as the lack of support for culture from the state and public indifference to art. However, what is quite provocative in his argument is the observation about the absence of an *artistic atmosphere*, a fact which the exposition, and subsequently the museum, would help to reverse. Even though the notion of 'atmosphere' does evoke positivistic theories predominant at the time, the reasons brought forth by Quesada rather contradict such a reading. The artistic *milieu* necessary for cultural production is, according to him, neither determined by races – creole or cosmopolitan – or by climate, nor by any other biological factor, but by strictly social determinants, the responsibility for which belongs more to the elite than to the immigrant communities usually blamed for racial degradation. The Ateneo's activity, then, might certainly contribute to modify this situation whose main cause was the indifference among the educated public and the concomitant poverty of Buenos Aires's cultural life. The Fine Arts Museum was thus conceived as an institution endowed with a specific, productive impact on traditions, and capable of generating effects beyond its own limits.

The Ateneo's fourth exhibition was reviewed by Rafael Obligado in an article entitled 'On National Art', where he insisted that Argentina's painting should give up European trends and look to the pampas instead, the rural landscape that ought to be its chief subject and theme. The reply Obligado received from Eduardo Schiaffino (1933: 354–55), the museum's future director and a painter himself, deserves to be quoted extensively:

> Mr. Obligado supposes that the election of theme or matter is more important than that of the spirit, and he is inclined to reject from his republic the artist capable of expressing himself on canvas. […] He considers it a crime of lese patriotism not to have a loving glance towards imported sheep, or a tender gesture for horses and bulls. On the contrary, he finds it highly patriotic to weep ceremoniously about the immigrants who come to settle on our soil; who bring with them the generous blood of humanity as a whole, to immerse themselves into the melting pot where our race is forged, transformed by the action of a vigorous environment. He rises against cosmopolism, whose great social function he ignores and laments the disappearance of those more or less backward American nations, among which the indigenous element predominates, peoples unfit for the exercise of high civilisation, and whose anaemic appearance is due to persisting endogamy. The cosmopolitan age will represent among us – as it has in the United States – a relatively short period of transition, the indispensable factor of our numerical importance, and the cause determining the selection of a race, which fate has chosen for higher purposes. (Our translation)[16]

Perhaps his words can serve the purpose of challenging the idea of the entire elite's unanimous conformity with regard to cosmopolitanism, in order to reconsider the debates over the formation of cultural citizenship. Schiaffino not only disagreed with those who considered immigration as the culprit of the spiritual crisis, but saw immigration as a way to solve the real causes of the crisis: bigotry, isolation, and provincialism. Although

not devoid of racist ideas, particularly with regard to other Latin American nations, his reply to Obligado postulated a more innovative use of memory, as an intervention that considers culture as a battlefield over images rather than as the rigid crystallisation of a self-identical past.

Material culture – relics, paintings, historical objects – possess in this perception an almost magical quality, a power to model collective identity that was useful for the production of a future subject of a symbolic order about to emerge. Yet this subject could never speak for itself. Instead, it had to be represented through the collections assembled by the managers of material memories. In the case of Argentina, there is a significant portion of the population that never passed through the doors of the museum: Indians, women, Afro-Argentines, the working class, certain groups of immigrants, subalterns of every kind. All of them were rarely invited to the museum's stage – and they are still absent from visual representation in permanent exhibitions of national museums, except for a reduced and mostly stereotypical depiction.[17] They are the forgotten component that by rule accompanies the building of traditions, since amnesia and remembering go parallel in the texture of memory. Identity and alienation, as Slavoj Žižek puts it, are thus strictly correlative (Žižek 1989: 24). Argentina's cultural remembrance is no exception. Indeed, its official memories constructed a monochrome narrative that reduced social antagonism to a confrontation between a Creole elite and a European subaltern awaiting to be nationalised.

Translated by the author and Jens Andermann

Bibliography

Andermann, Jens. 2001. 'Reshaping the Creole Past: History Exhibitions in late Nineteenth-Century Argentina', *Journal of the History of Collections* 13, 2: 145–62.

Appadurai, Arjun & Beckenridge, Carol A. 1999. 'Museums are good to Think: Heritage on View in India' in: *Representing the Nation: A Reader. Histories, Heritage, and Museum*, eds. David Boswell and Jessica Evans, London, New York, Routledge / The Open University.

Arendt, Hannah. 1969. *The Human Condition*. Chicago, London: The University of Chicago Press.

Bennett, Tony. 1995. *The Birth of the Museum: History, Theory, Politics*. London: Routledge.

———. 1999. 'Useful culture', in: *Representing the Nation: A Reader. Histories, Heritage, and Museum*, eds. David Boswell and Jessica Evans, London, New York, Routledge / The Open University.

Bertoni, Lilia Ana.1992. 'Construir la nacionalidad: héroes, estatuas y fiestas patrias, 1887–1891', in: *Boletín del Instituto de Historia Argentina y Americana "Dr. E. Ravignani"*, Tercera Serie, 5, 1st. Semester of 1992: 77–111.

———. 2001. *Patriotas, cosmopolitas y nacionalistas. La construcción de la nacionalidad argentina a fines del siglo XIX*. Buenos Aires: Fondo de Cultura Económica.

Boswell, David & Jessica Evans, eds. 1999. *Representing the Nation: A Reader. Histories, Heritage, and Museums.* London, New York: Routledge / The Open University.

Burucúa, José Emilio, ed. 1999. *Nueva historia argentina: arte, sociedad, política.* Buenos Aires: Sudamericana.

Certeau, Michel de. 1988. 'The Scriptural Economy', in *The Practice of Everyday Life*, transl. Steven Rendall. Berkeley: University of California Press.

Chastel, André. 1997. 'La notion de patrimoine', in: *Les Lieux de Mémoire*, ed. Pierre Nora. Paris: Gallimard.

Clifford, James. 1988. *The Predicament of Culture: Twentieth-Century Ethnography, Literature, and Art.* Cambridge, MA: Harvard University Press.

Crary, Jonathan. 1992. *Techniques of the Observer: On Vision and Modernity in the Nineteenth Century.* Cambridge, MA: MIT Press.

García Canclini, Néstor. 1992. *Culturas híbridas. Estrategias para entrar y salir de la modernidad.* Buenos Aires: Sudamericana.

————— . 1997. 'El patrimonio cultural de México y la construcción imaginaria de lo nacional', in: *El patrimonio nacional de México*, Enrique Florescano (coord.). México: FCE.

Geertz, Clifford. 1973. *The Interpretation of Cultures: Selected Essays.* New York: Basic Books.

Glusberg, Jorge. 1996. 'El Museo Nacional de Bellas Artes: Apuntes para su historia', in: *Obras Maestras del Museo Nacional de Bellas Artes.* Buenos Aires: MNBA.

Huyssen, Andreas. 1997. *Twilight Memories: Making Time in a Culture of Amnesia.* London, New York: Routledge.

Hobsbawm, Eric & Terence Ranger, eds. 1983. *The Invention of Tradition.* Cambridge: Cambridge University Press.

Klugg, Diana & Miguel Ruffo. 1993. 'Un análisis de la mentalidad fundadora del Museo Histórico Nacional: Archivo de correspondencia de A. P. Carranza', in: *Segundas jornadas de los museos: patrimonio, investigación y difusión.* Buenos Aires: Secretaría de Cultura.

Lascano González, A. 1980. *El Museo de Ciencias Naturales de Buenos Aires. Su historia.* Buenos Aires: Ediciones Culturales Argentinas.

Lloyd, David & Paul Thomas. 1998. *Culture and the State.* London, New York: Routledge.

Lopes, Maria Margaret. 2000. 'Nobles rivales: estudios comparados entre el Museo Nacional de Río de Janeiro y el Museo Público de Buenos Aires', in: *La ciencia en la Argentina entre siglos.* Marcelo Montserrat, ed. Buenos Aires: Manantial.

Ludmer, Josefina. 1999. *El cuerpo del delito: un manual.* Buenos Aires: Perfil.

Macdonald, Sharon & Gordon Fyfe, eds. 1996. *Theorizing Museums: Representing Identity and Diversity in a Changing World.* Oxford: Blackwell.

Mitchell, Timothy. 1991. *Colonizing Egypt.* Berkeley and Los Angeles: University of California Press.

Munilla Lacasa, María Lía. 1999. 'El Siglo XIX: 1810–1870', in: *Nueva historia argentina: arte, sociedad, política*, ed. José Emilio Burucúa. Buenos Aires: Sudamericana.

Muñoz, Miguel Angel. 'Un campo para el arte argentino. Modernidad artística y nacionalismo en torno al centenario', in: *Desde la otra vereda: Momentos en el debate por un arte moderno en la Argentina (1880–1960)*, ed. Diana B. Wechsler. Buenos Aires, Ediciones del Jilguero.

Murilo de Carvalho, José. 1990. *A formação das almas: o imaginário da República no Brasil.* São Paulo: Companhia das Letras.

Nora, Pierre. 'Between Memory and History: Les Lieux de Mémoire', in: *Representations* 26, Spring 1989: 7–24.

————— . ed. 1996. *Realms of Memory: the Construction of the French Past*, New York: Columbia University Press.

————— . dir. 1997. *Les Lieux de Mémoire.* 3 vols. París: Gallimard.

Obligado, Rafael. 1974. *Prosas.* Buenos Aires: Academia Argentina de Letras.

Oyuela, Calixto. 1943. 'La raza en el arte', in: *Estudios Literarios*, Buenos Aires: Academia Argentina de Letras: 199–222.

Palomar, Francisco A. 1962. *Primeros salones de arte en Buenos Aires: reseña histórica de algunas exposiciones desde 1829*. Buenos Aires: Municipalidad de la Ciudad de Buenos Aires.

Pérez Gollán, José Antonio. 1995. 'Mr Ward en Buenos Aires: los museos y el proyecto de nación a fines del siglo XIX', in: *Ciencia Hoy* 5, 28: 52–58.

Podgorny, Irina. 1997. 'Alfred Marbais du Graty en la Confederación Argentina. El Museo Soy Yo', in: *Ciencia Hoy* 17, 38: 48–53.

Pomian, Krysztof. 1990. *Collectors and Curiosities. Paris and Venice, 1500–1800*. Cambridge: Polity Press.

Quatrocchi-Woisson, Diana. 1995. *Los males de la memoria: historia y política en la Argentina*, transl. César Aira. Buenos Aires: Emecé.

Quesada, Ernesto. 1893. *Reseñas y críticas*. Buenos Aires: Lajouane.

———. 1897. *El museo histórico nacional y su importancia patriótica*. Buenos Aires: Kraft.

Rubione, Alfredo V. E. 1983. 'Estudio preliminar', in: *En torno al criollismo: textos y polémica*, Buenos Aires, CEAL.

Schiaffino, Eduardo. 1933. *La pintura y la escultura en la Argentina (1873–1894)*. Buenos Aires: Edición del autor.

Schwarcz, Lilia Moritz. 2000. *O espetáculo das raças: cientistas, instituições e questão racial no Brasil 1870–1930*. São Paulo: Companhia das Letras.

Sheets-Pyenson, Susan. 1988. *Cathedrals of Science: The Development of Colonial Natural History Museums During Late 19th Century*. Kingston/Montréal: McGill/Queen's University Press.

Stocking, George W., Jr., ed. 1985. *Objects and Others: Essays on Museums and Material Culture*. Madison: University of Wisconsin Press.

Urry, John. 1996. 'How Societies Remember the Past', in: *Theorizing Museums: Representing Identity and Diversity in a Changing World*, eds. Sharon Macdonald, and Gordon Fyfe. Oxford: Blackwell.

Wechsler, Diana B., ed. 1998. *Desde la otra vereda: Momentos en el debate por un arte moderno en la Argentina (1880–1960)*. Buenos Aires: Ediciones del Jilguero.

Zimmermann, Eduardo. 1993. '*La época de Rosas* y el reformismo liberal del cambio de siglo', in *La historiografía argentina en el siglo XX (I)*, ed. Fernando Devoto. Buenos Aires: CEAL.

Žižek, Slavoj. 1989. *The Sublime Object of Ideology*. London: Verso.

Notes

1. I take the concept of 'cultural coalition' from Josefina Ludmer (1999: 25). On the Ateneo see Schiaffino 1933; Palomar 1942; Rubione 1983. There are minor discrepancies regarding the duration of the Ateneo. Rubione proposes the dates mentioned, according to Palomar and Schiaffino it lasted until 1898.

2. I am using the concept of civic symbol as it is developed by José Murilo de Carvalho in *A formação das almas* (1990).

3. Schwarcz 2000: 67–8. See also the concept of 'scriptural economy' in De Certeau 1988.

4. Lawrence D. Kritzman observes this displacement in the case of the Eiffel Tower, suggesting that the corrosive force of time strips away the ideological roots of the monument (its function as a symbol of revolutionary modernism) and thereby transforms that 'realm of memory' into its contemporary incarnation as part of the 'poetry of Paris'. Prologue to the English edition of Pierre Nora, *Realms of Memory: the Construction of the French past* (1996: xiii).

5. In a similar mode to other postcolonial contexts, Latin American museums operate as producers of their audiences. As Appadurai and Breckenridge observe: 'What is needed is the identification of a specific historical and cultural public, one which does not so much *respond* to museums but is rather *created,* in part, through museums and other related institutions. In India, museums need not worry so much about finding their publics as about making them' (Appadurai & Breckenridge 1999: 405–6, original emphasis).

6. The proliferation of scopic signs in the age of mechanical reproduction has been signalled by Jonathan Crary (1992: 27) as typical of modernity. The techniques of the observer will try to 'regiment the activity of the eye, imposing visual attentiveness, rationalizing sensation, and managing perception'. The subjection and objectification of the observer intends to regulate vision, conducting to a fixation of meaning. As a result of this process the observer came to occupy a position detached from his object.

7. As Chastel (1997: 1444) observes, the concept of patrimony always opposes forms of vandalism that challenge material culture's integrity and in relation to whom strategies of preservation are developed.

8. Bertoni (2001) observes that it was Estanislao S. Zeballos who established the iconography of Argentina's national shield in 1900.

9. See Quattrocchi-Woisson 1995, Bertoni 2001, and Zimmermann 1993. Ernesto Quesada's text on Rosas – *La época de Rosas: su verdadero carácter histórico* (1898) – has been considered by revisionist historians as a precursor of the revisionist historiography. This hypothesis is rejected by contemporary historiography.

10. Rubione sustains that two factions coexisted in the Ateneo; a more conservative one commanded by Obligado, and a more 'cosmopolitan' one lead by Darío.

11. See Pérez Gollán 1995 and, on the the Public Museum of Buenos Aires, Lascano González 1980 and Lopes 2000.

12. Whose original name, ironically, before its timely rebaptism, had been '*Cosmopolitan* Gymnastics and Fencing Club of Buenos Aires'.

13. This phenomenon has usually been regarded as one of 'assimilation' or 'homogeneisation'. My view suggests to switch the perspective and look at immigrant communities as in a less passive position. Appropriation can also be seen as a form of resistance.

14. The original paragraph reads: 'Debe consignarse que el museo no ha dejado pasar una sola oportunidad patriótica, sin contribuir a conmemorarla. En los días patrios ha distribuido profusamente al pueblo láminas conteniendo los retratos de varios próceres, y reproduciendo el ejemplar original de nuestro himno nacional: de esa manera permitía a las clases inferiores de la población familiarizarse con el recuerdo de los grandes argentinos, y adornar con esas láminas hasta las habitaciones más humildes.'

15. The original passage reads: 'El hecho sólo de que en un centro de más de medio millón de almas que se distingue especialmente por su carácter de factoría ultramarina, haya sido posible formar una agrupación exclusivamente intelectual como el Ateneo, y éste a su vez se haya sentido bastante autorizado como para crear el *Salón* anual de Bellas Artes, es un signo halagüeño de progreso que no puede tratarse de modo baladí y que merece fijar nuestra atención.'

16. The original passage reads: ' Supone el señor Obligado que la elección del tema o asunto importa más que la selección del espíritu, y se muestra inclinado a arrojar de su república al artista capaz de volcarse a sí propio sobre el papel o la tela, [inconsciente o desdeñoso del ambiente en que su cuerpo se agita]. Le parece un crimen de leso patriotismo el no tener una mirada de amor hacia las ovejas importadas, un gesto de ternura para los caballos y los toros, pero en cambio, encuentra altamente patriótico lamentarse a gritos de esa inmigración que viene a arraigar en nuestro suelo; que trae consigo el vasto espíritu, la sangre generosa de la humanidad entera, a sumergirlos en el crisol hirviente en el que se funde nuestra raza, modelada, transformada, transfigurada por obra y gracia del

poderoso medio. Álzase en contra del cosmopolitismo, cuya grandiosa función social ignora, y echa de menos en un acceso regresivo a las naciones americanas, más o menos rezagadas en las que prima el elemento indígena; esos pueblos impropios para el ejercicio de la alta civilización, que parecen anemiados por la persistencia de uniones consanguíneas. La era cosmopolita será entre nosotros – como ya lo fue en los Estados Unidos –, un período de transición relativamente breve, el factor imprescindible de nuestra importancia numérica, la causa determinante de la selección de una raza destinada por la suerte a mayores designios.'

17. Blacks were located in colonial time and represented as part of a remote past; Indians are almost totally absent in the National Museums of History and Fine Arts, except as a threat to civilisation; women occupy a similar position, as do immigrants and working class representations. All of them only appear as represented by male, white, upper-class artists and certainly never as protagonists of historical events or authors of artworks.

Part II

Self and Other in the Avant-Garde

Chapter 5

Exoticism, Alterity, and the Ecuadorean Elite:

The Work of Camilo Egas

Trinidad Pérez

The early work of the Ecuadorean painter Camilo Egas, produced between 1916 and 1923, rests on a long tradition of representation of the Indian in the iconography of Ecuadorean identity, in which the concepts and norms that govern this type of representation are defined. While never ceasing to belong to this tradition, Egas's work introduces innovative elements: large-scale easel painting and a dramatic and declamatory style. He thus gives a new status to the representation of the Indian, which is transposed from a secondary visual tradition to one of high art: official, institution-alised, based on an artistic heritage derived from Europe, and therefore accepted and promoted by Ecuadorean elites. Integrating the European 'high art' tradition with local subject matter, Egas's painting projects a new image of the Indian as a visual symbol of the nation.

Until recently, Egas was virtually unknown and little studied as an artist despite his importance in the history of twentieth-century Ecuadorean art. The paucity of research on his work has led to a number of misunder-standings. For example, Egas appears to belong to the social realism and *indigenismo* of the 1930s and 1940s, and to thus be influenced by Mexican muralism.[1] The first results of a close investigation of his work show how-ever that his *indigenista* production goes back to the latter part of the sec-ond decade of the twentieth century, while his social-realist work belongs to the end of the 1920s and 1930s, and within the context of social realism in New York. Ecuadorean social realism clearly had connections both with *indigenismo* and with Mexican muralism; until recently, however, its antecedents in the work of Egas were not recognised.

Egas was born in Quito in 1889 at the dawn of the Liberal Revolution, a period of extensive structural change. In the field of art, the most important reform was the establishment in 1904 of the School of Fine Arts in Quito. Egas studied there until 1911 when he traveled to Rome on a government scholarship, the first of many journeys to Europe between 1910 and the 1920s. The style of his early work is defined in large part by stimulations and influences encountered on these trips, integrating local traditions of representation with those of nineteenth and early twentieth-century European modern art. He paints indigenous fiestas, dances, and scenes of everyday-life from the Andes on large-scale canvases and in a rhetorical style. The subject matter is related to *costumbrista* painting, which itself has direct sources in the vision of the Noble Savage through the eyes of the traveller-scientists who criss-crossed America from the end of the eighteenth to the beginnings of the twentieth century. Egas's work also references a plethora of fin-de-siècle European movements, such as romantic orientalism, realism, Gauguin's primitivism, and Spanish *modernismo*. All of these influences serve to construct a discourse on the Indian; this chapter will seek to analyse the visual tradition that Egas reworks in his own production. Through a conjunction of elements from diverse sources, Egas synthesizes a new image of the Indian as symbol of the nation (Guerrero 1994: 200–201, 214–15). It is a discourse that goes hand-in-hand with the nationalist and modernising projects of the beginning of the century. It is precisely the mechanisms which Egas uses to give the Indian visibility that I want to explore: the way in which, in a particular social and artistic context, he reworks the codes that derive from both the local visual tradition and European 'high art'.

We can begin by placing Egas's work in the context of Latin American artistic and cultural currents. In the broad sense of the term, Egas's painting is *indigenista*: that is, one in which for the most part it is the Indians who are represented. But it is not yet social realist in that it does not denounce the Indian's misery, but rather emphasises their visual attributes: their slender bodies and colourful clothes set in a dramatically portrayed environment.

The scope of the term *indigenismo* has been the object of much dispute. The most general way to understand it is through its social realist variant which developed more or less between 1920 and 1945, articulating a political condemnation of the subaltern position of the Indian with respect to the dominant society. In this way it can be distinguished from *indianismo,* which had a rather different political agenda.[2] However, a wider and more adequate way of understanding the term would be to see it as a process of construction of the image of the Indian whose representation emerges in different historical contexts and in different fields, through a rich and complex interplay among disciplinary perspectives in

which sociologists, physicians, politicians and artists all play their part.[3] Within the historical process, in the field of the arts, we can distinguish between romantic *indigenismo*, and modernist and social-realist versions. 'This way of understanding it allows *indigenismo* to be seen as a broad and almost uninterrupted sequence whose origin lies in the chronicle [and] which is expressed differentially according to the variants that history [...] can detect' (Cornejo Polar 1980: 36–37).[4] In this categorization, the work that Egas produced between 1916 and 1923 could be identified as a modernist *indigenismo*; it emphasises the formal values of painting in order to give the Indian visibility. On the other hand, the paintings that he produced in New York from about 1929 to 1940 already reveal the political concerns and attitudes that characterize social realism.

Earlier, José Carlos Mariátegui had defined *indigenismo* as a discourse on the Indian produced by non-Indians, saying that: 'It is still a literature of *mestizos*. That is why it is called *indigenista* and not *Indian*' (1963: 292). It thus reveals its intrinsically external character, contradicting the claim of many *indigenistas* to give an account of the Indian world from within (Cornejo Polar 1980: 62–66). The recognition of the externality of *indigenismo* is a fundamental requirement for any discussion of the movement. And this is where Cornejo Polar begins. His theory of heterogeneity gives an account of the duality or plurality of cultural processes that is typical of societies like those of Latin America, which are built on conquest and colonization (Cornejo Polar 1982: 73–74). Heterogeneous art and literature are thus inscribed in a sociocultural context that is also heterogeneous (80). Their referents might belong to the world of America, but the production norms, representation canons, creative systems, and consumption patterns correspond socially and culturally to the Western order. That is precisely because the producers, writers or artists, identify themselves with the hegemonic pole of their societies (Cornejo Polar 1980: 64–66; 1982: 73–74, 81).[5] This heterogeneity and externality also require a reader (or viewer in the fine arts) who is distant and outside the world represented in the work (Cornejo Polar 1982: 82). What we are faced with, then, are works that represent the least Westernized aspects of Latin America by means of strategies of representation and circulation that belong to the West. Understanding *indigenismo* as a heterogeneous cultural project therefore entails accepting that the point of view from which the Indian is represented is always external.

The concept of heterogeneity is consonant with theories of the representation of the Other precisely in this recognition of an external perspective. The Other is a familiar representation for the European who uses it to contain everything that is racially or culturally unknown, incomprehensible or notoriously different. The Greeks were the first to

formulate the category in relation to the Persian world. As Said has pointed out, the construction of the Other's image is necessary for the hegemonic culture in order to define its own identity, precisely because this Other is 'its image, idea, personality, contrasting experience' (Said 1979: 1–2). Like individuals, cultures require an exercise in opposition and resemblance in order to define themselves (Amodio 1993: 17–24); our identity is confirmed by gazing at ourselves in the Other's mirror. When the concept of the Other is constructed by a culture as dominant as that of the West, this Other, Oriental or American, can no longer be named independently of how it has been defined by the dominant culture (Said 1979: 23).

The American elites who see themselves and their culture as extensions of Europe project this vision of the Other onto the Indian and thus not only feel entitled to define them but also to construct their consciousness (Trujillo 1993: 22). They thus created representations of the Indian when their project of constructing modern American nations required symbols to distinguish them from Europe. In doing so, they found themselves in a paradoxical situation: they defined what belonged to them using the Other as their starting point, although this Other was part of their own reality. This is because in a heterogeneous society, the representation of the Other expresses the social and cultural dichotomy of two worlds that coexist, but do not integrate, and that only relate to each other in a relationship of unequal power (Lienhard 1992). To investigate Egas's representation of the Indian, then, we need to keep in mind the notions of alterity that flow from nationalist discourse as it was constructed at the end of the nineteenth century and beginning of the twentieth.

The Era of Costumbrista Representation

The perception of the Indian as the Other is confirmed by a long tradition of visual representation to which Egas's work belongs. It is one which takes different perspectives and stances and performs different functions in the course of its development, but which from the start reflects a vision of America as seen from Europe: that is of America as the Other. From very early on in the colonial period, the conquerors and travellers name, describe, tell and interpret the newly-discovered continent from the only possible perspective: their own. It is one that starts out from a definition of themselves through their differentiation from the Other. The first illustrations made by such chroniclers and travellers, such as those of Benzoni (1572) and De Bry (1617), represent customs and ways of life that seem strange to them as Europeans or by which they feel threatened. Benzoni comments visually on the nakedness and greed of the Indians; De Bry

emphasises cultural differences, attitudes and customs (such as cannibal-
ism) rather than racial distinctions. The need to illustrate transcends the
lack of knowledge of the object represented. Thus, Indians are repre-
sented according to European expectations, based on the classical canons
that were spread in sixteenth century Germany by Dürer: men, are naked
but bald, and women seem to have been taken precisely from *The Fall
(Adam and Eve)* by the same artist (1504).

In the Colonial period, the so-called 'pintura de castas', in which social
types were depicted, inaugurated a tradition of representation which con-
tinued in nineteenth-century costumbrista painting, passing through
Egas's work to reach its culmination in the *indigenismo* of the 1930s and
1940s. It is a transition from a space in which painting is highly valued to
another where it was considered secondary to engravings, drawings,
watercolours and photographs. In Ecuador, its origins are found in
Andrés Sánchez Gallque's painting *The Black Chiefs of Esmeraldas* pro-
duced in 1599 as documentary testimony to the conversion to Christian-
ity of the black population of Esmeraldas, and as such was sent to King
Philip the Second by the Magistrate of Quito (Navarro 1991: 33–35). The
work represents the symbolic legitimation of the submission of the black
people of Esmeraldas, as a local power, to the superior power of the
Christian and civilizing Spanish Crown.[6] Hence, the three figures are
placed in the foreground of the picture and although portrayed with their
ethnic group's symbols – spears, nose-rings, ear-rings – they are dressed
in the Spanish fashion with cloaks, ruffs and hats.

This vision of the Other as subaltern is maintained in the different
types of representation of the Indian produced since the colonial period.
At the same time, the rhetorical strength, technical level and scale of
Sánchez Gallque's painting are extraordinary and only reappear in Egas's
paintings at the beginning of the twentieth century. If the former serves
to confirm the absolute power of the monarch over the non-Spanish peo-
ples of America, the large-scale representations of the Indians that Egas
produces in oil at the beginning of the twentieth century allow the elites
to confirm their own identity in a new image of the nation.

The representation of America and Americans as the Other is rede-
fined in the period, which coincides with the apogee of scientific voyages
to Latin America, between 1750 and 1910. It is precisely in the eighteenth
century that Americanism emerges as an analogous concept to that of
Orientalism in European Enlightenment and Romantic thought (Fitzell
1994: 36) and as such denotes the distance and estrangement felt in rela-
tion to the represented object. The specific representation of the Indian is
also framed in wider terms in the general conventions of this tradition. In
fact, in magazines such as *Le Tour du Monde,* the representation of the
Indian is marked by the same estrangement which European gaze

bestowed upon the indigenous inhabitants of other regions, such as India, Pakistan or China.

For Europeans, the scientific voyages of the eighteenth and nineteenth century function on two levels. Firstly, as a rediscovery of America revealing those aspects of the continent which had continued to be hidden from Europeans during the colonial period: its geography and its people (Catlin 1989: 45). Secondly, in the twilight of Spanish imperial power, they were a reaffirmation of the new European empires (Said 1979: 4). In the zeal to classify the 'new world' these expeditions described in visual and written terms what had just been 'discovered'. Just like their predecessors, the colonial chronicles, the scientific accounts and reports of this period were lushly illustrated with images that ranged from landscapes to botanical descriptions. Depictions of the American population were generally classified under the rubric 'customs and habits', but also appeared in the allegorical images on the title pages of the books or inside a landscape in the company of the travellers. Three illustrated publications of scientific journeys undertaken towards the end of the eighteenth century are important for Ecuador in this respect. These are the journeys of Jorge Juan and Antonio de Ulloa who accompanied the French Geodesic Mission in 1736, the Botanical Expedition to New Granada by José Celestino Mutis in 1784, and Alexander von Humboldt's and Aimée Bonpland's expedition between 1799 and 1804.

Figure 5.1 Illustration from Jorge Juan & Antonio de Ulloa, 1748.

In *An Historical Account of a Voyage to South America* (1748) Juan and Ulloa include illustrations of human types in which, with great graphic subtlety, they describe the racially stratified society of America, and one can already discern to some extent the precedents for representations of social types. In the plate illustrating the Royal Tribunal of Quito, six figures are placed in a landscape representing the Southern Andes. If we read the image following the logic of the pre-established visual grammar from left to right and from the bottom to the top (Dondis 1985: 45) we can see that the distribution of the figures in both the horizontal plane and in three-dimensional space describe a society clearly differentiated by ethnic group and class (Fitzell 1994: 29). The social groups that are in a superior position in the hierarchy appear in the lower left corner and those who are inferior appear towards the right-hand edge of the plate in the middle ground. These differences are also defined in terms of clothing. According to Fitzell (1994: 30), Juan and Ulloa recognised that the American social hierarchy not only stemmed from race and class but also from distinctions between 'people who lived in towns or in the country, persons of noble ancestry and those who exercised a trade, and also between the sexes'.

From this point on, and in the course of the nineteenth century, a type of visual representation developed that was devoted to the marking of just such distinctions. This process moves from illustrations in travellers' books to those in albums and, finally, to pictures completely independent of the book. Within the travel book, the image has already become a distinctive type. Thus we are faced with a change in the function of the image, which at the same time implies a change of audience. Travellers' books were aimed largely at 'evaluating the existing social conditions in the new democratic republics which were emerging from Spanish colonialism' (Fitzell 1994: 27), hence the interest in social categories and types. But they also aimed to satisfy the taste of a European public anxious to consume images of the exotic along with all kinds of empirical information (40–41). The *costumbrista* albums maintained the same function. Under the rubric 'customs and habits', clothing and attributes of trade or office are brought together in order to indicate the social place occupied by the category of person represented.[7] We can see this in Humboldt's influential work, and later in the books of those travellers who passed through Ecuador, such as *An Historical and Descriptive Account of a Twenty Year Journey Through South America* by W. B. Stevenson and the *Esplorazione delle Regioni Equatoriali...* (1854) by the Italian Gaetano Osculati. By the middle of the nineteenth century, the representational norms of this type of image and the vocabulary of 'costumbrista painting' were already well established. In *The Indian Water Carrier and the Woman Carrying Wood, Quito* and *Yumbo Indian and Indian of Los*

Colorados which illustrate Stevenson's book, the figures appear outside any sort of context: the more or less depictional landscape of Juan and Ulloa has been altogether simplified and is hardly more than a strip of land floating in space and acting as a base for the figures. What is now important is the emphasis placed on dress, insignia or impedimenta, and the position of the figure with respect to the plane of the picture as part of an ethnic and occupational depiction. The water-carrier, the woman carrying firewood, and the Yumbo are represented in profile with legs and torso bent to demonstrate graphically that they are indeed carrying something heavy and walking towards a fixed destination in order to hand over their merchandise. On the other hand, the frontality of the Colorado Indian allows a better depiction of his ethnic qualities. The muscular bodies display a knowledge of academic naturalism. Nevertheless, the representation of the body, the figure's insignia and the spatial context have reached high levels of stereotypification. Osculati dedicates more than half of the thirty plates that illustrate his book to the subject matter of the 'customs and habits' of Ecuador. The plates are watercolours, numbered and identified, and their figures, as in Stevenson, are placed in the foreground on a type of terrace which represents in synthetic fashion the surroundings of the depicted group. Poses and gestures assist the iconographic identification of each plate: frontal view, profile, and three-quarters representations are all used as mechanisms of exposition. Thus between the plates of Juan and Ulloa's *Social Types of the 18th Century* and those of Osculati's book, the process of decontextualization has progressed quite appreciably, and within this process, iconization has become more important.

As well as exemplifying the high level of conventionalization, Osculati's images are interesting because they have an accompanying identification by the author. Osculati painted maps and landscapes himself, as is indicated by the caption in the lower left-hand corner: 'Oscualti dis. dal vero'. By contrast, the inscription on the plates illustrating customs says 'Salas di Quito dis.' Vargas has identified the author as Ramón Salas (c. 1815 – ?) (Vargas 1984: 376, note 8), son of Antonio Salas, one of most celebrated Ecuadorean painters of the first half of the nineteenth century.[8] The linking of Salas with Osculati's plates points us towards the subsequent stage of development of these images: the emergence of costumbrista painting precisely through the contact of Ramón Salas with another traveller who was in Quito at this time.

Figure 5.2 Ramón Salas, 'Cuchurucho chiedente', 'Yumbos o Indiani del Quixos in Viaggio', illustration from Osculati 1854.

Figure 5.3 Gaetano Osculati, 'Panorama della Cittá e Porto di Guayaquil nell'Equatore, preso dalla montagnola della la Polverera', 1854.

There is no precise information as to how long Ernest Charton remained in Ecuador. This French traveller and painter was the brother of Edouard Charton, director of *Le Tour du Monde* (Fitzell 1994: 41). He visited the Galapagos Islands in 1848 (Villacís 1981: 22) and was named director of the School of Painting in Quito when it was founded in 1849 (Navarro 1991: 231; Vargas 1984: 372). One of the artists connected to the school was Ramón Salas. Around 1862, Charton published an article in *Le Tour du Monde* in which he described a journey to Guayaquil and Quito and illustrated it with seven engravings of views of Quito and its inhabitants. These engravings were not of the 'customs and habits' type. Nevertheless, during the period when he was in Ecuador, 1849 and 1862, Charton produced a costumbrista album of forty-eight watercolours,[9] in which he represented various types of popular characters: porters, yumbos, and spinners, as had Osculati. Others depict social types like the traditional *Bolsicona*, ethnic stereotypes like the '*Savage Indian*' or '*Indian at the Festival*', or characters from religious festivals like '*Indian Dancing in a Procession*'.

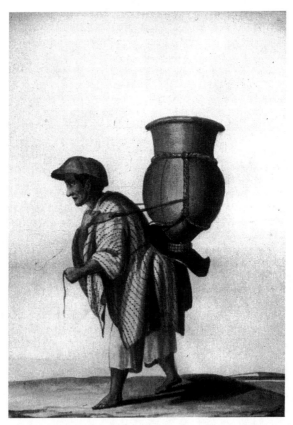

Figure 5.4 Ernest Charton, *Aguatero*, watercolour on paper, 18 x 13 cm. Costumbristic album, Museo del Banco Central, Quito.

Apart from those which illustrated books like Osculati's, these water-colours have come down to us in the form of albums, small notebooks or handmade books, in which these types of painting have been collected. Juan Agustín Guerrero, who among other occupations worked as a cos-tumbrista painter 'put together albums of the paintings of his friend – Ramón Salas – as well as his own and those of his disciples' (Navarro 1959: 7).[10] So we can see that from the middle of the nineteenth century, some Ecuadorean painters and also foreign artists like Charton were beginning to produce their own costumbrista works already independent of travel books.

In the costumbrista album, both subject matter and formal representa-tion follow the same patterns as before. Their function continued to be that of satisfying a public that sought images of what was different and distant. As in the 'habits and customs' illustrations, costumbrista painting repeats poses and subject matter in an almost identical fashion, to such an extent that once the authorship of the album has been lost it is virtually impossible to determine it from formal analysis alone. It is difficult to establish exactly what the relation is between traveller and illustrator or painter. But by the middle of the nineteenth century, this relation takes one of the following forms: either travellers contracted local painters to produce the illustrations for their books, or commissioned them, or they bought pre-existing watercolours. On the one hand what was important was that the image be sufficiently stereotypical or iconic to be easily identified by the viewer, as in book illustrations. On the other, it was also important that the traveller have an object of appropriate size for it to be portable, a souvenir or record of the place that he had visited and gotten to know.[11] By contrast, if the plates were going to be used as models for engravings to illustrate books, these could be used prior to their binding or easily separated from the album. The function of costumbrista paint-ing thus continued to be that of illustrating different social types so that viewers could satisfy their hunger for information about a strange and distant world. The works by Ramón Salas and Charton show that, at least in Ecuador, costumbrista painting emerged from travel illustration.

What happens when the same type of image is no longer produced by the European traveller/illustrator but by a local painter, and when the images are addressed to an Ecuadorean audience and not a European one? What happens when the Ecuadorean painter of local customs repro-duces images of Ecuadorean types, which had hitherto been produced for Europeans and now offers them to an Ecuadorean audience? And why would Ecuadoreans want to produce and consume an image that connotes estrangement and distance with respect to the social groups among which they live? Possibly because, as Fitzell has noted, there exists 'a coinci-dence of hegemonic interests between European travellers and the land-

owning class in nineteenth-century Ecuador, although they might have used different discourses to explain the existant racial hierarchy' (Fitzell 1994: 29). Nineteenth-century Ecuadorean society preserved in its still rigid social structure features of the *casta* system of the colonial era, in which social position was indicated principally by race but also by occupation and dress (Fitzell 1994: 29; Rout 1976: 126–34). Therefore costumbrista painting should not be seen just as an inherited feature from the images of 'habits and customs' of travellers' books, even if their depiction of attire and activities of certain social groups is effectively an ethnographic contribution (Fitzell 1994: 56). It is also the way in which the elites order, classify, and keep in their place those whom they consider different from them. Paradoxically, it is on the basis of this system of distinction that the image of the nation will be built.

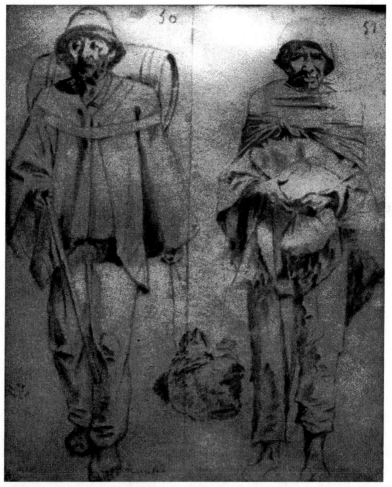

Figure 5.5 José Joaquín Pinto, *Indio (ciego cargando barril)*, pencil on paper, 19 x 11 cm, Museo del Banco Central, Quito.

Right at the end of the nineteenth century José Joaquín Pinto began to produce costumbrista work for albums in which such nationalist concerns are already expressed. He keeps the small-format paper plate with an inscription or caption in which the different types of social characters continue to be represented in an isolated and decontextualized way. Yet he moves away from stereotyping the figures to the point where, without ceasing to represent social and ethnic types, he individualizes them in terms of physical features, anatomy, range of gestures, expression, volume and colour, and thus comes much closer to the canons of French realism. In addition, more than any previous costumbrista artist, he concentrates on the representation of the characters in relation to their occupation, thus encouraging an identification with the worker on the part of the beholder, as is the case with French realism and the working class (Fitzell 1994: 65, 66). Pinto's work, moreover, reduces the distance between the image and the viewer by humanizing the figures. He abandons any claim to objectivity in the gaze and takes up a position directly facing the characters he represents. These costumbrista scenes form a sort of pictorial dictionary of social typology at the end of the nineteenth century. Although the Indian has not yet become an exclusive symbol of the nation in these images, they already express a notion of Ecuadorean identity (Pérez 1987: 23–24; 1991: 3).

Modernity as Continuous with Tradition: Camilo Egas

With Pinto's death in 1906, the era of costumbrista painting comes to an end: that is, production on paper, in small format, and as part of an album whose main consumers were foreign travellers. During the first two decades of the twentieth century, there is a great change in the representation of social types. The sporadic presence of the figure of the Indian in *costumbrismo* gives way to a concentrated attention upon it. This process is shown in a powerful way in the early work produced by Camilo Egas between 1916 and 1923. There he represents the Andean Indian by keeping elements of the costumbrista illustration but reworking them through the introduction of larger scale oil painting and by deploying a dramatic and decorative style. He thus constructs much more formally and conceptually complex images. That is, he breaks with the tradition both in scale and in rhetoric. On the other hand, he also does so by distancing himself from the visual production of the most facile commercial kind of work practised at the time: portraits, landscapes, and even copies of European works of art. It is precisely his originality that the critics of the period discerned as one of the virtues of his work (Lista 1917: 1; Anónimo 1917: 1). Egas's work is indeed based on two traditions, one local

and the other European, both of which are reformulated in order to make them appropriate to the new aesthetic and ideological needs of the period. His painting seems to respond, on the one hand, to what is thought of as 'high art' as in European tradition, and on the other to the need to construct a symbol of the nation.

Let us first consider how Egas reworks and recomposes the costumbrista tradition. The first change is technical: watercolour on paper is now oil on canvas and the format of album plate has changed to large-scale rectangular painting. The second is formal: there is a move towards more complex figurative compositions, which are no longer isolated characters, or at most groups of figures with no connection between them, but true narrative ensembles. In costumbrista painting the figures are generally placed in the foreground on a sort of embankment which represents in a very stereotyped way the natural context in which the figure moves. In Egas's painting this environment is now a well-defined platform (a road, a plain) on which the figures move in a horizontal direction, reinforcing the rectangular format of the painting. Poses and gestures, formerly rigid and schematic, and clearly functioning to depict the social, ethnic or religious position of the character, are now naturalistic and even theatrical. This dramatic gestural repertoire perfectly harmonizes with the stage-like background, no longer neutral, which provides the figures with a specific spatial context: the mountains near Quito.

Figure 5.6 Camilo Egas, *Caravana*, oil on canvas, 99,2 x 368 cm, Museo del Banco Central, Quito.

Many of the figures and much of the subject matter in the series Egas produced for Jacinto Jijón y Caamaño between 1922 and 1923, appear for the first time in nineteenth-century travellers' books and costumbrista painting. In *Caravan*, the yumbos are represented with their travel gear, in poses and with gestures that indicate movement, just as we see in Stevenson, Osculati (Tav. VI) and Charton (39-30-84). *Going to the Market* represents a series of porters and sellers: in the centre is the water carrier, whose forerunners appear in Stevenson, Osculati and Charton (38-30-84) and later in Pinto in his famous *Orejas de palo* (1904). Other characters in this type of painting have a tangential relation with a whole repertoire of sellers in costumbrista images such as those of Osculati (*Brush seller*

in Quito [Plate 7] *Mat Seller*[9] and *Cloth Merchant* [9] and Charton (*Herb Seller* [11], *Cloth Seller, Outskirts of Quito* [18], *Vegetable Merchant* [36]). Another work by Egas that alludes to costumbrista painting is *Procession*, which may represent Corpus Christi. Likewise Osculati and Charton include numerous religious scenes, which like those of merchants and sellers, do not always represent indigenous types.

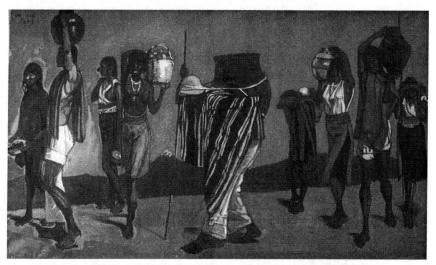

Figure 5.7 Camilo Egas, *Camino al Mercado*, oil on canvas, 98 x 167 cm, Museo del Banco Central, Quito.

Egas takes costumbrista painting and gives it a monumental and dramatic quality on the basis of a reworking of another tradition, that of nineteenth-century grand European painting: principally Romantic Orientalism, Realism, Gauguin's Primitivism, and Spanish *modernismo*. In Egas's painting all these elements are taken up to produce a new discourse, different from any previous one. Access to these sources possibly stems from two related factors: the institutionalization of artistic production in Ecuador through the foundation of the School of Fine Arts in Quito in 1904, and the Europeanized taste of Ecuadorean elites. Egas is undoubtedly a product of the artistic education and ideology that was instilled in the School of Fine Arts. If we look at how Egas represents the human body in the pictures of the period, we can see not only how far he has moved from the typical stereotyping that was characteristic of costumbrismo but also that his observation of naturalistic detail is perfectly framed within the academic canons of representation. It is evident that Egas is no longer the self-taught nineteenth-century painter, and he owes his accurate knowledge of naturalism to the academy. It is precisely his formal artistic education at the School of Fine Arts that allows him to gain access to a broader visual repertoire and to assert that an art pro-

duced in a country far away from the metropolis can nonetheless belong to European high art.[12]

At the turn of the century, the elite families of the highland cities shared this vision. To the extent that they could, the aristocracy and bourgeoisie of Quito collected European art or acquired reproductions of works by the great European masters. Ecuadorean artists for whom copying had been part of their training at home and in Europe often produced these. The programme of scholarships to study in Europe, which was established in 1911, implicitly required that the student produce and send back replicas to Ecuador.[13] Thus copying was more than a didactic method: it provided the public with access to European art. The national exhibitions promoted by the School of Fine Arts demonstrate that this tradition was in force at least until 1915 (Andrade 1915: 265–67). The School of Fine Arts was also defined by the composition of its faculty, which during its early period was predominantly made up of Europeans who not only introduced academic methods but also disseminated a knowledge about the art of the Old Continent.

Figure 5.8 Anonymous photographer, *View of the National School of Fine Arts*, Quito, ca. 1908.

The canons of 'good art' established by the School of Fine Arts are taken over by Egas in his representation of the Indian, which in the 'grand art' of large-scale oil painting, acquire value and legitimacy in artistic and social circles. It can be argued that Egas is proposing something similar to what the French Realists did in their time. For Linda Nochlin 'a new demand for democracy in art, which accompanied that for political and social democracy, opened a whole new space for themes and subject matter that up until then had failed to be noticed or had been considered unworthy of pictorial or literary representation' (Nochlin 1977: 33). As in French Realism, in representing the Indians in large scale oil paintings, Egas situated them as a legitimate subject matter for 'high art'.[14]

A second point of reflection concerns the treatment given to the subject matter. In *Gregorio and Carmela* (1916) Egas appeals to the 'high art' tradition, in the placement of the three Indian figures in the foreground of the painting so that they occupy the greater part of its vertical space. He also appeals to Giorgione's pastoral *Symphony* for representation of a nude woman and a clothed man. Carmela, who is an Indian woman, undoubtedly refers to Venus as the prototype of ideal beauty. Her position and ornaments, the headdress and necklaces that fall over her naked torso, recall the odalisques of nineteenth-century Romantic Orientalism, while the positions of the figures on the left recall those in Gauguin's Tahitian paintings, *Nafea Faa Ipoipo?* and *Parau Api* (1892) for instance, and also the woman in the foreground of Manet's *Déjeuner sur l'herbe* (1863). In any event, Egas's design is closer to Giorgione's sensual and pastoral air and to the formal simplicity, decorativism and monumentality of Gauguin than to Manet. The male figure, on the other hand, finds its prototype in Toulouse Lautrec's *Ambassadeur Aristide Bruant dans son Cabaret*: he wears his poncho round his neck like the latter wears his cape and scarf. Egas's Indian in *Gregorio and Carmela* thus comes to embody the canons, gestures, and attire that distinguish

Figure 5.9 Camilo Egas, *Gregorio y Carmela*, oil on canvas, 74,8 x 185 cm, Museo del Banco Central, Quito.

'good' painting in Europe, according him a legitimate place within that tradition.

Another dominant reference in Egas's work from this period is Spanish *modernismo*, a movement related to Art Nouveau and also highly valued by the School of Fine Arts, one of whose chief exponents was Santiago Rusiñol. This movement interested Egas in two respects: its modernity and concern for the construction of the nation. *The Sanjuanito* (1917) represents an Indian dance, which was widespread both in the countryside and in the city. The use of the triptych is a legacy of Art Nouveau, as is the rectangularity of the series of pictures for Jijón y Caamaño. As in many Art Nouveau works, this series was produced to fit into an already defined architectural space. In addition, the concentration of visual activity in the foreground, the theatricality of the figures' movements, the dramatic quality of the landscape which is presented as a stage-like backdrop, the often artificial and strident colouring, all produce clear allusions to Spanish *modernista* painters, especially Ignacio Zuluaga (Pérez 1987: 53–4; 1995: 153). Egas's figures, like those of Zuluaga, are elongated and highly stylized and their facial expressions are often artificial and theatrical. Egas's interest in Spanish *modernismo* is well documented: before visiting Madrid in 1920, he had already expressed a desire to see the work of these artists first hand.[15] His good friend the writer Raúl Andrade mentions that during his stay in that city, Egas visited the painter Hermenegildo Anglada Camarasa's studio (Andrade 1956: n/n). But Egas's relation to Spanish *modernista* painting goes beyond the formal, revealing a relation in terms of content: much of

Figure 5.10 Camilo Egas, *El Sanjuanito*, oil on canvas, 159 x 260 cm, Private Collection, Quito.

Spanish *modernismo* engages local subject matter and is connected to the late nineteenth-century nationalist movement within Spain.

Egas's positioning necessarily implies an ambiguity. It is as if he disguised the painting as European in order to represent the non-European, and had done so by employing those conventions used within European art to represent the Other. This act of appropriation and resemanticization of European conventions is indicative of the new place that the Indian was required to occupy in Ecuador in the second decade of the twentieth century: that of symbol of the nation. The Indian has entered the space of the Quito aristocracy's salons, as did Fortuny's Arab or Ingres's or Gérome's Odalisques, yet the relationships are different.[18] Unlike the Arab who for the European is a distant and remote being, the Indian is the Other who nevertheless belongs to the unitary space of the nation. The figure of the Indian becomes iconic, as do ideas of progress and modernity, whence the introduction of *modernista* visual language into Egas's painting.

During the same period, nationalist thought that took upon itself the task of constructing an image of the Indian developed in different fields: in ethnographic, archaeological and historical research, and in political thought and sociology. Two of Egas's principal patrons in this period, Jacinto Jijón y Caamaño (1890–1950) and Carlos Tobar y Borgoño (1883–1920), not only belonged to the dominant socio-economic groups in the country but through their professional activity they also contributed to the construction of the modern idea of the nation. At the turn of the century there was an intense interest in ethnography, archaeology and national history. Federico González Suárez founded the Society for American Studies and through its publications established a new type of historiography based on documentary research and archaeology.[19] Upon his death in 1917, Jijón y Caamaño, who had been educated under him, took over as head of the society, established even more rigorous standards of research and forging relations with the most important Americanists of the time. Until around 1940 it was mainly his thinking that defined what was considered Pre-Columbian Ecuador. His versatility also found expression in his efforts at refounding the Conservative Party and rewriting its statutes during the 1920s.[20] In 1917 he acquired Egas's *The Incense Carriers* and in 1922 he commissioned fourteen large canvases for the frieze of the Americanist Library, the building which also contained his archaeological collection. This series follows the general thematic and stylistic structure of Egas's work of the previous decade: the Indian as subject matter, his environment, customs, and myths, the horizontal composition, foregrounds, and busy backgrounds. Even though no documentation on the commission has come to light, Jijón y Caamaño would undoubtedly have intervened at least in the scenes with Pre-Colombian subject matter.[21] The remote, mythical Pre-Columbian past

that archaeology was gradually uncovering also fulfilled a symbolic function with regard to the construction of the idea of the nation. This is how it was understood by, amongst others, José Gabriel Navarro, art historian and then director of the School of Fine Arts, who believed that contemporary Ecuadorean art ought to come out of the 'foundations of the nation' and should be a reflection on its time and context (Traversari, Navarro, Durán 1915: 26 and Navarro 1914: 48).[22]

The idea of the nation was also developed within political thought. According to Andrés Guerrero, the Liberal Revolution of 1895 inaugurated the construction of a new political image of the Indian, promoted by Liberalism as the battle flag against the church and conservatives. This continued right up to the 1990 Indian Uprising, when Indian communities became the agents of their own destiny, forcing the rest of society to take up a different position in relation to them (Guerrero 1994: 199–200). Its origins can be traced back to the middle of the nineteenth century when a change in the administration of ethnic groups by the state takes place. Whereas between 1830 and 1857 the State had administered the Indian population directly, 'subsequently and until the middle of the twentieth century, ethnic administration became a private phenomenon [...] the condition of tributaries was eliminated [...] and the status of citizen extended in principle to all Ecuadoreans'. 'With citizenship extended – potentially – towards the population previously recognised as Indian "tributaries", there emerged a strange and contradictory phenomenon. The Ecuadorean state hid the existence of an ethnic majority of non-Spanish speakers. However, rather than simply ignoring this majority, what it did was remove from its codes and organising principles the presence of populations marked by ethnic difference [...] They remained enclosed in a silent category, never legislated upon, hidden beneath the body of the citizenry [defined as] adult, male, literate and wealthy white-*mestizos* – the unthought was practically unthinkable, namely, that the Indians, people whom they were accustomed to treat as their inferiors at home, on the land, in the streets and markets, could possibly be free and equal Ecuadorean citizens' (Guerrero 1997: 214). The political discourse on the Indian that therefore emerges at the end of the nineteenth century in Ecuador is a result of the discovery of the Indian 'concealed beneath the shadow of citizenship' (Guerrero 1997: 201).[23]

Guerrero suggests that this paradox might be understood through Sartre's idea that the formation of an image presupposes an omission (Guerrero 1994: 202). In the case of the Indian population this omission 'was undoubtedly the condition of possibility (in a transformation of the discourse-image concerning the Indian) for one of the political forces in conflict (Liberalism) to sculpt a figuration of the Indian to the measure of its interests' (Guerrero 1994: 202). In order to defend their own liberal

political ideas Pedro Fermín Cevallos and Abelardo Moncayo, between 1875 and 1915, denounced the social inequalities and harsh working conditions suffered by indigenous Ecuadoreans (Guerrero 1994: 215–16).[24]

The struggle against economic inequality and exploitation of the Indian begun by the liberals at the end of the nineteenth century continued into the first decades of the twentieth. It was precisely another of Egas's patrons, Carlos Tobar y Borgoño, who acquired *The Flower Sellers* (1916) and *The Sanjuanito* (1917) at that time,[25] who contributed to this debate in two fundamental essays, 'Legal Protection of the Worker in Ecuador' (1913) and 'Prejudices and Mistakes with Regard to the Indian' (1916).[26] Tobar y Borgoño was also an important public figure, Rector of the Central University and Minister of Foreign Affairs. He wrote on international law, education and also on folktales and myths. In the two essays mentioned, he reveals his interest in the social problems of his time and tries to offer solutions for them that were appropriate in the local context. Change should begin with the landowners that should alter work habits and encourage the education of the Indian (1916: 289). Belisario Quevedo and Agustín Cueva Tamariz also stress that social inequalities are the result of a poor economic structure (Quevedo 1913: 61; 1916: 283–87; 1921: 89).[27] In addition, Cueva encourages the elimination of *concertaje* and links the socio-economic problem of the Indians of the Ecuadorean *sierra* to what he conceives of as the fundamental dilemma facing the country: the construction of the nation within a progressive framework. The solution to the situation of the Indians would be resolved, he suggests, through the implementation of an educational programme designed to assimilate them into the 'superior national culture' (Cueva 1915: 58). One can then understand Cueva's notions of cultural 'whitening' as analogous to the stylization of the Indian in Egas's paintings.

An exemplary instance of the first *indigenista* intellectuals is Pío Jaramillo Alvarado, who shares the notion of assimilation of the Indian held by Cueva and the majority of his contemporaries, but expands it to define a concept of the nation based on the image of the Indian. In 1922 he publishes *The Ecuadorean Indian*, one of the most influential books of the subsequent thirty years in terms of its impact on political, social, ethnographic and artistic ideas, in which the Indian is defined as the core of Ecuadorean nationality. In order to do this, he refers to a myth that was being questioned at precisely that very moment: the Shyris as the tribe who founded Quito. When, in 1918, historians and archaeologists began to doubt the existence of this tribe for lack of archaeological and historical evidence (Jijón y Caamaño 1918: 33–63), Jaramillo Alvarado produced an unsustainable defence of the claim, arguing that the 'history' of the Shyris could not be erased from the memory of Ecuadoreans since it had become the very symbol of nationality (Jaramillo 1925: 55–72).[28] He believes that

it is necessary to study and defend the Pre-Columbian past '… as legend or fable, but in any case as the genesis of Ecuadorean nationality and its basic element: the Indian' (224). As Sartre says, the construction of an image does not have to be equivalent to social or economic reality. Thus, in young states in search of symbols, it is a representation that asserts the sense of the nation, which would identify and distinguish it. In Ecuador this symbol is to be found in the figure of the Indian.

The construction of the Indian as the symbolic image of the Ecuadorean nation, which climaxes during the second and third decades of the twentieth century, thus has its origin in a tradition of the representation of the Other initially produced by Europeans and then appropriated by Ecuadoreans. In the process, the image of differentiation, which the representation of the Other entails, is extolled so as to be assimilated into the hegemonic and unifying concept of the nation. This happens because the Indian is an integral part of it. The process thus set in motion is altogether paradoxical precisely because it implies an intention to assimilate what is different to a concept that necessarily tends to erase differences. The paradox is resolved in the symbolic sphere of the arts through a representation of the Indian through a language that reworks codes of representation deriving from Europe.

Translated by Philip Derbyshire

Notes

1. I would like to thank Cory Blatz, Fulbright Fellow, and Jorje Zalles, Professor at the Universidad San Francisco de Quito, who have generously offered their collaboration in this article, Cory as research asssitand and Jorge as a critical reader. The Universidad San Francisco provided financial support.

 See the two publications that have marked our knowledge of Ecuadorean art history during the last thirty years: *Historia del Arte Ecuatoriano* (Crespo 1977) and Mario Monteforte (1985). Based on more exhaustive research, Hernán Rodríguez Castelo (1988) sees him as an *indigenista* producing as early as 1910.

2. According to Concha Meléndez (1961), *indianismo* is a representation of the Indian divorced from his economic and social reality. Cornejo Polar (1980: 36) understands it as part of the aesthetic and ideological system of romanticism. Thus, *indianismo* is romantic *indigenismo*. Aída Cometta Manzoni (1939: 243), meanwhile, differenciates between literary and revolutionary *indigenismo*. Both Meléndez's and Cometta Manzoni's distinctions conceal the differences and coincidences between the two periods.

3. Kim Clark studies the development of *Indigenismo* in Ecuadorean sciences and social sciences (Clark 1999).

4. Angel Rama also understands *indigenismo* as a historical process ('El área cultural andina: Hispanismo, mesticismo, indigenismo', *Cuadernos americanos* 6

(noviembre–diciembre 1974): 136–73). Mirko Lauer (1997), meanwhile, distinguishes between the artistic body of social-realist indigenismo – 'Indigenismo II' – and its political manifestation – 'Indigenismo'. The *indigenista* Moisés Sáenz (1933) makes the following distinctions, according to attitude: *Indianistas* are those who study the Indians from a scientific perspective; *indianófilos* represent the Indian in their artistic production; *indigenistas* take a political stand and act as their liberators.

5. Cornejo Polar (1978: 7–8) developed this theory. See also Cornejo Polar 1994. *Escribir en el aire: ensayo sobre la heterogeneidad socio-cultural en las literaturas andinas*. Lima: Editorial Horizonte, 1994.

6. For an analysis of how local power was established in colonial times, see Carlos Espinosa Fernández de Córdova 1989 (26–39).

7. Vicente Albán's six 1783 oil paintings are an extraordinary precursor to such representations outside the book format. As Sánchez Gallque's work, they are currently held at Madrid's Museo de América.

8. Navarro and Vargas attribute the production of various costumbrista albums of water colours to Ramón Salas (Navarro 1991: 178–79). According to Castro 'the attribution of these works is based on previous inventories in which José Gabriel possibly took part' (Castro 1990: 10). Both the Museum of the Ecuadorean Central Bank and the Museo de Arte Moderno de la Casa de la Cultura hold costumbrista work attributed to Ramón Salas.

9. This album belongs to the museums of the Ecuadorean Central Bank. The book itself was destroyed for museographic ends: to show the paintings as pictures.

10. Hallo (1981) reproduces Guerrero's album.

11. According to Hassaurek, Ramón Salas's main patrons were foreigners (Hassaurek 1993: 225). Some costumbrista albums were exported to Europe; according to Navarro 'on the shop of an old book-seller I saw a very interesting collection of costumbrist water-colours by Ramón Salas. They had been brought there by some intelligent diplomat, merchant or tourist' (Navarro 1991: 178). Guerrero's album was made to remind the Ecuadorean exiles of the land they had left behind.

12. The School of Fine Arts introduced and provided the curricular frame that made it possible to understand the artistic canons under the concept of previous academic traditions: classicism, in the first place, though from the beginning of the twentieth century notions and conventions of Baroque and even Romantic art also came to be included. One of the first steps that the newly inaugurated School takes is to order an enormous number of plaster replicas of the most famous European sculptures. The purpose of this was to allow Ecuadorean artists to see 'great art', if not at first hand, at least through copies. The representation of the human body in Egas's painting is born of this conception of art, which was disseminated in the School of Fine Arts. See AEBA: *Libro copiador de oficios* (1905–1913) oficios # 36 (c.1905): 28; # 9 (6/1906): 10; # 77 (26/6/1907): 54. In 1908 forty-nine pieces arrived, although '… mostly in ruins.' Among them came the Lacoonte. (Oficio # 109 (9/3/1908): 73–74).

13. AEBA: *Libro copiador de oficios* (1905–1913) oficio # 9 (6/1906): 12.

14. Linda Nochlin argues that such a process takes place in French Realism with the introduction of the worker as subject of large scale oil paintings (Nochlin 1977: 34).

Latin American art has generally been seen as an imitative derivation from that produced in Western cultural centres. I would suggest that the relationship of Latin American to European art is the result of the former's colonial history, from which a complex cultural production derives that consists of processes of appropriation, imitation and transformation of the dominant discourse. Egas's painting is in dialogue with the European canon without ceasing to belong to a particular local space.

15. AMRE: *Libro de oficios de la Legación del Ecuador en Francia al Ministerio de Relaciones Exteriores,* # 58, T. 120 (14/8/1919): 86–88.

18. The Ecuadorean turn of the century highland elites had a highly European taste. They preferred European crystal chandeliers, porcelain, and carpets. The curtains contributed to the elegance and refinement of their homes, built or remodelled during the first quarter of the century. The final touch was given by paintings, which were European if at all possible or reproductions, if not: marines, Alpine landscapes, views with shepherds and peasants.

19. Among his most important works, *Historia General de la República del Ecuador* (1890–1903) and *Atlas Arqueológico* (1892).

20. See Ricardo Muñoz Chávez (c. 1980).

21. In other papers I have examined in more detail the series' iconography and the nature of the commission (see Pérez 1987 and 1995: 143–60).

22. For a larger analysis see Perez 1995 (148–51).

23. Direct quotations from the English translation of Guerrero's article, 'The construction of a ventriloquist's image: liberal discourse and the "miserable Indian race" in the late 19th Century Ecuador', *Journal of Latin American Studies*, Oct. 1997, 29, 3.

24. Guerrero cites Cevallos's *Resumen de la historia general del Ecuador desde su origen hasta 1845; Geografía política,* s.p.i., 1887 and Moncayo's *El concertaje de indios* (in Marchán R., Carlos (compiler), *Pensamiento agrario ecuatoriano.* Quito: Banco Central del Ecuador y Corporación Editora Nacional, 1986.

25. The first is held today at the Museo Nacional del Banco Central del Ecuador and the second at the Colección Diners, both in Quito.

26. In the first essay he points to the deficiency of Ecuadorean laws with regards to the protection of the workers, who in Ecuador are mainly peasants or Indians. His discussion is framed within the contemporary debate on *concertaje*. This system, which was only eliminated in 1918, consisted of a series of situations (inadequate wages, loans, debt and the resulting legal claims) which tied the peasant to the landowner for life. Tobar y Borgoño centres his discussion on legal problems in the first essay and on cultural attitudes in the second, and thus argues that the inadequacy of the laws not only affects the worker but also the employer himself: 'We must try to move forward not just out of motives of humanity and justice, but also out of self-interest and for our own advantage' to avoid the workers claiming their rights by force'. Referring to the ruling classes he adds: 'precisely this lack of resistance on the part of our people allows us (and here I refer to the ruling classes) to grant them the enjoyment of their rights, an enjoyment of rights which elsewhere in this day and age, in this very hour, is seized by force, through the victory of the workers' (Tobar y Borgoño 1913: 137).

27. In the second article, by contrast, Tobar links the resistance of the elites to legislative reform concerning the Indians and workers to racial and cultural preju-

dices, but which are in reality based on economic interests 'The current economic and social situation [...] of the Indians of a good part of the *sierra* rests on a series of prejudices, fears and suspicions which, to tell the truth, are baseless' but are in fact the fear of the landowner that the worker will seize his goods once his rights begin to be granted (1916: 289). On the other hand, he argues that *concertaje* is kept in force not only by legal documentation which the worker accepts (or signs) but by the loyalty that debt presupposes. That is to say, 'morally he feels more committed by the advances he receives from his employer, and the employers know this and this is why they try to get their *peones* into debt' (Tobar y Borgoño 1916: 289)

Other views exist: Espinosa Tamayo moved from race-based to positivist views. He prompted the identification of those essencial characters of the American people in order to replace them with European ones (Arturo Andrés Roig (introductory essay to Alfredo Espinosa Tamayo's *Psicología y sociología del pueblo ecuatoriano*, Quito: Banco Central del Ecuador, Biblioteca Básica del Pensamiento Ecuatoriano, No.2, 1979: 42). I have examined this point in more detail in Pérez 1991.

28. This debate is described in greater detail in Pérez 1991: 5–6.

Bibliography

Archives

Archivo de la Escuela de Bellas Artes, Quito (AEBA).
Archivo del Ministerio de Relaciones Exteriores, Quito (AMRE).
Biblioteca Archivo Aurelio A. Espinosa Pólit, Quito (AEP).
Archivo Personal de Camilo Egas, Quito (In custody of Trinidad Pérez) (ACE).
Fondo Jacinto Jijón y Caamaño, Banco Central del Ecuador, Quito.

Secondary sources

Anónimo. 1917. 'Concurso de pintura: Informe del jurado', *El Comercio* (Quito), 26 de junio: 1.

Amodio, Emanuele. 1993. *Formas de alteridad: construcción y difusión de la imagen del indio americano en Europa durante el primer siglo de la conquista de América.* Quito: Abya-Yala.

Andrade, Javier. 1915. 'La Tercera Exposición Nacional de Bellas Artes de Quito', *Letras* Año IV, III (33) (octubre): 265–67.

Andrade, Raúl. 1956. 'La evolución pictórica de Camilo Egas', *El Comercio* (Quito [Suplemento Dominical]): 26 de agosto.

Benzoni, Girolamo. 1572. *La historia del Mondo Nuovo.* Venecia: Appresso gli Heredi di Giovan Maria Bonelli.

Castelo, Hernán Rodríguez. 1988. *El siglo XX de las artes visuales en Ecuador.* Guayaquil: Banco Central de Guayaquil.

Castro y Velásquez, Juan. 1990. *Pintura costumbrista ecuatoriana del siglo XIX (de la colección Castro y Velásquez).* Quito: Centro Interamericano de Artesanías y Artes Populares.

Catlin, Stanton L. 1989. 'Traveller-Reporter Artists and the Empirical Tradition in post-Independence Latin American Art.', in: *Art in Latin America,* Dawn Ades. New Haven and London: Yale University Press.

Clark, Kim. 1999. 'La medida de la diferencia: las imágenes indigenistas de los indios serranos en el Ecuador (1920–1940)', in: *Ecuador racista: imágenes e identidades,* edited by Emma Cervone & Fredy Rivera. Quito: FLACSO.

Cometta Manzoni, Aída. 1939. *El indio en la poesía de América española.* Buenos Aires: J. Torres.

Cornejo Polar, Antonio. 1980. *Literatura y sociedad en el Perú: la novela indigenista.* Lima: Lasontay.

———. 1982. 'El indigenismo y las literaturas heterogéneas: su doble estatuto socio-cultural', in *Sobre literatura y crítica latinoamericanas.* Caracas: Ediciones de la Facultad de Humanidades y Educación, Universidad Central de Venezuela.

———. 1994. *Escribir en el aire: ensayo sobre la heterogeneidad socio-cultural en las literaturas andinas.* Lima: Editorial Horizonte.

Crespo Toral, Hernán. 1977. *Historica del aube ecuatoriano.* Quito: Salvat Editores Ecuatoriana.

Cueva Tamariz, Agustín. 1915. 'Nuestra organización social y la servidumbre', *Revista de la Sociedad Jurídica Literaria* 14 (25/26/27) (enero, febrero, marzo): 29–58.

———. 1917. 'El problema de las razas y los factores étnicos de nuestra civilización', *Revista de la Sociedad Jurídica Literaria* 18: 77–98.

De Bry, Johann-Theodor. 1617. *America. Buchhandlern und Burgern zu Oppenheim. Gertrudt zu Frankfurt am Mayn* / Durch Nicolaum Hoffman, Anno M. DC. XVII.

Dondis, D. A. 1985. *La sintaxis de la imagen: introducción al alfabeto visual.* Barcelona: Gustavo Gili.

Espinosa Fernández de Córdova, Carlos. 1989. 'La mascarada del Inca: una investigación acerca del teatro político de la Colonia', *Miscelanea Histórica Ecuatoriana,* Quito: Banco Central del Ecuador 2: 26–39.

Espinosa Tamayo, Alfredo. 1979. *Psicología y sociología del pueblo ecuatoriano.* Vol. 2 of Biblioteca Básica del Pensamiento Ecuatoriano, with an introductory study by Arturo Andrés Roig. Quito: Banco Central del Ecuador y Corporación Editora Nacional.

Fitzell, Jill. 1994. 'Teorizando la diferencia en los andes del Ecuador: viajeros europeos, la ciencia del exotismo y las imágenes de los indios', in *Imágenes e imagineros representacciones de los indígenas ecuatorianos siglos XIX y XX,* ed. Blaura Muratovío. Quito: FLACSO.

Guerrero, Andrés. 1994. 'Una imagen ventrilocua: el discurso liberal de la 'desgraciada raza indígena' a fines del siglo XIX', in *Imágenes e imagineros: representaciones de los indígenas ecuatorianos, siglos XIX y XX,* ed. Blanca Muratorio. Quito: FLACSO.

Hallo, Wilson. 1981. *Imágenes del Ecuador del siglo XIX: Juan Agustín Guerrero.* Quito & Madrid: Ediciones del Sol y Espasa-Calpe S.A.

Hassaurek, Friedrich. 1993. *Cuatro años entre los ecuatorianos* (1867). Quito: Abya-Yala.

Humboldt, Alexander von. 1815–34. *Voyage de Humboldt et Bonpland.* Paris: F. Schoell.

Jaramillo Alvarado, Pío. 1922. *El indio ecuatoriano.* Quito: Editorial Quito.

———. 1925. *El indio ecuatoriano: contribución al estudio de la sociología indoamericana,* 2nd ed. Quito: Imprenta y encuadernación nacionales.

Jijón y Caamaño, Jacinto. 1918. 'Examen crítico de la veracidad de la Historia del Reino de Quito del P. de Velasco de la Compañía de Jesús', *Boletín de la Sociedad Ecuatoriana de Estudios Históricos Americanos* 1 (1), (junio–julio): 33–63.

Juan, Jorge & Antonio de Ulloa. 1748. *Relación Histórica del viaje a la América Meridional*. 4 vols. Madrid: Antonio Marín.

Lauer, Mirko. 1997. *Andes imaginarios: Discursos del indigenismo 2*. Lima: CBC-CES.

Lienhard, Martin. 1992. *La voz y su huella: escritura y conflicto étnico-cultural en América Latina 1492–1988*. Lima: Editorial Horizonte.

Lista, Pancho. 1917. 'El Concurso de pintura', Quito: *El Comercio* (Quito*)*, 9 de junio: 1.

Mariátegui, José Carlos. 1963. *Siete ensayos de interpretación de la realidad peruana*, Lima: Amauta.

Mario Monteforte. 1985. *Los signos del hombre: plástica y sociedad en el Ecuador*. Cuenca: Pontificia Universidad Católica.

Meléndez, Concha. 1961. *La novela indianista en Hispanoamérica (1832–1889)*. Río Piedras: Ediciones de la Universidad de Puerto Rico.

Muñoz Chávez, Ricardo. c. 1980. *Jacinto Jijón y Caamaño: Política Conservadora* (Vol. 7 of Biblioteca Básica del Pensamiento Ecuatoriano). Quito: Banco Central del Ecuador y Corporación Editora Nacional.

Muratorio, Blanca. 1994. 'Nación, identidad y etnicidad: imágenes de los indios ecuatorianos y sus imagineros a fines del siglo XIX', in: *Imágenes e imagineros: representaciones de los indígenas ecuatorianos, siglos XIX y XX*, ed. Blanca Muratorio. Quito: FLACSO

Navarro, José Gabriel. 1959. 'La acuarela y la miniatura', Quito: *El Comercio*: 7.

———. 1991. *La pintura en el Ecuador del XVI al XIX*. Quito: Dinediciones.

Nochlin, Linda. 1977. *Realism*. New York: Penguin Books.

Osculati, Gaetano. 1854. *Esplorazione delle Regioni Equatoriali lungo il Napo ed il Fiume delle Amazzoni: Frammento di un viaggio Fatto Nelle due Americhe negli anni 1846–47–48*. Milano: Presso y Fratelli Centenari e Comp.

Pérez, Trinidad. 1987. *The Indian in the 1920's Paintings of the Ecuadorean Painter Camilo Egas*. Master's Thesis. University of Texas: Austin.

———. 1991. 'The Indian as Symbol of Nationalism: The Painting of Camilo Egas', in: *Drawing on the Past: Pre-Columbian and Native American Imagery, sources and Issues in the Modern Arts*. Paper delivered at the 47th International Congress of Americanists, New Orleans, LA., Julio 7–11.

———. 1995. 'La apropiación de lo indígena popular en el arte ecuatoriano del primer cuarto de siglo: Camilo Egas (1915–1923)', in *I Simposio de Historia del Arte Ecuatoriano: artes 'académicas' y populares del Ecuador*, edited by Alexandra Kennedy Troya. Cuenca: Fundación Paul Rivet y Abya Yala.

Puga, Miguel A. 1994. *La gente ilustre de Quito*. Vol. I, Colección Ecuador Mestizo. Quito: C. Sociedad Amigos de la Genealogía.

———. 1995. *La gente ilustre de Quito*. Vol. II, Colección Ecuador Mestizo. Quito: C. Sociedad Amigos de la Genealogía.

Quevedo, Belisario. 1913. 'Importancia sociológica del concertaje', *Revista de la Sociedad Jurídico Literaria* 11 (7) (Julio): 57–61.

———. 1916. 'El concertaje y las leyes naturales de la sociedad', *Revista de la Sociedad Jurídico-Literaria* 16 (36) (mayo): 283–87.

———. 1921. 'Cuatro palabras', in *Almanaque Ecuador Ilustrado*. Quito: Imprenta y librería Sánchez.

Rama, Angel. 1974. 'El área cultural andina: Hispanismo, mesticismo, indigenismo', *Cuadernos americanos* 6 (noviembre–diciembre).

Rout, Leslie B. Jr. 1976. *The African Experience in Spanish America: 1502 to the Present Day*. Cambridge: Cambridge University Press.

Sáenz, Moisés. 1933. *Sobre el indio peruano y su incorporación a la realidad nacional*. Mexico: Secretaria de Educación Pública.

Said, Edward W. 1979. *Orientalism*. New York: Vintage Books.

Sartre, Jean-Paul. 1986. *L'imaginaire*. Paris: Gallimard.

Stevenson, W. B. 1826. *Relation historique et descriptive d'un séjour de vingt ans dans L'Amérique du sud... suivie d'un précis des révolutions des Colonies Espagnoles de L'Amérique du Sud...* Paris: A. J. Kilian.

Tobar y Borgoño, Carlos. 1913. 'La protección legal del obrero en el Ecuador', *Revista de la Sociedad Jurídico Literaria* 10 (3 & 4): 133–65.

———. 1916. 'Prejuicios y errores con respecto al indio', *Revista de la Sociedad Jurídico Literaria*, 16 (36) (marzo y abril): 288–92.

Traversari, Pedro P., José Gabriel Navarro, Sixto M. Dorán. 1915. 'Las bellas artes en la instrucción pública de América', *Revista de la Sociedad Jurídico-Literaria* XV (31) (julio–diciembre): 22–35.

Trujillo, Jorge. 1993. *Indianistas, indianófilos, indigenistas: Entre el enigma y la fascinaccón: una antología de testos sobre el 'problema' indígena*. Quito: ILDIS, Abya-Yala.

Vargas, José María. 1984. 'El arte ecuatoriano en el siglo XIX', *Cultura, Revista del Banco Central del Ecuador* (Quito) VII (19) (mayo–agosto).

Villacís Verdesoto, Eduardo, ed. 1981. *Grabados sobre el Ecuador del siglo XIX: Le Tour du Monde*. Vol.2, Colección Imágenes. Quito: Banco Central del Ecuador.

Chapter 6

Primitivist Iconographies:

Tango and Samba, Images of the Nation

Florencia Garramuño

> 'Se o Santo Padre soubesse
> o gosto que o tango tem
> viria do Vaticano
> dançar maxixe também'
> Revista *Cá e Lá*, 1913

Tango and samba can be considered as symbolic sites of construction of a national iconography.[1] Although they have been referred to as national symbols of Brazilian and Argentine identity, the story of their transformation into such 'symbols' presents a more complex story of ardent negotiations and struggles. If a symbol, following Barthes's suggestion, is characterised by its lack of ambiguity, then tango and samba were never symbols. If, on the other hand, tango and samba did arguably become privileged symbols of national identity, this may have been due, precisely, to the fact that both cultural forms were – and to an extent still are – the battlefield upon which national identity is fought over and continuously redefined. It seems more appropriate, then, to understand tango and samba, as well as the cultural narratives both have generated, as locations of cultural negotiation and of the articulation of cultural differences. In any case, it is only by the 1930s, and after a long historical process that parallels those of modernisation and nationalisation of Brazilian and Argentine cultures (roughly, between 1870 and 1930), with all their vicissitudes, that tango and samba become two of the most persistent images of national identity.

Carmen Miranda, in a song recorded in 1937, entitled 'O tango e o samba', speaks of the differences between tango and samba as reflecting those between Argentineans and Brazilians:[2]

Hombre, yo no se por qué te quiero
Yo te tengo amor sincero
Diz a muchacha do Prata
Pero, no Brasil é diferente
Yo te quiero simplesmente
Teu amor me desacata.[3]

Is this song a samba or a tango? And how do you dance it? Do you tango or samba it? And, again, in what language should it be listened to, Spanish or Portuguese? While the song, on the one hand, opposes tango and samba and the national identities they supposedly represent, it also merges rhythms and languages to create a song that contradicts the representative character of the music. The ambivalence of this song is paradigmatic of the ambivalence that one encounters when trying to study the construction of tango and samba as *national* symbols of Argentina and Brazil.

Primitivism's Parable

One of the most common ways to understand the transformation of tango and samba into national symbols has been to read it as a process of 'cleansing'. Originally underclass popular forms, tango's and samba's 'indecencies' (read: their ethnic and class characteristics) were supposedly cleansed as they were being appropriated by the dominant classes of their respective countries. In spite of this traditional history – a linear, evolutionary one permeated by a teleological aim –, the image of tango and samba as primitive and exotic forms persists even today. While in the 1880s the primitive character of tango and samba was the reason to expel them from the national space, after the 1920s it is precisely this characteristic that will be considered one of the reasons to construct tango and samba as national symbols.

A poem published in 1913 in an issue of the Argentine magazine *P.B.T.* describes the character of tango as something foreign that can never represent the nation. It reads:

> En Francia lo han transformado
> Y lo llaman *le tango*
> Puede ser que allí resulte
> Digno de Madame Argot
> Que era capaz de bailarse
> La Marcha de Ituzaingó
> Richepin[4] ha defendido
> Hasta en la Academia el tango
> (para mí que está chiflado
> desde la punta hasta el mango)
> ¡Dejad que bailen el tango
> donde ha nacido: en el Congo![5]

The reason to consider tango as something unable to embody the nation is precisely its supposed African origin. *Cosas de Negros*, a seminal work on the history of tango by the Uruguayan writer Vicente Rossi, considers

the music to have been born among the *candombes* of African-Argentine and Uruguayan groups around the end of nineteenth century.[6]

While today the African legacy plays a very different role in the Brazilian and Argentine cultural imaginary – particularly after the process of re-evaluation of African legacies that Gilberto Freyre initiated with his *Casa Grande & Senzala* –, at the turn of the century things where very different. Just as with the Argentine intellectuals, members of the Brazilian elite were reluctant to consider African heritage a part of Brazilian history.

Considered as strictly African and savage, samba is therefore rejected at the turn of the century as a form unable to represent the nation. Brazil's Minister of the Treasury Rui Barbosa publicly complained about the playing of *cortajaca*, a sister of samba, in a national reception at the Presidential Palace: 'But, the corta-jaca, of which I first heard a long time ago, what is it, Mr. President? It is the most obnoxious, the most under-class, the most vulgar of all the savage dances, the twin sister of batuque, catereté and samba.'[7]

Exoticism, as an aesthetic category, is just as historically contingent as any other category. As Victor Segalen has put it, 'l'exotisme n'est pas seulement donné dans l'espace, mais également en fonction du temps' (Segalen 1994: 23). While the category of the primitive seems in these texts to represent 'uncivilised' and 'savage' societies, in the 1920s and following avant-garde experiments such as those of 'ethnographic surrealism',[8] it will come to represent instead the possibility of a different destiny for the Latin American countries. Antonio Candido saw this new relationship between European avant-garde and modernism in Brazil: 'In Brazil, primitive culture either merges with daily life, or it is still alive as a reminder of a recent past. The incredible transgressions of a Picasso, a Brancusi, a Max Jacob or a Tristan Tzara were, in the end, more coherent with our cultural heritage than with theirs.' (Candido 2000: 121)

While on the one hand, this new *congeniality* (to use Haroldo de Campos's term) of primitivism with Latin American cultures explains certain changes with regard to the meaning and function of the figure of the primitive, it also seems to contradict one account of modernisation in Brazilian and Argentine culture. The parable of tango and samba, first despised because of their primitivism and then accepted and converted into national icons, seems to contradict the idea of a culture that is unanimously 'civilised' and 'modern'. Yet this was precisely the image that Brazil and Argentina were trying to construct for themselves during these very same decades. If, on the one hand, modernisation entailed for these countries the introduction of new technology and new ways of living, the conservation of a past and 'primitive' popular form was, on the other hand, going to present a problem for the discourse of modernisation.

One of the solutions to address this problem was to point to tango and samba as something that had become civilised and modern. A publicity ad also published in *P.B.T.*, in 1914, depicts tango from this new perspective (figure 6.1). The advertisement consists mainly of a sketch of a dancing salon, with young people dancing the tango and an old lady seated on the side, watching them. The caption below the picture reads:

> Most popular dances performed these days in aristocratic salons, have been of popular origin, and not few of them have even been truly barbarian and savage. But tango has evolved, and as it was once exclusively danced by people from the underclasses, who didn't wash their face even for Easter, today it is danced in fancy salons by people who bath themselves with Reuter's rich soap, whose suggestive influence has passed on to tango, as well as that poetic and languid abandon that distinguishes tango, a delicious movement of 'glissage' in which Reuter's soap seems to have taken part directly. (My translation)[9]

This is an advertisement for a product typically associated with modernity: the cold soap which enters the Argentine market during the 1920s.[10] This symbol of modernity is attached to the tango, an old and primitive dance that is now being turned into a fad. Tango, the same dance which, just one year before, had been despised on the pages of the same magazine as an old and primitive thing, in this ad appears as literally *cleaned* by Reuter's soap. Although as yet no reference is made to the *national* character of tango, from 1913 to 1914, in just one year, it had moved from uncivilised and savage to the emblem of a modern and young culture.

Figure 6.1 Soap advertisement, *Revista PBT*, Buenos Aires, 1914.

What interests me in this picture is its clear division: tango, as a modern icon, is something that does not unify but divides. The picture is very clearly framed by an old woman seated on the side. She is seated facing the audience, but her face is turned to the space where tango is being danced. She is older than the dancers, and her face does not seem to share the gaiety of the young tango dancers. The frame of the picture is continued by another figure, located on the same lineal axis, another old woman with feathers on her head, and also not dancing. The dancers are young, the onlookers, old. The division insinuated in the picture is clear.

A very similar narrative exists of the evolution of samba as linked to modernisation and civilisation. H. Dias da Cruz saw it in this way: 'That classical type, with his long pants, heels and hat, has disappeared. He has been civilised. Instead of a scarf, a tie. He does not sit outside his log cabin anymore to make sambas. He descends to the boulevard, and sits at the Nice café, wearing well-tailored clothes.' (Dias Cruz 1941, quoted in Antelo 1984)[11] One particular point seems to be at play in these stories of tango and samba: it is because tango and samba have been 'civilised' that they can now be signs of the modern. But this modernisation has been worked on a primitive form, and this primitivism is still present. It is as if the modern and sophisticated symbols were recalling their primitive origin. It is, in Freudian terms, the return of the repressed.

What these stories show, on their flip side, is that modernisation, like in the soap ad, entails exclusion.[12] Indeed, the narratives of tango's and samba's evolution call attention to the cultural processes of modernisation in Argentina and Brazil, in the sense that, once tranformed into modern objects or forms, they can be read as allegories of these processes at large.[13] For modernisation would entail for Brazil or Argentina, and indeed the whole of Latin America, more than a simple incorporation of technology or European ways of living. It would imply, more properly, the construction of a new space for Brazil and Argentina in the world system. Samba and tango, and the changing meanings of the primitive that they have come to embody, will be one of the strategies for constructing this new place.

The Plots of Tango and Samba

A group of novels written during the 1920 and 1930 provide a narrative representation of the worlds of tango and samba that contains remarkable similarities with some of tango's and samba's own lyrics: the story of upward social mobility, seen through a critical prism. It is interesting to note that these novels were written by authors who have traditionally been considered writers of what one could call an 'alternative moderni-

sation'. Critical of the processes of modernisation that were taking place in Argentina and Brazil, they themselves participated at the same time in a profound modernisation of literature and narrative that could not, in both cases, be completely assimilated into the avant-garde.

Lima Barreto, one of the most recognised writers and critics of modernisation, wrote *Clara dos anjos*, a novel first published as a serial in the *Revista Souza e Cruz*, in 1923/1924. It was only published in book form in 1948 (Mérito, R. J.).[14] Manuel Gálvez, a nationalist writer recognised as one of the first literary activists fighting for and achieving, some important conquests with regard to the professionalisation of literature and writing in Argentina (Viñas 1996), devoted two novels to the world of tango: *Nacha Regules* (1919) and *Historia de arrabal* (1922). Marques Rebelo, a writer from the Modernist tradition who wrote in the *Revista de Antropofagia* – the modernist avant-garde's principal organ – and was considered the chronicler of modernity (Antelo 1984), wrote *A estrela sobe* (1937). Although deeply involved with issues of modernisation, these writers were not, at least while writing these particular texts, participating actively in the contemporary avant-garde movements.

The four novels share many similarities. First, although they are all about change and modernisation in an urban context, they are constructed within the limits of a realist paradigm intended for the representation of national customs and facts. Gálvez in particular would go so far as to say that, for him, every realist novel was a kind of historical novel (Gálvez 1962). The novels also share a very similar kind of plot, as they all tell the story of a feminine protagonist who is corrupted by an infamous man involved with the worlds of tango or samba. Despite their employing different narrative strategies, they all tell the story of the *perdida*: the feminine protagonist who is lost, corrupted by tango and samba. Last but not least, then, these novels are also city narratives: they map an urban territory that ranges from the slums or *arrabales* where these women live, to the centre of the city.

A similar kind of narrator tells all these stories: a third-person narrator who never distances himself from the narrative proper, so as, for instance, to tell the reader how much he condemns the protagonist's actions. At the same time, however, this narrator constructs the protagonist as a victim; he is compassionate with the protagonist. All protagonists have 'sinned', but the narrator does not even give them the credit for their sins which are, in the last instance, attributed not to their own agency but that of an evil man.

The geography of these novels is also very peculiar. All of them are urban novels that map the city, describing a constant displacement through the city's topography. Suburbs, margins and limits are their special places:

if the novels happen to map the centre, they do it as if without right, as if their characters, especially the feminine ones, were escaping from something. The protagonists are, in fact, escaping from their 'natural' place: the home, and more particularly the home in the suburbs. The stage for these novels is unambiguously public: they tell the story of a 'public' woman, and in doing so, they replace the private space of the home with the public space of a café, a cabaret, a bordello or a factory, or a private space that has something public about it, such as the garçonnière.

Clara dos anjos is the only novel that is somewhat different in this respect. Rather than telling the story of a public woman, it narrates the becoming-public of its protagonist. Clara does not much frequent public places, but her private home figures in the novel as a kind of public space, where people meet to celebrate parties, play cards, or chat about public facts.

All the novels make some reference to nationality: *Nacha* opens with the celebration of the Centenary in Argentina, and Clara's seduction occurs exactly when the celebration of the Centenary in Brazil is being prepared. Despite these references and historical contextualisations, the novels seem to refuse to talk about the nation; their reference to it symbolically operates, instead, by marking the discrepancy between the big space of the nation and the particularity of the city. In mapping the city the novels are not mapping a homogeneous space, nor the nation. Instead, they emphasize the many differences that divide the heterogeneous texture of the city. Lima Barreto stated this very clearly:

> Suburbs are the shelters of the unhappy. Those who have lost their jobs, their fortunes; those who have failed in their business, all of those who have lost their normal situation take refuge in the suburbs. Every day they descend from there to look for a loyal friend who could protect and give them something to feed themselves and their children. (Lima Barreto 1948: 70)[15]

The novels, then, present an interesting paradox. They attempt to register, in an almost documentary way, the customs and situations typical of a particular era, and particularly of the city. But in taking the worlds of tango and samba as paradigmatic forms of the nation, they all break with one of the paramount conditions of nineteenth century realism: the articulation of meaning and the idea of totality; or, the containment of fragmentation. These urban novels, in trying to represent a national symbol, map instead the heterogeneity of the city and signal, through different strategies, the fragmentation of experience and narration. The novels thus undermine a realist and representative narrative that pretends to be the chronicle of a national symbol. In one way or another, all of them break, at some point or another, with certain realist requirements on which they are nonetheless constructed.

In *Clara dos anjos*, this split comes as a complete break with the chronological succession of realist temporality, imposed by the numerous characters and the importance that the narrative gives to the life story of each of them. The narrative is, in fact, constructed in a series of different chronicles whose articulation in the narrative is never very clear. If Clara's story is no more than an excuse for showing the social prejudices faced by mulattos (Buarque de Hollanda n.d.: 8), the importance conferred by the narrative to all the other characters' stories leads novelistic progression astray from Clara's plot. This strategy radically breaks with the temporal structure of the novel, giving post facto explanations for the most central facts of Clara's story, as it happens with the scene of seduction, which, however, is never directly referred to but from the perspective of Clara herself, who attempts, but ultimately fails, to completely remember what had happened.

One of the most common representations of women's seduction in realist novels is precisely this interruption of narrative. Not only in Latin American fictions, but also in European ones, the scene of seduction is something which the realist narrative does not seem to be able to tell but through the use of ellipsis. Consider *Madame Bovary* or *O primo Basílio.* However, what happens in *Clara dos anjos* is even more radical than in those classic examples of narrative ellipsis, for the scene of seduction only occurs towards the end of the text, many pages further on from where it should have been from the point of view of the chronology of events in the narrative.

A estrela sobe shows even more signs of fragmentation in the narrative. The protagonist, Leniza, is a *perdida* as well, lost in a double sense. In the first place, she becomes a 'lost woman', after having had sex with many men – and even with a woman –, in order to ascend the social scale. This social ascension is accompanied by a gradual fragmentation of the narrative that reflects Leniza's progressive isolation. At the beginning of the novel, the third person omniscient narrator follows Leniza on her wanderings through the city and fantasy. But, towards the end, and after a nearly fatal abortion, the third person narrator almost altogether disappears, the novel now adopting the structure of a very impersonal journal, whose point of view is nevertheless closely associated to the protagonist. The narrator thus abandons his function of articulating meaning, to the point of only just insinuating several situations of prime importance for the course of the narrative. Towards the end, after Leniza has been abandoned even by her own mother, the narrator confesses he has lost her:

> Here I finished Leniza's story. I didn't abandon her, rather, as a novelist, I lost her. I still
> think, many times, of that poor soul, as weak and miserable as mine. I tremble: what would

be of her, in the inevitable balance of life, if a light from heaven failed to illuminate the other side of her vanities? (Marques Rebelo 1937: 115)[16]

Nacha Regules is the only novel that has a more traditional happy ending. It remains more constrained within the realistic paradigm, since the protagonist is recovered here by the narrative. She ends up marrying a 'good' man. But the presumed realism is actually a construction, and an ambiguous one, too, of a reality whose ideological message seems very difficult to describe. Having first published the work in the socialist daily *La Van*guardia as a serial novel, Gálvez was accused at the time of having deserted the catholic cause. He justified his action by claiming that only in this way he could have reached a working-class audience. 'I had only one single objective: that working-class families would become acquainted with the perils revealed in my book, so that they would watch over their daughters' (Gálvez 1919: 123). Literature here is not merely a document; it is a form of denunciation and warning. But the ideological problems of the novel were not restrained to its format of publication in a socialist newspaper. Moreover, the rupture with realism in this novel occurs by way of the construction of characters: instead of the unified and unambiguously ideological character, *Nacha's* novelistic cast actually seems to contradict, rather than confirm, the realist mandate.[17] In fact, Gálvez had to write another novel on the 'bajo fondo', *Historia de Arrabal*, rewriting the happy ending of *Nacha* with a more apparent 'perdition' of the protagonist, in order to reconcile his religious critics.

Tango and samba figure in these novels as forms of the national, as embodiments of the modern changes that Brazilian and Argentine societies were undergoing at the time. In representing a national world that has become modern, these novels do not seem to be able anymore to close the narrative cycle through marriage and thus re-establish social cohesion. Even while referring to the national symbol, they represent the fractures, the conflicts, and the differences that constitute the nation. This is clearly the ambivalent figuration of tango and samba in all of the novels: both modern and primitive, they are on the one hand the channels that allow women to ascend on the social scale, but also the one that morally corrupts them. It is interesting to note that while tango and samba open the novels as forms that define the worlds of the *bajo fondo* or the *suburbio*, they finally come to be a kind of generalised figuration of in-betweenness, by which tango and samba relate the 'good' to the 'bad' side of the novels, but without unifying them. In *Clara dos anjos,* the musical form of *modinha* is both the one which Cassi – Clara's seducer – uses to attract her towards him, and the genre favoured by Clara's father (actually, it is him who introduces Cassi into his home and

to Clara). In *Nacha Regules*, tango is the cultural commodity that mediates between Montsalvat, el Pampa Arnedo, and Nacha. *Nacha Regules* opens with a scene in the cabaret. Tango dancing, *malevos*, and an outsider who observes the dancers, convert the tango into a space of in-betweenness:

> Noisy libertinage mixed with curiosity in the cabarets. The *Porteño* cabaret is a public dancing hall: a salon, with tables to sit down and drink, and an orchestra. Young men of the elite, their lovers, curious people and some easy girls, who come on their own, are the clients of cabaret. Tango, almost the exclusive dance here, with its typical orchestra, provides the soul in the midst of the champagne and the smokings. (Gálvez 1919: 1)[18]

For Gálvez, this ambiguity has to do with the simultaneous consideration of tango as a cosmopolitan and national icon: tango is 'a product of cosmopolitism, a hybrid and revulsive music, a grotesque dance, the very expression of our national mixture' (Gálvez 1962: 123). For Gálvez, even if tango is cosmopolitan, it is this same characteristic that turns it into an expression of national identity. This ambivalence has to do with the ambivalence of nationalism in Argentina during the first decades of the twentieth century (and the fluidity of Gálvez's ideology is but a byproduct of this attitude).

Pheng Cheah has studied the fluctuating relationship between cosmopolitism and nationalism, as a constant oscillation between different degrees of alliance and opposition (Cheah 1998: 31). In the case of Argentina and Brazil during the 1930s, this fluctuating relationship is a way of constructing, at one and the same time, a modern (cosmopolitan) and a national culture. The ambivalence of nationalism during these decades is that to become national is to be modern and, to be modern is to be like Europeans.

Painting the National Icons

Just as their narrative counterparts, visual iconographies of tango and samba also expose a complex ambivalence. I would like to consider here some paintings by artists who were traditionally associated with the Brazilian and Argentinean avant-garde: *Samba* by Emiliano Di Cavalcanti, *Bailarines* (figure 6.2) and *La canción del pueblo* (figure 6.3) by Emilio Pettorutti, and a series of designs created by the catholic poet Cecília Meireles, which were exhibited in the Pró-Arte Gallery in Rio de Janeiro in 1933.[19]

Figure 6.2 Emilio Pettorutti, *Bailarines,* oil on canvas, 1918.

Figure 6.3 Emilio Pettorutti, *La canción del pueblo,* oil on canvas,

Di Cavalcanti painted *Samba* in 1925, after his return to Brazil from Paris. Although Páulo Reis considered Di's return to Brazil as a condition for his breaking with the language of the avant-garde, *Samba* can also be seen as part of the *rappel à l'ordre* that European avant-garde was undergoing during these same years.[20] Carlos Zilio has pointed out the specificity this kind of re-alignment took on within the Brazilian context:

Curiously, if the return to order, in Europe, represented a recovery of the moderns by the market, in Brazil this same development attained a revolutionary connotation. Without the presence of an organised market, the modernist self-affirmation took place in the confrontation with cultural institutions dominated by the Academy. (Zilio 1997: 113).

For Murilo Mendes (1949), Di Cavalcanti, of all Brazilian painters, is the one who secures and conventionalises the iconography of samba and of national characters under threat of disappearing under the pressure of modernisation. Di Cavalcanti, says Murilo, is 'the one who stabilizes carioca lyricism, which will be lost under the pressures imposed by the new cycle of civilisation (or barbarism), into which we have just entered.' However, *Samba* could be read as a double return: in the first place, as a return to representation which is, as Rosalind Krauss has pointed out with regard to the work of Picasso, nonetheless an avant-garde gesture. And secondly, as a return to regional visualities (to use Tadeu Chiarelli's expression). Regional and modern, or – better – national and modern: a very Brazilian type of modernism.

Di Cavalcanti is widely recognised for painting the sensuality of the mulata.[21] In *Samba*, though, this sensuality is very soft; its sexual undertones being clearly played down. Of the three dancing women, two look directly at the spectator, while the men in the picture look at the women with a gaze devoid of any apparent desire. The man on the left is not even looking at the women and just seems to be listening to the music. As if samba were, more than a music to be sensually danced, a music to be intellectually appreciated.

Pettorutti created several paintings whose titles refer to tango: *Bailarines* and *La canción del pueblo* are among them. Whereas the national reference lingers on the titles, the paintings themselves, in the way they distance themselves from representation, erase any kind of local colour. Pettorutti's 'Bailarines', painted in 1918, is similar to other visual renderings of tango and samba in its use of the language of cubism, as *the* visual rhetoric of modernity, to represent the 'primitive' national dance. In fact, the Argentine avant-garde of the 1920s seems not to have been able to entirely abandon the representation, albeit in a modern way, of Argentine 'customs' and local reality. Note that *Bailarines* and *La canción popular* were included in *Martín Fierro*, the journal of Argentina's

'official' avant-garde, at least according to canonical literary history (Segunda época, año 1, n° 10 y 11).

Cecília Meireles chooses a different path to modernise the national icon. Her very 'feminine' designs depict black women in their traditional dresses, but rendered with a sophisticated movement that could be compared to the style of fashion designs. Her picture of the baiana costume would actually become a fashion sample, even though Carmen Miranda, who would make this costume famous, was only to use it for the first time several years later, in the 1937 film *Banana da terra*. Meireles's *Roda de samba* strips the dance of its traditional association of sexual undertones, and, in fact, of tones in general. It is a design in black and white, shaded, all of whose participants are women. At the bottom, the caption reads: 'In the carioca carnival,where the expansion of normally civilised people is as grotesque and rude as anywhere, negro carnival has a unique aspect of respect, elegance, and even artistic distinction' (Meireles 1983: 62).[22] With their different strategies and meanings, these visual representations of tango and samba as icons of nationality point towards the problematic encounter of the modern and the national in the work of art, as well as to the tension it must inexorably generate.

The Ambivalent Legacies of Modernity

The 1920s and 1930s, in conclusion, can be seen in Brazil and Argentina as a turning point, when modernisation – which, according to some critics had begun in the 1870s or 1880s- began to coincide with the nationalisation of culture. Antonio Candido (2000) and Angel Rama (1983) have pointed out the coevalness of these two processes. There is, however, a tradition of considering modernisation and nationalisation in Brazil and Argentina as contradictory rather than complementary processes: to become modern is to become 'like Europe', and to become national would therefore be the opposite of that mandate. Debates about modernisation and nationalisation are thus seen as two different but coincident polemics, which distribute their antagonistic participants according to a clear-cut pattern: on the one hand, those championing modernisation, on the other hand, the nationalist intellectuals who supposedly rejected modernisation (Wechsler 1999: 281). For Angel Rama, this conflict translates into the conflict between avant-gardism and regionalism, or between cosmopolitanism and nationalism (Rama 1983).

The iconography of tango and samba reveals that the process could be viewed from another perspective. It is possible to argue that modernisation and nationalisation, at least in Latin America, were not just two different processes coinciding in one and the same moment, but two

different faces of the same historical condition. What does it mean, for a Latin American country, to become modern? If we take the names of the two best known avant-garde movements from Brazil and Argentina, we can see the similar call to the primitive problem: *Pau Brasil* and *Antropofagia*, in Brazil, and *Martín Fierro* in Argentina, were all claiming a 'primitive', yet also 'national' symbol, so as to be able, for the first time, to create a modern iconography of nationality. If, with the exception of surrealism, this combination of primitivity and modernity would be a contradiction in terms for a European avant-garde, it seems not to have been one in a Latin American context.

The problem of 'the primitive' in Brazilian and Argentine culture is linked to the dynamics of modernisation. In the 1920s it is an amphibious signifier that implies both a sophisticated and modern gesture towards European surrealism, the creator of this *problématique*, and another towards the national past, where this primitive is 'discovered'. Changes in the meaning of the primitive cannot be explained simply in terms of the 'imitation' which the Latin American avant-garde would be seen as performing on the European models, as James Clifford (1981), among others, has suggested. As we have seen, the primitive also figures in aesthetic productions not traditionally associated with the avant-garde, such as the novels analysed above. Those changes in meaning entailed different strategies of nationalisation for avant-garde and non-avant-garde artists,[23] but the figurations of primitivity nevertheless pervaded both spaces of artistic production and inter-connected them in an interesting way. To some extent, then, these figurations compose an allegory of modernisation that runs counter to the traditional ways in which modernisation and nationalisation have been conceived both in Argentina and Brazil. In its constitutive difference, the status of the primitive as a national icon during the decades of modernisation can be explained, rather than merely as an effect of contemporary artistic production in Europe, by taking into account the historical condition of Latin Americans in the first decades of the twentieth century. In this way, modernisation and nationalisation in Latin America might be revealed not only as two coincidental processes, but rather as constituting, in their interplay, the very production of modernity. For, in Latin America, to be national would sometimes mean to be modern and, to be modern, could mean to be national. Tango and samba, and the idea of the primitive they came to embody, would therefore turn into one of the *speculums* in which to look for the ambivalent legacies of modernity in Latin American culture.

One of the reasons tango and samba became national icons by the 1920s and 1930s is because they reveal this interplay. Of course, there were other factors such as the exoticising of both musical genres through the intervention of Paris and its musical scene – often to the horror of the

more conspicuous among the Argentinean and Brazilian elites – and the uses of tango and samba as primitive forms in the wake of surrealism and avant-garde ethnographic primitivism. But the complex web of modernisation and nationalisation, or nationalisation qua modernisation, seemed to be the final touch in this process of tango's and samba's enshrinement. If this seems paradoxical, I think it is because the modernisation of tango and samba, as entangled within the contradictory and conflictive struggles over modernity in Latin America, was in itself full of ambivalence.

Notes

1. I would like to acknowledge the support received from my research assistant Belén Hirose, while writing this paper, as well as thank Beatriz Resende, Fred Goés and Marildo Nercolini for their comments when I was just starting to investigate this topic.

2. I would like to thank Fred Goés for calling my attention to this song.

3. ' Hombre, I don't know why I love you, / I truly love you, / Says the girl from the River Plate / But in Brazil it's different, / I just love you / And your love makes me mad.' It is interesting to note that this song was also sung by Caetano Veloso to open his show *Fina Estampa Ao Vivo,* and its corresponding CD, Caetano's hommage to Spanish American popular music, although it wasn't included in his album *Fina Estampa.*

4. Jean Richepin was a French writer. He was born in Algeria and, after some years as an adventurer, published in 1876 a long poem, the *Chanson des gueux,* exalting the poetry of wanderers. This poem, close in some ways to *poésie maudite,* shows Richepin's knowledge of argot. The book was considered to incite to vice and crime, and censored. Richepin himself was condemned to spend a month in prison. In 1908 he was nominated as a member of the Académie Française. As an *académicien,* he would introduce tango into the very space of the Académie Française in 1913, giving a lecture entitled 'A propos du tango' (Guillermo Cassió, 1999).

5. 'In France they've changed it / And called it *le tango,* / It may be they consider it / Worthy of Madame Argot / Who even might have danced to / the march of Ituzaingó!/ Richepin has defended tango / Even in the Académie / (I have for myself he is / a complete loonie!) / Let the tango be danced / Where it was born / In the Congo!' (My translation, F. G.)

6. The African origin of tango would be one of tango's history most contested ideas. One could even say that the process of nationalisation of tango is mostly constructed on the erasure of its African origin. Borges, one of the first Argentine intellectuals to dispute tango's *argentinidad,* also disputed Rossi's idea that tango was born in the candombes. See Borges, 1955.

7. The original passage reads: 'Mas o corta-jaca, de que eu ouvira falar há muito tempo, que vem a ser ele, sr. Presidente ? A mais baixa, a mais chula, a mais grosseira de todas as danças selvagens, a irmã gêmea do batuque, do cateretê e do samba.'

8. On the problem of the primitive in European avant-garde, see Clifford (1981) and Foster (1985).

9. 'La mayoría de los bailes que se usan hoy en los salones aristocráticos, son de origen popular y no pocos primitivamente bárbaros y salvajes [...] Pero el tango ha hecho su evolución, y así como primitivamente fue de la exclusividad de las gentes de baja estofa, que no se lavaban la cara ni las manos – que es el ABC de la limpieza – sino por Pascua Florida, hoy impera en los salones lujosos y es bailado por gente que se baña y se lava con riquísimo jabón Reuter, cuya sugerente influencia ha transmitido al tango, así como ese lánguido y poético abandono que lo distingue, un delicioso movimiento de "glissage", en que parece que el mismo jabón Reuter tuviera una inmediata participación.' *P. B. T.*, 4 de abril de 1914.

10. In *Una modernidad periférica: Buenos Aires 1920–1930*, Beatriz Sarlo studies changes in publicity during these decades, marking soap as one of the new products being publicized in these years (Sarlo 1988: 22–23).

11. 'Aquele tipo clássico, de calças largas e inteiriças, de salto carrapeta, chapéu de banda, desapareceu. Civilizou-se. No lugar do lenço a gravata. Não senta mais à beira do barraco para compor sambas. Vem para a Avenida. Vem fazê-los à mesa do Nice. Usa roupas de bom alfaiate.'

12. There are many articles that work on the exclusionary character of modernity and modenization in Brazil and Argentina. See, for instance, Beatriz Resende (1993). The urban reform directed by Pereira Passos, which received the popular name of Bota-abaixo, was seen even at its own time as a way of excluding from the city space that which was not considered modern.

13. José Ramos Tinhorão has very poignantly related the evolution of samba to the modernisation of Brazilian Culture : 'Os gêneros de música urbana reconhecidos como tipicamente cariocas –o samba e a marcha– surgiram e fixaram-se no período de 60 anos que vai de 1870 (quando a decadência do café no vale do Paraíba começa a liberar a mão de obra escrava destinada a engrossar as camadas populares do Rio do Janeiro) até 1930 (quando uma classe média urbana gerada pelo processo de industrialização anuncia a sua presença com o Estado Novo).' (Tinhorão 1997: 17).

14. The novel ends with the indication of the date when it was finished, 1922, the year that marks the most important event of the modernisation of Brazilian culture, the 'Semana', traditionally seen as the inauguration of avant-garde for Brazil.

15. 'O subúrbio é o refúgio dos infelizes. Os que perderam o emprego, as fortunas ; os que faliram nos negócios, enfim, todos os que perderam a sua situação normal vão se aninhar lá ; e todos os dias bem cedo lá descem a procura de amigos fiéis que os amparem, que lhes deem alguma cousa, para o sustento seu e dos filhos.'

16. '... aquí termino a história de Leniza. Não a abandonei, mas, como romancista, perdi-a. Fico, porém, quantas vezes, pensando nessa pobre alma tão fraca e miserável quanto a minha. Tremo : que será dela, no inévitavel balanço da vida, se não descer do céu uma luz que ilumine o outro lado das suas vaidades?'

17. For Alain Rouquié (1972: 108), '*Nacha Regules* est l'œuvre de Galvez qui exprime et traduit dans toute sa contradictoire richesse un populisme chrétien, un humanitarisme vague et confus'.

18. 'En los cabarets se codeaban el ruidoso libertinaje y la curiosidad. El cabaret porteño es un baile público: una sala, mesas donde beber y una orquesta. Jóvenes de las altas clases, sus queridas, curiosos y algunas muchachas "de la vida" que

acuden solas, son los clientes del cabaret. El tango, casi exclusivo allí, y la orquesta típica, instalan, entre el champaña y los smokings, el alma.'

19. An article in the newspaper *A Nação* announces 'a interessantíssima exposição de Cecília Meireles fixando os ritmos do samba através de uma grande coleção de desenhos, aquarelas e estudos, bem como as figuras típicas da baiana e do bamba.' The exhibiton was accompanied by a presentation of the famous escola de samba, a Escola da Portela. The designs can today be found in a book entitled *Batuque, Samba e Macumba. Estudos de Gesto e Ritmo, 1926–1934*, which includes an explanatory note on samba and batuque.

20. Páulo Reis suggests: 'Ele só quebraria a grande influência do Cubismo de Picasso (e eventualmente de Braque) quando retorna ao Brasil e decide fazer uma radiografia do nosso povo transformando mulatas em madonas.' (Reis 1994)

21. Aracy de Amaral (1976) calls him 'o pintor da mulata brasileira'. Di Cavalcanti was also the illustrator of a beautiful book containing some poems by Mário de Andrade, first published in *Remate de Males*, titled *Poemas da Negra*.

22. 'Dentro do carnaval carioca, inegavelmente licencioso e grosseiro, como em toda parte, na expansão das pessoas habitualmente civilizadas, o carnaval dos negros guarda um aspecto único de respeito, elegância e, digamos, mesmo, distinção artística espantosa'

23. On the idea of primitivity in two avant-garde writers, Mário de Andrade and Jorge Luis Borges, see Garramuño (forthcoming).

Bibliography

Antelo, Raúl. 1984. *Literatura em revista*. São Paulo: Ática.

Borges, Jorge Luis. 1955. *Evaristo Carriego*. Buenos Aires: Buenos Aires: Manuel Gleizer.

Buarque de Holanda, Sérgio. n.d. Prefácio. In *Clara dos Anjos,* Lima Barreto, Rio de Janeiro: Brasiliense.

Candido, Antonio. 2000. 'Literatura e Cultura de 1900 a 1945 (Panorama para estrangeiros)', in: *Literatura e sociedade. Estudos de teoria e história literária*. São Paulo: T. A. Queiroz.

Campos, Haroldo. 1971. 'Prefácio', in: *Poesias reunidas,* Oswald de Andrade, Rio de Janeiro: Civilização Brasileira.

Cassió, Guillermo. 1999. *Jean Richepin y el tango argentino*. Buenos Aires: Corregidor.

Cheah, Pheng. 1998. 'Introduction Part II: The Cosmpolitical Today', in: *Cosmopolitics. Thinking and Feeling Beyond the Nation*, eds. Bruce Robbins and Pheng Cheah. Minneapolis: University of Minnesota Press.

Clifford, James. 1981. 'On Ethnographic Surrealism', in: *Comparative Studies in Society and History*, vol. 23, no 4.

Foster, Hal. 1985. 'The Primitive Unconscious of Modern Art, or White Skin Black Masks', in: *Recodings. Art, Spectacle, Cultural Politics,* ed. Hal Foster. Seattle: Bay Press.

Gálvez, Manuel. 1922. *Historia de Arrabal*. Buenos Aires: Deucalión, 1956.

———. 1919. *Nacha Regules*. 1960. Buenos Aires: Losada.

———. 1962. *En el mundo de los seres ficticios*. Buenos Aires: Hachette.

Gramuglio, María Teresa. 1994. 'La persistencia del nacionalismo', in: *Punto de Vista* 50: 23–27.

Krauss, Rosalind. 1999. *Los papeles de Picasso*. Barcelona: Gedisa.

Lima Barreto. 1948. *Clara dos Anjos*. São Paulo: Brasiliense, n.d.

Marques Rebelo. 1937. *A estrela sobe*. Rio de Janeiro: Ediour, n.d.

Meireles, Cecília. 1983. *Batuque, samba e macumba. Estudos de gesto e ritmo, 1926–1934*. Rio de Janeiro: FUNARTE.

Mendes, Murilo. 1949. 'Di Cavalcanti', in: *A Manhã*. Suplemento Letras e Artes, Rio de Janeiro, 6 de febrero de 1949.

Resende, Beatriz. 1993. *Lima Barreto e o Rio de Janeiro em Fragmentos*. Rio de Janeiro: UFRJ.

Rouquié, Alain. 1972. 'La genèse du nationalisme culturel dans l'œuvre de Manuel Gálvez', in: *Cahiers du Monde Hispanique et Luso-Brésilien (Caravelle)*, 19.

————. 1973. 'Manuel Gálvez, écrivain politique (Contribution a l'étude du nationalisme argentine)', in: *Cahiers des Amériques Latines*, Série Arts et Littérature 3/4: 93–110.

Sarlo, Beatriz. 1988. *Una modernidad periférica: Buenos Aires 1920–1930*. Buenos Aires: Nueva Visión.

Segalen, Victor. 1994. *Essai sur l'exoticisme. Une esthétique du divers*. Cognac: Fontfroide, Bibliothéque artistique et littéraire.

Reis, Paulo. 1994. In *Jornal do Brasil*, 6/7/1994.

Tinhorão, José Ramos. 1998. *História social da música brasileira*. São Paulo: Editora 34, 1998.

Vianna, Hermano. 1995. *O mistério do samba*. Rio de Janeiro: Jorge Zahar Editor e Editora UFRJ.

Viñas, David. 1996. *Literatura argentina y política. De Lugones a Walsh*. Buenos Aires: Sudamericana.

Wechsler, Diana. 1999. 'Impacto y matices de una modernidad en los márgenes', in: *Nueva historia argentina. Arte, sociedad y política*, ed. José Emilio Burucua. Volumen 1. Buenos Aires: Sudamericana.

Zilio, Carlos. 1997. *A querela do Brasil. A questão da identidade na arte brasileira: a obra de Tarsila, Di Cavalcanti e Portinari*. Rio de Janeiro: Relume Dumará.

Chapter 7

'Argentina in the World':

Internationalist Nationalism in the Art of the 1960s

Andrea Giunta

In 1965, the Torcuato Di Tella Institute organised an exhibition which, rather than as a promise, was instead offered as verification. The exhibition, containing the works of those Argentine artists considered to have 'triumphed' on the world stage, was presented to the public of Buenos Aires as proof that a national project had been realised. On the walls of the institute an ideological programme was displayed, organised around a set of principles which implicitly contained a series of negotiations and deals. The text, written by the Argentine critic Jorge Romero Brest (director of the Centre for Visual Arts at the Torcuato Di Tella Institute),[1] that introduced the exhibition catalogue gave an indication of the various 'edits' that had characterized his selection: of all the artists who had contributed 'significantly' to cementing the 'prestige' of Argentine culture, he had chosen the youngest ones. Furthermore, the exhibition did not encompass all Argentine art of 'quality'; it included only that which had received international recognition. The dilemma that crept inadvertently into the curator's decision-making was that quality and international recognition did not necessarily go hand in hand. In this sense, the exhibition as a whole could be considered as the reflection of a pivotal moment in which the signs were already there of what would soon be considered a disaster or an irreversible defeat: Argentine art had no place in the great story of modern art and Buenos Aires had not succeeded in establishing itself as an international centre of art, on a par with Paris and New York. This 'desire to be at the centre' had triggered one of the strongest movements to represent Argentine culture. In it were combined fate and destiny:[2] that Buenos Aires should become an international centre for art was no more than the inevitable conclusion of a whole array of material and symbolic conditions (the city's demographic composition, its accumulation of cultural capital, and kinship with European culture)

which placed the city in an exceptional position. Such assumptions were taken on board by the new industrial bourgeoisie, allied to international capital, which understood the internationalist project as complementary to the project of nation-building. The internationalisation of Argentine art was a central argument in the narrative fiction that organised its evolution: the 'absence' of prehispanic and colonial art freed Argentine art from any pact with the past and situated it instead before the unique and exceptional alternative of being able to shape the future, taking as a point of departure the most recent transformations in artistic language.[3] This logic was also integral to the evolutionary model of modern art which, bathed in the aura of progress, understood each rupture by the avant-garde as a transcendental event. Those people such as Romero Brest, who thought out the development of Argentine art, did so within the organised structure of a precise chain of events: first, art had to be actualised, and once that was achieved, it had to incorporate itself actively into the story of modern art. International recognition would come as a natural consequence. Such thinking made the desire to play a role seem achievable because of the very logic on which the story was based. Using an economic metaphor that circulated in artistic discourse of the period, it was argued that, by importing the necessary tools, Argentine art could arrive at a competitive position that would enable it, in a short space of time, to achieve 'export quality' (Squirru 1963: 30).

In this chapter I propose to consider the analyses of the policies of cultural expansion organised by artistic 'centres' during the postwar period, for example, studies on the cultural policies designed by United States institutions during the Cold War (Eva Cockroft [1974], Max Kozloff [1973], Serge Guilbaut [1983]). These studies analyse the relationship between Europe and the United States from the viewpoint that considers imperial strategies to act on spaces in which only two alternatives exist: that is, surrender or resistance. This model is also applied in the analyses by Shifra Goldman (1978; 1981) and Eva Cockroft (1989) of the relationship between the United States and Latin America.[4] I wish to further develop the complementary point of view, which also takes into account the strategies that were adopted in Latin America with a view to incorporating itself into world art. The São Paulo Biennial or the Torcuato Di Tella Institute are magnificent examples of this firm desire to place local art in the international showcase.

'Internationalism' was a term that circulated incessantly in the discourse over art in Latin America during the 1960s. It was a word that everyone used as an indicator of quality (if a piece of work was 'international', it was good), but which was not understood as meaning the same thing by everyone. Over its possible and contradictory meanings, a covert battle raged where triumphalism, messianism, propaganda and over-

weening ambitions came to blows. It is not my purpose to define a single or 'correct' meaning for the term, but to disentangle the different meanings that got attached to it, each of which carried with it a different agenda, which were often antagonistic, and among which transitory agreements got established which, over time, became unsustainable. As Raymond Williams (1976) points out, where 'important ideas' are concerned, the meaning of certain words, even within one language, can be contradictory. Here I am referring to the words 'international' or 'internationalism' as *key words* in the artistic debate of the 1960s. These were words that contained within them a variety of meanings and which, at the same time, became linked with other words establishing formations of particular meanings, some of whose elements became consolidated while others were lost. These were words that bound the aesthetic together with the political and which, in the 1960s, after the Cuban Revolution had displaced the frontline of the Cold War to Latin America, were also used as tools and weapons of battle.[5] The negotiations and disputes around the meaning of the word also reflect the conflicts that revolved around the value and legitimacy of Latin American art in the 1960s. It is possible to differentiate at least three principal meanings within the term 'international' in accordance with how it was understood on the artistic scene during those years. The first is linked to the tradition of the avant-garde: an art that makes advances into new territory and understands this dynamic as one of progress, in the form of conquests in a territory without frontiers. In that sense the aspiration is to an international style, sharing certain common features in its language. It is an aesthetic front, which also links itself with certain social revolutionary principles, a characteristic feature of historical vanguards which, in a number of ways, was revisited in the 1960s. For the North American institutions, international art was that which separated itself from all nationalistic tendencies in so far as it avoided all local references. That is to say it was an art that could be understood anywhere. Without local heroes or stories, without Indians, peasants or workers, and above all without politics, abstract art (both in its geometrical and informal expressionist strands) was able to cross all borders and did not require any specific explanation. For Argentine artists and institutions, to have an 'international' art meant to enjoy the support of the hegemonic artistic centres. It meant success and recognition, no matter which particular style was in question.

At the heart of the term was a question of power, and its meaning changed with the same rhythm and intensity as international history did during those years.

The American Family

At the end of the 1950s, José Gómez Sicre, director of the visual arts sec-
tion of the Organization of American States, repeatedly proclaimed in the
Boletín de artes visuales of the OAS that the cultural map had changed
and that now all the cities of the Americas (New York, Buenos Aires, Rio
de Janeiro, Lima, Mexico City, São Paulo, Caracas, Washington) were
centres of international art (Gómez Sicre 1959: 1–3). This declaration,
which expressed a deeply-rooted desire, took hold and became translated
into specific cultural policies. The programme of exhibitions of Latin
American art which had been held in the headquarters of the OAS since
1947,[6] the selections that were presented in various North American and
European museums, together with initiatives that were put in place in
each and every Latin American country generated a concentrated traffic
of images that travelled far and wide in search of recognition. In Latin
America as in the United States, institutions were created and reorganised
to satisfy the purpose of favouring the new currents of exchange.

But this intensification of dialogue also had a political motivation.
Faced with the Cuban Revolution and the threat of Communist expansion
among the Latin American republics (a threat whose danger could be bet-
ter appreciated after it was recognised that the continent's poor territories
could be converted into bases for missiles aimed at the United States), it
became a priority to improve the relationship of exchange with Latin
American countries. The 'Alliance for Progress', launched by Kennedy in
a speech given on 13 March 1961 to the Latin American diplomatic corps
in the White House, was a form of response. Its ten points established an
assistance programme aimed at social, cultural and economic develop-
ment, and to spread knowledge about Latin America in the United States.
On the cultural level, this political will was translated into exchange pro-
grammes, which led to an increase in invitations extended to intellectu-
als, translations of books and art exhibitions.[7] 'Knowledge', 'dialogue'
and 'exchange' were words that filtered through all the programmes that
sought to overcome the policy of confrontation between the United States
and Latin America.

In 1959, shortly after the end of a tour that displayed the 'triumph' of
the new North American painting in eight European countries,[8] and in the
same year as Gómez Sicre announced the new order in world culture, a
set of exhibitions was inaugurated in the United States which showed dif-
ferent aspects of Latin American art. During the summer months, along-
side the Pan American Games, three Festivals of the Americas were held
in Chicago, Denver and Dallas, in which art exhibitions played a promi-
nent role. This meeting, which brought together both culture and the

economy, was also closely linked to the wave of investments that were taking place in several Latin American countries.[9] Faced with this invasion of images, the critics had to catch up. The magazine *Art in America* ('Editorial' 1959: 21), dedicated a whole issue to Latin American art and conducted an informal survey with the intention of establishing the differences between the art of North and South America. The results were surprising:

> The comments underlined the basic lack of differences, the extraordinary coincidence in style and viewpoint. The fact that the language across the entire Western continent is so clearly related is proof of the strength of the bonds that unite the Americas. As the world gets smaller and becomes in truth 'one world', art more than ever, will be accepted as a universal language.

The idea of a world unity based in an 'extraordinary' coincidence of style became established on the basis of unifying principles defined by a single regulatory power. After the success of Mexican muralism in the United States during the 1930s, North American art had developed its own modernist project eliminating contamination by local influences and, above all, any social content. In this process, North American art purged its own past, and that of the artists who were at the centre of the artistic scene: the abstract expressionists. Some had been connected to the Mexican muralists and their political ideology,[10] they had taken part in the Federal Art Project, supported by the Work Progress Administration, implemented in 1935 during the New Deal (for instance, Gorky, Pollock, de Kooning, Baziotes, Gottlieb, Rothko, Guston) and had also been Communist Party sympathizers. Now they were the representatives of the last avant-garde to have been generated by the West. Articles such as 'On the Fall of Paris', by Harold Rosenberg (1940), or 'The Decline of the Cubism', by Clement Greenberg (1948), were part of the ideological apparatus that contributed to spreading the conviction in the world that the centre of modern art had shifted from Paris to New York.

In the postwar scene, the term 'internationalism', rather than signifying exchange, meant instead the success of one aesthetic model over another and this model was represented, fundamentally, by abstract art, understood to be the diametrical opposite of socialist realism. Abstraction and 'freedom' were words which, in the artistic space, formed part of the same discourse. However, the promotion of abstraction conflicted with the strongest school of Latin American art – Mexican muralism. The biggest surprise in the exhibitions showing Latin American art resided precisely in the fact that now they were no longer expressing nationalist or indigenist tendencies.[11] On the contrary, Gómez Sicre affirmed that Latin America was now using 'the international language of art, just as this (was) used in the United States' (Gómez Sicre 1959: 22). The act of

recognition was backed by several important critics. In 1961, Thomas Messer, director at that time of the Institute of Contemporary Art of Boston, organised an exhibition *Latin America, New Departures* for which he selected abstract artists, or artists who used abstract figuration.[12] His introduction to the catalogue was like the announcement of a new birth:

As recently as half a decade ago, the mention of Latin American art brought, to the general observer of the international art scene, visions of basket-bearing peasant women. This and other cliches had about them the air of the bureau rather than the artist's studio. Even after the names of a few pioneers have become well established in the United States, the existence of an art situation that is active, creatively intelligent, and through its top achievements, notable, has largely been ignored in this country before the late fifties. In 1959 a Pan American wave swept across the art world in form of magazine articles and museum exhibitions, giving special attention to the situation in Latin America. (Messer 1962: s/p)

The spread of this current of optimism makes it possible to appreciate that the idea of finding a place for Argentine art in the world was not just a vain project, product of the irrational messianism of a ruling class. To believe in the viability of such recognition was an option afforded by the new environment of possibilities.

The confrontations, some more, some less, direct, which started to occur, along with the set of frustrations that laid low the enthusiasm of the artists and silenced the passionate proclamations that were being made by the new institutional programmes, soon left it clear to what extent words like 'internationalism' or 'exchange' could disguise different, or even antagonistic, agendas.

Internationalism as a Form of Nationalism

The exhibition displayed in 1965 on the walls of the Torcuato Di Tella Institute was the result of a cultural and ideological programme developed during post-Peronism and conceived as a negative image: if during Peronism, Argentine art had fallen into a 'suicidal introspection', according to Jorge Romero Brest (1956: 7–8), the dominant agenda after the fall of Perón was to establish international contacts and show Argentine art abroad. To do this it was necessary to reorganise the art scene and bring it up to date. In this respect, the Buenos Aires Museum of Modern Art was founded,[13] the Torcuato Di Tella Institute was established and Kaiser Industries created the American Art Biennials.[14] All of these institutions fostered the necessary climate for the artists of Buenos Aires. Once the institutions that would cherish the new Argentine art had been created, it was surely only a matter of time before this new art would be born.

From 1959 to 1963, groups and exhibitions flying the flag of the avant-garde followed one another in rapid succession: from the Argentine informalists (such as Kenneth Kemble or Alberto Greco) to the artists who organised the *Destructive Art* exhibition or the Argentine New Figurative group (Luis Felipe Noé, Rómulo Macció, Ernesto Deira and Jorge de la Vega). In all of them the formative influence of European artistic language could be detected (from Dadaism to the Cobra group or Nouveau Réalisme) but so too could the differences: from a new iconography – like the references to Perón which appeared in the work of Luis Felipe Noé, or the series produced by Antonio Berni of Ramona Montiel (a prostitute) and Juanito Laguna (a shanty town child) – to a distinctive use of materials (like the montaged reliefs of Jorge de la Vega, his collages of objects related to the popular culture of Buenos Aires or the monsters he created through violent anamorphosis). Faced with this torrent of 'innovations', in a short space of time a confidence was generated that Argentine art was not only keeping pace with that of the great centres, but that it was even advancing ahead of it. For example, Kenneth Kemble has stated: 'I remember that up until the 1960s, every time I opened a European or North American magazine there was something that surprised me there. But during the 1960s nothing surprised me, all of it had been done by us ... now we were in the era of the Torcuato Di Tella Institute, and we were at the forefront of the world' (in Giunta 1997: 85). In the light of such self-confidence, it was understandable that, in 1963, Rafael Squirru (who after directing the Buenos Aires Museum of Modern Art had moved on to run the Cultural Affairs Department of the OAS) told the magazine *Primera Plana* that Argentine art had finally broken through to the international scene, winning over the European critics in the process.

For Squirru, the internationalisation of Argentine art was a mission in which he saw himself as a crusader committed to the conquest of a sacred territory, represented in his imagination by the world. In his zeal for creating metaphors that linked art with areas which, since the beginnings of modernity, it had attempted to distance itself from (such as the export economy or sports), Squirru's feverish imagination turned artists into athletes and international competitions into the Olympics: 'Just as the athlete must prove himself in successive contests that measure the power of his strengths – maintained Squirru – so must the artist match his talent with that of his contemporaries, so as not to rest on the soporific laurels of his local club. Confrontations invigorate production, and demand a greater imaginative effort' (Squirru 1963). Although Squirru managed to invest his public declarations with traces of an overblown fanaticism that we do not find in all actors of the period, nonetheless his discourse was not an isolated expression. The postulates behind economic development theory, which proposed that evolution obeyed laws, and that there

were ways of establishing them, also filtered into cultural discourse. The 'dramatization' of social and economic change, which as Carlos Altamirano (1998: 75–94) points out, permeated developmentalist discourse, could also be found in the programmes that formed the thrust of the artistic institutions. The concept of historical time as a variable that could be manipulated, which supposed that interventions by institutions could produce changes in the quality of Argentine art and its international prominence, was a central pillar of the policies for artistic promotion that were introduced during the second half of the 1950s.[15]

However, in spite of Squirru's enthusiasm and the institutional programmes, North American critics soon began to question the 'international' character that Latin American painting had supposedly acquired. In 1964, the Torcuato Di Tella Institute and the Walker Art Center of Minneapolis organised an exhibition called *New Art of Argentina,* which travelled around various museums in the United States.[16] From the pages of the *New York Times* John Canaday slated it, writing that many of the works displayed were no more than the repetition 'ad nauseam' of 'familiar styles' (Canaday 1964: 27).

The reasoning went that if Latin American art were so international that it resembled art you could find anywhere, then its contribution was questionable. The age-old question that started to resurface from the mid-1960s centred on the identity of Latin American art. The answer turned into an unsolvable problem. Thomas Messer, who in 1961 had shown himself to be so confident and enthusiastic, tried to define the boundaries within which Latin American art could achieve an international style without renouncing local influences:

An imitative, international style deprived of its indigenous substance will not do this. Therefore, both – picturesque unreality and its opposite, neutral abstraction – must be rejected. *A true Latin American art, if it exists, will be rooted in the realities of Latin American life.* If these realities are coherent, their formal equivalents may emerge as a visually identifiable form language. A style, in other words, may come into being. The concept of a Latin American art must be rooted in a grasp of the Latin American identity. *That identity, however, resists definition.* An adequate definition would have to be impossibly comprehensive, for it would embrace geography, history, economics, religion, psychology, politics, and many other factors as well. Reason and emotion, facts and ideas, the past with its memories and its conditioning force, the present in all its fluid immediacy, and an indiscernible future foreshadowed in terms of vague aspirations would all need to be part of it. It would have to be applicable simultaneously to the individual and to the larger entities of family, nation, continent, and world. Only the artist is equipped to evoke this identity. (Messer 1966: xiv–xv; my italics)

The responsibility for giving form to such vague yet unavoidable aspirations was an immense one. The difficulty lay in finding the balance between expressing the authenticity of Latin American art without rejecting the universal.

However, the spirit of pragmatism that dominated among the Argentine cultural players in those years prevented these difficulties, for the time being, from creating a mood of pessimism. In 1965, the exhibition entitled *Argentina en el mundo* showed signs of a subtle change in direction of the internationalist project. By this time, the newspapers and magazines of Buenos Aires had repeated time and again that Argentine art had finally attained the necessary 'export quality' and had managed to install itself in the great centres of art. Although the galleries that were showing Argentine art were a far cry from the dizzy heights necessary for a triumphal entry (the great museums had never opened their doors) this exhibition ignored that fact and was presented in Argentina as the proof of a successful achievement.[17]

It would be hard to find a better example of the kind of criteria that were now being used to gauge achievement than the assessment tables drawn up by the juries in order to select which artists would be offered as proof of the triumph. A system of scoring (from zero to three) was used to grade artists in terms of international influence, quality, success, exposure overseas and current importance. Artists came to resemble a group of athletes demonstrating their skill before a panel of judges, which was to award them a point score; they ceased to figure as active agents taking their place in a cultural debate but rather as members of a team representing their country in order to win medals for her. The metaphor employed by Squirru to try and stir competitive passions in the cultural arena, which stated that artists should think of themselves as athletes, ready to compete so that the country would be able to 'export culture', now found dramatic expression in the points table which decided who were the Argentine artists that had made it 'in the world'. As Romero Brest himself explained in the catalogue, the determining factor had been international success: '…we have had to choose the contributors, not only on the basis of the quality of their work, but also for the influence they have been able to exert abroad; and for this reason, it is to our regret that we have excluded certain artists whose quality appears to be very positive'.[18] Was this now art? In the 'regret' expressed by Romero Brest, this question was tacitly sidelined. These parameters, which were not subject to any criticism, and which gave the public no opportunity to see what it was that the international community accepted and what it rejected, meant that an artist like Líbero Badii, awarded maximum points by quality, but none by success, was excluded from the exhibition.

For the Argentine institutions, *internationalism* was, in the end, a notion that involved a programme that was to have more repercussions at home than abroad, where it had initially been intended to intervene. Begun as a tactic designed to provoke instantaneous support, and to direct individuals towards actions that would only be measured by their

own goalposts, for large sections of the artistic vanguard, and above all, for the projects organised by institutions, it was a term that got redefined whenever it was necessary to bring a change in strategy. Some players (particularly Romero Brest) took it on themselves to eliminate all the contradictions, and all the rejections that inevitably went along with its implementation. Like robots, they went on dusting down the remains and rebuilding again and again their project of international success. The game which, from then on, developed between Argentine artistic institutions and those which organised the inter-American circuit from the United States had much in common with a parody. A spectacle in which one party feigned recognition and the other was obstinately determined to understand it as such.

But in 1965, while the enthusiasm still dominated, the exhibition *Argentina in the World* awoke a dangerous nationalistic fervour. Córdova Iturburu (1966: 30) explained in the pages of the daily paper *El Mundo* how this exhibition was proof of the 'timeliness' of Argentine art:

> Our neo-figurative artists, our pop artists, appear in the international showcase with their unmistakable national accent, and with defining features that not only exemplify a national individuality but also a profile and essence that are innovative. [...] Argentine artists adhering to op-art, our visual investigators [...] are leading figures in the great laboratory of advances in the plastic arts of our time. In this sense, our art is moving towards hitherto unheard-of inventions and creations. We have completely left behind the last traces of the colonial aftertaste, to begin perhaps in the not too distant future to become colonisers ourselves, or at least, to coin a less disagreeable phrase, to become discoverers.

In this description by Córdova Iturburu, Argentine art was not only 'present' in the world, but it was capable of conquering it. The internationalist project incorporated, within its folds, the promise of (and the desire for) a colonizing expansion.[19]

The Decline of Internationalism

The celebratory and enthusiastic tone that had dominated the reception of the first exhibitions of Latin American art in the United States eventually began to give way to one of criticism and disenchantment. In 1967, shortly after he had participated on the panel at the third American Art Biennial, organised by Kaiser Industries in the city of Córdoba, Sam Hunter (director of the Jewish Museum of New York) wrote an article that was capable of dashing all expectations. For a start, his description of the socio-economic context in Argentina was sufficiently dramatic to discourage not only any desire to contemplate the art in question, but also to visit the country where it was being shown. The Biennal was held on the campus of the University of Córdoba, shortly after Onganía's military

coup (1966). It was permeated by the climate of political conflict that was besetting the country:

> High politics and the battle of ideologies, both political and artistic, provided the exhibition with a dramatic background on its opening night, which the more enthusiastic artists were later heard to describe with fair accuracy as a 'happening'. During the preceding week, scattered student groups demonstrated in the streets of Córdoba, and the acrid smell of tear gas hung in the air; the Under Secretary of Culture came out publicly for 'virtue', traditionalism and intelligibility in the arts, a declaration that carried the ring of hysterical nationalism. [...] The somewhat buffo atmosphere of conspiracy and futile intrigue persisted through the official opening and prize-giving ceremonies, where artists in far-out mod dress appeared before the assembled military, state and church dignitaries, and dedicated their awards to the university students while pointedly snubbing a tightlipped and obviously baffled provincial governor by refusing to shake his hand. (...). But the tensions of the moment later dissolved in high spirits as artists, students and dignitaries tangoed until dawn in a festive setting at the hospitable Kaiser plant, over whose entrance a sign says 'Bienvenido'. (Hunter 1967: 85)

Surprised and probably slightly shaken by this experience, Hunter indicated to the world that the Latin American republics had returned to their original, uncivilised state. The era of uninterrupted progress, of the formulas for assured success and international recognition, crumbled in the face of this spectacle in which works of art, far from the pure and luminous objects they were supposed to be, capable of dialogue without conflict and of crossing borders, were being dragged along by the most immediate reality. As if this were not enough, Hunter (1967: 85) also took aim at the erstwhile celebrated internationalism:

> The bitter if intermittent struggle for political freedom is matched in the exhibition itself by the evident, somewhat uncritical embrace of the ideology of 'advanced' art as a cultural 'cause' and form of individual liberation. Rarely, I think, has an exhibition so dramatically demonstrated the erosion of local and provincial traditions and their supression by international styles that range somewhat erratically from a convincing maturity to the most naive and shallow imitation.

Hunter's criticisms were directed, like a well-aimed dart, at the heart of the institutional networks that had driven and coordinated the whole internationalist project through international communication, prizes with international juries, international curators:

> Lacking the originals, the emerging artists alertly make contact with the 'tradition of the new' through the reproduction and slide lectures of itinerant critics and curators who, like missionaries, descend regularly from the United States, Paris or London to convert the natives to the latest innovations. (Hunter 1967: 86)

Sam Hunter's condemnation of the internationalist project was categorical: 'the third Biennial Exhibition of Latin American art, financed and sponsored by Kaiser Industries, demonstrated dramatically the erosion of

local traditions and their replacement by an international style that emanates from New York, London and Paris' (Hunter 1967: 84).

This sentence makes clear to what extent the idea of the power of international styles to create a world without frontiers had fallen into discredit and how the term now served as a term of disqualification. Now what was wanted was originality of style, and identifying signs that would allow the originality of a piece of art to be recognised at first sight. If the forms of Latin American art were the same as those to be found in the centres (these, truly international), in that case, what were the incentives for getting to know this art? The situation was doubly irreparable if, as Hunter maintained, the internationalism that had dominated in the aesthetic products of the 1960s had eroded all the local traditions.

For Latin American art, at the end of the 1960s, there did not seem to be any possibility of entering as a protagonist into the great story of the history of Western art. From the moment in which this story became organised around a system of priorities such that all that counted were changes and transformations implying advances in the 'progressive' development of the language of modern art, there seemed to be no reason to include in it an artistic production that was judged to be an undistinguished copy. From then on, the term 'international', when applied to Latin American art, functioned as a mechanism of exclusion and subordination, which served to place it outside the history of art. Terms like 'derivative', 'dependent' or 'epigonal' replaced 'international' when classifications and qualifying judgements were being made. Definitively, if Latin American art was equally international as the art to be found in the centres that had generated and transformed the language of modern art, a language, incidentally, to which it had failed to add anything new, then it could rightfully be left out of the history of modern art.

In 1965, the exhibition *Argentina in the World* still had not taken this into account. On the contrary, it was presented as definitive proof of a triumph. However, it was a triumph that was plagued with compromises, omissions and digressions. Romero Brest had experienced this, when in selecting the works of the artists who had enjoyed most international recognition, he had had to omit some of those he considered to be the best. The exhibition was also proof of what had to be sacrificed in gaining international recognition. It showed that the value criteria of the international circuit were not the same as local ones. In its material presence, hung out on the gallery walls, the exhibition raised a new set of questions: to what extent had the artists being exhibited there really been integrated into the international circuit and received international recognition? To what extent had all the effort expended by the artists and the institutions enabled them to achieve their aims? None of their work was to be found in the collections being shown in the MoMA or the

Guggenheim. Although it still provided arguments capable of sparking enthusiasm, the exhibition also foresaw that the last stop on the international circuit would be a return home.

Translated by Emma Thomas

Notes

1. The Torcuato Di Tella Institute brought together a number of centres for research in the arts (visual arts and music), economics and medicine. It received funding from the Di Tella family, the Ford Foundation and the Rockefeller Foundation. The Di Tella family owned a collection of contemporary art which included works by Jackson Pollock, Mark Rothko, Louise Nevelson, Pablo Picasso, etc. Between 1962 and 1968, the institute held national and international art competitions, in which artists like Rosenquist, Morris, Nevelson, Chamberlain, Larry Rivers, Rauschenberg, Alechinsky took part, and which were judged by art critics like Clement Greenberg, Lawrence Alloway, Pierre Restany, etc.

2. Benedict Anderson states that 'the magic of nationalism is to convert fate into destiny' (Anderson 1993: 29).

3. In a paper published in *Ver y Estimar* (a magazine published in Buenos Aires between 1948 and 1955) Romero Brest sought to establish the guidelines for a rapid development in Argentine art. With no prehispanic culture or colonial legacy, Argentine art found itself in a unique position, with the possibility of incorporating the most recent developments in European art and starting from there down its own path. See Romero Brest 1948: 12.

4. In the same line of analysis, the work of Serge Guilbaut (1997: 807–16) on the founding of the Modern Art Museum in São Paulo could also be cited, where he analyses the strategies of the French critic Léon Degand but not of the Brazilian industrial Ciccilo Matarazzo.

5. As Martin J. Medhurst points out, the Cold War was a war of words, images and symbolic actions; rhetoric discourse was designed with the object of achieving certain effects on certain audiences (Medhurst 1990: 19).

6. Between 1947 and 1968 there were approximately 370 exhibitions of Latin American artists, mostly young ones, in the OAS art gallery. Cf. 22 June 1994, OAS Records Transmittal and Receipt, from Museum to OAS Records Center, Room ADM-B3, Archivo OEA, Washington, D.C.

7. After the Office for Inter American Relations was opened in 1939, during the Roosevelt administration, a variety of programmes and institutions were developed, all of them on the understanding that the policy of exchange with Latin America was important for the economic and political interests of the nation. Art exhibitions had their place in the exchange programme. When Roosevelt named Nelson Rockefeller as director of the office, one of his first initiatives was to send an exhibition of North American art to tour around several cities of the Americas (the tour visited museums in New York, Mexico, Havana, Caracas, Bogota, Quito, Lima, Rio de Janeiro, Santiago, Montevideo and Buenos Aires) and to arrange for exhibitions of Latin American art to be received in the United States. From the

beginning he understood images and exhibitions to be instruments of persuasion in the 'good neighbourhood' policy. But while the North American exhibition went to national museums in the Latin American countries, the Latin American exhibitions travelled around marginal spaces during the 1940s and 1950s. Among the most distinguished was the exhibition hall belonging to the OAS in Washington.

8. The exhibition was called *The New American Painting*. It was organised by the International Program of the MoMA in New York, under the auspices of the International Council of the museum. In 1958–9 it was shown in museums in Basle, Milan, Madrid, Berlin, Amsterdam, Brussels, Paris and London.

9. The exhibitions and activities were the following: in Chicago, host of the Pan American Games, a Festival of the Americas was organised between August and September, which brought together representative activities from Canada, the United States, Central America and the Caribbean; the city's museums and galleries planned exhibitions and there were also presentations of architecture, music, theatre, cinema, literature and education in order to introduce the citizens of Chicago to the art and culture of Canada and Latin America. The Denver Art Museum, for its part, opened an exibition in September, coinciding with the seventh UNESCO national convention, which was called *Latin America – Then and Now*, showing precolumbian and colonial art from Central and South America, alongside contemporary work by Latin American artists. Also in Dallas, an extravagant event was held, called *South American Fortnight*, which combined exhibitions and cultural activities with visits by celebrities from South America. In this event there was an exhibition of contemporary art organised by José Gómez Sicre at the Museum of Fine Arts and also a collection of South American folk art curated by Grace Line situated in the Neiman-Marcus building. This last event also involved lunches, dinners and dances held in honour of South American ambassadors who were invited to the occasions. There was also a forum organised by the magazines *Visión* and *Time-Life International*, with a programme of presentations given by prominent businessmen from South America. As we can see, cultural and economic initiatives advanced, from the outset, in a brotherly embrace.

10. As well as to the murals and the work these artists had done in the United States during the 1930s when the conservative Calles regime led the muralists to work there: Diego Rivera painted murals in San Francisco and Detroit, Orozco in Pomona College, Claremont, California and in the library at Dartmouth College (Hanover, New Hampshire); and Siqueiros taught *plein-air* painting at the Chouinard Art School in Los Angeles and in 1936 organised the experimental studio in New York attended by Jackson Pollock. Several North American artists (like Lucienne Bloch, Marion Greenwood and Philip Guston) also painted murals in the U.S.

11. In this regard, José Gómez Sicre argued, in the same issue of *Art in America*: 'For some, Latin American art is like a carnival, a superficial and descriptive pictorial chronicle of the people and customs, which draw in visiting tourists. This limited concept could damage the reputation of legitimate Latin American art among the serious collectors in the world. A possible explanation for the persistence of this concept of picturesque art, with no hope of change, is that in a number of countries we have not managed to establish a set of artistic values that recognise and include – rather than ignore- some of the interesting *new* artistic movements. To a certain extent, it seems that the experimental artist, dissatisfied with the old

modes of expression and keen to explore new ones, has and is being overtaken and excluded from exhibitions by artists who, protected by political parties or by organizations, have found ways to combat any efforts to change the situation' (Gómez Sicre 1959: 22).

12. Among the first were, Alejandro Otero (Venezuela), Manabú Mabe (Brazil), Fernando de Szyszlo (Peru), Alejandro Obregon (Colombia) and José Antonio Fernadez-Muro, Sarah Grilo, Miguel Ocampo, Kazuya Sakai, Clorindo Testa, all from Argentina. The only artists using abstract figuration were Ricardo Martínez from Mexico and Armando Morales from Nicaragua. Note the importance of the Argentine representation in what was supposed to offer a vision of Latin America.

13. In 1956 Rafael Squirru managed to get the decree signed ordering its foundation.

14. The American Art Biennials took place in 1962, 1964 and 1966. In contrast with the Torcuato Di Tella Institute that sought to place Argentine art and Buenos Aires on the international circuit, the Kaiser Biennials were set up from an inter-American perspective. They brought together art from across the American continents.

15. In this regard, the speech given by Enrique Oteiza on the day of the inauguration of the Di Tella Prize in 1964 is revealing: 'In its artistic activities, the Institute is committed to the adventure of participating in the development of a vital vanguard movement, with a character of its own whilst belonging to the world of today. We are interested in living artists, since as an institution we are dedicated to the future; and among those living artists we favour those who are aware of contemporary issues and are open to experiencing the unknown. [...] It's essential to know what would have a chance of succeeding at a foreign biennal, for example, and to use that knowledge to determine the strategy and presentation of our contribution, regardless of petty internal obligations. If we did this at important international competitions it would not only be our artistic movement that would benefit, but also, and on a transcendental scale, Argentina itself, and on a massive scale. There are artists in our country capable of achieving these triumphs, what is lacking is adequate institutional support. Internally, museums, prizes and galleries can also play a very important role, provided that the people in charge know their field, and have the necessary levels of intelligence and courage.' Archive of the Torcuato Di Tella Institute. CAV. Box 3, 1964 exhibitions.

16. The exhibition travelled around Akron (Ohio), Atlanta (Georgia) and Austin (University of Texas). The contributing artists were Hugo R. Demarco, Julio Le Parc, Luis Tomasello, Carlos Silva, Eduardo A. Mac-Entyre, Víctor Magariños D, Miguel Angel Vidal, Sarah Grilo, Fernández-Muro, Miguel Ocampo, Kazuya Sakai, Clorindo Testa, Mario Pucciarelli, Osvaldo Borda, Víctor Chab, Martha Peluffo, Rogelio Polesello, Ernesto Deira, Rómulo Macció, Jorge de la Vega, Luis Felipe Noé, Antonio Seguí, Delia Cancela, Carlos Squirru, Delia Puzzovio, Marta Minujín, Antonio Berni, Rubén Santantonín, Libero Badii, Noemí Gerstein, Ennio Iommi, Gyula Kosice, Alicia Penalba, Marino Di Teana.

17. In 1963 the United Nations agreed that 1965 would be the year of international cooperation. To celebrate it, the Ministry of Foreign Relations and Culture organised in the halls of the General San Martín Theatre a reunion of artistic, scientific and sporting works by Argentines that had earned praise abroad. There were more than 500 works of literature which had been translated or published abroad, musical compositions of international stature and photographs by artists with successful careers outside Argentina. There were also scientific, artistic, technological and philosophical essays by Argentine researchers, which had been published in

foreign magazines and specialist publications. The art exhibition was in two parts: the first, in the Museum of Modern Art, included Argentine art up to 1949. The second part, curated by Romero Brest, Hugo Parpagnoli and Samuel Oliver (representing the Torcuato Di Tella Institute, Museum of Modern Art and National Museum of Fine Arts, respectively) was hung in the Torcuato Di Tella. The idea was to show the Argentine public which artists had been recognised abroad.

18. Jorge Romero Brest, introduction to the exhibition *Argentina en el mundo. Artes visuales 2*, Torcuato Di Tella Institute, 1965–66.

19. These shifts in meaning are even more concerning given that they came from someone like Córdova Iturburu, a supporter of the Spanish Republic, and a member of the Communist Party up until 1948, when he left the party because he disagreed with its dogmatic line on realism, and who had also defended the new artistic expressions not because he thought of them as part of the propaganda system of an empire in its infancy, but because of their potential contribution to the creation of a better society.

Bibliography

Altamirano, Carlos. 1998. 'Desarrollo y desarrollistas', *Perspectivas. Revista de historia intelectual* 2.

Anderson, Benedict. 1993. *Imagined Communities. Reflections on the Origins and Spread of Nationalism*. London: Verso.

Canaday, John.1964. 'Hello, Sr. Brest. A Dialogue on Art, Half Imaginary', *The New York Times,* 13 September, Art X.

Cockcroft, Eva. 1974. 'Abstract Expressionism, Weapon of the Cold War', *Artforum*, XII, 10, June 1974.

————. 1989. 'The United States and Socially Committed Latin American Art', in: *The Latin American Spirit: Art and Artists in the United States, 1920–1970, exhibition catalogue,* Luis Cancel et al. New York, Bronx Museum of the Arts-Harry N. Abrams.

Córdova Iturburu, Cayetano. 1966. 'Argentina en el mundo', *El Mundo*, 2 January.

Giunta, Andrea. 1997. 'Historia oral e historia del arte: el caso de Arte Destructivo', *Estudios e investigaciones* 7 (Facultad de Filosofía y Letras, Universidad de Buenos Aires).

Goldman, Shifra. 1978. 'La pintura mexicana en el decenio de la confrontación: 1955–1965', *Plural* 85 (Mexico, October).

————. 1981. *Contemporary Mexican Painting in a Time of Change*. Austin: University of Texas Press.

Gómez Sicre, José. 1959. 'Nota editorial', *Boletín de artes visuales* 5 (Panamerican Union, Washington D.C., May–Dec).

————. 1959. 'Trends-Latin America', *Art in America* 47, 3 (Fall 1959).

Greenberg, Clement. 1948. 'The Decline of Cubism', *Partisan Review* XV, 3 (March).

Guilbaut, Serge. 1983. *How New York Stole the Idea of Modern Art*. Chicago: The University of Chicago Press.

————. 1997. 'Dripping on the Modernist Parade: the Failed Invasion of Abstact Art in Brazil, 1947–1948', in: *Patrocinio, colección y circulación de las artes. XX Coloquio Internacional de Historia del Arte*, edited by Gustavo Curiel. Mexico City, Institute of Aesthetic Research-UNAM.

Hunter, Sam. 1967. 'The Cordoba Biennial', *Art in America* 2 (March–April).

Kozloff, Max. 1973. 'American Painting During the Cold War', *Artforum* XI, 9 (May).

Medhurst, Martin J. 1990. 'Rhetoric and Cold War: A Strategic Approach', in: *Cold War Rhethoric. Strategy, Metaphor, and Ideology*, edited by Martin J. Medhurst, Robert L. Ivie, Philip Wander & Robert L. Scott. New York, Connecticut and London: Greenwood Press.

Messer, Thomas M. 1961–62. *Latin America: New Departures*. Boston: Institute of Contemporary Art and Time, Inc.

———. 1966. *The Emergent Decade. Latin American Painters and Painting in the 1960's*. Ithaca, New York: Cornell University Press.

Romero Brest, Jorge. 1948. 'El arte argentino y el arte universal', *Ver y Estimar* 1.

———. 1956. 'Palabras liminares', in *XXVIII Exposición Bienal Internacional de Arte de Venecia. Participación de la República Argentina*. Exhibition catalogue. Buenos Aires: Ministerio de Educación y Justicia.

Rosenberg, Harold. 1940. 'On the Fall of Paris', *Partisan Review*, VII, 6 (Nov–Dec).

Squirru, Rafael. 1963. 'Arte. Con un poco de promoción el país puede exportar cultura', *Primera Plana* II, 12 (29 January).

Williams, Raymond. 1976. *Keywords: A Vocabulary of Culture and Society*. London: Fontana Press.

Part III

Masses and Monumentality

Chapter 8

'Cold as the Stone of which it Must be Made':

Caboclos, Monuments and the Memory of Independence in Bahia, Brazil, 1870–1900

Hendrik Kraay

On 2 July 1895, a rainy winter day in Salvador, Bahia, state government officials and representatives of the city's elite inaugurated an enormous marble and bronze monument to commemorate the expulsion of Portuguese troops from the city in 1823 (figure 8.1).[1] The new monument completely dominated a barren Campo Grande, centre of a rapidly-growing upper-class residential area. Although today surrounded by high rises and towering palms planted soon after the inauguration, the monument remains an impressive structure, relatively well-maintained and unaltered from its original design (figure 8.2).

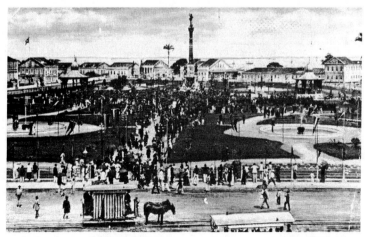

Figure 8.1 Inauguration of the *Dois de Julho* Monument, Campo Grande, 2 July 1895. Coleção Antônio Marcelino, Museu Tempostal, Salvador.

Figure 8.2 The *Dois de Julho* Monument, Campo Grande, 1895. Photograph by Hendrik Kraay, July 2000.

In raising such a monument, Bahians were participating in a nineteenth-century phenomenon. The construction of historical monuments was widely considered a mark of civilisation and a necessary way to beautify rapidly-growing cities. Both the 'statuomania' of Third Republic France and the proliferation of (mass-produced) Civil War soldier statues in the United States were part of this diffusion of public art into the urban spaces of the Atlantic World. Monuments sought to fix historical interpretations into acceptable forms – emancipation in the United States, for example, could be commemorated through statues of Lincoln but not monuments to slaves – but were themselves sometimes the objects of bitter contestation. Successive French regimes removed and replaced the monuments of their predecessors as they imposed their symbols on public space.[2] Much of the literature on monuments focuses on the complex political and artistic processes that led to their construction. While these are important issues, the real test of many a monument came after its construction, as it was inserted into civic commemorations. Certainly this was the case for the principal independence monument in Rio de Janeiro, the 1862 equestrian statue of Emperor Pedro I (figure 8.3). It became a

major part of the 7 September commemoration of the monarch's declaration of independence in 1822, celebrating his 'Grito de Ipiranga' as the founding moment of the Brazilian nation. But the statue soon faced challenges from a very different hero, Tiradentes, the scapegoat for the 1789 Inconfidência Mineira (a republican conspiracy in Minas Gerais) whom republicans advanced as a more suitable national symbol; after the 1889 proclamation of the republic, some went so far as to call for the equestrian statue's removal (Carvalho 1990: 57–73; Galvão 1962: 33–43; Ribeiro 1999; Rochet 1978).

Figure 8.3 The Equestrian Statue of Pedro I, Rio de Janeiro, 1862. Photograph by Hendrik Kraay, November 2001.

In Bahia, the commemoration of independence focused on 2 July – Dois de Julho – which presented an interpretation of Brazilian independence that recalled the expulsion of Portuguese troops from Salvador in 1823 and, more important, the popular mobilisation entrained by the independence war in that province. A key theme in Dois de Julho commemorations was the popular origin of independence and, indeed, the festival contained important plebeian elements. As such, it was more difficult to represent in public art than Pedro's declaration of independence. The Dois de Julho monument was part of an effort by some members of Bahia's elite to do away with the popular festival, for this holiday's mix of carnivalesque elements and civic ritual had become increasingly embarassing to them by the 1870s, both because of the extensive popular participation and because of the Indian figures, the *caboclos*, that symbolised Bahian independence and were the centrepieces of Salvador's celebrations. Constructing a fixed monument and making it the focus of patriotic celebrations of Dois de Julho offered a more modern, respectable way to

celebrate the holiday, just as in republican France, where fixed allegories (statues) of Marianne were more moderate images than the mobile ones associated with radical interpretations of the revolution (Agulhon 1981: 88). While official commemorations of Bahian independence after 1895 took place around the monument, the popular festival moved to the other end of the city, Santo Antônio além do Carmo Parish, where the caboclos remained the focus of commemoration. This development revealed the durability of the popular patriotism expressed in Dois de Julho celebrations, which the monument and its advocates could not suppress.

More broadly, the Dois de Julho monument can be set into several additional political, social, and cultural contexts. By the end of the imperial regime and the proclamation of the Republic – Emperor Pedro II was overthrown by a military coup on 15 November 1889 – Brazil's second city of Salvador and the province (state after 1889) of Bahia were in rapid economic and political decline relative to Rio de Janeiro. With its vibrant Afro-Brazilian popular culture and inability to attract even a tiny share of the European immigrants who flooded into the country after 1889, Bahia seemed to be the antithesis of the emerging modern Brazilian society. Indeed, Bahians had not wanted the regime change, only belatedly accepting the fait accompli of a republic on 17 November, when it became clear that Pedro II had gone into exile.[3] In the early twentieth century, Bahian governments struggled to match Rio de Janeiro in urban reforms, widening narrow downtown streets and laying out a broad (but not quite straight) Avenida Sete de Setembro, a pale imitation of the capital's Avenida Central (Leite 1998; Meade 1997: 75–101; Needell 1987: 22–8, 31–45). The Dois de Julho monument can be seen as a precursor to these later urban reforms; certainly it expressed many of the ideals inscribed on Salvador's urban geography after 1900. Yet the monument included a statue of the caboclo atop its pillar, suggesting that this demotic Indianist symbol, center of the popular festival, could not be so easily cast aside, even at a time when Indianism had fallen from favour. Critics of the caboclo could only hope to tame the symbol, freezing it in bronze and fixing it in the monument. This incorporation of the caboclo – originally a popular, even radical symbol – points, like the continuation of the festival, to the strength of popular patriotism.

Dois de Julho and its Commemoration, 1870–1894

By the 1870s, Dois de Julho was well established as the premier civic holiday in Bahia.[4] While sanctioned by the imperial government in 1831, it was celebrated only in the province, not in the rest of the country. Its complex, multifaceted celebrations have long fascinated folklorists but

have only recently drawn scholarly attention.[5] The outlines of this elaborate festival as it existed in the early 1870s are clear enough. It began with the raising of a 'maypole' on 3 May (the traditional date on which Brazil's parliament convened) in the downtown Terreiro de Jesus Square. In late June, the city council issued a *bando* or proclamation, calling on residents to participate in the festival. The *bando* was read aloud throughout the city, accompanied by bands and masked revellers. An overnight vigil at Lapinha on the northern outskirts of Salvador preceded the great parade, during which the Indianist symbols of independence, the caboclos, were conducted from their pavilion to the Terreiro. In a re-enactment of the 1823 reoccupation of Salvador, this parade included civil and military authorities, army and National Guard battalions, informally-organised patriotic battalions and all of the city's brass bands, followed by large crowds.

After a *Te Deum* in the cathedral, authorities led the crowd in vivas to the emperor (whose portrait was unveiled), to Brazil and Bahia and to heroes of the independence wars from a specially-constructed stage in the Terreiro de Jesus (figure 8.4). Authorities and leading citizens then repaired to the Teatro São João for an evening gala, which began with another unveiling of the emperor's portrait, followed by several rounds of cheers, singing of the national anthem and reading of patriotic poetry, after which they settled in for an opera or drama drawn from the theatre company's mostly-European repertoire. At the same time, the illuminated stage was given over to amateur poets and bands who entertained the crowds that flocked to the Terreiro. The caboclos remained on display in the pavilion for several nights, during which the poetry readings and rituals of cheers to authorities were repeated. Finally, the caboclos were returned to Lapinha during a boisterous evening parade that took them through most of the city.

A complex amalgam of diverse elements, Dois de Julho has proved difficult to analyse. Virtually all scholars of both modern and historical Dois de Julho celebrations note that they escape the logic of Roberto DaMatta's classification of three types of Brazilian rituals – military parades, religious processions and carnivals – combining elements of all three in a single festival (Albuquerque 1999: 67; DaMatta 1991: 26–60; Kraay 1999: 263–64; Sampaio 1988: 154; Serra 2000: 148–59). It offered a complex political message, presenting the popular mobilisation in the Bahian independence war as Brazil's founding, rather than the actions of Pedro I, commemorated in Rio de Janeiro's equestrian statue and officially celebrated on 7 September. The caboclos, multivalent Indianist symbols, represented the nation with demotic, popular figures, something akin to secular saints to be paraded through the city and venerated by their followers. Together with the festival's indubitable popularity and even carni-

valesque features, these elements of Dois de Julho suggest that a significant degree of identification with the state came from below.

Figure 8.4 The *Dois de Julho* Stage, Terreiro de Jesus, 1871.*
Illustration from *O Reverbero*, 6 Aug. 1871, pp. 4–5.

Dois de Julho presented a complex political message. On the one hand, it was the premier Bahian holiday, commemorating events that took place in the province. All knew that it was not celebrated elsewhere in Brazil but Dois de Julho editorials repeatedly asserted that it was 'a glorious date not only in the annals of Bahia but also in those of the fatherland [*pátria*]', to cite one typical effort to associate Dois de Julho with Brazilian independence.[6] Asserting the centrality of Dois de Julho in Brazilian independence offered Bahians an opportunity to demonstrate their symbolic importance in the face of relative economic and political decline.[7]

Dois de Julho also celebrated Bahian independence's popular origins and Salvador's newspapers clearly distinguished it from 7 September.[8] By the 1870s and 1880s, the more radical elements of Dois de Julho – aggressive lusophobia and vigorous assertions of popular sovereignty – common in earlier years, were generally absent from the press but they were certainly implicit in the popular participation in the festival. I have elsewhere interpreted the recurring violence against regular soldiers and army bands during the celebrations of the 1870s and 1880s as a rejection of hierarchical national state institutions (Kraay 1999: 282–83). The frequency with which newspapers reported the peaceful passage of Dois de Julho (or hoped and expected it) reveals elite concerns about maintaining order. With unintended irony, the city council reminded Bahians in 1880

* The caption reads: 'Illuminação na Praça do Conde d'Eu pelo Festim da Independencia no Dia Dous de Julho de 1871'. Portraits and figures from left to right: Emperor Pedro I, the caboclo, General Pedro Labatut, Princess Isabel (hidden), Emperor Pedro II (hidden), General José Joaquim de Lima e Silva (hidden), Viscount of Pirajá, the cabocla, Baron of Belém (Rodrigo Antônio Falcão Brandão).

of the importance of 'labour, [the] powerful element of modern nationalities' progress'. Furthermore, Dois de Julho celebrations customarily served as an occasion for opposition newspapers (and patriots more generally) to criticise the government with a greater degree of liberty than otherwise. In 1882, the *Gazeta da Bahia* lamented that, on the day on which Bahians celebrated their 'liberty', the people suffered under the 'reign of a dictatorship, governed by despotism!'[9]

The caboclos, male and female, exemplify the popular interpretation of independence and the nation. The caboclo – an Indian stabbing the serpent of (Portuguse) tyranny – dated back to the 1820s (figures 8.5, 8.6, 8.7). Its origins in lusophobic post-independence patriotism are clear and caboclos appeared on the masthead of anti-Portuguese newspapers (figure 8.8). The caboclo was also part of the broader efforts to associate newly-independent Brazil with a relatively safe, Amerindian past, familiar from Indianist literature. The Indians' resistance to Portuguese incursions offered a certain parallel to the Brazilians' own struggle for liberty from the mother country (Brookshaw 1988: 34–5; Treece 2000: 91–3, 96). According to Manoel Raimundo Querino and Alexandre José de Mello Moraes Filho, the *cabocla* was sculpted in the 1840s, on the insistence of a Portuguese-born provincial president (governor) who found the caboclo to be offensive (figure 8.9). The story, however plausible, has yet to be confirmed in the surviving press records of these years but the cabocla is clearly a more passive figure (Moraes Filho 1946: 127; Querino 1923: 86).[10] By the 1870s, both figures were paraded and displayed together (figure 8.4).

Figure 8.5 The *Caboclo*, 1871. Illustration from *O Reverbero*, 6 Aug. 1871, p.1. This is a mirror-image, for the caboclo is right-handed. See figs. 8.4, 8.6, and 8.7.

Figure 8.6 The *Caboclo* and its wagon, Lapinha, 2 July 2000. Photograph by Hendrik Kraay.

Figure 8.7 The *Caboclo*, Lapinha, 2 July 2000. Photograph by Hendrik Kraay.

Figure 8.8 The *Caboclo* used on the masthead of an anti-Portuguese newspaper. Illustration from *O Abatirá* (Santo Amaro), 2 July 1851.

Figure 8.9 The *Caboclo*, Lapinha, 2 July 2000. Photograph by Hendrik Kraay.

The complex meanings of the caboclos in popular culture have not been fully traced. Although caboclos are non-white figures, they originally constituted a rejection of Bahia's African heritage, much as they also distinguished Bahians from the Portuguese. Indianism was, at its origins, highly exclusive (Schwarcz 1999: 148). As the African population gave way to a creole Afro-Bahian population after the mid-century end of the slave trade, the caboclos resonated ever more deeply in popular culture. Today caboclos are important deities in some Candomblé (Afro-Brazilian religion) traditions and signs of this transformation may be visible in nineteenth-century complaints about *batuques* (Afro-Brazilian dances) during Dois de Julho celebrations (Kraay 1999: 268–69; Santos 1995: 39–51).

By the early 1870s, Dois de Julho celebrations were a well-established half-century old tradition; indeed, newspaper reports frequently refer to customary activities during the festivities without describing them. They also posed problems for some in Bahian society. Real or latent popular excesses were worrisome and the caboclos were becoming increasingly problematic images as Indianism went out of fashion. As do all traditions and rituals, Dois de Julho was continually evolving and some later chroniclers saw the early years of the 1870s as the festival's apogee. João da Silva Campos (1880–1940) considered 1875 the last of the great festivals 'of the olden days' and, to the extent that they were writing about their experiences, Querino (1851–1923), Mello Moraes Filho (1843–1919) and Xavier Marques (1861–1942) captured the festival of these years.[11] On the surface, however, relatively little changed and, year after year, Bahians repeated the well-established programme of parade, *Te Deum*, salutes to the emperor and authorities, night-time illuminations in the Terreiro de Jesus accompanied by poetry and martial music, a theatre gala and the caboclos' return to Lapinha three days later.

Nonetheless, several major changes in Dois de Julho took place at this time. The first was the increasingly explicit association of the festival with abolitionism. While Dois de Julho emancipations were recorded as early as 1855, the practice of freeing slaves on 2 July became more common as the campaign against slavery gathered strength in the 1870s.[12] Emancipation moved into the centre of Dois de Julho celebrations in 1877, when a newly freed child was featured on a float immediately following the caboclo in the main parade; in 1881, the theatre gala would begin with an 'apotheosis, for which the stage will be appropriately transformed, at which time the manumission papers will be given to the people freed by the festival's organizing committee'.[13] Newspapers of the 1880s and later chroniclers regularly associated Dois de Julho with abolitionism and, when slavery was finally abolished on 13 May 1888, a remarkable demonstration of the caboclos' significance to the Afro-Bahian popular classes took place. According to the *Diário da Bahia*,

formerly 'enslaved people' requested that these symbols of liberty be brought into the streets for an impromptu parade.[14] In 1888 and 1889, Dois de Julho continued, for some at least, as a celebration of abolition. A Princesa Isabel Patriotic Battalion marched in 1888 in honour of the regent who had signed the law abolishing slavery and a handbill that circulated in either 1888 or 1889 recalled the major laws that ended slavery, connecting them to the struggle for independence.[15] While abolitionism was a largely middle-class, educated movement, the association of Dois de Julho with the campaign against slavery probably served to cement the holiday's popularity among the Afro-Brazilian lower classes.

A second development in Dois de Julho commemorations in these years was the proliferation of neighbourhood or parish Dois de Julhos, which continued the festival into July and sometimes even August and spread it throughout the city and its suburbs. These were, in many cases, miniature reproductions of the main festival, complete with visits from the caboclos, illuminations, stages for poetry readings and patriotic speeches and martial music. Dozens of locales for such festivals can be documented in the press of these years. Most parish Dois de Julhos were popular or plebeian in their orientation, bringing the festival and its patriotism closer to the urban population (Kraay 1999: 262; Vianna 1976–77).

A third set of developments in Dois de Julho during the 1870s and 1880s is more difficult to analyse. Newspapers frequently commented that the holiday was commemorated with less enthusiasm than formerly. In 1889, the *Diário do Povo* lamented the 'indifference of the population and associations who did not take part'. 'Half-hearted and poorly attended were the festivities', remarked the *Gazeta da Bahia* in 1880 and it later attributed the lack of enthusiasm to the province's political and economic crises: 'What can the ordinary people do but protest through their apathy?'[16] Several newspapers noted a gradual decline in upper-class and official participation in Dois de Julho. Already in 1871, *O Alabama* had sharp words for the town council, all but one of whose members had missed the *Te Deum*, and the National Guard, none of whose commanders had paraded. In 1877, *O Monitor* remarked that some 'even mock the popular demonstrations, laugh at the symbols of liberty [the caboclos] and consider them inappropriate for modern civilisation'.[17] Dois de Julho traditions, however, also had their defenders. In 1886, *O Faisca* condemned those who, 'stuck in the narrow shell of their egoism, judge that *it is high time to do away with patriotic nonsense [patriotadas]'.[18] Even as it lamented Dois de Julho's decline, the *Gazeta da Bahia* defended the popular celebrations: 'These noisy festivities, in which the ordinary people let loose and jubilate, are not merely oubursts of a wild enthusiasm. They are a noble adoration of the fatherland's traditions. They are a sincere homage to the memory of the heroes who gave us [our] independ-

ence'.[19] Such defences of Dois de Julho are, of course, telling evidence of the criticisms that its customs were facing.

The proclamation of the Republic shook the traditional Dois de Julho customs and the Bahian populace. Not only were republicans a tiny minority in Bahia (they consisted mostly of medical students and army officers) but the imperial regime was genuinely popular in its last years, principally because of the royal family's perceived support of the cause of abolition (Barman 1999: 346; Carvalho 1999: 29). The new republican state government apparently doubted the wisdom of supporting Dois de Julho celebrations; only at the last minute did it grant the traditional 2,000 mil-réis subsidy to the city council to organise a festival for 1890. Two newspaper accounts of this Dois de Julho concur that it was poorly attended by an indifferent population. For the Catholic *Leituras Religiosas*, this was to be expected, given the secularizing Republic's hostility to the church; the *Pequeno Jornal*, still supporting the regime change, could only lament that the people failed to demonstrate sufficient patriotism: 'An indifferent people will never have a free fatherland'.[20] It also reported with horror on the 'serious incidents' in Valença, where 'the rabble, on the occasion of the Dois de Julho festivities, tore republican flags and tried to stone the portrait of the provisional government's head, Generalíssimo Deodoro [da Fonseca]'.[21] Significantly, there are no indications that organisers attempted to display Deodoro's portrait in Salvador or even that authorities participated in the celebrations at all. By 1892, the *Pequeno Jornal* was completely disillusioned with the Republic, while the *Jornal de Notícias* sought to associate Dois de Julho with republican virtues. The celebrations of that year in Salvador more closely resembled those of the late empire, although authorities (including the governor) only attended the *Te Deum* and no efforts were made to conduct public rituals recognizing the state and its representatives.[22] Dois de Julho, it appears, was too closely connected to the imperial regime to be easily absorbed by the Republic, and republican authorities were too uncertain of support for themselves to risk leading public vivas as imperial authorities had done in the 1870s and 1880s.[23]

In short, from the 1870s to the 1890s, Dois de Julho had suffered a gradual withdrawal of upper-class participation and a loss of elite identification, a process that the proclamation of the Republic may have accelerated. The first explicit discussion of these developments came in a long analysis of the festival's transformation, published in 1896. After a survey of traditional commemorations as thorough as any of the later folklorists' accounts, 'Tupinambá' turned to the changes that had taken place:

> Dois de Julho began to be seen not as a legitimate and beautiful manifestation of the people's soul, but as just some patriotic nonsense [*patriotada*], of no importance and with no

practical purpose. It got to the point that there were those who were ashamed to go out in patriotic battalions. To pull the caboclos it was now necessary to draft people, because it looked bad for a a man of a certain class to tow those old broken-down wagons, which should have been locked up for good so that foreigners did not laugh at our expense, because we were showing off our savagery and ignorance symbolising Brazil with the statue of a caboclo who did not even wear pants.

Noting that carnival had recently outstripped Dois de Julho in popularity, Tupinambá blamed this on the shame that some felt at the caboclo 'who is not white and only wears feathers. If only he had been imported from abroad', he continued, without finishing the sentence.[24] In this analysis, Tupinambá identified the desire for modernisation, Europeanisation and whitening on the part of the city's upper and middle classes as the principal cause of Dois de Julho's decline. His verdict came a year after the inauguration of the Dois de Julho monument, which featured a four-meter tall bronze caboclo, founded in Italy, and he thus also chided the Bahian elite for its acceptance of a foreign caboclo while rejecting the domestic version.

Tupinambá's comments must be seen in the context of an increasingly popular Dois de Julho, as suggested by the identification of the festival with abolition and the proliferation of parish Dois de Julhos, which were turning it into something beyond elite and government control. Thus, when newspapers lamented declining enthusiasm for Dois de Julho, they were speaking of the literate middle- and upper-class publics to whom they were directed, the men 'of a certain class' ashamed to pull the caboclos. Part of these developments, as Tupinambá had noted, was the campaign to erect the Dois de Julho monument.

The Dois de Julho Monument, 1876–1895

While the earliest known reference to a Dois de Julho monument proposal dates from 1849, when the Sociedade 2 de Julho called a meeting to discuss the selection of a monument and Bahians occasionally lamented the lack of even 'a humble work of masonry' to commemorate independence,[25] the first sustained campaign for a monument began in 1876. Bahian independence was a historical fact that could not easily be reduced to a single allegorical monument, much less a personal statue. To be sure, the caboclos offered well-established symbols but they were already controversial in the government and elite circles whose support would be necessary for any monument. Moreover, no single individual lent himself to serve as a symbol in the way that Pedro I could be seen as the empire's founder. Not surprisingly, then, the earliest known design for a Dois de Julho monument, dating from 1877, contains nothing distinc-

tively Bahian: It proposed a female allegory atop a column, holding laurels and broken chains in her hands.[26]

The monument campaign of the 1870s was officially led by the directors of the Dois de Julho celebrations, whose public appeal for donations stressed the need for a popular monument. Pedro I was certainly deserving of his monument in Rio de Janeiro but was he greater than 'the people, who struggled, sacrificed themselves and triumphed,' asked the directors? In short order, they began raising money. The 1876 stage featured donation boxes and students received permission to put on a theatrical benefit, during which they would perform Antônio Frederico de Castro Alves's *Glória bahiana*. The cash-strapped provincial government weighed in with a promise of 30,000 mil-réis in matching funds (fifteen years' worth of the annual contribution to Dois de Julho celebrations). Deputy João de Brito argued that this was money well spent, for 'the utility of monuments has always been recognised, and there is no civilised nation on the globe that does not have them'. Monuments were, he continued, history lessons, far more eloquent than the words of historians.[27]

Brito's comments were, of course, true as far as they went but he did not address the issue of what history should be commemorated in the monument. Moreover, not all agreed with the monument project. From Feira de Santana, *O Motor* railed against it, 'cold as the stone of which it must be made', proclaiming that its advocates were seeking to suppress the popular festival.[28] While *O Motor* may have been right, the campaign sputtered along and, in 1881, the monument's cornerstone was blessed and laid in the Praça dos Mártires (Campo da Pólvora). The official record of the ceremony notes the presence of all of the executive and legislative authorities in the province and reports that the large crowd gave 'enthusiastic cheers to the state religion, to His Majesty the Emperor and to the imperial family, to the immortal date of 2 July, to the imperial constitution, to the Bahian people, etc.'[29] It is not clear how this site was selected or whether the organisers had already chosen the monument's design.

At this point, the campaign faltered. Dois de Julho coverage in the mid-1880s reveals nothing about the monument but, in 1887, the abolitionist writer, Luiz Anselmo da Fonseca, responded to the appointment of a new committee to continue the project by calling on Bahians not to erect a monument as long as slavery persisted in Brazil (Fonseca 1988: 240). His appeal went unheeded and, in April 1888, plaster models were exhibited in Salvador; the *Diário do Povo* assured its readers that the price of the finished work was 'comparatively quite modest' but another newspaper shortly thereafter called for more donations. The following year, the *Diário do Povo* urged organisers to hurry the construction of the monument and the provincial assembly voted a substantial sum for the 'work of national gratitude'.[30] *A Locomotiva* wondered, however, whether

any sufficiently clean and tidy squares could be found in Salvador for the monument. It ran a tiny cartoon showing a befuddled bourgeois gentleman gazing at a monument overgrown with weeds and surrounded by grazing livestock (figure 8.10). Erecting a monument in such a square would be like putting on a jacket and white leather gloves 'and going in slippers to pay respects to Their Majesties'. Continuing with the metaphor of inappropriate dress, the newspaper recommended more attention to street cleaning, calling on the assembly to decree 'the purchase of boots so that the old mulatto woman [*mulata velha*, a pejorative nickname for Salvador] shoes herself before she dresses in silks and shows off luxurious adornments'.[31]

Figure 8.10 Urban Reform and the *Dois de Julho* Monument: 'The Cart before the Horse'. Illustration from *A Locomotiva*, 1889.*

In the early 1890s, the issue of the monument's location bedevilled the organisers. What prompted a reconsideration of the Campo dos Mártires is not clear but a bitter debate ensued and the *Diário de Notícias* organised a plebiscite to settle the matter. More than 32,000 votes were cast; by comparison, only 7,800 men were eligible to vote in state and federal elections in Salvador in 1906. A slight majority selected the Campo do Barbalho; the Campo dos Mártires finished a distant second and Campo Grande came in third. Barbalho, close to Lapinha, was a popular choice in more than one sense, for it was a lower middle-class neighbourhood, quite different from the posh Campo Grande. The monument commission was not, however, bound by the popular vote and, backed up by the recommendations of an engineering committee, its members chose Campo Grande. This debate left is mark on urban

* The caption reads: 'O carro adiante dos bois'.

popular culture and the saying, 'to cry at the caboclo's feet', came to mean the only possible response to a decision over which one had no control.[32]

Blessed by the archbishop, the monument's cornerstone was laid at the end of the 1892 Dois de Julho celebrations. Patriotic battalions, army bands, philharmonic societies, the city council, all of the city and state authorities and a 'great mass of the people' were on hand, along with the caboclos, to celebrate this beginning. The *Jornal de Notícias* called on all Bahians to join in this 'new movement of civilisation and, more important, patriotism'. Senator Manuel Vitorino Pereira set the tone for the celebrations in a long speech. After invoking the 'august religion of the past, pious cult of the most holy traditions', he cryptically and cautiously alluded to some of the issues that the monument had raised: 'The tenacious resistance that we offer to innovations, the struggle that we sustain between the audacious invasions of progress and our primordial and deep-rooted customs, express the effort with which we seek to save the past, which for us merits holy respect for the virtues and nobility of our first citizens'. He praised the 'patriotic cult and enthusiasm, dedicated to the aboriginal, the Indian in whom we symbolise our origin, constantly resonating in the soul of these commemorative celebrations'. Nevertheless, he hailed the monument: 'These statues were founded far, very far from us, there in that country where ... humanity underwent the solemn transfigurations of Michaelangelo'.[33] The old traditions, in short, could best be celebrated in new ways, especially if they incorporated the cultural traditions of Europe.

Construction could then begin and the monument was completed by 1895. Almost twenty-six meters tall, designed by Carlo Nicoli, Brazilian consul in Carrara, Italy, and a little-known sculptor, it is topped by a four-meter statue of a caboclo in the classic pose of trampling and stabbing the serpent of tyranny. The column bears the names of twenty-four independence-era heroes; they are, however, too small to be easily read from the ground. Two allegorical figures flank the column: Catarina Paraguaçu, the semi-legendary Indian who aided the first Portuguese in Bahia, and a robust female allegory of Bahia in the act of proclaiming her independence. Beneath these female allegories, reclining male figures represent Bahia's two principal rivers, the São Francisco and the Paraguaçu. The other two sides of the square base are decorated with victorious eagles rising over war trophies, behind which bronze bas-reliefs commemorate two battles: 25 June 1822 in Cachoeira and 7 January 1823 in Itaparica. Four other dates are explicitly mentioned, providing a history of Brazil with Bahia at its centre: the discovery of Brazil (22 April 1500), the founding of Salvador (6 August 1549), the proclamation of independence (7 September 1822) and the

entry of the patriots into Salvador (2 July 1823). The dates of four other battles are also inscribed on the monument.[34]

Until the records of the design selection surface, we can do little more than speculate on some of the monument's features. The bas-reliefs ensured that the monument was as broadly Bahian as possible by including events that were significant to the state's second city, Cachoeira, and the residents of nearby Itaparica Island (25 June and 7 January were respectively commemorated in these districts). The major Battle of Pirajá (8 November 1822) got short shrift (being included with three other lesser battles) but it had never become a significant focus of celebration. No recognizable independence-era figures are represented in the statues – the entire monument is allegorical – and historical actors are only commemorated in the names on the column. Most are officers or leading political figures but the list also includes Cornet Luiz Lopes, whose erroneous playing of the orders for a cavalry charge allegedly prompted the key Portuguese retreat during the Battle of Pirajá.

Three years after the laying of the cornerstone, the finished monument was inaugurated (figure 8.1). The *Diário da Bahia*, then the governing party's official newspaper, effusively covered the inauguration, devoting its entire 2 July 1895 issue to historical documents on the independence war and classic Dois de Julho poetry dating from the 1820s to the 1870s. The inauguration itself began with a carefully-organised parade from the Terreiro de Jesus, to which the caboclos had been brought on 1 July by a team of municipal firemen.[35] Led by a police picket to escort the caboclos and the firemen, the parade included the Dois de Julho festival committee, the city council, medical and law students with their standards, secondary school students, an artisans' patriotic battalion, a numerous contingent from the Centro Operário, two Italian mutual aid societies, a float with three elderly independence-war veterans, representatives of industry and other societies not mentioned by name in the accounts, and at least four bands. Apparently Governor Joaquim Manuel Rodrigues Lima, the acting archbishop and the representative of the Brazilian president awaited the parade at the monument. There, after an outdoor mass, the monument was blessed and a large children's choir sang the Dois de Julho hymn. The monument was hailed in speeches, panegyrics and verse. The governor unveiled the bronze bas-reliefs and led the crowd in vivas to the Republic, 'one and indivisible', to the president, to Bahia, to Dois de Julho, and to the Bahian people. All were warmly echoed. Telegrams from the vice-president, Bahian Manoel Vitorino Pereira, and the state's senator, Virgílio Clímaco Damásio, were read. The president's representative then invited the governor, the festival committee, the city council, and other 'gentlemen' to a 'delectable lunch' served in his nearby mansion. Mag-

nesium lamps lit the well-decorated Campo Grande that night, much to the delight of the 'enormous confluence of families and ordinary people [*pessoas do povo*] who went to appreciate the grandiose memorial'.

The *Diário da Bahia*'s Dois de Julho editorial presented an official interpretation of the monument. It emphasised Bahia's centrality in Brazilian history as the site of the first Portuguese landing and the first mass, which made it the 'first cell of the current Brazilian society'. Repeating the republican interpretation of independence, the author argued that Pedro I's proclamation merely consummated developments already well underway since the 1789 Inconfidência Mineira. Portuguese resistance meant that 'here the passion of Brazilian independence was celebrated'. Three-quarters of a century later, it was high time that 'the timber of the generation and the people who made and consolidated independence be immortalized in permanent bronze'. The editorial called on Bahians to make the monument the centrepiece of their 'patritotic worship', finally hailing it as a republican symbol: 'Monument erected in honour of liberty, do not repel, rather embrace the republican belief, which is a development of the cold codes, repealed or perfected with the influx of the new doctrine that the apostles of '89 spread throughout the world'.[36] In short, the editorial linked two disparate elements to Dois de Julho: the church, which also had a leading role in the inauguration, and the Republic, whose connections to Dois de Julho were neither obvious nor accepted in the early 1890s.

A few discordant notes marked the inauguration. The *Correio de Notícias*, an opposition newspaper, failed to muster as much enthusiasm for the monument as did the *Diário da Bahia*. It remarked that the festival 'has run indifferently' and churlishly observed that Gaensly and Lindemann's commemorative poster (figure 8.11) revealed the 'irregular placement of the figures, set out in a poor perspective'. Even the *Diário da Bahia* opened its columns to two critical commentaries. One anonymous author lamented the decline of Dois de Julho's 'former pride' under the 'attacks on your traditions which have been perpetrated by many of your degenerate sons!' Another writer accepted the monument as a 'consecration of the past' but, noting the numerous burdens under which the population was suffering, declared that, were this monument 'an affirmation of the present', he would have to proclaim it 'a lie of bronze inside a cruel joke of marble'.[37]

The caboclos' return to Lapinha from Campo Grande on 7 July offered important contrasts to the official celebrations. Residents of Santo Antônio além do Carmo Parish had prepared 'dazzling and noisy diversions' and a group of citizens led by 'the bold abolitionist and determined republican', Frederico Lisboa, resolved to dedicate this day to three elderly veterans of the independence war: Francisco Assis Gomes,

Figure 8.11 The Gaensly and Lindemann Print of the *Dois de Julho* Monument, 1895. Coleção Antônio Marcelino, Museu Tempostal, Salvador.*

Inácio Alves Nazaré and Constantino Nunes Mucugê. Only Nazaré felt well enough to join the parade and Lisboa called on the people to pull his carriage, noting that 'by happy coincidence the old soldiers of liberty were not viscounts nor marquises, but simply three or four men of the people, two of them honorable artisans or goldsmiths and the other a blacksmith'. The paraders left an exhausted Nazaré at his downtown residence and continued into Santo Antônio Parish. Here the fire brigade, which had up to this point drawn the caboclos, turned them over to the 'people, who demanded ... to conduct them to Lapinha'.[38]

The contrast between this celebration and that of the monument's inauguration five days earlier could not have been greater. Here the people, abolitionists, artisan veterans of the independence war and the caboclos took centre stage, supplanting authorities and the monument. But when the caboclos left Campo Grande and the Terreiro de Jesus, it would be the last time for many years that they would be seen in those parts of the city.

* This image appears to be one in a series done by these photographers. See, for example, the very similar photograph, including many of the same people, in Ferrez 1988: 186.

Transforming Dois de Julho, 1896–1900

The inauguration of the Dois de Julho monument initiated significant changes in the social geography of the holiday's commemorations. Newspaper accounts of the years immediately following 1895 all concur that a bifurcation of the celebrations took place.[39] Two centres of commemoration emerged, one around the monument, the other in Santo Antônio além do Carmo Parish's main square, at the opposite end of the city. The Campo Grande celebrations were organised by the city government, while the Santo Antônio festival was coordinated by local notables.

Heavy rains marred the festival in 1896 and the *Diário da Bahia* reported that the celebrations 'ran in an indifferent way'; not even 'Joe Public [*Zé povinho*] is interested in his great days any more', lamented this newspaper's social columnist, wondering whether the reserves of patriotism were finally exhausted.[40] Such laments were common in these years but to focus on them would be to miss the nature of the celebrations that actually took place. In 1896, they began at noon on 2 July, when the caboclos were drawn from their pavilion in Lapinha through Santo Antônio Parish to its main square. They were accompanied by the parish festival's organizing committee, the municipal intendant and his secretary, a police band, a picket of police cavalry and a small crowd that braved the rain. After leaving the allegories in specially-prepared stages (figure 8.12), a 'small cortège', including presumably the intendant and some of the parish organisers, hurried to the Terreiro de Jesus, where they attended the Te Deum, along with the city's authorities. A second parade in the late afternoon headed from downtown to Campo Grande, where students in the Liceu's band braved torrential rains to circle the monument, playing patriotic music. That these two celebrations were distinct events was underscored by the publication of separate announcements for them.[41]

Figure 8.12 The *Dois de Julho* Stage, Santo Antônio além do Carmo Parish, c. 1900. Arquivo do Instituto Geográfico e Histórico da Bahia, pasta 6, reg. 0378.*

* This image has been dated by W. R. Albuquerque to the period 1900–20; she incorrectly identifies its location as the Terreiro de Jesus (Albuquerque 1999: 144).

In subsequent years, this pattern of commemoration became firmly established. The afternoon parade from the Terreiro de Jesus to Campo Grande, the 'great civic pilgrimage', orderly and carefully organised, included government officials, military and police officers, schoolchildren and representatives of the press, industry and other associations. The city government funded the celebration at Campo Grande, which usually included fireworks, illumination of the square and the playing of martial music for two or three evenings. In 1897, the intendant served champagne and ice cream to the wives of the official guests who watched the fireworks from a specially-constructed stage. Both the *Correio de Notícias* and the *Diário da Bahia* noted the presence of numerous 'families', underscoring that this was an elite festival. The *Jornal de Notícias* reported in 1898 that the municipal government 'knew how to fulfill its obligations regarding the decoration and illumination' at Campo Grande but the evening celebrations had moved downscale: Instead of fireworks, the city held a large bonfire, 'a diversion that so pleases our people that it is an obligatory complement to their festivals'. In 1899, the city was roundly condemned for putting up only some flags around the monument, failing to illuminate the square, which produced a 'poor effect'.[42]

The monument itself had a rather limited role in these celebrations. It did not, as the *Diário da Bahia* hoped in 1896, become the focus of a 'popular pilgrimage'. Nor did it become a sacred symbol like the caboclos. One journalist condemned the 'treason [*lesa-civismo*]' of those who sat on the steps and even scrambled up the bronze statues to gain a better view of the 1897 celebrations.[43] The use of the monument's image in advertising, however, appears not to have prompted critical comment and a shoe store's advertisement appeared regularly in the press of the late 1890s (figure 8.13).

In contrast to the limited 1899 decorations on Campo Grande, Santo Antônio Square was 'ostentatiously bedecked with flags' and lit by electricity. For four nights, it would feature band concerts and, judging by the 'great influx of people' on the first night, this festival far exceeded that of Campo Grande. Here the caboclos, rather than the monument, were the centrepieces of the celebrations, which according to the *Correio de Notícias*, in 1897 followed the 'form of the ancient festivals held in this capital'. A few years later, this newspaper noted that 'although with different origins, two festivals, one complementing the other, were held'.[44] In short, all of the traditional popular symbolism and practices of Dois de Julho commemorations had been transferred to Santo Antônio Parish, leaving the monument as the object of a primarily state-directed civic ritual – the afternoon parade – which failed to take root in Salvador society. The whole cycle of traditional popular Dois de Julho activities took place in Santo Antônio: the raising of a 'maypole', the *bando* (which in 1899

began at Lapinha and covered the entire city), the caboclos' parade, their display for several nights amid a popular festival and their return to Lapinha. Official participation was largely absent from Santo Antônio's festival, which according to the *Correio de Notícias*, was 'entirely popular' in 1897.[45]

Of course, the separation between the two festivals was never absolute. In some years, the intendant and municipal officials found time to partic-

Figure 8.13 The *Dois de Julho* Monument Used in Advertising. Illustration from *Revista Popular*, Sep. 1897, unnumbered pages.

ipate in the Santo Antônio parade and the parish committee also invited representatives of the press to join their parade.[46] Portions of the Santo Antônio parade were sometimes destined for the 'civic pilgrimage' – in 1899, for example, an allegorical float, featuring a child representing the state of Bahia, bore a wreath that would be laid at the monument. So too, the police lancers, navy apprentices, firemen and battalions of students, orphans and workers occasionally joined the afternoon parade. The few patriotic battalions mentioned in these years – Patriotas de Santo Antônio, Legião de Labatut and Defensores de Santo Antônio – did not leave the parish.[47] And the caboclos remained in Santo Antônio. The images of modernity and progress that we expect to find in the afternoon parade also turned up in Santo Antônio. In 1900, the workers of the Empório Indus-

trial do Norte, accompanied by a band and led by their employer, marched behind a white banner with the slogans of 'Peace' and 'Labour'. School-children were on hand in 1899 to welcome the caboclos with the national anthem and the hymn to independence; that year, the newspaper also praised the parish's police officials, who had ensured that no 'illegal gaming' took place, a sharp contrast to Campo Grande, where journalists had seen people taking and making bets in the numbers game [*jogo do bicho*] during the commemorations.[48]

In short, in the second half of the 1890s, Santo Antônio além do Carmo emerged as the centre of popular Dois de Julho celebrations that outshone the city government's efforts to promote Campo Grande and the monument as the premier locale for Bahian independence celebrations. Oral tradition today attributes Santo Antônio's importance in the festival to the fact that the patriot army had entered Salvador through this parish in 1823 but this simplifies a much more complex process.[49] The location of the caboclos' pavilion at Lapinha no doubt helped cement local identification with Dois de Julho celebrations. More important, perhaps, were the determined efforts of parish notables to preserve the festival, rather than join those of the city's elite who rejected it. Organizing the festival involved extensive participation, at least judging by the parish committee structure: Block committees appointed by the central committee to supervise decorations along the parade route.[50] Little is known about those involved but Colonel Manoel Lopes Pontes, president of the parish committee in 1899, was described in his obituary as a 'political broker in the district of Santo Antônio'. Owner of the Colégio Santo Antônio and a Liberal Party stalwart in the late Empire, he was a National Guard colonel and had served in the state legislature.[51] For such men, organizing a parish festival might have been simply an extension of their political activity on behalf of their local community. His obituary further noted that he was an 'oppositionist' in the Republic, so perhaps fostering a parish Dois de Julho reflected his opposition to the government and its celebrations at the monument. More broadly, such men reveal the complex cultural politics of a Bahian elite not unified in its desire to modernise or civilise Dois de Julho celebrations.

The transformations in Dois de Julho celebrations from the 1870s to the 1890s raise several additional issues. While the story of the monument can readily be fitted into interpretations that stress late nineteenth-century Brazilian elite desire for modernisation, Europeanisation, progress and civilisation, it also reveals the complexity of this process. Monuments aim to fix historical interpretations into acceptable forms, thus becoming, once constructed, natural features of the urban landscape, their interpretations going uncontested, even though their design selection may have been highly controversial (Knauss 2000: 299; Savage

1997: 7–8). The Dois de Julho monument, by contrast, failed to suppress the caboclos and the popular festival, which merely moved to Santo Antônio além do Carmo Parish, from which they regained their role in the city-wide festival in the middle of the twentieth century.

The monument is what Paulo Knauss would characterise as one of gratitude that 'symbolically fixes the alliance between State and Society' but this alliance was far from clear during Dois de Julho celebrations as large sectors of society repudiated the state (Knauss 1999: 9). States may state, to paraphrase an often-cited work (Corrigan and Sayer 1985: 3), but people do not always listen. They choose to accept, reject, ignore or modify the statements embodied in monuments. However, the extent to which Santo Antônio além do Carmo's Dois de Julho was truly a civic ritual, as opposed to merely a popular festival, and the degree to which it expressed patriotism or nationalism remain difficult issues to ascertain. Certainly the festival played (and plays) an important role in defining Bahians' collective identity and, given the highly exclusionary political order of the republic, it offered an alternative space for the expression of a certain political identity, at a basic level the rejection of official nationalism. In this regard, José Murilo de Carvalho's discussion of Rio de Janeiro after 1889 reveals similarities to the Bahian experience. While the ordinary people of the Brazilian capital may have been 'bestialized' in the eyes of elite and foreign commentators, they were more likely 'rogues [*bilontras*]' who turned their backs on the state and its political order that excluded them, building identity and community in mutual aid societies, popular festivals like that of Penha and the (eventually) characteristically *carioca* soccer, samba and carnival (Carvalho 1999: 140–60).

Dois de Julho followed a similar trajectory and, in the mid-twentieth century, the caboclos returned to Salvador's streets as the old nineteenth-century traditions were reworked into the modern parade that brings them from Lapinha to downtown in the morning and to the monument in the afternoon.[52] Today, civil and military authorities (including the mayor and the governor) accompany the entire parade on foot. Whether this reflects a victory of the popular festival or its cooptation by the dominant elite is inherently difficult to determine. Scholarship on analogous developments in carnival and other forms of popular culture tends to see them as cooptations of popular practices that serve to bring them under control (Levine 1984; Oliven 1984). Unlike the modern Brazilian black movement, whose leaders have vigourously debated the efficacy of cultural politics (Butler 1998b), Dois de Julho lacked and lacks a core of conscious ideology, such that the political meaning of the popular festival remains difficult to elucidate. Perhaps, however, a better way to analyse modern Dois de Julho is to recognise that the century-old struggle

between the caboclos and the monument continues, with neither fully victorious.

Notes

1. I would like to thank the Social Sciences and Humanities Research Council and the University of Calgary for research funding. Sonya Marie Scott and Lucineide dos Santos Vieira provided research assistance. Earlier versions of this paper were presented at the Rocky Mountain Council for Latin American Studies Conference (Tucson, AZ, 3 March 2001), at the conference, 'Images of Power: National Iconographies, Culture and the State in Latin America' (Institute of Latin American Studies, University of London, 2 May 2001), and at the Department of History, Universidade Federal Fluminense (29 August 2001). I thank Richard Graham, Jens Andermann and the audiences for their comments. The following abbreviations are used in the notes: APEB (Arquivo Público do Estado da Bahia); and Rio (Rio de Janeiro [city]).

2. The literature on monuments is vast; useful studies include Savage 1997, Driskel 1995, Bogart 1989, Agulhon 1978, and Cohen 1989. On Brazil, see the articles collected in Knauss 1999.

3. On Bahian politics and society after 1889, see Sampaio 1998, chap. 1, Pang 1979, Borges 1992, 1993, Levine, 1993, Butler 1998.

4. On independence in Bahia, see Kraay 2001, chap. 5.

5. The principal folkloric chronicles of Dois de Julho can be found in Moraes Filho 1946: 121–52, Marques 1922, chaps. 25, 27, Querino 1923: 77–105, Campos 1937: 295–304. Historical studies of Dois de Julho include Kraay 1999, Albuquerque 1999, Martinez 2000.

6. 'Dous de Julho', *O Monitor*, 2 July 1876, p. 1.

7. Albuquerque (1999: 30–48; 111–23) analyses this phenomenon for a later period.

8. See, for example, *Correio da Bahia*, 2 July 1878, p. 1; 'Dous de Julho', *Gazeta da Bahia*, 2 July 1879, p. 1.

9. *O Asorrague*, 3 July 1878, p. 3; *Gazeta da Bahia*, 1 July 1884, p. 1; 4 July 1886, p. 2; *Correio de Noticias*, 5 July 1897, p. 1; *Jornal de Noticias*, 4 July 1898, p. 1; Edital, *Gazeta da Bahia*, 27 June 1880, p. 1; 'A dictadura', *Gazeta da Bahia*, 4 July 1882, p. 1.

10. Martinez (2000: 71–2) analyses the chroniclers' contradictions.

11. See Campos 1937: 458. Moraes Filho (1946: 126), the oldest of the chroniclers, describes a patriotic allegory he had heard about from his mother, a model steamship used to collect donations for the Paraguayan War, which can be independently dated to 1866. See also O *Alabama*, 5 July 1866, pp. 1–2, 8; 'Carta Particular', Salvador, 30 June 1866, *Jornal do Commercio*, 7 July 1866, p. 2. Most of Querino's 'Noticia' (1923) refers explicitly to the 1870s and Marques's *Feiticeiro* (1922) is set in the late Empire.

12. 'Carta particular', Salvador, 3 July 1855, *Jornal do Commercio*, 10 July 1855, p. 1; 'Carta particular', 15 July 1864, *Jornal do Commercio*, 20 July 1864, p. 2; *O Reverbero*, 6 Aug. 1871, p. 7; Fonseca 1988: 257–8.

13. Querino 1923: 100; 'Festejos do Dous de Julho', *Gazeta da Bahia*, 9 July 1882, p. 1.

14. *O Faisca*, 27 June 1886, p. 282; Querino, 'Noticia,' p. 100; Moraes Filho, *Festas*, p. 131; *Diário da Bahia*, 13 May 1888, quoted in Martinez, 2000: 115. See also Albuquerque 1999: 89.

15. Commander of Arms to President, Salvador, 26 June 1888, APEB, m. 3464; Handbill, Arquivo do Instituto Geográfico e Histórico da Bahia, pasta 44, doc. 5-K.

16. 'Dous de Julho', *Diário do Povo*, 3 July 1889, p. 1; 'Festejos do Dous de Julho', *Gazeta da Bahia*, 4 July 1880, p. 1; 'O dia 2 de Julho', *Diário do Povo*, p. 1.

17. *O Alabama*, 6 July 1871, p. 1; 'La vae verso', ibid., p. 3; O *Monitor*, 1 July 1877, p. 1.

18. 'De relance', *O Faisca*, 4 July 1886, p. 289.

19. 'Dous de Julho', *Gazeta da Bahia*, 2 July 1882, p. 1.

20. 'Dous de Julho', *Pequeno Jornal*, 20 June 1890, p. 1; *Leituras Religiosas*, 6 July 1890, p. 112; '2 de julho', *Pequeno Jornal*, 3 July 1890, p. 1; 'Porque tanta indiferença?' *Pequeno Jornal*, 3 July 1890: p. 1.

21. 'Graves acontecimentos', *Pequeno Jornal*, 5 July 1890, p. 2. The following day, after arresting 'the most daring troublemakers', republican authorities placed Deodoro's portrait on the stage amid 'repeated enthusiastic cheers', *Pequeno Jornal*.

22. 'Revista diaria', *Pequeno Jornal*, 1 July 1892, p. 1; 'O Dia da Patria', *Jornal de Notícias*, 1 July 1892, p. 1; 'Festejos do 2 de Julho', *Pequeno Jornal*, 4 July 1892, p. 1; and 'Os Festejos do 2 de julho', *Jornal de Notícias*, 4 July 1892, p. 1; and 6 July 1892, p. 1.

23. Two recent studies have stressed the festive nature of the imperial regime and suggest that the empire's decline coincided with a decline in traditional festivals, Schwarcz 1999: 247–94; Abreu 1999.

24. Tupinambá, 'Cavaquemos', *Diário da Bahia*, 2 July 1896, p. 1.

25. *O Século*, 18 Oct. 1849, p. 4; 'Carta particular,' Salvador, 5 July 1864, *Jornal do Commercio*, 10 July 1864, p. 1.

26. Arquivo Municipal da Cidade do Salvador, Fototeca, pasta 771, foto 582.

27. *O Monitor*, 7 June 1876, p. 1; 1 July 1876, p. 2; Petition of Students to President, Salvador, 22 June 1876, APEB, m. 1569; Resolução 1626, 10 July 1876, *Coleção das Leis e Resoluções da Bahia*; Speech of João de Brito, 25 May, *Anais da Assembléia Legislativa da Província da Bahia* (1876), vol. 1, p. 129.

28. *O Motor*, 30 June 1877, p. 1.

29. 'Acta da collocação da primeira pedra', 5 July 1881; *O Monitor*, 13 July 1881, p. 1; *Gazeta da Bahia*, 7 July 1881, p. 1 and 13 July 1881, p. 1.

30. See *Diário do Povo*, 10 April 1888; *Diário da Bahia*, 4 July 1888, quoted in Martinez 2000: 114–15, 116–17; *Diário do Povo*, 3 July 1889, p. 1; Commissão do Monumento ao Dois de Julho to President, Salvador, 17 Aug. 1889, APEB, m. 1569.

31. *A Locomotiva*, 3 May 1889, p. 125.

32. *Diário de Notícias*, 4 Aug. 1891, quoted in Martinez 2000: 118. On eligible voters, see Sampaio 1988: 52; Martinez 2000: 118; *Pequeno Jornal*, 13 Nov. 1891, p. 1.

33. 'O Monumento', *Jornal de Notícias*, 6 July 1892, p. 1; 'Festejos do 2 de Julho', *Pequeno Jornal*, 6 July 1892, p. 1; 'O Munumento [sic]', *Jornal de Notícias*, 5 July 1892, p. 1; Speech of Manoel Victorino Pereira, 5 July 1892, *Jornal de Notícias*, 6 July 1892, p. 1.

34. See the descriptions in 'Monumento ao Dous de Julho', *Diário da Bahia*, 2 July 1895, p. 3; Vianna. 1893. 344–7; also Mattos 1956: 167–72. On Nicoli, see Bénézit 1999: vol. 10, p. 205.

35. The following discussion is based on 'Festejos do 2 de Julho', *Correio de Notícias*, 3 July 1895, p. 1; and 'Noticiario', *Diário da Bahia*, 4 July 1895, p. 1.

36. *Diário da Bahia*, 2 July 1895, p. 1.

37. 'Festejos do 2 de Julho', *Correio de Notícias*, 4 July 1895, p. 1; 'Photo-gravura', *Correio de Notícias*, 3 July 1895, p. 1; 'A maior data', *Diário da Bahia*, 2 July 1895, p. 2; R. Bizarria, 'Outr'ora e hoje', *Diário da Bahia*, p. 2.

38. '2 de Julho', *Correio de Notícias*, 6 July 1895, p. 1; 'Festejos de 2 de Julho', *Correio de Notícias*, 8 July 1895, p. 1; 'Volta dos emblemas patrioticos', *Diário da Bahia*, 9 July 1895, p. 1.

39. Scholarship on Dois de Julho appears to have missed this development, although Martinez (2000: 124) alludes to it in passing.

40. '2 de Julho', *Diário da Bahia*, 4 July 1896, p. 1; Rabelais Neto, 'Aos Domingos', *Diário da Bahia*, 5 July 1896, p. 1.

41. '2 de Julho', *Diário da Bahia*, 4 July 1896, p. 1; 'Festejos ao 2 de Julho', *Diário da Bahia*, 1 July 1896, p. 1; 'Dous de Julho: Freguesia de Santo Antonio', *Diaário da Bahia*, 2 July 1896, p. 1.

42. '2 de Julho', *Cidade do Salvador*, 12 July 1897, p. 2; '2 de Julho', *Correio de Notícias*, 1 July 1900, p. 1; '2 de Julho', *ibid.*, 5 July 1897, p. 1; 'Festejos do Dois de Julho', *Diário da Bahia*, 6 July 1897, p. 1; 'Dois de Julho', *Jornal de Notícias*, 4 July 1898, p. 1; '2 de Julho', *Jornal de Notícias*, 3 July 1899, p. 1.

43. 'Dous de Julho', *Diário da Bahia*, 2 July 1896, p. 1; Paul Kine, 'Cavaquemos', *Diário da Bahia*, 4 July 1897, p. 1.

44. '2 de Julho', *Jornal de Notícias*, 3 July 1899, p. 1; '2 de Julho', *Correio de Notícias*, 5 July 1897, p. 1; 'Dois de Julho', *Correio de Notícias*, 4 July 1900, p. 1.

45. '2 de Julho', *Correio de Notícias*, 5 July 1897, p. 1; 'Festas', *Jornal de Notícias*, 27 June 1899, p. 1; 'Dous de Julho', *Correio de Notícias*, 4 May 1900, p. 2; '2 de Julho', *Correio de Notícias*, 3 July 1897, p. 1.

46. '2 de Julho', *Jornal de Notícias*, 3 July 1900, p. 1; '2 de Julho', *Correio da Bahia*, 22 June 1897, p. 1; Commissão dos Festejos to *Diário da Bahia*, 18 June 1897, *Diário da Bahia*, 23 June 1897, p. 1.

47. '2 de Julho', *Correio de Notícias*, 3 July 1897, p. 1; '2 de Julho', *Jornal de Notícias*, 3 July 1899, p. 1.

48. '2 de Julho', *Jornal de Notícias*, 3 July 1900, p. 1; '2 de Julho', *Jornal de Notícias*, 4 July 1899, p. 1; 'Festas: 2 de Julho', *ibid.*, 6 July 1899, p. 1.

49. Interview with Raimundo de Almeida Gouveia, 17 Nov. 1998, in Araujo 1999: 48.

50. See, for example, '2 de Julho', *Correio de Notícias*, 26 June 1897, p. 1.

51. 'Necrologia', *Jornal de Notícias*, 7 July 1899, p. 1.
52. Martinez (2000: 143) dates the caboclos' return to 1943, while Vianna (1977: 176–77) cites 1959 as the year in which the old traditions were resurrected.

Bibliography

Abreu, Martha. 1999. *O império do divino: festas religiosas e cultura popular no Rio e Janeiro, 1830–1900*. Rio and São Paulo: Nova Fronteira and FAPESP.

Agulhon, Maurice. 1978. "La "statuomanie" et l'histoire'. *Ethnologie française* 8: 145–72.

———. 1981. *Marianne into Battle: Republican Imagery and Symbolism in France, 1789–1880*. Cambridge: Cambridge University Press.

Albuquerque, Wlamyra R. 1999. *Algazarra nas ruas: comemorações da independência na Bahia (1889–1923)*. Campinas: Editora da UNICAMP.

Araújo, Ubiratan Castro de, ed. 1999. *Salvador era assim: memórias da cidade*. Salvador: Instituto Geográfico e Histórico da Bahia.

Barman, Roderick J. 1999. *Citizen Emperor: Pedro II and the Making of Brazil, 1825–1891*. Stanford: Stanford University Press.

Bénézit, E. 1999. *Dictionnaire critique et documentaire des peintres, sculpteurs, dessinateurs et graveurs de tous les temps*. Rev. Ed. 14 Vols. Paris: Grund.

Bogart, Michelle. 1989. *Public Sculpture and the Civic Ideal in New York City, 1890–1930*. Chicago: University of Chicago Press.

Borges, Dain. 1992. *The Family in Bahia, Brazil, 1870–1945*. Stanford: Stanford University Press.

———. 1993. 'Salvador's 1890s: Paternalism and Its Discontents'. *Luso-Brazilian Review* 30, 2 (Winter): 47–57.

Brookshaw, David. 1988. *Paradise Betrayed: Brazilian Literature of the Indian*. Amsterdam: CEDLA.

Butler, Kim D. 1998. '*Ginga Baiana* – The Politics of Race, Class, Culture, and Power in Salvador, Bahia'. In: *Afro-Brazilian Culture and Politics: Bahia, 1790s–1990s*, ed. Hendrik Kraay. Armonk: M. E. Sharpe.

———. 1998. *Freedoms Given, Freedoms Won: Afro-Brazilians in Post-Abolition São Paulo and Salvador.* New Brunswick: Rutgers University Press.

Campos, João da Silva. 1937. 'Chronicas bahianas do século XIX'. *Anais do Arquivo Público do Estado da Bahia* 25: 295–304.

Carvalho, José Murilo de. 1990. *A formação das almas: o imaginário da república no Brasil*. São Paulo: Companhia das Letras.

———. 1999. *O bestializados: o Rio de Janeiro e a república que não foi*. São Paulo: Companhia das Letras.

Cohen, William. 1989. 'Symbols of Power: Statues in Nineteenth-Century Provincial France'. *Comparative Studies in Society and History*, 31, 3 (July): 491–513.

Corrigan, P. & Derek Sayer. 1985. *The Great Arch: English State Formation as Cultural Revolution*. Oxford: Blackwell.

DaMatta, Roberto. 1991. *Carnavals, Rogues, Heroes: An Interpretation of the Brazilian Dilemma*, transl. John Drury. Notre Dame: Notre Dame University Press.

Driskel. Michael Paul. 1995. *As Befits a Legend: Building a Tomb for Napoleon, 1840–1861*. Kent: Kent State University Press.

Ferrez, Gilberto. 1988. *Bahia: velhas fotografias, 1858–1900.* Salvador and Rio de Janeiro: Banco da Bahia Investimentos S.A. and Livraria Kosmos Editora.

Fonseca, Luis Anselmo da. 1988. *A escravidão, o clero e o abolicionismo,* facsimile edition. Recife: Fundação Joaquim Nabuco, Editora Massangana.

Galvão, Alfredo. 1962. 'A estátua eqüestre de D. Pedro I', *Arquivos da Escola Nacional de Belas Artes,* 8: 33–43.

Knauss, Paulo ed. 1999. *Cidade vaidosa: imagens urbanas do Rio de Janeiro.* Rio de Janeiro: Sette Letras.

———. 2000. 'Imagens da cidade: monumentos e esculturas no Rio de Janeiro'. In: *Entre Europa e África: a invenção do carioca* Lopes (ed.) 2000, pp. 289–300.

Kraay, Hendrik ed. 1998. *Afro-Brazilian Culture and Politics: Bahia, 1790s–1990s.* Armonk: M. E. Sharpe.

———. 1999. 'Between Brazil and Bahia: Celebrating Dois de Julho in Nineteenth-Century Salvador'. *Journal of Latin American Studies,* 31: 1 (May): 255–86.

———. 2001. *Race, State, and Armed Forces in Independence-Era Brazil: Bahia, 1790s–1840s.* Stanford: Stanford University Press.

Leite, Rinaldo Cesar Nascimento. 1998. 'A civilização imperfeita: tópicos em torno da remodelação urbana de Salvador e outras cenas em torno da civilidade, 1912–1916'. *Estudos Ibero-Americanos* (Porto Alegre) 24, 1 (June): 95–129.

Levine, Robert M. 1984. 'Elite Intervention in Urban Popular Culture in Modern Brazil'. *Luso-Brazilian Review* 21, 2 (Winter), 9–22.

———. 1993. 'The Singular Brazilian City of Salvador'. *Luso-Brazilian Review* 30, 2 (Winter): 59–69.

Lopes, Antônio Herculano, ed. 2000. *Entre Europa e África: a invenção do carioca.* Rio: Topbooks and Edições Casa Rui Barbosa.

Marques, Xavier. 1922. *O feiticeiro: romance.* Rio: Leite Ribeiro.

Martinez, Socorro Targino. 2000. *2 de Julho: a festa é história.* Salvador: Prefeitura Municipal do Salvador, Secretaria Municipal de Educação e Cultura, Fundação Gregório de Mattos.

Mattos, João Baptista. 1956. *Os monumentos nacionais: estado da Bahia.* Rio: Imprensa do Exército.

Meade, Teresa A. 1997. *'Civilizing' Rio: Reform and Resistance in a Brazilian City, 1889–1930.* University Park: Penn State University Press.

Moraes Filho, Alexandre José de Mello. 1946. *Festas e tradições populares no Brasil.* 3rd ed. Rio de Janeiro: F. Briguiet.

Needell, Jeffrey D. 1987. *A Tropical* Belle Epoque: *Elite Culture and Society in Turn-of-the-Century Rio de Janeiro.* Cambridge: Cambridge University Press.

Oliven, Ruben George. 1984. 'The Production and Consumption of Culture in Brazil'. *Latin American Perspectives* 11, 1 (Winter): 103–15.

Pang, Eul-Soo. 1979. *Bahia in the First Brazilian Republic: Coronelismo and Oligarchies, 1889–1934.* Gainesville: University of Florida Press.

Querino, Manoel Raimundo. 1923. 'Noticia historica sobre o 2 de Julho de 1823 e sua commemoração na Bahia'. *Revista do Instituto Geográfico e Histórico da Bahia* 48: 77–105.

Ribeiro, Maria Euridice de Barros. 1990. 'Memória em bronze: estátua eqüestre de D. Pedro I', in *Cidade vaidosa: imagens urbanas do Rio de Janeiro,* ed. Paulo Knauss. Rio de Janeiro: Sette Letras.

Rochet, A. 1978. *Louis Rochet: sculpteur sinologue, 1813–1878.* Paris: A. Bonne.

Sampaio, Consuelo Novais. 1998. *Partidos políticos da Bahia na Primeira República: uma política de acomodação.* 2nd Ed. Salvador: EdUFBa.

Sampaio, José Augusto Laranjeiras. 1988. 'A festa de Dois de Julho em Salvador e o 'lugar' do índio'. *Cultura* 1, 1: 153–9.

Santos, Jocélio Teles dos. 1995. *O dono da terra: o caboclo nos candomblés da Bahia*. Salvador: SarahLetras.

Savage, Kirk. 1997. *Standing Soldiers, Kneeling Slaves: Race, War, and Monument in Nineteenth-Century America*. Princeton: Princeton University Press.

Schwarcz, Lilia Moritz. 1999. *As barbas do imperador: D. Pedro II, um monarca nos trópicos*. 2nd ed., São Paulo: Companhia das Letras.

Serra, Ordep. 2000. *Rumores de festa: o sagrado e o profano na Bahia*. Salvador: EdUFBa.

Treece, David. 2000. *Exiles, Allies, Rebels: Brazil's Indianist Movement, Indigenist Politics, and the Imperial Nation-State*. Westport: Greenwood.

Vianna, Francisco Vicente. 1893. *Memoria sobre o Estado da Bahia*. Salvador: Tip. e Encad. *Diario da Bahia*.

Vianna, Hildegardes. 1976–7. 'Dois de Julho de bairros'. *Revista do Instituto Geográfico e Histórico da Bahia* 86: 275–85.

——— . 1977. 'Folclore cívico na Bahia'. In *Ciclo de conferências sobre o sesquicentenário da independência na Bahia em 1973*. Salvador: Universidade Católica do Salvador.

Chapter 9

Photography, Memory, Disavowal:

the Casasola Archive

*Andrea Noble**

If you had to select one photograph that signals and evokes the Mexican Revolution in contemporary cultural memory, it might well be *Francisco Villa en la silla presidencial*.[1] Arguably *the* photo opportunity of the revolution, this image was made during the brief occupation of Mexico City by Zapatista and Villista troops in December 1914 and captures Pancho Villa on the presidential 'throne' with Emiliano Zapata seated beside him. The pervasive presence of this photograph in the Mexican cultural landscape, obsessively reproduced and reinvented across a range of cultural texts, cannot be overestimated. Like the heroic statues of revolutionary leaders that sprang up in the aftermath of the conflict, *Villa en la silla* has become something of a (photographic) national monument in its own right.[2] Indeed, in testimony to its enduring fascination, this iconic photograph was the subject of two articles in a recent issue of *La jornada semanal*. The first, 'Historia y mito del Archivo Casasola' by graphic historian John Mraz, examines three iconic photographs of the revolution, including this one. And the second, 'La mirada de Zapata sin silla', is devoted entirely to the image, and constitutes a lyrical meditation on the famous photograph by artist Mauricio Gómez Morin, culminating in a reflection on its on-going significance in the context of post-1994 cultural politics (Gómez Morin 2000; Mraz 2000).

To claim *Villa en la silla* as *the* image of the revolution is not, however, to deny the existence, nor to downplay the importance of, other photographic images of the struggle that enjoy an equally iconic status. As an eminently newsworthy historic event, the revolution generated hundreds and thousands of photographs. The Casasola Archive alone, to which this

photograph belongs, numbers some 600,000 images (Gutiérrez Ruvulcaba 1996). Yet, as Carlos Monsiváis remarks in 'Notas sobre la historia de la fotografía en México', in the aftermath of the conflict as the new ruling elite established itself in power, from the 1940s on only a select handful of images was to receive the kind of exposure that leads to iconic status. Indeed, in a direct address to his reader, Monsiváis names some of them:

> You already know them: a group of Zapatistas with indecipherable expression having breakfast in the Porfirista palace of Sanborns / a Soldadera looking at us from a train / an executee facing the firing squad with premeditated contempt or refined irony / Zapata and Villa accommodate themselves in the seats of power / Carranza distributing his maturity and gravity amongst a bunch of youngsters / Obregón observing the manoeuvres of a regiment / Villa entering Torreón on horseback / Eufemio, Emiliano and their wives attesting to the survival of the couple in the turmoils of revolution... (Monsiváis 1980–81: unnumbered pages).[3]

The actual images themselves are conspicuous by their absence from Monsiváis's essay. Their presence would, of course, be superfluous: 'usted ya los conoce'.

There are, nevertheless, nuances of iconicity that underpin meaning across the photographs on Monsiváis's list which, as the ellipsis indicates, is in no sense exhaustive. Let us take the first three as an example. 'Zapatistas en Sanborns', 'Soldadera' and 'Pelotón' (images to which I will return towards the end of this essay) are linked to specific moments or features of the revolution, on which their meaning hinges. 'Zapatistas en Sanborns', also taken in December 1914 during the Zapatista/Villista occupation of Mexico City, represents the transgressive, but temporary irruption of the rural, racial Other into the sacred space of urban 'civilisation'.[4] Similarly, 'Soldadera', taken some time between 1911 and 1914, has come to stand in for female participation in the armed struggle, as its reproduction on the cover of the recent selection of images of women combatants, 'Las Soldaderas', bears witness (Poniatowska 1999).[5] The firing squad image represents the revolution as heroic struggle, whose participants laugh in the face of imminent death.

Unlike these photographs, which are imbued with quite particularized meanings, *Villa en la silla*, I would argue, has come to stand in for the revolution as an historic event *tout court*. The cut in time that is this photographic object has subsequently come to stand in for the ten years of the revolution's violent phase. That this is so, is confirmed by a brief glance at some of the uses to which the photograph has been put, the places in which it has appeared and also the transformations that it has undergone.

The Wind That Swept Mexico
The History of the Mexican Revolution of 1910–1942 NEW EDITION
Text by Anita Brenner, 184 photographs assembled by George R. Leighton

Figure 9.1 Front cover of Anita Brenner, *The Wind that Swept Mexico: The History of the Mexican Revolution of 1910–1942* (4th edition, 1996).

A cropped, sketched version of one of the original photographs appears on the cover of Anita Brenner's didactic account of the revolution destined for a North American readership, *The Wind that Swept Mexico: The History of the Revolution of 1910–1942*. This text, originally published in 1943 and introduced by Brenner's written narrative chronicling the revolution, is first and foremost a photographic essay. In addition to the cover image, the book figures a sequence of photographs among its 184 images, that contextualize *Villa en la silla* in terms of chronology, location and cultural significance. Each is accompanied by a caption:

105. Mexico City was No Man's Land. One day Zapata and his men made a triumphal entry. It was thought that the Attila of the South would butcher the people, but he did not and, after a little while, moved out again.

106. Generals swept in and out and no one could be sure at any time who was supposed to be sitting in the presidential chair … and most of the time no one was …

107. One day Carranza and his staff were photographed standing in front of it …

108. Villa had his picture taken lolling in it, with Zapata beside him …[6]

Figure 9.2 Front cover of Enrique Krauze, *Biografía del poder: caudillos de la Revolución mexicana, 1910–1940* (1997).

The photograph also appears on the cover of Enrique Krauze's 1997 *Biografía del poder: Caudillos de la Revolución mexicana (1910–1940)*, where once again it has been cropped and the photograph has been manipulated to bring into golden relief the elaborate plumed throne on which Villa 'lolls'. Significantly, Krauze's text includes biographies of the seven *caudillos* of the revolution and its intense phase of institutionalization (1920–1940), from Madero to Lázaro Cárdenas; yet emblematically it is *Villa en la silla* that is inevitably reproduced on the cover and not, for example, an image of the other, less 'photogenic' *caudillos*.

Finally, the photograph has been reworked and rendered in painting by the Canadian artist Arnold Belkin in *La llegada de los generales Zapata y Villa al Palacio Nacional el 6 de diciembre de 1914* (1979, Acrylic/canvass, 230 x 350cm, colección Museo Nacional de Historia, INAH). A long-term resident in Mexico, Belkin worked from the famous photograph itself, as well as some fifty additional documentary images to bring in further revolutionary figures, such as Eufemio Zapata and Felipe Ángeles who stand in the foreground to right and left. As is perhaps fitting for an image that visually dissects the revolutionary leaders, affording the viewer with a penetrative vision of their internal organs and

skeletal structures, Belkin's painting appears on the cover of Joseph and Nugent's *Everyday Forms of State Formation: Revolution and Rule in Modern Mexico* (1994). This location of the painting is moreover in keeping with the trajectory of the original photograph, an image that seems to have a natural affinity with the front cover. What is more, Belkin's painting seems particularly appropriate for the cover of the insightful edited collection of essays that make up *Everyday Forms of State Formation*. The collection functions as a sophisticated corrective to the polarized either/or, populist/revisionist approaches that have tended to dominate | the historiography of the revolution; instead its concern is 'to fashion an analytical framework "from below" with a more compelling and nuanced "view from above"'.[7]

Figure 9.3 Front cover of Gilbert M. Joseph & Daniel Nugent, *Everyday Forms of State Formation: Revolution and Rule in Modern Mexico* (1994).

These three sources of *Villa en la silla* are in many ways diverse. The factor that unites them, however, is their focus on the revolution as a whole event: albeit as the recent political and social upheaval in a worryingly close neighbour (Brenner), a more distant product of charismatic human agents (Krauze), or a complex historical process of negotiation between the state and popular classes (Joseph and Nugent).[8] The point is that via

a synecdochal operation this photographic part-object that captures a brief moment in December 1914 has come to stand in for the whole: the revolution. However, if the old adage goes 'never judge a book by its cover', a similar principle is applicable to the (iconic) photograph: its very ubiquity hardly encourages us to pause to reflect as we hurry on to get beyond it to something of real 'substance'. Indeed, in this sense, iconic photographs of the revolution have much in common with their more 'solid' counterparts: statues of heroes. As national commemorative monuments with diametrically opposed defining characteristics – absolute immobility in the case of the statue, sheer mobility in the case of the photograph – meaning in both modes of representation undergoes a similar process. This process has been described by Monsiváis, who has the following to say of the sculptural public monument:

> [T]his rigid and contrived aesthetic concept soon blends into the landscape in the most unexpected forms, losing its heroic qualities and acquiring a familiarity that eludes the critics. It becomes so well known that it is actually endearing. And so endearing that it becomes invisible. (Monsiváis 1989: 122)

I suggest that this critic's comments might equally be applicable to the iconic photographic object. (Indeed, the image that is the focus of this essay, of the 'lolling' Pancho Villa – to use Brenner's quaint terminology – is nothing if not endearing.) As endlessly reproduced artefacts, such photographs become part of the cultural landscape to the extent that their ubiquity leads to invisibility: meaning, if certainly not evacuated from such documents, tends more often than not to be taken as self-evident and therefore unworthy of further comment.

If, however, we refuse the ubiquity of the iconic photograph and, drawing on Belkin's photograph *qua* painting as a critical metaphor, dissect *Villa en la silla*, a series of questions start to emerge. These questions relate not only to this individual image, but equally to the status and significance of the photographic image within the twin processes of post-revolutionary memorialization and nation/state formation. Why this photograph? Who 'owns' the meanings that circulate around the image: the popular classes who supported Villa and Zapata, the post-revolutionary state, or, perhaps more pertinently, is ownership more a matter of negotiation between these two mutually imbricated groups? What is it about *Villa en la silla* that captures the post-revolutionary cultural imagination? What is its relationship *qua* photograph to discourses of memory in this period? If iconic status comes about as a result of repeated exposure, what are the ramifications of this compulsion to repeat the image? As one of a number of culturally consecrated photographic images, what can the iconization of a photograph like *Villa en la silla* tell us more generally about the relationship between memory, revolution and photo-

graphic representation in Mexico? At the risk of repetition: 'usted ya los conoce': this essay sets out to explore *why* it is that we know iconic images and *what* is at stake in the forms of knowledge that they, in their turn, produce.

The Photograph in/as History

The photograph under examination here is a visual document that represents an historical encounter between Villa and Zapata. So, the first step on which we must embark in the process of anatomization is, inevitably, to return the immobile bodies traced on the surface of the image back into the flow of history. That is, it is essential to consider the circumstances that brought the *caudillos* to their encounter with one another in the National Palace and that gave rise to the famous photograph; a photograph that has, moreover, become an emblematic cover image on a range of historical studies of the revolution. Villa, Zapata and their troops had been propelled into the city at a crucial moment in the revolution shortly after the resignation of the reactionary 'villain' Victoriano Huerta, an event that had given rise to the struggle to define and control the direction that the revolution would take henceforth. This struggle took place between the two official, Constitutionalist factions: Carrancistas and Villistas. Geographically and politically remote from the Constitutionalist north, the southern Zapatista movement was essentially a populist, regional peasant uprising, one that fervently adhered to the 1911 agrarian Plan de Ayala. The months between Huerta's political demise in July 1914 and the October Convention of Aguascalientes, which brought together representatives from the three factions, saw frantic to-ings and fro-ings as both Villistas and Carrancistas attempted to broker a deal with Zapata who adamantly refused to concede any compromise position on the Plan de Ayala. Finally, the three-way vying for power reached an accord of sorts at Aguascalientes, with the nomination of Eulalio Gutiérrez as provisional president and the forging of an uneasy and short-lived alliance between Villa and Zapata. Carranza, who had been occupying Mexico City, left swiftly for Veracruz at this juncture, vacating the capital for occupation by Villista and Zapatista troops and thereby setting the stage for the mythical meeting of their respective leaders.

Now that we have located Villa, Zapata and their troops in the city, let us turn to the *Historia gráfica de la revolución, 1900–1940,* a volume that records how the two leaders spend Sunday 6 December: parading through the capital in a visual display that provokes the fear-tinged delight of the urban onlookers who cannot help but admire 'la caprichosa indumentaria de este temible ejército'. The parade ends up at the heart of

the capital city and also nation, at the Palacio Nacional where the leaders are received by interim President Gutiérrez, before making their way to the presidential balcony to witness the parade and where they are 'largamente ovacionados por la muchedumbre'. Despite the adulation of the crowd, 'como el desfile de numerosos contingentes fué tan largo y tedioso, en un momento oportuno se retiran al interior de los salones los generales Francisco Villa y Emiliano Zapata, sentándose Villa en la silla presidencial' (Casasola 1947: 873–74).[9] In this instant, the photograph is taken. At Villa's suggestion that it is now his turn to pose on the presidential 'throne', Zapata apparently refuses, arguing that the 'silla' as icon of national power is emphatically *not* what he is fighting for. Afterwards, of the *silla presidencial*, Zapata is said to assert: 'deberíamos quemarla para acabar con las ambiciones' (Krauze 1987). Or so the story goes. Made to relieve the tedium of the endless military parades (if we are to believe the anecdotal evidence provided in *Historia gráfica*), who was ever to guess that this informal and ironic photo opportunity was to echo so resoundingly in the future?

Photography and Memory

To return *Villa en la silla* into the flow of history is undoubtedly a necessary step in the anatomization of the photograph. The image demands historical anchorage, without which meaning effectively breaks down. The historical narrative provides an 'objective' context in which to understand not only how the image came about, but also the historical significance of what it represents: the unprecedented meeting of key revolutionary figures, figures who were of course soon to exit the revolutionary stage as the conservative revolution subsequently triumphed. As discourses of knowledge with a purchase on the past, however, history and photography become bound together in an epistemological hierarchy, whereby the latter occupies a secondary position – as mere illustrative tool – within history's narrative of linear time, linked by cause and effect. To reduce the photograph to its illustrative function, to such a linear historical narrative, is to overlook the photograph's own narrative potential which is arguably much more complex than history's linearity will allow.[10] To reinsert the photograph into the flow of history also falls short of the mark when it comes to offering an account of how photographs become iconized and to asking what might be at stake in this process. This is because such photographic images suffer a similar fate to that of the cover images with which I opened this essay: their meaning is taken as self-evident and is therefore glossed over in the reader's desire for historical substance. In short, official history, while it can furnish answers to

'who', 'where' and 'when', fails to provide the kind of analytical framework that answers the 'how' of *Villa en la silla*'s iconization and the 'why' of the photograph's enduring fascination.

Even as photographs carry the burden of history, the contemporary turn to memory is arguably a more productive approach to the historical freight of the iconic photograph. In the excellent introduction to *Memory and Methodology*, Susannah Radstone (2000: 3) asserts that what she describes as the recent interdisciplinary 'explosion' of interest in memory is due, in part at least, to a 'postmodern' overturning of modernity's (blind) faith in 'futurity, progress, reason and objectivity.' In the turn to memory, therefore, official history and its associations with objectivity, the public sphere and authoritative master narratives of progress have become a site of contestation. Work on memory, on the other hand, is concerned with subjectivity, and with private and micro narratives. Furthermore, it places an emphasis on the status of memory as representation, where representation is bound up with the structures of narrativization, and focuses on issues of selection, condensation, repression, displacement and denial. Although the revolutionary photograph as a public, objective and ultimately authoritative document may seem naturally allied with official history, the historical narrative tends to eclipse the photographic image. If we are to offer an account of the photograph that privileges the productivity of the image, I would argue that it is only to be achieved through a radically different methodology, that of memory. This is not to claim, however, that photography enjoys a comfortable relationship with memory. Rather, in what follows, I will suggest that this relationship is governed by a paradox that turns on photography's status as ambiguous (counter)memory text. For all that the photography/memory dyad is ambivalent, it is nonetheless a productive one when it comes to analysing iconic photographs.

Photography as Memory in Post-Revolutionary Discourses

In the aftermath of the revolution in Mexico, discourses of memory came to play an important role in the post-revolutionary drive to institutionalize the armed struggle as a foundational narrative of national identity, where identity was to be forged on a notion of national unity. Indeed, unity was a political exigency at this time. This is because, as Alan Knight (1986: 2) states:

Mexico of 1910 was, borrowing Lesley Simpson's phrase, 'many Mexicos', less a nation than a geographical expression, a mosaic of regions and communities, introverted and jealous, ethnically and physically fragmented, and lacking common national sentiments;

these sentiments came after the Revolution and were [...] its offspring rather than its parents.

If, as Knight's comments suggest, Mexico was more a collection of fragments than a coherent whole in 1910, so too was the revolution, which was ultimately a highly factionalized and bitter civil war. For the revolution to function within the post-revolutionary political and cultural imaginary as the desired unifying foundational narrative of identity, it therefore had to be remembered and thereby *reinvented* as a unified struggle. Furthermore, given that it was the middle-class, conservative Constitutionalists embodied by Carranza and Obregón that emerged as victorious (and not the *campesinos* or radicals), the revolution had to be retrospectively re-presented not only as coherent, but also (in appearance at least) as propelled by a social and political *revolutionary* agenda.

The dynamic of post-revolutionary discourses of memory can be understood in the light of theories of collective memory which, as is by now well established, is crucial to the processes whereby nations and national identities are 'imagined' (Anderson 1991: 187–206). Drawing on Maurice Halbwachs's (1980) work on collective memory, Nancy Wood (1999: 2) provides a helpful definition of this mode of memory, a mode that she sets up in opposition to individual memory:

> What differentiates these two modes of memory [individual and collective] is that while the emanation of individual memory is primarily subject to the laws of the unconscious, public memory – *whatever its unconscious vicissitudes* – testifies to a will or desire on the part of some social group or disposition of power to select and organise representations of the past so that these will be embraced by individuals as their own. If particular representations of the past have permeated the public domain it is because they embody an intentionality – social, political, institutional and so on – that promotes or authorizes their entry.[11]

In pursuit of its analysis of the iconicity of *Villa en la silla*, this chapter takes its cue from Wood's definition of collective memory as the will by one social group – in this case the ruling elite allied to the Mexican State – to select and organise representations of the past. At the same time, however, by picking up on this critic's notion of the 'unconscious vicissitudes' of public memory, it seeks to qualify and thereby render more complex the relationship between 'above' and 'below'. It does so in the spirit of Mary Kay Vaughan's recommendation that ' the postrevolutionary state's cultural politics are best understood as an improvised, multivalent, accumulative process that grew through interaction between state and society' (Vaughan 2001: 272).

Questions of the interaction between state and society are certainly not absent from the work of scholars in the post-revolutionary Mexican context. In his recent book *La Revolución: Memory, Myth and History*,

Thomas Benjamin explores the way in which, in the aftermath of the armed conflict, successive governments turned to remembrances, rites, celebrations, monuments and histories to transform the revolution into tradition within popular memory. In a chapter on monuments, echoing Wood's notion of representations that embody an intentionality, Benjamin (2000: 117–18) asserts:

> Certain monuments are designed to create a setting for ritual performances, for commemorations and celebrations. [...] The monument, the setting, the performance and the particular day combine to evoke symbolic reassurance that the state, the regime, or the leader is faithful to those considered the community's founding fathers, and that authority therefore is legitimate. As stages for commemorative performances, monuments encourage people not simply to remember but to remember together, thereby affirming group solidarity and unity.

Although not explicitly articulated within such paradigms, discourses of collective memory are also central to Ilene O'Malley's excellent study of hero cults in the institutionalization of the Mexican State. O'Malley (1986: 113) traces the evolution of the four principal revolutionary leaders in the period 1920–1940, examining the transformations that the *caudillos* as political personages underwent as the state consolidated:

> The propaganda surrounding these four heroes [Madero, Zapata, Villa, Carranza] had a number of common traits: the claim that the government was revolutionary; the promotion of nationalism; the obfuscation of history; the denigration of politics; [...] patriarchal values and the 'masculinization' of the heroes' images. These characteristics form the internal ideology and psychology of the myth of the Mexican Revolution.

Despite their different object, focus and scope of study, both Benjamin and O'Malley concur that, with the rise of the new post-revolutionary elite, the revolution became a prime site of memory, wherein those representations that entered the social sphere were harnessed to the project of the revolution as foundational myth of origin.

A curious omission, however, to my mind at least, is a detailed discussion of the role of photography in post-revolutionary discourses of memory: an omission that attests further to the ubiquitous invisibility of the photographic object.[11] That photographic representation occupies an important position within such discourses and therefore merits discussion is evident on a number of levels. First, the revolutionary leaders themselves clearly had an eye to the role of photographic technology in their memorialization when they hired photographers and filmmakers to follow their campaigns. Indeed, Villa's relationship with his photographic and filmic image is the stuff of legend (De los Reyes 1985; De Orellana 1992). And furthermore, Olivier Debroise (1998: 218) notes that, by comparison, contemporary European conflicts (i.e., World War I and the Russian Revolution) generated relatively few photographic images,

unlike the Mexican Revolution which, he claims, 'dependió en extremo de sus representaciones, y en particular de las fotografías desde sus inicios.'[13] Second, if the photographic representation of the revolution was endowed with privileged status during the conflict, in the aftermath visual media, including photography, film and art were central to the post-revolutionary project of state and forging of nation.[14] Third, of the visual media involved in this project, none has the kind of special, if equivocal relationship with memory than that which obtains between photography and memory: a relationship that is at once one of counterparts and antagonists, and equally demands our attention.

Photography and memory are structurally akin insofar as both represent 'windows' on the past. Memory provides access to a mediated representation of the past that is subject to the processes of selection, repression and revision. Photography, both despite and because of its privileged purchase on the real, also offers us a vision of the past that is structured according to the same logic of selection, repression and revision. As a 'cut inside the referent' – to cite Christian Metz's definition – the photograph, like memory, is defined as much by what it does not represent as by what it does (Metz 1999: 214). Photographs are, of course, also material manifestations of memory. As traces of what Roland Barthes famously describes as the 'this has been' ('ça a été'), photographs appear to permit access to the past like no other mode of representation. And yet, even as photographs and memories represent mediated openings onto the past, and even as photographs on one level are the very stuff of memory, they are not, suggests Barthes, commensurate. Indeed, in *Camera Lucida*, he goes so far as to suggest that they are antithetical:

> Not only is the Photograph never, in essence, a memory [...] but it actually blocks memory, quickly becomes a counter-memory. [...] The photograph is violent: not because it shows violent things, but because on each occasion it fills the sight by force, and because in it nothing can be refused or transformed. (Barthes 1993: 91)

Drawing, on the one hand, on Barthes's fundamental belief in photographic reference as the essential effect of photography and, on the other, on his formulation of the photograph as counter memory, I now wish to focus on the function of *Villa en la silla* at the level of visual rhetoric, in underwriting a hegemonic conception of post-revolutionary national identity. As an iconic memory-text anchored within the specific processes of post-revolutionary state formation, meaning in *Villa en la silla* hinges on an equivocal relationship between photographic rhetoric and collective memory. That is, as a visual document that entered into circulation in the post-revolutionary cultural landscape, signification in *Villa en la silla* turns on its status as photograph that is structured like

memory, that is structuring of memory and that ultimately constitutes a counter-memory.

Villa en la silla as Counter-Memory

What, then, in the 1940s might the post-revolutionary subaltern viewing subject 'see' on encountering *Villa en la silla*?[15] This viewing subject would be steeped in the ambient discourses of 1940s cultural politics. As Joseph, Rubenstein and Zolov have argued in *Fragments of a Golden Age*, the 1940s represent a pivotal moment in Mexican historiography. Although, for these critics, the 1940s mark the beginning of the end of revolutionary promise, the period is, nevertheless, evoked as a 'Golden Age': 'a period when lo mexicano still invoked a series of roughly shared assumptions about cultural belonging and political stability under a unifying patriarchy' (Joseph, Rubinstein and Zolov 2001: 9). In the encounter with *Villa en la silla*, the viewing subject is overwhelmingly presented with a sea of faces assembled in front of the camera that clamour to get into the frame. As an iconic image – i.e., as an image reproduced so frequently to have become familiar to the point of invisibility – *Villa en la silla* contains a series of condensed meanings that would be instantly recognizable to this viewing subject and that combine to make of it a complex memory-text. Of the figures assembled, some look directly at the camera, others look inwards at the spectacle of the central leaders, while others still seem to have been caught unaware, their gaze directed at some off-frame space. There is nothing ordered or regimented about this sea of faces and sombreros: this is the revolution as popular struggle. The impromptu scene further bespeaks the mythical meeting of north and south and hence performatively enacts a form of unification that chimes with post-revolutionary discourses of cohesive nationhood. But more than this, the sea of faces with its range of somatic tonalities and associations with the revolution as popular struggle – from the dark-skinned indigenous faces, to the lighter *mestizos* and pale *criollos* – becomes the face of modern *mestizo* Mexico, where discourses of *mestizaje* played a key cementing role in the process of making the Mexican mosaic cohere (Knight 1990).

In the foreground sit the *caudillos*. If hero cults were constructed around the four principal *caudillos*, nevertheless, as O'Malley suggests, within a cultural context that valorized virility, Madero and Carranza were by far eclipsed by Villa and Zapata in the masculinity stakes. Both men were charismatic leaders, associated with hypermasculinity in the popular imagination through their legendary and voracious sexual appetites and acts of audacity in battle. Such attributes were consonant

with and therefore co-opted by the fundamentally patriarchal post-revolutionary state that O'Malley maps in her study. Similarly, both men were associated with a radical political agenda: in the case of Villa, certainly more radical than that of the triumphant conservatives; and Zapata genuinely espoused a radical cause, even if he had no designs on national power. What Villa was lacking in terms of his contradictory political agenda, he more than made up for on the nationalistic front: thanks to his famous raid on the North-American town of Columbus in 1916 he came to represent a supreme symbol of national resistance.

Finally, the photograph also constitutes an act of symbolic iconoclasm, a radical gesture in the context of a nation that was otherwise not given to such displays. As Benjamin argues, 'The defeat and discrediting of the regime of Porfirio Díaz [...] was not accompanied by any outburst of iconoclasm. This absence of symbolic violence is particularly noteworthy and significant since the Porfiriato was the first great age of commemorative monument building in modern Mexican history' (Benjamin 2000: 118). Just as the Porfiriato saw a proliferation of commemorative monuments, Díaz himself was similarly fond of ceremonial displays of his power and was quick to take advantage of the new visual technologies of film and photography to document that power (De los Reyes 1996). If the 'silla presidencial' was associated with anyone or anything, it was with the power of the deposed president. The revolution may have been lacking in coherent goals and ideals. The one thing it did achieve was, of course, the overthrow of the Díaz dictatorship. Hence the iconoclastic gesture that is enacted within this image revolves around its depiction of the desecration of a sacred space with key associations with the ancien regime, and points further to the photograph's status as an image in which meaning exceeds its photographic temporality. Rather than representing one, albeit pivotal moment, in the conflict, *Villa en la silla* has come to stand in for the whole event: an event that disenthroned the old order to replace it with the 'revolutionary' new order.

Condensed in this single image, therefore, is a series of meanings that are circumscribed by and thereby made consonant with the intentionality of the 'muscular' post-revolutionary state. These meanings, readily legible by its viewing subjects, turn on the image's compressed representation of the revolution as an equation with the following values: Popular+Masculine+Mestizo+Mexican=radical rupture with the past. It is this connotational configuration that on one level accounts for the way in which this photograph has become one of those that, in the words of Monsiváis: '[r]epetidas, comentadas – casi podría decirse "impresas en el inconsciente colectivo" –, las fotos seleccionadas muestran que el centro del interés no es el examen de la violencia popular sino la estetización mitológica del proceso revolucionario.' As an image 'imprinted' on the

collective unconscious, *Villa en la silla* is structured like memory in that within the post-revolutionary context its meaning is constructed via the selective appropriation of elements of the past that correspond to the needs of the present. In its address to the post-revolutionary viewing subject, the photograph is also structuring of memory in that through repeated reproduction it reorients popular memory of the conflict. To repeat, after all, is to memorize. Moreover, at the level of address, it must be stressed that this iconic image defies the linear logic of cause and effect that defines historical time. Rather the image is governed by another temporal modality, a modality that belongs to another disciplinary register: namely the psychoanalytic concept *Nachträglichkeit*. Drawing on a definition of *Nachträglichkeit* provided by Laplanche and Pontalis as a 'process of deferred revision', Susannah Radstone (2000: 86) formulates the significance of the concept for analytical approaches to memory:

> In place of the quest for the truth of an event, and the history of its causes, *Nachträglichkeit* proposes, rather, that the analysis of memory's tropes can reveal not the truth of the past, but a particular revision prompted by a later event, thus pitting psychical contingency against historical truth.

To the degree that the iconization of *Villa en la silla* represents a form of (obsessive) 'deferred revision', the photograph indeed does not provide access to 'historical truth'. Rather, to cite Barthes once again, it actually 'blocks memory [and] quickly becomes a counter-memory'. As a memory-text, *Villa en la silla* effectively circulates within a cultural realm that is saturated with visual and other discourses – monuments, murals, films, written histories etc. – that coalesce to confirm the state's revolutionary legitimacy. The state, however, does not have a total monopoly over photographic meaning. The image's semantic orientation is certainly overdetermined by the context of its dissemination. This is a context that serves to block out or disavow the possibility of other memories: memories that belong to popular actors and agents in the revolutionary processes.

Such memories hark back precisely to traces of a past that the photograph's function as legitimizing document seeks to mask. *Villa en la silla* can also be taken to invoke the occupation of the presidential throne by 'rogue' elements of the revolution and to thereby symbolize not so much the overthrow of Díaz – and hence the revolution *tout court* – as the profound power vacuum that was left in his absence. In short, the photograph evokes a fragmented and fractured revolution. Equally, the radical impulses of the agrarian revolution embodied by Zapata and co-opted by the state as rhetoric, while their radicalism was to some degree short-circuited in this way, do not for that cease to exist. Indeed, emphasizing the interactive relationship between state and society, Vaughan points out that 'in the early 1930s accelerating pressure from peasants to redress

grievances, material and religious, led the central government to induct the figure of the agrarian revolutionary, Emiliano Zapata, into the pantheon of patriotic heroes' (Vaughan 2001: 473). Read against the grain of the hegemonic discursive structures in which it circulated, *Villa en la silla* could also be seen – paradoxically – as a potentially radical and destabilizing image that speaks to the experiences and concerns of the popular classes. Instead, however, the photograph's sanctioned meaning turns on a disavowal of historical knowledge (both Zapata and Villa were vanquished by the conservative revolution embodied by Carranza and Obregón) in favour of belief: in the radicalism of the new order.

Iconicity and Repetition

To the degree that *Villa en la silla* captures the post-revolutionary gaze in the seductive belief in revolutionary unity to guard against the encroachment of knowledge of other memories of the struggle, our understanding of the photograph's iconic status and its function as counter-memory can, however, acquire more complexity. Having constructed a strategic working definition of the way in which the photograph might have interpellated its historically situated viewing subject, I want now to suggest another reading of iconicity and, in so doing, take the concept of the photograph as counter-memory a step further. As a photographic counter-memory, whose meaning turns on disavowal – disavowal not so much of the Barthesian 'what-has-been' as of 'what might-have-been' – *Villa en la silla* is also, at the same time, the site of traumatic memory within the parameters of a post-revolutionary hegemonic rhetoric of national identity.

Here it is instructive to bring back into focus alongside *Villa en la silla* other iconic photographs mentioned at the outset of this essay, namely 'Zapatistas en Sanborns', 'Soldadera' and 'Pelotón'. Within the terms of my argument, it is at once comprehensible and at the same time curious that these images – which would certainly figure in any list of *the* most reproduced and therefore iconic photographs of the revolution – invoke the revolution in a similar visual idiom: as a moment of acute rupture and transgression. Villa and Zapata occupy the sacred space at the heart of the nation; gun-toting indigenous peasants take light refreshment at Sanborns; women break out of the sanctity of the domestic sphere and are catapulted into the heart of the conflict; a revolutionary fighter faces death with laconic insouciance. Think by comparison of photographs of Francisco I. Madero whose diminutive figure often appears overwhelmed by his surroundings as if foreshadowing the way in which the revolution was to engulf him. Think also of photographs of members of the tri-

umphant faction, of Carranza and Obregón. A number of images that depict them have, to be sure, achieved a degree of iconicity, but they are tempered by a certain tameness that places them in a different semantic order to those of the *bola* and the *caudillos*, Villa and Zapata. Monsiváis sums this difference up in the following terms: 'Otras grandes figuras: Venustiano Carranza, Álvaro Obregón [...] no captan como Villa y Zapata la admiración popular y el odio de los sectores ilustrados y acaudalados' (Monsiváis 2000: 92). In short, Villa and Zapata pack the revolutionary 'punch' that Carranza and Obregón lack.

Insofar as what we might term 'radical' photographs are put to work in the service of post-revolutionary nation-state formation in a process whereby their meaning hinges on a disavowal of knowledge in favour of belief, their pervasive presence is indeed comprehensible. Nevertheless, to the degree that each of these photographs represents a scene of profound trauma or rupture in the social fabric, it is curious that these and not the 'tamer' images of the triumphant faction should predominate. As (counter) memory texts they represent a vision of the past that paradoxically cannot so easily be integrated into the elitist and conservative realities of the post-revolutionary present. Their affective force is, furthermore, made all the more compelling by their status as photographs. If there is one thing that their evidential force tells us it is that on some level what they depict really did happen.

It is this paradox, however, that may modulate our grasp of the iconicity of such photographs. Bearing in mind that iconic status is the product of repeated exposure, the compulsive repetition of *Villa en la silla*, 'Soldadera', 'Zapatistas' and 'Pelotón' within the hegemonic post-revolutionary cultural sphere can be seen as attributable to two interrelated and contradictory factors. On the one hand, repeated exposure of an image can be seen, as I have argued, as part of the post-revolutionary state's project to reprogram popular memory of the revolution in order to embed it in the collective (un)consciousness as a socially radical and cohesive event. If the subaltern subjects that are the receptacle of popular memory in this account of the image are viewing subjects, however, so too, of course, are those who embody hegemonic power. Viewed through the optic of those subjects who, to cite Wood again, 'promote or authorize' the entry and circulation of images within the cultural sphere, these iconic photographs that document profound rupture are uneasy reminders of a past, on one level at least, best forgotten.[16] On the other hand, then, the obsessive repetition of these photographs bespeaks a profound sense of anxiety harboured by those with access to hegemonic power in the face of these images as sites of trauma.

In the preface of *Trauma: Explorations in Memory*, Cathy Caruth suggests that 'traumatic recall or reenactment is defined, in part, by the very

way that it pushes memory away' (Caruth 1995: viii). Bearing this defi-
nition in mind, I suggest that we can give the iconicity of these photo-
graphs a further psychoanalytic inflection.[17] That is, to the very subjects
who, responding to the political exigencies of the day, authorize and con-
trol circulation, these photographic images represent the repressed of the
revolution: popular power. On their surface are inscribed traumatic traces
of the real: traces that represent a past that, ghost-like, haunts the present:
in the case of 'Soldadera' and 'Zapatistas', the ghost of what was; in the
case of *Villa en la silla*, of what might have been. Iconicity, in this read-
ing, is a form of compulsive repetition and in the Freudian account, tes-
tifies to a psychic need to return to the situation in which the trauma
occurred in an endeavour to master the external stimuli retrospectively by
reproducing the anxiety.[18] In the psychic domain, the compulsion to
repeat, which I am reading as resulting in iconicity, represents an attempt
to achieve some degree of mastery over the site/sight of trauma. The
iconic status of what I have termed 'radical' photographic images, there-
fore, ultimately represents an act of counter-memory in so far as iconic-
ity – as compulsive repetition – works precisely to push the trauma of this
memory away. At the same time, however, in this reading, the iconic pho-
tograph as counter-memory inevitably tacitly serves as a form of
acknowledgement of the potentially subversive charge that is contained
within such visual documents.

Usted ya los conoce...

What then is at stake in the forms of knowledge produced by the iconic
photographs that entered into circulation in post-revolutionary Mexico?
If we take *Villa en la silla* as emblematic of the revolution *tout court*, by
the same logic of synecdoche, it comes to stand in for not just the revo-
lution but also all photographic images of the struggle. As a simultane-
ously emblematic and iconic image, *Villa en la silla* defies the linear
logic of cause and effect of historical time. Rather, its meaning can be
dissected by recourse to the methodologies of memory. Such a reading
resists the apparent self-evidence of photographic signification and
eschews its conventional illustrative function alongside conventional his-
torical texts.

The reading of *Villa en la silla* traced in this chapter has to some extent
privileged an understanding of the image as embodying an intentionality
linked to the hegemonic project of state. Nevertheless, that such 'radical'
images were allowed to circulate testifies to the status of post-revolu-
tionary cultural politics and power as subject to the processes of negoti-
ation and accommodation between state and society. If we attend to the

'unconscious vicissitudes' that underpin these processes of accommoda-
tion and negotiation as they are played out in this individual image, what
ultimately emerges is a paradox. Iconic photographs may harbour mem-
ories that are so overwhelming that the remembering of them has the
potential to threaten the official account of post-revolutionary identity; at
the same time, these same memories are mobilised to shore it up.

Notes

* This essay and my interest in questions of memory in Mexico came about as a
 result of attending the wonderful summer school on cultural memory in June
 2000 at the Institute of Romance Studies, University of London, organised by Jo
 Labanyi. I thank Jo and the co-participants and invited presenters at the summer
 school for an extremely stimulating and thought-provoking week. As ever, I am
 grateful to John Mraz for his insightful comments on this essay.

1. There are in fact (at least) two versions of the photograph in circulation: one in
 which Zapata looks directly into the camera and one in which he stares to his right
 at Villa. For the sake of clarity, however, I refer to the image as a single image. In
 the reworkings of the photograph discussed below both versions are used, which
 leads me to think that the two versions are used interchangeably.

2. Vicki Goldberg (1993: 135) argues that during the twentieth century photographs
 increasingly came to displace (at least partially) public monuments.

3. Usted ya los conoce: unos Zapatistas con expresión indescifrable desayunan en el
 palacio porfirista de Sanborns/ una soldadera nos mira desde un tren/ un fusiable
 atiende con meditado desprecio o refinada ironía al pelotón/ Zapata y Villa se aco-
 modan en las sillas del poder/ Carranza distribuye su madurez y su gravedad entre
 un tropel de jóvenes/ Obregón ve maniobrar a un regimiento/ Villa entra a caballo
 a Torreón/ Eufemio, Emiliano y sus mujeres dan fe de la sobrevivencia de la
 pareja en el torbellino de la revolución...

4. As with *Villa en la silla*, there are (at least) two versions of 'Zapatistas en San-
 borns': one that features the waitresses and Zapatistas and another of the Zapatis-
 tas alone. For an analysis of the Zapatistas images, see Noble 1998.

5. For a discussion of issues of gender and photographic representation see my essay,
 'Gender in the Archive María Zavala and the Drama of (not) Looking', in Noble
 & Hughes, forthcoming.

6. Brenner 1996. Brenner is rather free with the chronology of events: Carranza had
 abandoned Mexico City for Veracruz prior to the arrival of Zapata and Villa and
 therefore could not have had his photograph taken in front of the presidential
 'throne' between their arrival and the making of the famous photograph. The
 sequence of 'throne room' photographs (numbers 106, 107 and 108) is, neverthe-
 less, visually striking and may justify the anachronism.

7. Joseph and Nugent 1994: 12. Revisionist interpretations of the revolution arose in
 the aftermath of the student massacre of 1968. They challenged the prevailing
 notion that the revolution had been a popular struggle that sought emancipation
 from backwardness and social inequalities and whose goals were achieved
 through post-revolutionary state policies. Post-68 historiography placed an

emphasis instead on the state as a monolithic, centralised entity that brokered power via the co-option and repression of the popular masses. More recently, a post-revisionist historiography has emerged that seeks to understand the revolution and post-revolutionary politics and power as a negotiation between state and society, rather than as a 'top-down' imposition. For an excellent overview of these issues see Vaughan 1999.

8. Clearly one of the major divergences between the three sources cited is their context of publication and dissemination: namely, Mexico and North America. I would argue that the presence of the photograph *Villa en la silla* across the two contexts attests further to the iconic status of the image: status which is not just confined to Mexico.

9. This parade and the Generals' appearance on the balcony were also captured on film. See Carmen Toscano, *Memorias de un mexicano* (1950).

10. As Manuel Alvarado (2000: 148) notes '[w]ork on the still image and, more specifically, on the single photograph has tended to leave out of account the question of narrativity. Conversely lists of cultural artefacts that can carry narratives seldom include the photograph.'

11. See also, Maurice Halbwachs, *The Collective Memory* (1980). The emphasis added is mine: I pick up on the notion of unconscious vicissitudes of collective memory below.

12. It should be clarified that neither scholar is blind to the workings of visual culture in the processes that they analyse. Benjamin incorporates some discussion of muralism and O'Malley includes material on film. However, neither scholar mentions the incredibly rich Casasola Archive other than in passing.

13. John King also notes: 'the newly developed technology could be put immediately to the service of the revolutionary struggle. This was a war in which representation was to become important, a field of destruction, but also of perception' (King 1995: 14).

14. In a recent paper John Mraz argues that '[T]hough photography was often not as immediately tied to the State as cinema, the only real outlets for photojournalist images were the illustrated magazines sush as *Hoy* and *Mañana*, which depended on the government for their existence' (Mraz 2001: 4).

15. There are, undoubtedly, inherent dangers involved in trying to imagine in such a totalising way this putative viewing subject. Within the context of post-revolutionary cultural politics, looking relations are invariably fraught with issues of regional, ethnic and class identities, not to mention issues of gender. However, in my project to account for the iconicity of this photograph, some form of construction of an encounter between a viewer and the image is essential and a strategic step in my argument that works towards an analysis of the iconic photograph as the site of resistant memory. I have attempted to start to work through questions of looking relations within a specifically Mexican (cinematic) context elsewhere, see Noble 2001.

16. Thanks to John Kraniauskus for prompting me to clarify this point.

17. The deployment of psychoanalysis in cultural studies – particularly those dealing with non-metropolitan areas – inevitably runs the risk of a-historicity. In this context, Abigail Solomon-Godeau makes a convincing case for the strategic usefulness of psychoanalysis as an analytical tool within different historical and cultural arenas. She argues that the persistent recurrence of certain phenomena and symp-

toms across histories and cultures cannot be explained without recourse to an understanding of the psychic domain. But, at the same time, such an approach should not preclude rigorous historical analysis. See Solomon Godeau 1997: 36.

18. The notion of the compulsion to repeat is at the centre of *Beyond the Pleasure Principle*, 1920, SE, 18, pp. 1–64. For a useful summary see Laplanche and Pontalis 1988.

Bibliography

Alvarado, Manuel, Edward Buscombe & Richard Collins, eds. 2000. *Representation and Photography: A Screen Education Reader*. Basingstoke: Palgrave.

Anderson, Benedict. 1991. *Imagined Communities: Reflections on the Origin and Spread of Nationalism*. London: Verso, revised edition.

Barthes, Roland. 1993. *Camera Lucida: Reflections on Photography*, trans. Richard Howard. London: Vintage.

Benjamin, Thomas. 2000. *La Revolución: Mexico's Great Revolution as Memory, Myth and History*. Austin: University of Texas Press.

Brenner, Anita. 1996. *The Wind that Swept Mexico: The History of the Mexican Revolution of 1910–1942*. 4th edition. Austin: University of Texas Press.

Caruth, Cathy, ed. 1995. *Trauma: Explorations in Memory*. Baltimore: The Johns Hopkins University Press.

Casasola, Agustín V. 1947. *Historia gráfica de la revolución, 1910–1940*, Cuaderno no. 10. Mexico, D. F.

De los Reyes, Aurelio. 1985. *Con Villa en México: testimonios sobre camarógrafos norteamericanos en la revolución, 1911–1916*. Mexico, D. F.: Universidad Nacional Autónoma de México, Instituto de Investigaciones Estéticas.

———. 1996. *Cine y sociedad en México, 1896–1930*. Mexico: UNAM.

De Orellana, Margarita. 1992. *La mirada circular: El cine norteamericano de la revolución mexicana*. Mexico, D. F.: Joaquín Mortiz.

Debroise, Olivier. 1998. *Fuga Mexicana: un recorrido por la fotografía en México*. Mexico D. F.: Consejo Nacional para la Cultura y las Artes.

Goldberg, Vicki. 1993. *The Power of Photography: How Photographs Changed our Lives*. New York: Abbeville Press.

Gómez Morin, Mauricio. 2000. 'La mirada de Zapata sin silla', *La Jornada Semanal*, 31 December 2000 (Mexico, D. F).

Graham, Richard. 1990. *The Idea of Race in Latin America, 1870–1940*. Austin: University of Texas Press.

Gutiérrez Ruvulcaba, Ignacio. 1996. 'A Fresh Look at the Casasola Archive', *History of Photography*, 20, 3: 191–95.

Halbwachs, Maurice. 1980. *The Collective Memory*. New York: Harper and Row.

Joseph, Gilbert M. & Daniel Nugent, eds. 1994. *Everyday Forms of State Formation: Revolution and the Negotiation of Rule in Modern Mexico*. Durham: Duke University Press.

Joseph, Gilbert M., Anne Rubenstein & Eric Zolov, eds. 2001. *Fragments of a Golden Age: The Politics of Culture in Mexico since 1940*. Durham and London: Duke University Press.

King, John. 1995. *Magical Reels: A History of Cinema in Latin America*. London: Verso.

Knight, Alan. 1986. *The Mexican Revolution*. Lincoln: University of Nebraska Press.
――――. 1990. 'Racism, Revolution, and *Indigenismo*: Mexico, 1910–1940'; in: *The Idea of Race in Latin America, 1870–1940*, ed. Richard Graham, Austin: University of Texas Press.
Krauze, Enrique. 1987. *Emiliano Zapata: El amor a la tierra*. Mexico: Fondo de Cultura Económica.
――――. 1997. *Biografía del poder: Caudillos de la Revolución mexicana (1910–1940)*. Mexico: Tusquets.
Laplanche, Jean & J.-B. Pontalis. 1988. *The Language of Psychoanalysis* London: Karnac Books.
Metz, Christian 1999. 'Photography and Fetish', in *Overexposed: Essays on Contemporary Photography*, edited by Carol Squiers. New York: The New Press.
Monsiváis, Carlos. 1980–81. 'Notas sobre la historia de la fotografía en México', *Revista de la Universidad de México*, Vol XXXV, 5–6, dic-enero: unnumbered pages.
――――. 1989. 'On Civic Monuments and their Spectators', in *Mexican Monuments: Strange Encounters*, edited by Helen Escobedo. New York, Abbevilles Press.
――――. 2000. *Aires de familia: cultura y sociedad en América Latina*. Barcelona: Editorial Anagrama.
Mraz, John. 2000. 'Historia y mito del Archivo Casasola', *La Jornada Semanal,* 31 December 2000 (Mexico, D. F).
――――. 2001. 'Envisioning Mexico: Photography and National Identity', Duke-University of North Carolina Program in Latin American Studies, Working Paper #32.
Noble, Andrea. 1998. '*Zapatistas en Sanborns* (1914): Women at the Bar', *History of Photography*, 22, 4: 366–70.
――――. 2001. 'If Looks Could Kill: Image Wars in *María Candelaria*', *Screen*, 42, 1: 77–92
Noble, Andrea & Alex Hughes, eds. 2003. *Phototextualities: Intersections of Photography and Narrative*. Albuquerque, University of New Mexico Press.
O'Malley, Ilene. 1986. *The Myth of the Revolution: Hero Cults and the Institutionalization of the Mexican State: 1920–1940*. New York: Greenwood Press.
Poniatowska, Elena. 1999. *Las Soldaderas*. Mexico: INAH/Ediciones Era.
Radstone, Susannah, ed. 2000. *Memory and Methodology*. Oxford: Berg.
Solomon-Godeau, Abigail. 1997. *Male Trouble: A Crisis in* Representation. London: Thames and Hudson.
Squiers, Carol, ed. 1999. *Overexposed: Essays on Contemporary Photography*. New York: The New Press.
Vaughan, Mary Kay. 1999. 'Cultural Approaches to Peasant Politics in the Mexican Revolution', *The Hispanic American Historical Review*, 79, 2: 269–305.
――――. 2001. 'Transnational Processes and the Rise and Fall of the Mexican Cultural State: Notes from the Past', in *Fragments of a Golden Age: The Politics of Culture in Mexico since 1940*, edited by Gilbert Joseph, Anne Rubenstein & Eric Zolov. Durham and London: Duke University Press.
Wood, Nancy. 1999. *Vectors of Memory: Legacies of Trauma in Postwar Europe*. Oxford: Berg.

Chapter 10

Mass and Multitude:

Bastardised Iconographies of the Modern Order

Graciela Montaldo

In her most recent book Susan Buck-Morss suggests that '[t]he construction of mass utopia was the dream of the twentieth century. It was the driving ideological force of industrial modernisation in both its capitalist and socialist forms. The dream was itself an immense material power that transformed the natural world, investing industrially produced objects and built environments with collective, political desire.' (Buck-Morss 2000: IX) The central role of the masses in the political imaginary of the twentieth century is to be found both in political processes and in utopias and collective dreams. What I want to consider here is how this 'centrality', which posits mass utopia as the dream of the twentieth century, is transformed into a bastardised and deformed 'image' in some texts of the Argentine literary and cultural tradition that confront the problem of what is 'national'. As the embodiment of problematic forms of nationality (forms which articulated determinate projects of State based either on the myths of integration and discipliniation of the immigrant, on the promotion and subsequent limitation of the social advance of the middle classes, or on the rapid modernisation of the elites with hardly any concern for that of the rest of the society), the masses find themselves reflected in the discourses characterising the politically decisive moments of twentieth-century Argentine history. Underneath a deceitful varnish of plurality, we can perceive various types of differences, which both the State and the intellectuals will interpret according to a particular political code. The 'masses' and the 'nation' are uneasy bedfellows during the entire twentieth century but, at the same time, it is impossible to think of one without the other. In the images of the construction of the 'nation', the 'masses' remain a privileged interlocutor when faced with the problem of power.

Subjects: Intellectuals and Masses

In his remarkable book *Mass and Power* (1960), Elias Canetti describes the mass as an impulse or force, contrary to instrumental reason, which necessarily comes into conflict with constituted power while this latter, in turn, tries to govern and tame it. The most surprising aspect of this surprising book, however, is the way in which Canetti breaches a phenomenon that we now consider so intimately linked to modernity, to industrialization and to urban culture – and which is evidently rooted in concepts of social positivism – without the least consideration of its historical determinants. Canetti, from a critical perspective (neither determinist nor referential), emancipates the problem of the masses from both time and space, and even from numbers, ignoring such dimensions precisely for its magnitude, associated with the growth of large cities and the emergence of the proletariat during the industrial revolution. He does not even analyse the masses as a scientific category that could be identified on the basis of particular social or psychological characteristics. On the contrary, in his extensive essay, the masses are a type of social behavior, which always, and necessarily, needs a representation; the mass is (or has become) a performance. The masses *are the representation of the social*. I would like to show a picture (figure 10.1).

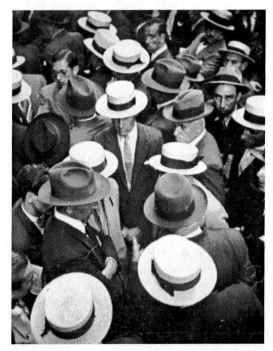

Figure 10.1 Electoral parade (1922). Elegant men in a Buenos Aires street. The multitude has no face. Archivo General de la Nación, Argentina.

(Following Buck-Morss's suggestion I use images in this essay not so much 'to illustrate' the text but to show different forms of performances and confront them with literary texts. All the images come from the Archivo General de la Nación (Argentina) and they are 'pieces' of the State collection – pieces of what the State thinks 'the national' is made of. They represent a narrative text written and salvaged by patrimonial practices: the State gathered these images and put them into boxes to preserve them both from being exhibited – except as a State collection – and from damage. Brought into dialogue with parody or critical texts, they can help us conceive the masses and the multitude not as a social subject but as a real actor who makes a performance of the social conflicts or alliances. When masses appear something will be happen. And the images don't always expose what they show… I remember, in this regard, Christian Boltanski's works of art: in his work, he uses the photograph not as a referential instrument but as a conflictive form of confronting real life and its representations (see Perloff 2001: 37–39). Through the images in this chapter I try to show a dimension of that complex relationship).

It may be useful to recall the recent definition that Antonio Negri and Michael Hardt offer of the 'multitude'. Having emerged as a phenomenon which positivism had represented and condemned as a dangerous and disruptive product of modernity, the categories 'mass' and 'multitude' are now being presented as alternatives to the category of 'the people' (a liberal subject, functional for the modern State and amply commented on by intellectuals). It now appears that the categories mass and multitude allow us to think in terms of alternatives to the basic power structures, as organised by modern society:

> The term 'multitude', as used by classical political science, was pejorative and negative. The multitude was a collection of persons living in a pre-social world, in a world that had to be transformed into a political society, a society and, as a result, had to be dominated. […] The multitude (multitudo) is a Hobbesian term, that has precisely that connotation. In all the classical political science texts, modern and postmodern, the term 'multitude' is transformed into plebe, people and so on. (Negri 2000: 52–53)

The idea of the mass (or multitude) as performance not only helps us reflect on contemporary struggles and events (Seattle, Genova, Buenos Aires, as the sequence proposed in *Empire* goes). We should also remember that modern, democratic political doctrines emerged in order to speak to and for the people; if the people are the great subject of modernity, the mass (the multitude) is the great threat to modern democratic ideals. If the State represented the people over and over again, the multitude always lacked representation, except as an abyss that opened up before modern life. As Paolo Virno indicates, 'the people'

has always been identified with national unity by means of a process of personification of the State, in the person of the sovereign: 'the progressive idea of "popular sovereignty" has as its bitter counterpart an identification of the people with the sovereign, or, if you like, the popularity of the king' (Virno quoted in Beasley-Murray 2000: 155). The dark side of this image is the mass: not the legitimate image of the national but its counterpart.

Mass and multitude are consolidated, in the discourse of modernisation, as the reprehensible face of the excluded, remnant of a barbarian past that unfortunately persists in modern times and which, as such, serves to impede or stem progress. Of course, it is made clear that, as a regressive force, it has little option: it must be destroyed or institutionalised. In the discourse of modernisation, the masses and the multitude do not speak, they only act or pose and, as a result, they are responsible for excluding themselves from the modern political pact, acting as subversives, without the option of returning to the rationality of politics: they have no place because they have no discourse. Hence, the insistence in seeing the masses as a phenomenon to be 'manipulated', and the need to create a specialised knowledge that explains and justifies its manipulation. In this case, however, we must ask how are we to study this subject, which is only constituted within hegemonic discourse?

We must not forget that the problem of the masses and the multitude begins, precisely, with their visualisation, before any attempt at quantification. For this reason, we can suggest that the mass is that which acts out and represents, in a specific situation, certain types of behavior – a performance – and which realises a series of ritualised practices, all of which are, above all, visible. The mass, in Canetti's text, is the potential for realising and representing a ritual. The number of individuals involved is not very important; what counts is the performance, the will to represent, and to do so in public space. And this happens, – according to Canetti – in the same way among small Maori tribes and modern urban masses (which, for Canetti, are made up by individuals who are already readers of newspapers). With regard to this point, it is not difficult to see the relevance of Walter Benjamin's idea, expressed in his classic essay *The Work of Art in the Epoch of its Technical Reproduction*. As Buck-Morss reminds us, discussing the values of images, 'when later Soviet generations "remembered" the October Revolution, it was Eisenstein's images they had in mind. The particular characteristics of the screen as a cognitive organ enabled audiences to see the materiality not only of this new collective protagonist, but also of other ideal entities: the unity of the revolutionary people, the idea of international solidarity, the idea of the Soviet Union itself' (Buck-Morss 2000: 147).

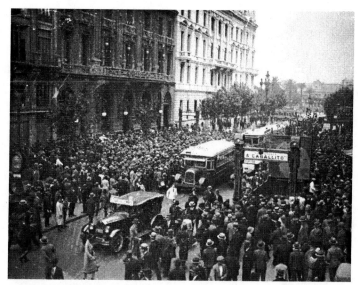

Figure 10.2 Meeting of the Popular Union (1914). Again: elegant men and women. Emblems of modernity: buses, cabs, metro station. And the Capitolio at the end of the street. This multitude is not a threat. Archivo General de la Nación, Argentina.

Faced with any constituted power, but particularly with the power embodied in the modern State, the public presence of the multitudes may be either spontaneous or directed. It is doubtless in the nineteenth century when the multitudes begin to exercise a political protagonism, but it is with the consolidation of the unified and centralized power of the State that the multitude appears, in Europe, as a dangerous subject with which it becomes progressively necessary to come to terms. In contrast to the individual 'nature' of the leader or the educated man, the multitude has an unstable status, between the 'spontaneous' grouping of subjects and the manipulation of blind forces based on the impunity derived from its anonymity. Since their appearance as a modern phenomenon, the masses are seen as a danger, the source of social chaos, the root of violence and a threat to established institutions. The images commonly used by the elites to represent this threat to values, order and institutions were those of peasants looting bakeries during the French Revolution or workers destroying machines, or marching on – invading – the cities, during the Industrial Revolution. Disciplines such as social psychology emerge in order to control, and to offer 'scientific' explanations of this menace to the elites.

But the problem is not limited to Europe, nor is it simply a question of modernity. Nineteenth-century Latin America is plagued with political movements that cannot be understood without taking into account the conjunctural alliances with those masses on the margin of society

and politics: *caudillos* leading armed peasants against Spanish troops or the early republican governments, Indians or blacks offering armed resistance throughout the region to the incipient order that was being imposed. For the *criollo* leaders, these experiences from the outset indicated the danger inherent to the alliances they were occasionally obliged to make with those 'dangerous classes' which, once mobilised for military ends, were prone to turn against those who had recruited them. Latin American intellectuals have considered this phenomenon ever since it first appeared and their reflections are registered in literature. Within the framework of the problem State/nation/modernity, the category of the masses was used in cultural and political terms as the emblem of the nation and, in many texts, was regarded as crucial for the modernising process in Latin America. The mass is always associated with a conflict, a problem, and a confrontation between different sectors disputing the control of power. It is a force that the factions in conflict need to control, discipline and finally dissolve, once the battle has been won.

In Latin American literature, this representation is evidently of central importance since the Independence period, but it had been so even before. During the process of modernisation, the masses appear as a central issue in the intellectual struggle for power, and the alliances of those of higher descent with different sectors of the excluded masses is a central issue of intellectual policies in different countries (see for example, on the case of the gaucho literature in Argentina, Ludmer 1988). It appears as no exaggeration to say that one of the fundamental rifts in Latin American culture – at least since Independence – is between intellectuals and the masses.

The mass does not exist, except to the extent that it is perceived or it perceives itself. An unstable subject or entity, which only knows how to act, the mass from very early on becomes a problem for cultural circles in Latin America. For, in Spanish, the word *masa* has the connotation, not only of quantity, but above all, of quality. It is not simply a case of 'a lot of people'; it also suggests that they are ordinary, vulgar, typical of those who 'make up the masses'. In this circumstance of a fusion with many others, there is one point I would like to single out: the mass is precisely the instance where particular subjects are cancelled out, giving rise to something unprecedented. The mass is a creature which cancels out individuals and produces something new, fearsome, powerful and perhaps given to destroy, that does not necessarily preserve human characteristics. That is to say: a monster. At least, that is the way it was seen by those who considered their individuality to be the condition for their identity within modernity: the intellectuals.

Figure 10.3 The birth of an immigrant nation: strike in the Conventillo. These people are immigrants: Jews, Italians probably. There is a strike: children are smiling, 'posing'. Archivo General de la Nación, Argentina.

It could be said that, in Latin America, these two cultural categories (intellectuals and masses) emerge as closely related in the post-Independence period. The masses and the educated men are the two faces of a single figure of identity, which does not recognise transitions but rather develops a belligerent polarisation without room for negotiations. This was the vision put forward by Sarmiento in his *Facundo* in 1845, but it had been anticipated by the early, lettered founders of the republican cultural order, with the writing of literary classics – building national history, telling the great epic of the heroes, with a mass of anonymous followers very much in the background, disciplined by the hero and captivated by his aura: Andrés Bello in the *Silvas americanas*, José Joaquín de Olmedo, in *La victoria de Junín. Canto a Bolívar* (1825), José María Heredia in *Niágara* (1825). That order, the first aesthetics imposed on the masses after Independence, is hinged on a theme that was to be developed by Sarmiento, who suffered the consequences of masses unwilling to submit themselves to order (of course, this refusal is precisely the core of their definition as a mass). Sarmiento pointed out the dangerous characteristics of the masses (which are referred to successively as barbarians, savages, people, Asian people, gauchos and also, occasionally, Argentineans), defining them in terms of an *otherness*, which necessarily had to be dominated; there were to be other ways of representing them within modernity ('gauchesque' litera-

ture). On all sides, the masses irrupt onto the scene but, if it is not far-fetched to think of them in terms of a representation of the social, then what is represented in their image when the masses 'represent' the nation?

Icons

The sea of bowler hats which, in photographs of the period, celebrate the initial attempts to introduce democratic reforms in Argentina towards the end of the nineteenth century, are an eloquent expression of the fractures within the elite. Contrasting with the workers' 'blouses' and the few working women's 'headscarves', they represent a scenario where what is at stake is a redistribution of the constellation of political forces in liberal Argentina, which attempts to consolidate a homogeneous set of values related to a national identity. The photos of the 'massive' celebrations on the occasion of the Centenary of the nation's birth, of elegant society at the Jockey Club, of the middle classes in the elegant streets of the city, of working class manifestations, exhibit a city – Buenos Aires – in which the masses are entitled to represent their rituals (their exhibitions of power and money, of elegance but also of social demands). The slums (*conventillos*) – frequently captured by the camera at the beginning of the century – also evidence a new sociability which is being integrated into the city, that of the poor immigrants. These images celebrate the nation from a State perspective, or in opposition to it, and form part of a struggle over national values. Henceforth, the representation of 'the essence of Argentina' was recurrent. And the disputes over the legitimacy of these different representations are part of the everyday cultural battles, with the masses always a central issue.

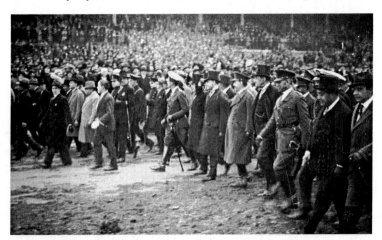

Figure 10.4 General Uriburu became President after a military coup; here he visits the Jockey Club with other members of the Army; the elegant multitude applauds. Archivo General de la Nación, Argentina.

Nevertheless, these different 'fragments of the mass' also reveal the conflicts inherent in the Argentinean elite's project for imposing homogeneity. And they also prepare the terrain for twentieth-century populisms. Leopoldo Lugones's, the national laureate's, reference to the masses as 'the overseas *plebe* which, like ungrateful beggars, create a scandal on our porch' (1972: 23), highlights the risks inherent in negotiating with the 'other' and the paternalist character of the Argentinean State project. And it evidences the demands of those who are seen as the obscure aspect of gregariousness, its dangerous aspect. Although the liberal State has not yet produced a 'utopia for the masses' (or maybe social mobility was that utopia…), it is clearly aware of the need to discipline them, as they represent a social threat. Masses are interpellated in order to homogenize them and incorporate them into the national model. These are the same masses that would actively support Yrigoyen and Perón in later decades, the basis for the great populist movements in Argentina. As Buck-Morss reminds us,

> there *is* no collective until the "democratic" sovereign – precisely in the act of naming the common enemy – calls that collective into being. Subsequently, any popular challenges to the sovereign's legitimacy can be defined as enemy acts. It follows that the sovereign's legitimate claim to the monopoly of violence cannot be granted by the people, that this power is not and can never be democratic. (Buck-Morss 2000: 9)

Argentinean literature was always conscious of this and took it into account in its struggles.

Although it can be argued that the composition of the masses which back the different Argentinean populisms, is varied, there is a fundamental active element: in the field of representation, the mass is the central icon of the nation. If the liberal governments chose to project an elegant multitude in elegant settings, reflecting their own desire for a Europeanized modernity without fissures, the masses that populism projects onto the political scene take to the streets in order to demand a protagonism that, once again without fissures, guarantees a dominant position in national politics. For this reason, the image of these bastardised masses is to be found throughout the twentieth century, occupying successively the nation, within or beyond the State. We need to recall the way in which this phenomenon developed in Europe: as McClelland (1989) points out, before the First World War the masses and the multitude were aspects of a single phenomenon which drew the attention of social theorists and of those in power. After the war, there can be no doubt that the era of the masses has arrived and that politics has been transformed into mass politics. Everyone begins to prepare for 'plebeian politics', which would find its main expression in populism.

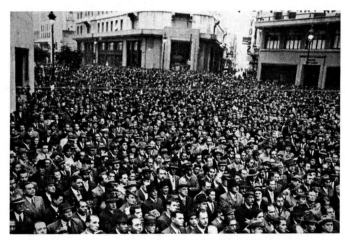

Figure 10.5 Meeting of Acción Argentina. Multitude celebrating Labour Day, 1941. Archivo General de la Nación, Argentina.

In this way, the old images of ordered groups of the local oligarchy have to dispute pride of place with the unordered multitude that takes to the streets. In contrast with the violence of the nineteenth century, that of the twentieth century has to take the law into account because it is the law that determines its legitimacy: and the State alone can, in a legitimate way, apply it. Any other violence is the violence of the enemy; and the groups, the multitude, the masses, become the favorite blanks for illegitimate violence. In his study of the history of the concept of masses, McClelland points out that the theory of the masses became a theory of violence almost from its birth, and one which incorporated anti-democratic arguments even before the process of democratisation was under way. This helps us to understand much of Argentinean political violence and the place occupied by the masses in the epochs of political turbulence.

Figure 10.6 Repression during the 'Tragic Week', 1919. Archivo General de la Nación, Argentina.

Early twentieth-century Argentina, 'infested' with immigrants, would clearly experience this process. It was not only the newspapers of the epoch, which registered it, with their images of the masses in the public space. It was also reflected in the literature of those years, which put different subjects under 'scientific' scrutiny: José María Ramos Mejía's *The Argentine Multitudes* [1899] (1977) is a key text for understanding the sociology of the turn of the century. The phenomenon of 'suggestion', so closely linked to the theory of the masses after the publication of Gustave Le Bon's classic best seller *The Minds of Crowds* (1895), permeates turn-of-the-century fiction from Leopoldo Lugones to Horacio Quiroga (see Molloy 1994 on the 'pose' characterising this group of writers). Early on, science contributed to the definition of a phenomenon that was basically political. Psychology and sociology sought to define its' limits and dangers. Political violence against immigrants, anarchists and proletarians has several well-known landmarks, of which the *Semana Trágica* of 1919 is the most outstanding. In that year, during a labor conflict at Vasena, a metallurgical company located in Buenos Aires, the workers went on strike demanding better salaries and a reduction in the number of hours per working day. When negotiations came to a standstill, the police intervened to disrupt the strike. Suddenly violence generalised reaching out towards union leaders and the immigrant working population as a whole. In addition to police intervention, in a spontaneous reaction nationalist groups organised pogroms against the 'Jewish anarchists'. For a whole week, persecutions, killings and imprisonments of immigrant activists went on.

The violence of the *Semana Trágica* may be better understood if we compare it with a case of the 'legitimate' application of mass power, just a year before, in the city of Córdoba, in favour of university reform. It might also be instructive to compare the representation of the students of Córdoba taking to the streets, as a group and shouting slogans, with the final scene of José Enrique Rodó's *Ariel* [1900] (1985), bedtime reading for an entire generation of intellectuals, where the 'students' come into conflict with the multitude:

> When the rough contact with the crowd brought them back to reality, it was already night. […] Only the presence of the multitude marred the sense of ecstasy. A warm breeze made the surroundings tremble with languid and delicious abandonment, like the trembling cup grasped by a daughter of Bacchus … And, in that moment, after a prolonged silence, the youngest of the group, called "Enjolrás" because of his reflexive introversion, pointed first to the gentle undulation of the human flock and then to the radiant beauty of the night and said: "While the crowd of people passes, I observe that, although they do not raise their eyes to heaven, heaven is observing them. Something descends from above over this mass, indifferent and obscure like ploughed earth. The vibrations of the stars suggest a sower's hand in movement'. (Rodó 1985: 56)

Multitudes and masses are differentiated by the nature and prestige of their manifestations: students, workers, immigrants, the elites gathered together in the elegant sites of the city: all of them represent a danger (for the State, for the subaltern sectors, for the middle classes). We will now examine more closely a couple of these representations.

Figure 10.7 Meeting of the Unión Cívica Radical. The main –populist– party prepares to win the election: elegant men, in an elegant theatre, listening and posing. Archivo General de la Nación, Argentina.

Jews-Communists

Masses, multitudes, crowds everywhere. I do not intend to present a panorama of how, when and where the masses appear in Argentinean literature; that would mean covering nearly all the authors of the first half of the twentieth century and it would be necessary to start in the nineteenth. My interest is rather to examine more closely some representations that reflect particular problems of the twentieth century. One of them appears in the fiction of a nowadays 'non-read' (to use the term proposed by Josefina Ludmer, 1999) but quite popular author in the twenties and thirties: I am referring to Arturo Cancela (1892–1957). Cancela, during a long period, was very popular, basically thanks to his participation in the culture industry and to his political satires of the populist governments of Hipólito Yrigoyen (1916–1920, 1928–1930). He parodied and criticised the relation between the masses, intellectuals and the State in the Argentinean culture of the 1920s and 1930s (the *Década Infame*), indicating the emergence of the masses as the centre of the conflicts.

Figure 10.8 Men and children in a meeting during the 'Tragic Week'. They are posing in this 'spontaneous' view of the conflict. Archivo General de la Nación, Argentina.

In his *Tres relatos porteños* (1922), we find 'Una semana de holgorio', a political satire on the violence of the *Semana Trágica*, which is presented in the form of a diary written by an upper-class Argentinean youth. Cynically, Julio Narciso Dilon begins by commenting on the fastidiousness of a strike day in Buenos Aires: the city is empty, devoid of the services that would enable him to fully enjoy his customary daily distractions. Sensing himself to be a legitimate representative of Argentinean nationality, he intimidates a 'gringo' (an Italian) into giving him a lift in his car to the horse races, where he loses all the money he has on him. When he leaves this emblematic haven of the Argentinean aristocracy, he is caught up in a sort of nightmare in which he is involved in the conflict that involves the entire city.

Figure 10.9 A strike in 1902: cars from the suburbs go downtown. Archivo General de la Nación, Argentina.

The emptiness of public spaces appears to affect his judgment. At first, he thinks of going to beat up the strikers – impossible to represent – but then he becomes distracted into following a young woman, which takes him to the suburbs; on returning to the city, he gets involved with a policeman and winds up in the local police station, still fighting against numerous invisible enemies who can only be identified by the sounds of occasional explosions. After other confusing incidents, a momentary arrest and after witnessing the disturbances, he finally returns to his bachelor's apartment and is attended by his maid, while his indignant friends defend his honour, insisting that he is a member of the Jockey Club. The fact is that he is the only one who has doubts about his honour and it is only when, the following morning, the newspapers register a strange incident, that he will calm down: the previous day, a Russian called Nicolás Dilonoff had assaulted a local police station, escaped, and gone on to organise the crowds in order to impose a Soviet in Argentina. Of course, this press version misrecognises the truth. Dilon and his friends are in fact an improvised gang of upper-class thugs, like so many others that appeared during the 'Tragic Week', loosely identified as the Patriotic Alliance, and who offered to 'help' the State suppress the strikers.

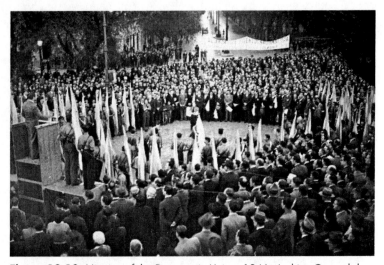

Figure 10.10 Meeting of the Democratic Union, 1946. Archivo General de la Nación, Argentina.

The author's assumption of Dilon's ingenuity allows him to visualise the enemy as an undifferentiated group, a group not of individuals but of shared characteristics:

> While I'm thinking about this, I find myself in the Market (Mercado de Abasto) and from here I witness an unaccustomed spectacle on *Calle Corrientes*. Small groups of young men with blue and white armbands, armed with clubs and shotguns, are stopping everybody

who has a beard and ordering them to put their hands up. While those who have clubs
threaten them directly, those with shotguns poke them in the stomach and others, who are
not armed, tug their beards. (Cancela 1946: 90–91)

When the city becomes a void, the most exaggerated images dominate:
the enemy is extremist and all extremists are the same (all of them are
men, all of them have beards), and they all look like, or are, anarchists (or
Jews). Cancela's parody fractures the mass and converts it, as a stereo-
type for the elites, into an 'invented' enemy, all the more dangerous,
because anybody can be seen to fit the image. This enemy dominates an
imagination obsessed with the threat of any difference or deviation from
the homogeneity of its model of national identity.

The gangs of the Patriotic Alliance beat up and kill and Dilon empha-
sises the gratuity of the act: '[Killing] is the most trivial act you can
imagine. You tie onto your left arm your cat's neck-ribbon or your maid's
garter, pick up your gun, take to the street and shoot the first suspicious-
looking person you meet' (Cancela 1946: 92). The naturalness of elite
violence is not put in doubt; the dangerous character of the enemy, even
less so. In the confrontation between the State and the strikers, between
the mass and power, the powerful can count, not only on the upper-class
gangs who aid the police, but also on the press, which corroborates the
State version of events. The surnames 'with a lot of consonants' to be
seen identifying many of the closed shops, indicate that their owners are
Jews, and they become the principal blank for the Patriotic Alliance. The
center of Buenos Aires is the scenario of an unequal confrontation
between the State and the mass of suspects who are not recognised as cit-
izens (they have 'Jewish' beards, their surnames have lots of consonants,
and they come from the Soviet Union); for his part, Dilon recovers his
honour, not when he shows his identity document, but when it is con-
firmed that he is a member of the Jockey Club, the authentic guarantee of
(legitimate) nationality (nationality is the ID). The mass of communist
Jews have their identity evidenced in their physical appearance, in their
body. Their identity is not the national one.

Upper-class kids (all in gangs) on the one hand; and on the other,
Jews-communists. These are the opposite extremes in the social equation
of the most reactionary elite in Cancela's tale which, furthermore,
restricts the ambit of the 'national' to the modern urbanized sectors of
Buenos Aires, for the suburbs appear not to belong to the nation. When
Dilon gets lost in the suburbs after following the young woman, he says:

Alone, lost, two leagues from downtown Buenos Aires, hungry and without money, I nat-
urally became desperate. But I am a *porteño*. I know that the streets of the capital are
organised in a regular pattern that makes it easy to orient yourself. Furthermore, they are
well illuminated and we have an excellent police service. For the first time I understood the
profound significance of Guido Spano's verses ['Argentinean to the death']; I celebrate the

prophetic genius of the guy who wrote them prior to the construction of those public works that guaranteed the health of the city and before the municipal government headed by Don Torcuato [de Alvear] and, reciting the famous couplet [which serves as epigraph to the tale] to keep up my spirits, I launched myself boldly in search of a street opening in order to follow the simple scheme of the municipal chequer-board'. (Cancela 1946: 74)[1]

Dilon identifies 'national' with *porteño*, with urban modernisation and with elite practices. We should remember here that the 'forces' of the State can be deployed to erect public works but also to repress the enemy.

The Sodomite Masses

'El Estado, ¿era hombre o mujer? Por aquella época, la respuesta simbiótica sin ambigüedad, "es hambre para todos" ' [Was the State a man or a woman? Back then, the symbiotic answer was, unambiguously: "it's hunger for everyone"] (Lamborghini 1994: 69). Hunger erases gender differences and joints men and women. In Osvaldo Lamborghini's strange text titled *Tadeys*, the three signifiers (in Spanish: hombre, hembra, hambre) which are condensed in the State, are presented in a conflictive relationship. *Tadeys* (written around 1983) is a sort of sexual-political fable, set in *La Comarca*; it is a novel about power and authority. Or, more precisely, it is a series of fragments on power and authority; rather than a reflection on the issue, it is a theatrical presentation of the violence of power as represented on the body and expressed as frenetic sexuality (present in almost all of Lamborghini's texts). *Tadeys* is an unfinished novel, first published after Lamborghini's death in 1994.

The protagonists of the drama are men and women and their shadows. The text represent a battle, between oppressors and oppressed, and this battle is to the death. In *Tadeys* sexual definition of the individuals is one of the main problems of the country but it is not just a problem of (sexual) identity, or, as a sexual problem, it is a question of the relation of each individual to power. To be defined as man or woman means being identified either as oppressor or oppressed and every individual risks his/her life in this definition; however, it is power that determines the result. Each individual is free to place his/her bet, but the identity of the people is always decided by power, by the State, which is male. In a repressive State, such as that of *La Comarca*, the central power is exercised by the director of the prison, Jones Hien who, together with the psychiatrist Dr. Ky, has invented an infallible remedy for opponents and criminals (or those merely suspected of being such, because to be and to pretend to be are one and the same): transform them (criminals are men) into women (the punishment), to feminise the prisoners by means of a physical and psychological violence that obliges them to become servants of the man who sodomises them and, by extension, of the State.

But there is an element which escapes from this neat binary logic because, in *La Comarca*, there is a problematic 'race' that is not to be found elsewhere: the Tadeys.

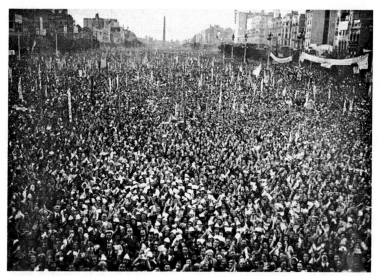

Figure 10.11 Meeting proclaiming the candidacy of 'Perón-Perón' (1951). Multitude in the streets; people, flags, posters. The multitude is flooding the city. Archivo General de la Nación, Argentina.

I will try to explain what the Tadeys are. According to the text, the Vomir, one of the founding families of the kingdom in the Middle Ages, were the first to study the Tadeys and promote their use for industrial purposes, instead of simply consuming them as food for the powerful; 'in an epoch, not so long ago, they were still assumed to be a kind of dangerous hairless monkey which could not be domesticated and only survived in mountainous caves, normally not accessible to humans as a result of the snow. [...] It was now necessary to study the Tadeys: their genetic code had become important for the Great Powers' (Lamborghini 1994: 109–110).

These creatures (monsters), which appear 'almost human', are food for the population, which breeds them like animals (although they look like humans); and they are problematic because of their uncontrolled sexual activity, as that which the males impose on the females, responding to the 'instinct' of the species, but also that which is common among males themselves: sodomy (as it is called in the novel).

During their long evolution, from the Middle Ages to the contemporary context of the story, the Tadeys passed through different forms of exclusion imposed by humans, in the same way as can be said of the indigenous populations during the expansion of Western civilisation. The main exclusions were defined by the institutions of church and State:

> The church rapidly found a solution. Humans could continue to eat the sodomite animals but the flocks of animals to be consumed every day had to be killed during a religious ceremony in which they would be staked ("penitence is implicit in the sin") [...] When the lances begin rip open the intestines of the Tadeys, their joyous chuckling transforms into horrible screams of pain. Precisely at that moment, the popular choir light their torches and, in their chants, ask Heaven for forgiveness, for having had to eat the contaminated animals. (Lamborghini 1994: 147)

The sentence that is constantly repeated in the course of the text ('Penitence is implicit in the sin') defines the ambit in which the sexuality of the oppressed is manifested and refers explicitly to the punishment for sexuality itself.

The humans eat Tadeys but the status of the Tadeys is not at all clear; these hairless monkeys, a tribe of sodomites, are important because the different political factions compete for their support in their struggles for power.

'They're human', say the extremists who are in a struggle to death with the 'New Patriots'. They organise pacific manifestations, distributing, free of cost, like the good fanatics they are, their pamphlet *The Tadeys are Human* and another one which is even more ideological (distortioned) and, whose title Dam remembered as *In Order to Overthrow the Bourgeois Order in La Comarca, We Must Unite with Our Subaltern Brothers, the Tadeys,* (Lamborghini 1994: 119).

The Tadeys (which, incidentally, is also the name of the national currency) are the class that potentially supports the different factions in their struggle for power, those who are used as cannon fodder in the moments of political violence (that is why they must be considered 'human'). They continue to be paradoxical and need to be legitimized by the church or the State (or by the political factions) but their destiny is still exclusion.

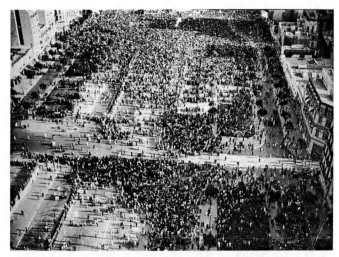

Figure 10.12 Anniversary of May Revolution, 1972. Shapeless masses are flooding the streets. Archivo General de la Nación, Argentina.

That is what the masses are like. They live in flocks, they reproduce without control and the males are constantly sodomising each other; they have horribly ugly faces and they are sensual. The incomplete picture of the Tadeys (successive fragments of the book offer partial descriptions of the same features, but the book is a group of fragments) paints them as an anomalous mass within a kingdom of discipline and order imposed by repressive violence. They are the excluded and subordinated who are used by the political classes, cannibalistically (they are food for the humans). A subaltern class, which constantly reproduces and serves as food for their bosses, the Tadeys function like the proletariat and are a model for defining the enemy. The word 'model' is related to one of the many theories to be found in the novel, but it is fundamentally a theory about mimesis and representation. This theory is developed in the teachings of Dr Ky and in the practice of feminization; in this experimental (as well as transatlantic) repressive location, *La Comarca's* concentration camp, the conversion of the prisoner (always a man) into a woman is achieved by progressively reducing the distance with respect to the required model (of a woman). On the different types of feminised prisoners, we read: '... such false moralism is out of place because our objective is to investigate the greater or lesser grade of absorption of a model, its capacity to degrade the individual' (Lamborghini 1994: 87).

Figure 10.13 Hunger March and repression. No face for the multitude, 1972. Archivo General de la Nación, Argentina.

The conversion to the model (which supposes the elimination of the difference between original and imitation, that is to say, alienation in terms of Marxist theory), is what gives the repressive method its political dimension: '... the fact is that we have succeeded in developing an almost perfect political method, the knotting together of the subject and the

model which, in some cases, it becomes impossible to distinguish'
because, some prisoners, after the treatment, are 'more woman-like than
women themselves' (Lamborghini 1994: 88). Womanised prisoners are
like Tadeys. To change the gender is an act of repression but also an act
of liberation. Feminised men converted by political domination into their
contrary, an act of absolute alienation. But also an act of simulation: this
is the reaction of the State when the masses appear on the scene. And
masses react: the Tadeys seduce a bishop and a member of *La Comarca's*
aristocracy and sexually submit them. In a sort of revolutionary parody,
the oppressed submit the oppressor by their sexual beauty: they have
notably delicate bottoms, smoother than those of a baby, permanently
inviting penetration. After that: repression, because the State (police chief
and psychiatrist) is more powerful than the masses.

Figure 10.14 The feet in the fountain. Loyalty Day (17 October 1945). Tired citizens put
their feet into the fountain of Plaza de Mayo waiting for Perón. They 'invade' a national
symbol. They look like 'Tadeys'. Archivo General de la Nación, Argentina.

This is the triumph of the model, the triumph of the State: 'The data of
the survey appear before our eyes: once again, it evidences the halluci-
nating effect of truth: there is no life beyond belief' (Lamborghini 1994:
88). The power machine that is the State is a machine made to kill, to
exterminate, which consumes those individuals now reduced to slaves,
one after another. The State is not able to resist the masses because it is
not able to tolerate any difference; so the subaltern mass, after being
reduced to the condition of animal, is symbolically and literally 'con-
sumed'. Masses, then, have a paradoxical destiny: they have to disappear
because they are the symbol of dispersion and contradict the nation, uni-

fied by the State; but their uncontrolled sexuality reproduces it to the infinite, and they always return. The transatlantic feminisation camp in *La Comarca* is the product of the nation: an iconography which is politically resisted by recurring to the disorganised and sexually uncontrolled masses, which continue to explore their bodies (both their own and those of others), producing a dangerous quantity of fluids which dissolve, in their search for freedom, the nation.

Masses and Nation

Lamborghini's unfinished novel depicts the masses as composed out of 'problematic subjects'. They are also always confronting the State, whose agents are obliged to repress them. As in Cancela's fiction, in *Tadeys* we can appreciate the full array of State power only by way of conceiving its 'other' as masses, as an imminent danger, as the threat of chaos. At the same time, in both texts, the masses appear not only as a threat to the State, law and order; the masses are a threat to the nation; and in its name the State undertakes its repressive task. The nation, as a particular form of disciplining subjects, is firmly located within the elite and, in consequence, is always in danger. The masses, which want to accede to the nation, are converted, in almost all the texts of this tradition, into a bastardised iconography, which represents the nation for the excluded; not an imagined community but the community of people who are outside.

Notes

1. The couplet is the following: 'He nacido en Buenos Aires / ¿Qué me importan los desaires / con que me trata la suerte! / Argentino hasta la muerte / He nacido en Buenos Aires'.

Bibliography

Beasley-Murray, Jon. 2000. 'Hacia unos estudios culturales impopulares: la perspectiva de la multitud', in *Nuevas perspectivas desde/sobre América Latina. El desafío de los estudios culturales*, ed. Mabel Moraña. Santiago de Chile: Editorial Cuarto Propio/Instituto Internacional de Literatura Iberoamericana.

Benjamin, Walter. 1989. 'La obra de arte en la época de su reproductibilidad técnica', in: *Discursos Interrumpidos*. Buenos Aires: Taurus.

Buck-Morss, Susan. 2000. *Dreamworld and Catastrophe. The Passing of Mass Utopia in East and West*. Cambridge and London: The MIT Press.

Cancela, Arturo. 1946. *Tres relatos porteños*. Buenos Aires: Espasa-Calpe Argentina.

Canetti, Elías. 2000. *Masa y Poder*. Barcelona: Muchnik Editores.

Chevallier, Louis. 1973. *Laboring Classes and Dangerous Classes in Paris during the first half of the Nineteenth Century*. New York: Howard Fertig.

Hardt, Michael & Antonio Negri. 2000. *Empire*. Cambridge and London: Harvard University Press.

Lamborghini, Osvaldo. 1994. *Tadeys*. Barcelona: Ediciones del Serbal.

Le Bon, Gustave. 1995. *The Minds of Crowds*. New Brunswick and London: Transaction Publishers.

Leopoldo Lugones. 1972. *El Payador*. Buenos Aires: Huemul.

Ludmer, Josefina. 1988. *El género gauchesco. Un tratado sobre la patria*. Buenos Aires: Sudamericana.

_____ . 1999. *El cuerpo del delito. Un manual*. Buenos Aires: Editorial Perfil.

McClelland, J. S. 1989. *The Crowd and the Mob. From Plato to Canetti*. London: Unwin Hyman.

Molloy, Sylvia. 1994. 'La política de la pose', in: *Las culturas de Fin de siglo*, ed. Josefina Ludmer, Rosario: Beatriz Viterbo.

Negri, Antonio. 2000. *Arte y multitudo. Ocho cartas*. Madrid: Edit. Trotta.

Nye, Robert. 1995. 'Introduction', in Gustave Le Bon, *The Mind of Crowds,* London: Sage Publications.

Perloff, Marjorie. 2001. 'Lo que realmente pasó. Sobre el jardín de invierno de Roland Barthes y los archivos de los muertos de Christian Boltanski', in: *Milpalabras 2*, verano.

Rama, Angel. 1983. *La ciudad letrada*. Montevideo: Fundación Internacional Angel Rama.

Ramos Mejía, José María. 1977. *Las multitudes argentinas*. Buenos Aires: Editorial de Belgrano.

Rodó, José Enrique. 1985. *Ariel. Motivos de Proteo*. Caracas: Biblioteca Ayacucho.

Rudé, George. 2000. *El rostro de la multitud. Estudios sobre revolución, ideología y protesta popular*. Valencia: Centro Francisco Tomás y Valiente UNED Alzira-Valencia. Fundación Instituto de Historia Social.

Salessi, Jorge. 1995. *Médicos maleantes y maricas*. Rosario: Beatriz Viterbo.

Sarmiento, Domingo Faustino. 1983. *Facundo o Civilización y Barbarie en las pampas argentinas*. Buenos Aires: Centro Editor de América Latina.

Terán, Oscar. 2000. *Vida intelectual en Buenos Aires fin-de-siglo. Derivas de la cultura científica*. Buenos Aires: Fondo de Cultura Económica.

Part IV

Spaces of Flight and Capture

Chapter 11

Marconi and other Artifices:
Long-Range Technology and the Conquest of the
Desert

Claudio Canaparo

'The world has emerged through thought rather than contemplation. This implies that
nature becomes intelligible through the metaphor of the book, in that it can be understood
not through contemplation but through thought, indeed that it becomes "readable"'.[1]
Hans Blumenberg, *Die Lesbarkeit der Welt* (1981)

This chapter will discuss the cultural ambit of the River Plate area through
a philosophical perspective based on space as an empirical form, rather
than through notions of time or temporalisation. *Muerte y transfiguración
de Martín Fierro* (1948) – and the work of Martínez Estrada (1895–1964)
in general – seems to me to be the last serious attempt to analyse the area
of the River Plate as constituting a cultural environment.[2] However,
Martínez Estrada's notion of culture – in line with that of the great major-
ity of contemporary authors – is based on a lettered or literature-centred
conception of culture itself, which, it seems to me, is insufficient these
days to carry out an analysis in which the notion of culture includes ele-
ments of sociology, philosophy, history, etc. Literature, in the strict sense,
does not allow any more for interesting analyses of the environment, or
the community, in which it circulates. This is perhaps one of the reasons
for the increasing tendency in recent years for literary authors (writers and
critics alike) to produce poignant essays about the 'national self' or 'the
social situation' which have nothing to do with the world in which their lit-
erary writings circulate. This paradox is one of the broad concerns of this
chapter, and is discussed at greater length in my forthcoming book,
Mueste y transfiguracíon de la cultura rioplateuse.

Plot-Line

The death of Adolfo Alsina in December 1877, at the age of forty-nine,
led President Nicolás Avellaneda to (1837–1885) to name General Julio

Argentino Roca (1843–1914) as his successor at the head of the Ministry of War and the Navy. To repeat Rosas's campaign against the Indians had been one of Roca's aspirations. In 1879, at the head of 6000 soldiers, Roca planned to annihilate the indigenous presence in the south and establish, once and for all, a *secure space* for the Republic.

The technique employed by Alsina of military incursions combined with a line of fortifications (*fortines*), had not been effective in that it failed to achieve the required homogeneity of terrain demanded by the construction of a territory – in the sense of the insertion of *signs* into the terrain as a means of producing a *spatial imaginary* indispensable to the governability of any given community. Colonel Suárez (1799–1846), one of Jorge Luis Borges's forebears, who had been in charge of *Fortín Federación*, 260 kilometers from Buenos Aires, during the 1840s, would provide evidence of the ineffectiveness of these urbanised islands in the midst of the pampean desert. His reports concerning the supposed fevers that decimated the indigenous population – yet which concealed large-scale executions – are proof of the authorities' ineffectiveness, who then had to fall back on the *physical suppression* of individuals due to their inability to generate other forms of imposition in the *local environment*. Unfortunately this lack of efficacy and competence would have an ongoing role to play in the relation between the military bodies and the civilian population.

General Roca, who was in agreement with Alsina on the need to establish a *Territorio Nacional*, differed with him, however, (and, not by accident, agreed with Rosas) on the theory of the *tabula rasa* or empty territory: the overriding need to ethnically and culturally empty the territory before establishing its topography. This military view of space, in spite of the institutionalisation of cartography, would remain operative in the River Plate even when serious symptoms of the disintegration of the Territorio Nacional began to show. The administrative technique of the *desaparición de personas* (disappearance of persons), for example, cannot be understood except as a form of perception of the space of the Republic.

Lines, Stations, Clocks

General Roca's success in the production of an *empty space* was without doubt due to countless factors, but there were three determining elements in the establishment of a modern form of space, whose relevance had been noted already by the North American envoy, Thomas Osborne: the telegraph, the Remington rifle and the early imposition of *official time* would give rise to the most radical and long-term consequences in the production of this territory.

Terrapleins and Morse Code

The telegraph lines not only speeded up communication but also *short-ened distances* by changing the speed at which news was disseminated. At first, they were seen to have a military purpose or as a necessary complement to the functioning of the railway, but the spread of *telegrams* – by the use of morse code – as a method of transmitting information radically altered this perception and the telegraph offices came to possess their own autonomy. Thus *Correos y Telégrafos* would be used as the name of several ministries and institutions over the years to come.

The most secure telegraph lines were those that ran alongside the railways. The cabling was made of high resistance copper wire with the cables themselves resting upon vertically placed poles up to seven meters in height, each duly numbered, with ceramic isolators for the cables and struts and guys to avoid any movement in the structure – a notable feat of technology and engineering for 1877. In spite of neglect and the passage of time, such cabling can still be seen alongside the now closed branch lines of the railways. Few undertakings in the pampa were realised with such success as regards the durability and continued existence of their physical signs.

This act of utilising technological developments to determine the frontiers of a territory is something that the authorities would lose sight of except when they came to consider 'the frontier' in bellicose terms. The idea of cutting a cable, for example, to *interrupt a communication* arose as a possibility in the River Plate towards the 1920s. Until then it would never have occurred to anybody that interrupting of a telegraphic cable could have any significance whatsoever. This, without doubt, was an element of great advantage to the authorities at the beginning of the comprehensive control of the movements of objects and individuals which the aforementioned militarised conception of space would slowly bring about.

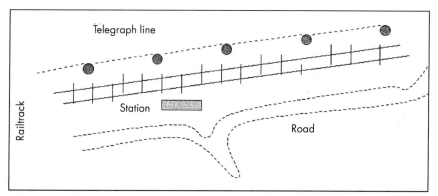

Figure 11.1 The building of the railway and the telegraph, and the establishment of roads and tracks.

The building of the railway in conjunction with the telegraph, followed by the establishment of roads and tracks, represented a formidable medium for the signification of space, or rather, a highly efficient way of converting a 'terrain' into a 'territory' (see figure 11.1). This one-way process of marking space, radiating outwards from Buenos Aires, would be perceived in every element of daily life, transforming its very nature, and would represent the first instances in the constitution of a citizenry based on the unification of common elements – an identification that would reach its peak with the introduction of finger-prints, developed by Comissioner Ramón Falcón (1855–1909), as a legitimate method for ordering and monitoring the population. The railway lines constituted the driving force behind the telegraph cabling and road building and it was precisely this joint development that found itself directed towards the establishment of a *network* – of movements, communications, transport – which would constitute the basic *texture* of modernized space.

This extension and spread of the railways meant that the countryside came to be considered as a *terrain* to be feasibly quantified through surveying, and that physical difficulties were now no longer considered as 'obstacles' but as 'accidents of topography'. Towards the end of the nineteenth century, the beginnings of a Registro Catastral Nacional for rural areas constitute irrefutable proof of this situation. The register, as can be deduced from what was being said at the time with regards to the relation between the territory of the pampas and the Territorio Nacional, would constitute an evolution of the land registry for the region of the River Plate which had been in existence since the time of the Enfiteusis law. The administrative system of territorial partition set up in the 1820s by Bernadino Rivadavia for the city of Buenos Aires with a population of 150,000 would be similarly instituted by Alsina and General Roca for that which was commonly identified as the countryside.

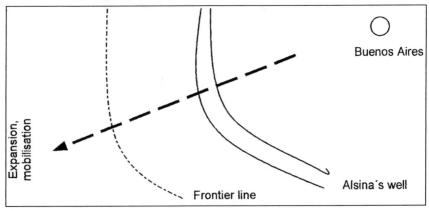

Figure 11.2 The railway and the expansion of the frontier.

The establishment of the railway on the pampas was not only the development of a means of freight transport or communication, as authors such as Julio Irazusta have, a little simplistically, maintained; more relevantly, it was a way of instituting the empty territory which was created by the two 'Desert campaigns'. The maps and plans commissioned by the Ministry of War and the Navy throughout the period of the so-called *zanja Alsina* and the expansion of the Indian frontier are confirmation of this function of the railway lines (see figures 11.2 and 11.3). The mobility and expansion of the frontiers was, then, realised principally via the aforementioned systematic development of transport and telegraph. The failure of the so called *zanja Alsina* was demonstrated by the efficacy of Roca's campaign but, above all, it was exposed by the way in which the telegraph and the railway rapidly changed the local life of the places it passed through.

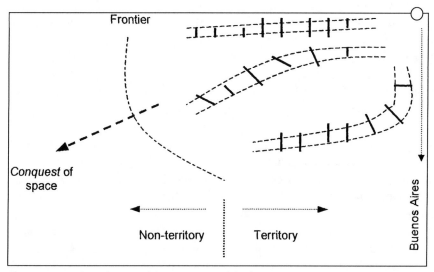

Figure 11.3 The railway and the expansion of the frontier.

If a territory can be defined as a space with which individuals are in continuous interaction while they move and act inside it, then the telegraph and the railway not only constituted the said territory, but they also gave rise to the possibility of imagining movements over great-distances – an event unimaginable a short time before. Thus, the scarce and incipient roads alongside the rail-routes would initially be destined only for local movements. It was not until 1930 that the national road network began to be built.

The expansion of the frontier what came to be marked out as the Territorio Nacional did not occur thanks to General Roca's military triumph over an already dispersed group of Indians on the verge of starvation – the defeat of Calfucurá, the leader of the Pampas in 1872 and that of his son Namuncurá

a decade later were probably the last warlike confrontations of the 'expansion'. If the Campaña al Desierto is viewed as a definitive way of introducing a notion of space, and therefore of territory, then the results of war are of less interest than the factors used to produce the said results. Thus, as has been stated, the 'conquest' in *real time* – as opposed to the narrative time of official history – of the space of the pampas was brought about by the railway lines, by telegraph cabling, by the Remington rifle and the imposition of a measurable and unified time.

The most effective form of topographical classification, in order to convert the *terrain* officially into *territory*, was to modify it. This meant not only taking measurements in accordance with pre-established, imaginary scales nor merely the construction of bridges to cross the innumerable marshlands therein, but it meant re-establishing the *signs* and *markers* necessary for making that space readable. The railway lines and the telegraph cabling would, initially, provide these great markers. They would, in time, become ever more specific until they arrived at the milestone with its indication of the route-number and the distance in kilometers (measured from 'kilometer 0') which every road in the Republic would carry as standard and which would constitute the degree zero of this topographical quantification.

Figure 11.4 shows the two most widely used systems for the construction of railway lines in the nineteenth century. Regardless of the origin of the operating or constructing company (French, English, etc.), the system employed on the pampas entailed the construction of a type of road, elevated above the level of the terrain, in the form of a terraplein, and upon which the sleepers and rails were then placed. This manner of railway design was, without doubt, related not only to the low-lying nature of the terrain of the pampas (the great number of marshlands, etc.) but, above all, to the intention with which the railway was initially developed: that of marker and advance guard. This system, for example, was employed by William Bragge y L. Mouillard in the construction of the Ferrocarril Oeste (1857 onwards), the first to be built on the pampas.

Figure 11.4 The two most widely used systems for the construction of railway lines in the nineteenth century.

The idea that the railway lines and the telegraph cabling, by their very presence as technological factors, could not be attacked, damaged or otherwise impinged upon by the Indians is a constant assumption among surveyors, cartographers and the military of the period. In this sense too, Alsina and Roca's Campaña al Desierto was a triumph of technology, and not of battles, which annihilated the population. The spread of technology into the biological sphere is something which would be realised later on, as Bruno Latour (1988) has demonstrated in his analysis of Louis Pasteur (1822–1895). What makes the Argentine experience an unprecedented event is both the material deployment of these technological factors upon the terrain itself and their presence in the social imagination. By contrast, the earlier physical annihilation of the Indians, from the time of Rosas up to General Roca's campaign, was defined by the need to produce an empty space, rather than by the attempt to produce a different prospect of space through the introduction of relevant administrative changes in the Rivadavian sense.

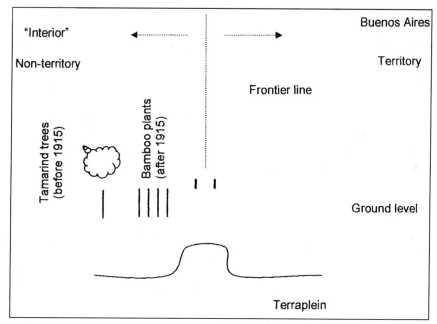

Figure 11.5 The utilisation of the railway tracks as lines of demarcation.

The type of railway engineering employed (figure 11.4), as much as the utilisation of the railway lines as lines of demarcation (figure 11.5) or as the advance guard of topographical substitution (figure 11.3), entailed a permanent *mobile demarcation* of frontiers – not only in the sense that they constituted a defense or an area of security but, even more pertinently, in that they signified the implanting of *signs of recognition* upon

the terrain, bringing about, by appropriation, the conversion of the terrain into territory. It is here that the origins of the Dirección General de Vialidad y Caminos (General Directorate of Roads and Communications), which would acquire definitive form in the 1930s, are found.

The telegraphic cabling would be an early indication of the control of the atmosphere which the Territorio Nacional would also presuppose in the future – not only in that the weather forecast, and meteorology as a discipline, would be found in the hands of the military and be considered as a public matter by governments but, even more, in that the atmosphere would become incorporated as a physical part of the territory, with the additional effect that the terrain (the ground) would begin to become blurred through the addition of this further layer of space.

Hyperboles, Ellipses and Parabolas of Rifle-Shot

More than for the fire-power it possessed, the general introduction of the Remington rifle during the governance of General Roca meant the supression of hand to hand combat in which the Indians had always turned out to be more effective than the regular troops of the *porteño* authorities. Yet more decisively, the sustained and organised capacity to kill rapidly and on a large scale signified a radical change in the logistical and administrative tempo of governments and countries. The constant increase in the speed of this symbolic capacity to kill – as Louis-Ferdinand Céline (1932) has masterfully shown – would constitute the most effective threat and strategy of all the military conflicts to come. The iniquitous massacres carried out between 1865 and 1870 during the so-called *guerra del Paraguay* were the first outing for this technique of symbolic disuasion wherein the slaughter on the battle field would not be directed at the supression of a specific individual but toward confirming the efficacy of a mechanical and technological army such as Roberto Arlt (1900–1942) would come to describe in his novels many years later. Looking at the photographs taken at the time by Esteban García (on behalf of William Bate y Cia. of Montevideo) is a visual lesson that is difficult to forget.

The implementation of this type of armament meant the appearance of the notion of a shot-radius and, in particular, the possibility of determining a territorial reach from a static point. The doleful messages from a distance, to which Michel Serres (1995) refers, began during this period and were further extended by the first radio messages beamed over the land in the 1920s.

In this sense the technological dimension affected the formation of the towns of the pampas most profoundly and with greatest effect, not so

much in the show of arms or the direct threat which they signified – as authors such as Lucio V. Mansilla (1831–1913) suggest in their narratives – but in the rapid modification of perceptions about death, about average life expectancy. Journeys by cart or horse, which over a long period constituted the *parameter of duration* and which were suited to biologically operative systems such as days and the seasons, ceased to be considered as valid. The slow ascendency of an artificial time (calendarial time, official time, etc.) over biological estimations begins here. Individuals would not now go to their beds to die nor would they count the passage of time by moons or events linked to the local environment – as does Eduardo Gutiérrez's folk hero Hormiga Negra. Those elements which would give a temporal point of reference for the organization of individual and collective life would be systems such as the calendar, or standard signs in the territory.

The great advertising campaigns, deployed in the mis-named *zonas rurales* and in the 'interior' of the country, which were based on offering a calendar as a gift to their customers, were significant in this sense. The sandal-making company Rueda Luna and the match factory Fragata used this technique for years with unprecedented success among the population. Awaiting the arrival of the almanacs was a social event of some importance in the majority of the *Ramos Generales* stores on the pampas and in the interior of the country.

Mechanisms, Extensions and Artifices

The development of the European railways – the networks of England and France in particular – made evident the inevitability of a *single* and *abstract* time. The need for an 'official time' is at the origin of the very principle of communication and transport, which the railways attempted to implement in functional ways. The existence of this abstract parameter, to which individuals, communities and institutions began to refer, was shown to be a formidable tool for social standardization – and not that social habit produced standardized time, as certain ingenuous neo-Marxist and Gramscian analyses have, and continue to, put forward.

The telegraph cabling and the railway lines required, then, for their organization (timetable coordination, works systems, etc.) the implementation of a common time for every station and stopping place. To this end, among the fundamental pieces of equipment was to be found a clock that was wound every twelve hours and whose time was coordinated every day, at least in the beginning, by means of the telegraph. In this way railway time came to constitute an incipient form of *official time* for the territory. For years it was a habit of individuals to adjust the

time of their pocket-watches to the train station clock. In some rural places of the pampas this habit came to be one of the rituals of the bourgeois and petty bourgeois classes.

The introduction of the clock as public time is a part of the foundation of any given territory and it signified the gradual compartmentalization of time which, carried to its extreme towards the end of the twentieth century, would signify the nullification of time as a shared narrative and the institutionalisation of an urban immobility with great speculative consequences.

Waves, Signals and Atmospheric Control

In 1903 *The Times* of London published the first ever radiotelegraphic dispatch, transmitted from the United States via what were then called 'marconigraphic waves'. Although the fact went unnoticed by the great majority of the population, it constituted the implementation of a technology comparable only to the introduction of micro-processors towards the end of the 1960s.

In 1910 there began to exist in the space of the Republic an incipient network of radio enthusiasts who tried to cover the Territorio Nacional. Their presence became more evident in the Capital thanks to the visit, in the same year, of Guglielmo Marconi (1874–1937). However, it was only from 27 August 1920 – the date of the first radio transmission – that the ether began to be regularly covered by sonorous presence. The Sociedad Radio Argentina began broadcasting in 1922, after a series of experimental periods, from the terraced roof of the Guerrico & Williams auction house in the Federal Capital which at the time possessed a wooden antenna thirty-five meters in height.

The 'marconigraphic waves' covered the territory of the pampas but still did not reach all areas of the interior of the country. However, and in contrast with that which would occur with the railway lines and the telegraph, the radio did not establish visible signs on the territory but constituted a constant aerial presence. On the other hand, ownership of an apparatus to receive the signals – the first 'crystal sets' – was a capital outlay that few individuals or institutions could afford. Thus, in the beginning, radio listening was a collective and social event which differed greatly from the use of audio to which we are accustomed to today.
Another notable aspect of the proliferation of radio-waves (and of the changes in the perception of space which it produced) was the fact that they reached all places, i.e., that individuals did not have to travel to

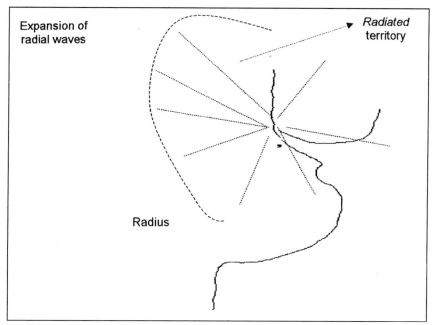

Figure 11.6 Expansion of radial waves.

receive them, as in the case of the railway station or the telegraph. In this sense it is plausible to equate these waves with *invisible signs* of territory.

Radio coverage also contributed to developing the idea of an *imaginary space*; of a feasible space of virtual form. Its signposting was *semiotic* in the strictest sense. The classic identifiable signs in the terrain now came to be signs in need of interpretation. The kind of literacy imposed by the signposting of the roads and railways was not sufficient anymore to instruct and direct radio listening. Insofar as the signposting of the territory was a way of organising the movement of people and goods (at least according to public declarations by the authorities), it constituted an educational curriculum, a *cursus honorum*, which is quite a different matter from distributing, organising and classifying radio and television waves whose possibilities of being organised in that particular way are, in spite of the creation of university courses dealing with this very topic, remote.

The imposition of a common language, of an official time and a series of aims and common opinions was the immediate consequence of radio transmissions. Given its importance – and as would occur on many future occasions – the authorities tried to legislate the reach of the radio medium before it had even developed. On 12 of July 1917, Hipólito Yrigoyen (1852–1933) instituted the first decree regarding radiotelephony which would form the basis around which LR3 Radio Belgrano, the immediate precedent for *Radio Nacional*, would emerge.

The idea of a *radiated* area, in the sense of an area affected by cathode rays and electromagnetic waves, is something that Martínez Estrada himself would employ as a metaphor in his analyses. The idea that nothing in space remains to be occupied, that every portion that can be occupied has been auscultated, or 'sounded' and penetrated by the waves, was a principle which the authorities and military would apply to the extreme as a metaphor for collective and individual *observation* of the population; an early notion of surveillance by the close circuit television (CCTV) which is so predominant these days in large urban areas.

Perhaps the first intentional realisation of collective and individual observation began in 1929 when the first aerial photographs of the terrain were developed and, above all, in 1933 when the use of photogrammetric techniques was introduced on a large scale. The notion of visual surveillance has its roots, as Paul Virilio (1986 and 1989) has observed, in this form of the perception of space.

This visual situation would be further reinforced with the arrival of television, whose first official transmission took place in 1951. The Instituto Experimental de Televisión (IET) had been carrying out tests since 1944, the year in which the first experimental transmission took place. The coverage of the atmosphere of the territory was now not only audial but also visual, that is to say, the imagining of the territory could now be generated directly and the invisible signs could now take on a tangible form. The televisual waves would be understood as signs by which the aforementioned semiotic character of the terrrain would now become extreme. The signification of the territory would not now be visible in the traditional sense, but would operate with reference to an imaginary in which signs could be situated in variable ways. The future disappearance of antennae, with the generalised use of satellites, would be further evidence of this saturated but invisible manifestation of territory.

Figure 11.6 can similarly be considered in relation to the broadcast of television signals which, unlike radio, achieved higher and higher quality (of power and definition of the wave) from their transmissions. The installation in 1961 of the first coaxial cable – an early antecedent of transmission via parabolic antennae and micro-waves – is, doubtless, proof of this. The existence of a televised territory can, then, be understood in three ways: (1) as a minimal auscultation of the territory, or (2) as the necessity of visual recognition of the same, or (3) as producing a space that is constantly observed and filmed. The widespread introduction of television – as a phenomenon of the daily life of individuals – has had radical consequences regarding the way in which they became accustomed to reading their space. Although that way of reading was explicitly displayed only by artists or architects, the coming of a *televised territory* obliged every individual to situate objects, narratives and biographies

inside it. The fact is that television, virtually, fulfilled of the dream of the early cartographers of the Republic, i.e., the possibility of having the same territorial homogeneity, with the same level of territorial signposting, in the most distant provinces as in the Capital.

The original positioning, in 1951, of the antenna and studios of the future *Canal 7* on the roof of the building in the Avenida 9 de Julio in Buenos Aires that housed the *Ministerio de Obras y Servicios Públicos* was doubtless a foretaste of the administrative and governmental character by which the spread of television would be undertaken in the Republic. In this sense it is mistaken to talk of censorship in relation to the spread of television given that its purpose, from the very beginning, was linked not to any excersise in knowledge or opinion but to the utilisation of technological resources to produce, in the most effective way possible, a homogeneous territory. At the same time, radio waves, as much as television signals began to take on an accentuated function with the hopes, or horizons of expectation, of individuals. This is the enormous power which, in the sense of the excercising of an authority, these media would slowly aquire. To function in relation with the horizon of expectation of the inhabitants of a given territory signifies not only that the inhabitants, in some way, recognise themselves in the said territory but also that they continually project that which they expect to occur in relation to that which they are doing in order that it should occur. These 'temporal scissors', which Hans Blumenberg (1996) referred to, would contribute more to the control of the world of the River Plate than the endless deployments of troops and artillery which would be seen on the streets of the Republic in support of successive, pathetic and insignificant dictatorships. Thus, almost twenty years after the last dictatorship in the Republic, the consequences of this way of understanding space still prevail.

The hourly time signals – at first on radio then on television – are perhaps the most complete example of the way in which the use of technology would contribute to the homogenisation of the territory. To provide the 'official time' of the country was one of the basic principles of Radio Nacional from its beginnings and one of the constant pieces of information given by television presenters. The prices at the animal market at Liniers and the regular weather reports, for example, would function similarly; the former in the hands of the Ministry, the latter under the control of the military.

With the televised territory – the paramount expression of the Territorio Nacional – the Republic became concentrated and reduced, the frontiers became tangible but at the same time unstable, labile. Thus, the great expansion and efficacy in the definition of space also brought with it the mechanism which would unleash its gradual desintegration.

Translated by Peter Cooke

Notes

1. 'Anders ausgedrückt: Die Welt ist durch Denken, nicht durch Anschauung ent-
 standen. Darin liegt, daß die Natur erfaßbar wird für die Metaphorik des Buches,
 indem sie nicht durch Anschauung, sondern durch Denken verstanden, nämlich
 "gelesen" werden kann.'
2. Author's note: I have analysed some of these perspectives in greater breadth and
 detail in my forthcoming book *Muerte y transfiguración de la cultura rioplatense*
 (in press).

Bibliography

Blumenberg, Hans. 1981. *Die Lesbarkeit der Welt*. Frankfurt/Main: Suhrkamp.
————. 1996. *Höhlenausgänge*. Frankfurt/Main: Suhrkamp.
Céline, Louis-Ferdinand. 1932. *Voyage au bout de la nuit*. Paris: Gallimard (English
 edition *Journey to the End of the Night*, trans. Ralph Mannheim, London: Calder,
 1988).
Latour, Bruno. 1988. *The Pasteurization of France*. London: Harvard University Press.
Martínez Estrada, Ezequiel. [1948] 1983. *Muerte y transfiguración de Martín Fierro,*
 4 vols. Buenos Aires: Centro Editor de América Latina.
Serres, Michel. 1995. *The Natural Contract*. Ann Arbor: Michigan University Press.
Virilio, Paul. 1986. *Speed and Politics: an Essay on Dromology*. New York: Columbia
 University Press.
————.1989. *War and Cinema: the Logistics of Perception*. London: Verso.

Chapter 12

Desert Dreams:

Nomadic Tourists and Cultural Discontent

Gabriela Nouzeilles

When we start considering this possibility, we come upon a contention which is so astonishing that we must dwell upon it. This contention holds that what we call our civilization is largely responsible for our misery, and that we should be much happier if we gave up and returned to primitive conditions.

Sigmund Freud, *Civilization and Its Discontents*

The primitive does what we ask it to do. Voiceless, it lets us speak for it. It is our ventriloquist's dummy.

Mariana Torgovnick, *Gone Primitive*

In the hyperbolic grammars of emptiness, deserts embody the idea of an absolute limit, of extreme natural formations where humanity confronts its own negation. In this tradition, fables of annihilation and death co-exist with fantasies of liberation and transformation. The vertigo that, according to the travellers, these white spaces evoke, points at the same time towards the visceral fear of the void and towards the infinite possibilities of a radical outside. In its positive version, to withdraw into the desert means to put a distance between oneself and the restrictions of the social, giving up the security of the community so as to escape the agony of sociability, of being submitted to and determined by others' judgements and expectations. Therefore, those who enter the desert are not seeking to find but to loose their identity, to become anonymous. Within this imagination of spatial alterity, the desert is the refuge of the raw, naked, and primal: an absolute freedom that only the absolute lack of limits can provide.

The image of the desert as an alternative space where it is possible to become someone else has as its remote antecedent the Christian hermits who went into the desert in search of an unscathed spatial relation: eternity. The force of this primordial iconography has been such that its effects can still be observed in today's most inconspicuous discourses and

practices. According to Caren Kaplan, the utopian vision of the desert is fundamental to certain contemporary manifestations of theoretical reflection on the left, in a secular and postmodern version marked despite its own intentions by the principle of imperial representation, according to which the Occident requires for its own constitution the postulation of open spaces and unpopulated areas. Just as the representation of Africa as a black continent served to define modernity, by opposition, as a white and disembodied reason, the luminous spaces of the desert provide new opportunities for self-invention. In the new ideological articulations of the desert, the celebration of the desertic opening implies the recovery of the figure of the nomad who emerges as the only one capable of tracing a path across an apparently illogical space without succumbing to the spatial power of the State and the market.

Nature, then, is no longer merely the dark side of modernity but becomes a utopian site of critical and individual emancipation, whereas the nomad represents a position of non-fixity, associated with an ideal model of movement as perpetual displacement (Kaplan 1996: 66). *A Thousand Plateaus* (1980) by Gilles Deleuze and Félix Guattari constitutes, at least in part, an example of this postmodern appropriation of the desert. Their recurrent metaphor of the 'lines of flight' and the rallying call to 'become nomads' point at once to an anarcho-nostalgic celebration of the primitive, and to an understanding of critical reflection as a translation that releases a primordial impulse (Deleuze and Guattari 1996: 351–423). In a similar fashion, Jean Baudrillard's *America* (1986) promotes nomadic drifting as a form of 'pure travelling', in the strongest possible contrast to the domesticated movements of tourism. 'Nothing is further from pure travelling than tourism or holiday travel', says Baudrillard: 'That is why it is best done in the banality of deserts', blank stages rather than locales of pleasure or culture (Baudrillard 1986: 9). Here the desert is the scenario of an epiphany, an anti-place where the loss of history and tradition drags the traveller into a confrontation with the meanings of humanism and modernity. Yet be it as pre-history or as post-history, to enter the desert provokes a radical disorientation through which the transpolitical finds its generic mental space and its aesthetic form: 'For the desert is simply that: an ecstatic critique of culture, an ecstatic form of disappearance' (Baudrillard 1986: 5).

Despite Baudrillard's disdain for tourism, the liberating image of the desert and the notion that certain 'primitive' practices such as nomadism could provide access to qualitatively different – and even superior – forms of experience and thinking, are both closely linked to the figure of the alternative tourist in search of unmediated experiences of nature, in the aim of accessing a space outside (and prior to) modernity. Although this kind of traveller has only recently turned into one of the most lucrative tar-

gets of international tourism,[1] it is a variation that emerged towards the end of the nineteenth century, in the very moment when tourism became the dominant mode of imperial travel to peripheral regions of the globe.

The tourist's transformation into the protagonist of the colonial journey produced a substantial rearrangement of imperial imaginations of adventure and exploration. In *Through the Brazilian Wilderness* (1914), Theodore Roosevelt interpreted the state of siege of nature's last refuges on behalf of tourism as a planetary degradation and loss. According to him, one had only to look at the Euro-American travellers who were touring South America during these years, to verify the gradual disappearance of adventure. Even though many of these travellers were still aspiring to that ideal, their experiences had ceased to qualify them as genuine explorers. The explorer embodied a superior mode of travelling, the remnant of an era when it was still possible to clearly identify an outside of modernity. Nothing, then, according to Roosevelt, could be further apart than the intentions of the tourist and the explorer. The latter's objectives emerged directly from the interests of science and the State, therefore transcending the triviality of mere distraction, or the strange tastes of bourgeois eccentrics (Roosevelt 1922: 354–58).

Yet, rather than to establish a definite distinction, Roosevelt's antagonistic typology in fact already pointed to the difficulty of distinguishing inequivocally between the modern forms of travel. The very rhetoric of moral superiority which informs Roosevelt's condemnation of tourism is but a symptom of the overwhelming expansion of the touristic phenomenon. Self-rejection, meanwhile, is precisely one of the features that define tourism as a modern ideology of travel. What tourists are accused of is not to have toured the world, but to have let themselves be satisfied with superficial experiences of other places and peoples.[2] This very demand, however, is one of the motors of touristic desire. What Roosevelt failed to see was tourism's enormous capacity for adaptation, as a cultural practice, and the irreversible mercantilisation of all experiences of the natural. The new international travellers set out into the world not only with the equipment necessary for survival in unhomely environments, but moreover with the cultural archive of Empire and its repertory of stage personae, one of which was the explorer.

In the aftermath of the nineteenth century, a new type of explorations of the peripheries became popular that were essentially cultural simulacra of touristic counter-tourism. The new explorers were neither driven by the interests of the State or those of science, nor by the desire to evangelise or the perspective of easy wealth. The objects of their zealous quest, instead, were unmediated experiences of the real which urban life could no longer provide, and more authentic ones than traditional tourism as a means of escape from modern society's pressures could offer.

These simulacra were grounded in what Renato Rosaldo has called 'imperial nostalgia', and what Coco Fusco has identified as performative forms of primitivism (Rosaldo 1989: 69–70; Fusco 1995: 44). This nostalgia stemmed from a paradoxical reaction by which modernity lamented that which constituted it as such: the control and exploitation of nature. This notion of a 'loss of nature' included the lament over the irredeemably vanishing 'primitive' aboriginal communities which, at least since the Enlightenment, had been identified by the Occident as the cultural and biological remnants of its own remote past. As alternative tourists, the *fin-de-siècle* explorers would, for their own enjoyment, restage the original encounter with nature and the primitive other by inventing fantasies of investigation, discovery and adventure.

The nostalgia for a more authentic past thus generated a performative incorporation of primitive practices through rituals of corporeal experimentation. The reappraisal of the primitive modified the sexual and racial logic of the adventure story. Masculinity, which had always characterised the figure of the imperial explorer, was reorganised around a contradictory core inhabited simultaneously by the fantasy of rational control and that of a return to a more primitive and thus more 'natural' masculinity.[3] In the first case, the primitive male was the other of reason; in the second, he was the equivalent of the 'savage within'.

In contrast to an accelerated modernisation and globalisation, the vast deserts of Patagonia began to emerge in modern geographical imagination, as one of the last spaces of the globe where adventure was still possible. Different vectors of meaning converged in these counter-touristic representations. Among these, the image of Patagonia as the absolute limit of reason and of humanity that had underpinned its representations ever since the conquest, setting it apart as an extra-ordinary place, was the most productive for the ideology of alternative travel.[4] While Darwinist theory had the Patagonian Indians occupying an evolutionary stage inferior to all other parts of the world (Darwin 1989: 177), an additional and widespread belief held that Patagonian nature was in itself an insuperable and sterile frontier that repelled every project of modernising incorporation. Once there, the civilised traveller risked dying the most horrific of deaths, perishing in the midst of a storm or after a long agony caused by hunger, thirst, the attack of a puma, or the degradation beyond words suffered in the captivity of abominable tribes. In the narrative tradition which had conventionalized these images, the traveller was first and foremost a survivor who returned from the end of the world to tell his passage through an abject nature.

The desire to exit modernity which drove the alternative tourists, replaced Patagonia's representation as an abyss by that of a site of revelation where the civilised subject could reinvent itself. Just as the sur-

vivor, however, the tourist ended his journey by returning to civilisation, yet the previous passage through Patagonia's primordial nature no longer equalled a descent into the abject but a vigorous rejuvenation, an awakening of the body's dormant forces and sensibilities of which writing could only give an approximate account. In this second line of meaning, then, the abyss would open up towards the opposite side. It was precisely the excessively open space of the desert, which resisted the transforming inscriptions of progress, that allowed the metropolitan traveller to free himself, and thus to alleviate himself at least momentarily from that which Freud had cunningly identified as the endemic discontent in modern culture (Freud 1989: 38–42).

From Captives to Primitive Tourists

The intimate relation with the primitive sought by the alternative tourists of the turn of the century only compares to the process of cultural conversion that is at the core of the tales of captivity. An attentive overview of the counter-touristic accounts of travels to Patagonia that started appearing after 1860, will reveal a line of discursive continuity which takes up and inverts the rhetoric conventions of the fictions of captivity, thus permanently altering the meanings of the primitive. This sequence contains a progressive decrease or fading-out, from narrative fictions of 'touristic' contact where the captivity scheme is still visible, as in *Life Among the Patagonians* [1871] by George Chaworth Musters, to more schematic variations where the appropriation of the primitive becomes more and more virtual, such as *Wanderings in Patagonia* (1879) by Julius Beerbohm, *Across Patagonia* (1881) by Florence Dixie and *Idle Days in Patagonia* [1893] by William Henry Hudson.

The attraction of the captivity genre lay first and foremost in the implicit promise of immediate access to the other, which it extended towards the reader. However, the price for this access was particularly high, since the experience of captivity inverted the power relations that sustained the imperial order. In his new situation, the modern traveller, rather than acting out his role of coloniser, priest, or teacher, passed into the position of submission and, to an extent, of pupil. The cultural dialogue imposed by the condition of captivity followed an unknown set of rules, which the captive attempted to understand in order to survive. The encounter with a radical cultural difference and the desire to render it intelligible, then, approximate the figure of the captive to that of the ethnographer. 'The experience of captivity', Mary Louise Pratt suggests, 'resonates a lot with aspects of fieldwork – the sense of dependency, lack of control, the vulnerability to being either isolated completely o never

left alone' (Pratt 1986: 38). However, there is also an important difference between both types of practice. Whereas the explorer enters the realm of the primitive voluntarily, the captive does so against his own will, compelled by the circumstances. The function of writing consequently differs, too. The ethnographer has decided from the outset that he will write down the information he collects; in contrast, the captive's writing is, in the first place, a political manoeuvre *a posteriori*. The ethnographic descriptions that usually occupy the greater part of the captivity tale can therefore be seen as a means to re-establish the power relations subverted by the fact of captivity. In interpreting and classifying native culture, the author of the captivity tale offsets the physical humiliation he has suffered, through a symbolic victory (Sewel 1993: 42). In this way, even though his captors may have controlled the real events leading to his subordination, the ex-captive controls their transformation into narrative. One of the main strategies of recomposition is to transform the situation of captivity into the basis for an exemplary tale of heroic resistance against barbarism.

In the imperial genealogy of representations of Patagonia, two accounts of modern captives stand out: *The Captive in Patagonia, or Life among the Giants* (1853), by the North American adventurer Benjamin Franklin Bourne, and *Trois ans d'esclavage chez les Patagons: récit de ma captivité* (1864), by the Frenchman Auguste Guinnard.[5] Both of these were written by modern subjects driven by the desire to become rich, embodying the modern figure of the businessman whose displacements across the periphery are at the forefront of capitalist and commercial expansion. Bourne is taken hostage when travelling aboard ship to California with the intention of joining the gold-diggers; Guinnard loses his way in the foothills of the Patagonian desert during a frustrated attempt to obtain land rights. Captivity in Patagonia introduces an unbearable interruption, which hurls the travellers away from their intended itineraries and places them within an unexploited nature, cutting them off from the system of production and putting them at the mercy of a primitive economy.

Both texts observe the conventions of the captivity genre pointed out above. Their narratives depict the abject yet intimate experiences of an isolated European captive, presenting them as the ethnographic truth about the culture of his indigenous captors. The intimacy with the primitive, underscored by the preposition 'among' in both titles, guarantees the truth of the narrative. Again and again the travellers authorize their accounts by reminding the reader of the equivalent in suffering, which they had to pay in exchange for the information they now transmit. '[H]ere I was', Bourne recalls, 'put forcibly to the study of their character in the school of dame Experience, and I can testify to the truth of the saying that she charges roundly for tuition. Let the reader give me credit

for the cheapness with which I put him in possession of what knowledge was purchased at so exorbitant a price' (Bourne 1853: 62).

Captivity provides the means to explore the seductive aspects and the dangers implied when one immerses oneself in the primitive, opening up the possibility of self-definition in terms of another culture, only to then reject it. The rejection of the option of 'primitivity' becomes manifest on the level of writing, as a translation of the sensorial promiscuity of captivity into the temporal and spatial distance imposed on the materials of experience by the rhetorical conventions of ethnography. Yet despite all this, the intimacy with the primitive turns the captive into a suspect, an ambiguous subject probably contaminated by his contact with the Indians. In order to confront this suspicion, both Bourne and Guinnard emphasise the limits of the cultural negotiation in which they took part.

The rhetoric means most frequently applied to dissolve suspicion is the description of their own incorporation of indigenous habits as dissimulation. During their stay among the Indians, rather than true transculturation, what had occurred had been sheer pretence, a merely transitory use of the other's cultural masks, with the sole purpose of tempering the hardships of capitivity, while the travellers awaited an opportunity to escape and return to civilisation: 'The reader may smile or may frown, but it was my purpose [...] to humor them to the top of their bent; to ride, to hunt, and even steal my way into their confidence' (Bourne 1853: 132), insists Bourne. Meanwhile, Guinnard takes dissimulation to the point of renouncing all his civilised manners and meticulously imitating his masters, drilling himself in the physical exercises and tasks in which they excelled (Guinnard 1871: 189–91).

In the system of oppositions which rules the logic of dissimulation invoked by the ex-captives, a strong contrast opposes indigenous virility, based on physical accomplishments, to the European captive's masculinity, based on self-control and subordination of the passions to the mandate of reason. This distinction becomes evident in the hunting episodes in which Bourne participates reluctantly, adopting the viewpoint of an outside observer who cannot understand the Indians' excitement at the display of courage and skill in the moment of capturing wild animals (Bourne 1853: 71, 81). Guinnard, in contrast, maintains from the outset a much more ambiguous attitude in relation to the value of primitive maleness, whose virtues he acknowledges as much in the indigenous men as in himself. As a result, the mechanisms of identification implicit in his captivity tale take separate paths: the reader can either identify with the captive's efforts to regain his freedom and the distant perspective of ethnographic description, or imagine himself participating in the physical exercises during which Guinnard mingles enthusiastically with his captors. By leaving this second option at our disposal, Guinnard intro-

duces a dimension of corporeal and sexual pleasure, an opening towards the primitive, that remains repressed in Bourne's account. It is this hedonistic and gratuitous dimension of the transcultural experience which would come to occupy centre stage in the discourse of alternative tourism.

The publication, in 1871, of George Chaworth Musters's *At Home with the Patagonians* signals the emergence of a new kind of journey to the periphery in the imperial imagination, one whose principal if not exclusive motivation is the immediate encounter with the primitive. To this end, the international traveller sets out for the regions of the globe where modernity has not yet erased all traces of difference. In his prologue, Musters emphasises this change of purpose by setting his text apart from what had until then been the dominant genres, the tales of captivity and adventure as well as the journals and reports of scientific expeditions. In contrast, Musters promises a truthful yet unexciting account of his one year's stay with the famous nomadic tribe of the Tehuelches, during which he constantly accompanied them on their erratic criss-crossings of the desert, eating and sleeping among them in the most intense intimacy.

Yet the captivity tale undoubtedly remains the narrative mould within and against which Musters constructs his touristic fiction. As in the stories of the captives, the narrative is organised in order to highlight the passage into another world, from which the traveller re-emerges with an ethnographic knowledge that he will put into circulation in the civilised world. What is advertised, then, is once again the immediate access to the primitive, yet without the excuse of captivity. Musters enters the primitive at his own will, partly driven by the desire to penetrate and explore a little-known territory, partly by the State of physical excitement that the accounts of *guanaco* chases among the Indians awaken in him (Musters 1873: 2).

Musters, then, is neither a hostage nor a prisoner. While Bourne and Guinnard organised the story of their hardships with regard to the omnipresent horizon of escape, he has to make an effort in order to convince the chief Orqueque to let him join the tribe in its nomadic wanderings across Patagonia. If interacting with indigenous life, for the captive, had been an obstacle to be overcome in order to regain his freedom, for Musters it is one of the principal tasks he has to fulfil in order to show that he is capable – at least temporarily – of becoming an Indian (Musters 1873: 58).

It is this fusion with the indigenous, indicated in the title's 'at home', which constitutes the alternative tourist's ideal – to access the primitive not merely as a witness or *voyeur*, but in a performative way, by playing to be an other. It is important to recall, however, that in order to achieve the journey's touristic objectives, the identification between the two

worlds in contact can never be absolute. Part of the pleasure Musters derives from the experience of the primitive is generated precisely by maintaining the difference that separates the modern from the indigenous. Rather than to nullify the opposition between two cultural universes, Musters reduces the gap between them to its minimum, yet without ever allowing it to disappear.

His ethnographic report thus differs considerably from the information transmitted by previous imperial travellers. According to Musters, living with the tribe for an entire year entitles him to declare that the Tehuelches are not only extremely strong, robust and skilful hunters, as many others had already suggested, but also clean, family-loving, honest and industrious (Musters 1873: 194–95). Yet this vindicating gesture does not substract the Indians from the realm of nature; it simply inverts the terms of their being valued. Rather than as Bourne's ferocious giants uttering meaningless guttural sounds, Musters sees the Tehuelches as specimens of a vanishing race, remnants of a more authentic and free life, which he objectifies into a museum collection of spectacular moments.

Yet the secret of the primitive does not reveal itself so much in the representation of the other as in the inner life of the one who, in becoming a nomad, opens himself towards the depths of his own ancestral virility. In the primitivist simulacrum that the journey to Patagonia puts to work, the metropolitan traveller lets himself 'be taken away', attempting, in the intimacy of his contact with indigenous life, to recuperate the submerged memory of the species. What is at stake, then, is another mode of imitation. While the captive dissimulates in order to survive, at the same time as dissimulation protects him from suspicion, the alternative tourist simulates in order to approach the real.

Simulation, Adventure, Leisure

'It is the real, and not the map, whose vestiges persist here and there in the deserts [...]. *The desert of the real itself.*' (Baudrillard ...)

The one who dissimulates puts on a mask whose external shape, at least for its inhabitant, is clearly distinguished. In the simulator, by contrast, mask and face merge. Dissimulation leaves the reality principle intact, while simulation withdraws the boundary between the true and the false, the real and the imaginary (Baudrillard 1999: 3). The historical transition from the signs that permit someone to dissimulate to those which dissimulate that there is nothing behind them, signals the emergence of a society of spectacle whose culminating point will be postmodernity. When the real ceases to be what it used to, nostalgia takes charge of its

preservation by creating myths of origin and signs of reality. The result is an unprecedented escalation of truth, experience, and authenticity. In this context, simulation is in the first place 'a strategy of the real, of the neo-real and the hyperreal that everywhere is the double of a strategy of deterrence' (Baudrillard 1999: 7).

The primitivist simulacra put in motion by the alternative tourists on their journeys to Patagonia at the end of the nineteenth century were principally experiments during which they enacted authenticity, associating themselves to that which they identified as the real: nature and the primitive. The task was not an easy one. Under the sustained and merciless pressure of modernisation, the primitive was turning more and more into a rare commodity. Once the military occupation of the Patagonian territory on behalf of the Argentine State had been initiated, in 1879, Musters's primitivist option was definitely ruled out.

After Musters, travellers who went to Patagonia in search for their share of authenticity had to turn towards a much more flexible and virtual notion of the primitive. Although the indigenous tribes continued to be the absolute original of the real, the new travellers embraced nomadism as a practice anyone could adopt in a geography such as Patagonia's. Once on site, that which would allow them to make contact with the primitive was not intimacy with the native cultures, but the encounter with an absolute nature. In 1902, the English explorer Hesketh Pritchard described the phenomenon in these terms: '[in Patagonia] one stands face to face with the elemental. As you travel into the interior, Nature, with her large loose grasp, enfolds you. There is no possibility of being mentally propped up by one's fellow man. Empty leagues upon leagues surround you on every side, the inverted bowl we call the sky above' (Pritchard 1902: 4). The experience of emptiness activates a sensibility that had been buried in the modern subject's interior, and to which nature reveals its secret rhythms. Here nomadism is no longer, as in Musters, a feature of ethnic identity but the paradigmatic form of an antimodern mode of displacement.

From its very title, Julius Beerbohm's *Wanderings in Patagonia* (1879) alludes to the new primitivist articulation of travel. 'Wanderings' underlines the idea of drifting, of unregulated displacement, at the same time as it suggests a notion of deviance and unconscious impulses alien to intention. For Beerbohm, wandering across the desert meant stepping out of the paths trodden by the majority and the opportunity to pass through a world without fixed places. Yet this erratic criss-crossing is once again delimitated by the return. For, despite his insistence on depicting himself as a transgressor, Beerbohm never ceases to be the tourist for whom the passage through the periphery is a way of collecting difference so that it can be exhibited at home.

Beerbohm casts himself as an accidental adventurer set in motion by the effects of chance. While occupied in a survey of the coastline in the extreme south of Patagonia, he is called by his employers to embark immediately for England at the port of Punta Arenas, on the shore of the Magallan straits. To get there he joins four local adventurers and ostrich-hunters on a horse-ride across the desert. The unexpectedness of the trip, and the intimate day-to-day contact with his travel companions, turn the journey of economic exploration into one of experimentation, a process that imposes a radical change in values. If the technical survey had classified Patagonia as a land without any value, 'destined to remain almost entirely unpopulated and uncultivated til the end of time', the counter-touristic vision, on the contrary, reveals a primordial space without price, 'an unfinished portion of the globe' whose very incompleteness opens up the possibility of self-reinvention, of becoming an other:

> I seemed to be leaving the old world I had hitherto known behind me, with its turmoils and cares and weary sameness, and to be riding merrily into some new sphere of free, fresh existence, I felt without a pang I could break with old associations, renounce old ties, the pomps and the pleasures, the comforts, the bothers, the annoyances of civilization, and become as those with whom I was now travelling, – beings with no thought for the morrow, and therefore with no easiness for it either –, living the life of our nomadic ancestors, in continual and intimate contact with nature, – an unchequered, untroubled existence as wild, simple, and free as that if the deer that browse on the plains. (Beerbohm 1879: 15)

In this version of the passage into the outside of modernity, the other who has to be imitated are the gauchos, hunters and adventurers who inhabit the desert, suspended between two worlds. The subtitle of Beerbohm's book, *Life with the Ostrich-Hunters*, points the reader towards this other dimension of performative nomadism, in which the alternative model is associated to different kinds of desertion: from work, from the State, from the army, and from the family.

Not only men, but also women went to Patagonia in search of the pleasurable pains of adventure. In 1878, fed up with 'the shallow artificiality of modern existence' and looking for emotions more intense than those a woman could experience in Victorian England, the writer and feminist militant Florence Dixie set out on a journey to Patagonia. But why Patagonia? On the opening pages of her travel account *Across Patagonia*, Dixie explains that it was precisely the strangeness and remoteness of the place that decided her choice. While undoubtedly there were other wild regions more favoured by nature, in no other place could one feel so completely on one's own:

> Nowhere else is there an area of 100,000 square miles which you may gallop over, and where, while enjoying a healthy, bracing climate, you are safe from the persecutions of fevers, friends, savage tribes, obnoxious animals, telegrams, letters, and every other nuisance you are elsewhere liable to be exposed to. (Dixie 1881: 3)

If Patagonia was sterile, it had the advantage of being antiseptic, isolated, and empty. In addition to these attractions, there was the possibility of entering a vast and solitary nature, still devoid of the presence of (white) man. 'And I was the first to behold them? – an egotistical pleasure, it is true; but the idea had a great charm for me, as it has had for many others' (Dixie 1881: 3).

In Florence Dixie we come face to face with an accomplished tourist, deliberately using her spare time to go out looking for authentic and interesting experiences in order to share them with others on her return. Even as Dixie repeats the commonplace distinction from other less sophisticated travellers, not for a single moment does she hide the touristic motivations of her journey. In fact, her text can be read as a guide for future travellers, offering them, among other things, practical advice on essential camping accessories, clothing, and the choice of local guides (Dixie 1881: 35–37). Yet, being an alternative tourist, what she is most interested in, and willing to spend large sums of money on, is the pure and revitalizing experience of adventure, regardless of its possible pragmatic purposes. The idea of the desert as a limitless space, where modern travellers could reinvent themselves by slipping into cultural roles unaccessible to them in their home societies, proved particularly attractive to someone who, like Dixie, resented the restrictions imposed on sexuality by the bourgeois moral code. In the social void of Patagonia and in the virtuality of adventure a woman could appropriate all the poses of masculinity which contemporary society held in stock.[6]

As in Musters and Beerbohm, the crossing of the desert is depicted in Dixie's account as a rite of passage during which she has to deploy all her cunning and physical skill in order to survive. As a feminist who believed in the absolute equality of the sexes, crossing Patagonia provided her with the opportunity to prove that a woman could show a degree of physical resistance which few men were capable of. But at the same time as she revindicated her gender, Dixie longed to explore the possibilities of her own masculine sensibility. The never-ending horse-rides, the hunt for wild animals, the hunger and thirst that thrust the pleasure trip on the verge of tragedy, reactivated sensations within herself which she identified as proper to primitive man.

While *Across Patagonia* stages a tourist playing at being an explorer, *Idle Days in Patagonia* [1893] by William Henry Hudson tells an imaginary journey of exploration and adventure. Hudson reaches the margins of the Patagonian desert but, as his physical crossing of it is averted by an accident, he chooses instead to move across the fictions which have produced it as a cultural space. Hudson, in this sense, is a sentimental tourist who comes to understand immobility as a subtle form of movement.

His book, a rather heterogeneous collection of reflections, anecdotes and digressions devoid of a common narrative thread, pays particular attention to certain aspects of Patagonian nature and to the social characters inhabiting it, which capture the city-dweller's interest. Even though the conventions of adventure travel are only invoked in order to mark a distance towards them, the narrative frame of the book nonetheless points the reader towards the genre. The text opens with the frightening prospect of mutiny and shipwreck, two commonplaces of maritime storytelling. The boat finally runs ashore near the port of Carmen de Patagones, on the northern edge of Patagonia, where Hudson and the other passengers only arrive after a lengthy and dreadful ramble, frequently on the verge of losing themselves in the monotonous labyrinths of the desert.

The panoramic vision of empty Patagonia and the unease it inspires, not only contains a promise of danger but also one of liberation:

> At last, Patagonia! How often had I pictured in imagination, wishing with an intense longing to visit this solitary wilderness, resting far off in its primitive and desolate peace, untouched by man. Remote from civilization! There it lay full in sight before me – the unmarred desert that wakes strange feelings in us... (Hudson [1893] 1923: 4)

Just as in Beerbohm and Dixie, the actual eyewitness encounter only confirms what the imagination has already decided in advance. The sensation of relief, of escape, and of absolute freedom, which Hudson experiences in the Patagonian solitude – undisturbed as yet by Man, whose every trace, even where he has set foot, has long been erased – are part of an established cultural repertory of nature. Once again the open spaces of the desert serve as vehicles for the fantasies of liberation through which a divided modernity seeks to confront and contain the discontent in culture. What sets Hudson's travel narrative apart is the fact that the lines of flight made possible by the adventure, in its absolute exteriority vis-à-vis the domestic, never get to be translated into real movement.

For, instead of fulfilling the expectations awakened by the narrative of exploration that opens the book, the second chapter explains how Hudson became the immobile 'idler' referred to in the title. In contrast to the notion of 'free time' which underlies every touristic experience, in the sense of a time of non-production in which, however, the urge to ramble about persists, the notion of 'leisure' in Hudson's text is associated to the work of the imagination and of daydreaming.

The accident involving a firearm, which leaves Hudson temporarily invalid and prevents him from realising his original plan – to study and classify the birds and insects of the region –, also disqualifies him, because of his clumsiness, for the role of a hero who is at level with his surrounding, at the same time as it enables him to turn into a disinterested

collector of impressions and stories which he translates into writing. If there is any adventure, then, it is located in the stories and anecdotes circulating among the village dwellers, idlers themselves, stories that can only be assembled and circulated while there is a lack of adventure proper. The village is a space floating between two worlds, once a permeable frontline in the frontier wars with the Indians, now an unremovable dyke against a natural environment that resists all projects of incorporation. Its price notwithstanding, the pioneer's struggle with nature is an indispensable element for Hudson in order to maintain the margin of risk where the remnant of the real can be inscribed, the remainder which testifies to an outside of an artificial and oppressive modernity (Hudson [1893] 1923: 70–71). The preservation of an 'authentic' masculinity also depends on the sustained invocation of this primal conflict: 'It is a principle of Nature that only by means of strife can strength be maintained. No sooner is any species placed above it, or over protected, and degeneration begins', Hudson ([1893] 1923: 75) claims.

Against Darwin's idea that the Patagonian void activates the power of the creative mind, Hudson suggests that even a brief encounter with the solitude of the desert provides, rather, a momentaneous (yet nonetheless powerful) access to a primordial state beyond thought. Here it is not adventure anymore that enables the civilised subject to reach its goals by passing through a space which is experienced as exterior, but a virtual journey through the archaeological layers of his own subjectivity in the course of which he is 'over-come' by the past of the species (Hudson [1893] 1923: 199). This opening towards the natural world provokes an 'instantaneous reversion to the primitive and wholly savage mental conditions', which Hudson compares to the act of 'returning to a home, that is truly our home than any habitation we know'. Any modern man could experience this regression – once the privilege of soldiers, sailors and adventurers – if he attuned his body to the desert. To really enter a desert one has to do nothing, just sit down and wait. In this absolute stillness, the traveller will find within himself the other of civilisation, who will take him back to the moment of the original split between nature and culture, when we were 'all face' and did not wear masks (Hudson [1893] 1923: 207–8).

* * *

The appearance of alternative tourists imposed a profound transformation onto the imperial imaginary of travel. Their narratives inaugurate a series of travel fictions which, having spread across the entire twentieth century, finally converge in the contemporary figure of the alternative tourist in search of non-mediated experiences of nature.[7] Within this discursive genealogy, the Patagonian Desert was taking shape as an ideal geography upon which primitivist fantasies could be actualised. The trav-

ellers – real or imaginary, metropolitan or South-American – who, from the last decades of the nineteenth century to the present, have repeated the ritual of visiting the 'end of the world', all pursue the lost object of modernity whose loss is, paradoxically, their justification.

Translated by Jens Andermann

Notes

1. Contemporary versions of alternative tourism include variations such as eco-tourism, adventure trekking, agro-tourism, etc. According to the new, post-fordist ideologies of travel, traditional tourism is a mass phenomenon, organised, artificial and ecologically irresponsible, whereas the new tourism will be individual, flexible, real, responsible, experimental, and athletic. See *Tourism and Sustainability* 1998: 53, 132–36.

2. The critique of tourism departs from a desire to advance beyond the 'merely' touristic perspective, so as to achieve a more profound insight into foreign society and culture. See MacCannell 1976: 10. The contrast between tourism and the more 'real' and less 'commercial and superficial' forms of travel is an important element in the study of tourism. See, for instance, Boorstin 1964.

3. Gail Bederman calls the first of these fantasies 'manliness' and the second 'masculinity'. See Bederman 1995: 18–19.

4. To classify and consume a place as extraordinary forms part of the bundle of strategies which tourist culture applies to fabricate its scene. See Rojek 1997.

5. Both texts enjoyed considerable distribution, circulating in several editions and in different languages. Guinnard's book was published at least three times in French between 1864 and 1870, and was translated into English in 1871.

6. On the motivations of British women of the Victorian era for travelling to exotic and 'primitive' regions, see Catherine Stevenson 1982: 2–3.

7. This series would include Bruce Chatwin's *In Patagonia* (1977) and Paul Theroux's *The Patagonian Express* (1979), to name only the ones probably most widely-read.

Bibliography

Baudrillard, Jean. 1996. *America*. London & New York: Verso.

———. 1999. *Simulacra and Simulation*. Ann Arbor: University of Michigan Press.

Bederman, Gail. 1995. *Manliness and Civilisation. A Cultural History of Gender and Race in the United States, 1880–1917*. Chicago & London: The University of Chicago Press.

Beerbohm, Julius. 1879. *Wanderings in Patagonia or Life among the Ostrich-Hunters* London: Chatto and Windus.

Boorstin, Daniel J. 1964. *The Image: A Guide to Pseudo-Events in America*. New York: Harper.

Bourne, Benjamin Franklin. 1853. *Captive in Patagonia*, or *Life among the Giants*. Boston: Gould and Lincoln.

Darwin, Charles. 1989. *Voyage of the Beagle*. London: Penguin Books.

Deleuze, Gilles & Félix Guattari. 1996. *A Thousand Plateaus. Capitalism and Schizophrenia*. Minneapolis & London: University of Minnesota Press.

Dixie, Florence. 1881. *Across Patagonia*. New York: Worthington.

Freud, Sigmund. 1989. *Civilization and Its Discontents*. New York & London: W. W. Norton & Company.

Fusco, Coco. 1995. *English is Broken Here. Notes on Cultural Fusion in the Americas*. New York: The New Press.

Guinnard, Auguste. 1871. *Three Years of Slavery among the Patagonians. An Account of his Captivitiy*. London: Richard Bentley and Son.

Hudson, William H. [1893] 1923. *Idle Days in Patagonia, Complete Works*, Vol. XVI. London & Toronto: J. M. Dent & Sons LTD.

Kaplan, Caren. 1996. *Questions of Travel. Postmodern Discourses of Displacement*. Durham: Duke University Press.

MacCannell, Dean. 1976. *The Tourist. A New Theory of the Leisure Class*. New York: Schocken Books.

Musters, George Chaworth. [1871] 1873. *At Home with the Patagonians. A Year's Wanderings over Untrodden Ground from the Strait of Magellan to the Rio Negro*. London: John Murray.

Pratt, Mary Louise. 1986. 'Fieldwork in Common Places', in: *Writing Culture. The Poetics and Politics of Ethnography*, eds. James Clifford & George E. Marcus. Berkeley/Los Angeles/London: University of California Press.

Pritchard, Hesketh. 1902. *Through the Heart of Patagonia*. New York: Appleton and Co.

Rojek, Chris. 1997. 'Indexing, Dragging, and the Social Construction of Tourist Sights', in *Touring Cultures. Transformations of Travel and Theory*, eds. Chris Rojek & John Urry. London & New York: Routledge.

Sewel, David. 1993. '"So Unstable and Like Mad Men They Were": Language and Interpretation in American Captivity Narratives', in: *A Mixed Race. Ethnicity in Early America*, ed. Frank Shuffelton. New York & Oxford: Oxford University Press.

Stevenson, Catherine Barnes. 1982. *Victorian Women Travel Writers in Africa*. Boston: Twayne Publishers.

Roosevelt, Theodore. [1914] 1922. *Through the Brazilian Wilderness*. New York: Charles Scribner's Sons.

Rosaldo, Renato. 1989. *Culture and Truth. The Remaking of Social Analysis*. Boston: Beacon Press.

Torgovnick, Mariana. 1991. *Gone Primitive. Savage Intellectuals, Modern Lives*. Chicago, London: The University of Chicago Press.

Various. 1998. *Tourism and Sustainability. New Tourism in the Third World*. London & New York: Routledge.

Chapter 13

Why the Virgin of Zapopan went to Los Angeles:
Reflections on Mobility and Globality

Mary Louise Pratt

Every October in Guadalajara, Mexico, a city of four million in the western state of Jalisco, and the second largest city in Mexico, close to two million people converge on the city centre to accompany the Virgin of Zapopan on her annual journey from the cathedral of Guadalajara to her home in the basilica of Zapopan, eight kilometers away.[1] For hours, following a predawn mass, a river of people moves steadily up the long avenue accompanied by the drums, flutes and metal clogs of nearly two hundred teams of young *danzantes* from pueblos and barrios throughout the region, costumed in images of Indians. They have practiced their routines for months. Near the end of the procession comes the virgin herself, a rather plain-looking, doll-like figure about a foot high in a large glass case atop a flower-festooned car. It must be a new (virgin) car, one whose engine has never been started. It is pulled along by ropes held by hundreds of her devotees, and an official guard dressed in Spanish colonial costumes. Behind her come huge castle-like birdcages full of songbirds to entertain her as she makes the journey. After the Virgin of Guadalupe, she is the most powerful virgin in Mexico. She is 450 years old, and she has her own website.

The Virgin of Zapopan came into being in the 1530s during the process of evangelisation of the local indigenous population, merging, according to some accounts, with a local deity named Tepozintl, whose shrine she took over. She began developing divine powers, especially around matters concerning water – droughts, floods and the epidemics that came with them – and later around disasters of all sorts. In 1653 the church officially declared her *milagrosa*, capable of miracles, raising her credibility with the non-indigenous population of Spaniards, mestizos, *criollos*. By the

1730s, as she entered her second century of life, the demands on her powers had become so great, especially in the neighbouring city of Guadalajara, that she created a second version of herself called *la peregrina,* the pilgrim. *La peregrina*'s job was, and still is, to move around. She spends the rainy season rotating among the 172 parishes of Guadalajara helping to prevent flooding, a constant problem in its lowland location. She also supports the ecological movement trying to save the rapidly shrinking Lake Chapala, familiar to readers of Lawrence's *The Plumed Serpent.* Elaborate processions and *fiestas* accompany her from parish to parish, where hosting her is an honour and a serious obligation.

So since 1734 there have been two of her, *la original* who remains at home in Zapopan and *la peregrina*, who travels. These practices distinguish the Virgin of Zapopan from most other virgins, whose practice is not to travel themselves, but to appear as images in secular spaces like the walls of a house or the trunk of a tree. (Mexican anthropologist Renée de la Torre reports that in recent years these appearances have begun occurring in transitional spaces, or what she calls non-places such as freeway underpasses and airports.) The mutations of the Virgin of Zapopan trace the regional consolidation that from the 1500s led toward Mexico's self-definition as a rural-based pluri-ethnic nation-state with strong regional cultures.

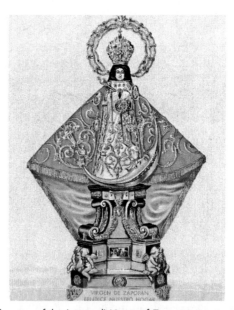

Figure 13.1 This drawing of the (original) Virgin of Zapopan is very widespread in popular iconography. It is sold widely, often in a rustic wooden frame with a small light bulb that can be plugged in to illuminate the image. I bought it outside the Basilica de Zapopan where *La original* lives. Her triangular shape makes her particularly recognisable, and links her to her 'sister' virgins of western Mexico, the Virgen de San Juan de Los Lagos and the Virgen de Talpa.

I invoke the Virgin of Zapopan not for divine protection (although I would not refuse it) but because she subsumes several of the themes I propose to take up in these pages: mobility, modernity and citizenship as they play themselves out in the late twentieth and early twenty-first centuries. I join those who are reflecting on what is being called globality by *thinking through mobility*. Particularly intriguing in this respect is the Virgin of Zapopan's strategy of self-duplication, *desdoblamiento* in Spanish, which enables her to be in more than one place at once, and to both go and stay at the same time. Though she exists in statue form, this ability to move and self-multiply makes her a kind of anti-monument, a genuine roving signifier – which may be why, though no icon could be more profoundly and complexly Mexican, the Virgin of Zapopan has never been incorporated into Mexico's official iconography or patrimony. She is part of local, popular religiosity and for many generations has been repressed or unwillingly tolerated by the official church. My title promises that we will get the Virgin of Zapopan to Los Angeles, and so we will. But I propose to get there, thinking through mobility, by considering some of the ways unofficial or vernacular imaginaries render processes that official parlance subsumes as globalisation.

Thinking through Mobility

One of the things that has made people want to call the world 'post-modern' – and 'post' almost everything else – is vastly altered patterns and scale of human mobility, two of its most conspicuous forms being mass labor migration and mass tourism. The latter is now the largest industry in the world after the drug trade. The former has produced, among other things, a reversal of modernity's diffusion from center outwards – large scale movement of ex-colonial subjects into the metropoles. In the U.S. today one person in ten was born in another country, and another one in ten have a parent who was. In California half the children entering school speak languages other than English (a fact stupidly viewed as a handicap rather than a huge national resource). There are 75,000 Russians in Sacramento. Every city in Europe and North America has sizeable diasporic communities from several parts of the globe, often from the country's ex-colonies, and these have impacted every aspect of institutional and everyday life. Fifteen percent of the population of Guyana lives in New York City; half of Surinam is in the Netherlands.

The metropole is a self-interested host to this reversed diaspora, but not necessarily a hospitable one. As a scholar of travel literature, it has been fascinating for me since the 1990s to observe the return of the dramatic tales of suffering and survival, monsters and marvels that 300 years

ago came back to Europe from faraway shores. Towards the end of the 1990s these stories began reappearing daily at the metropole's own borders. There are shipwreck stories, like that of the 900 Kurds who in spring of 1999 ran aground not in Tierra del Fuego but on the coast of Southern France. Today's stowaway stories tell not of European boys hiding under decks heading for the South Seas, but of African boys and young men usually found frozen to death in the wheel casings of jets landing in European airports (for a telling analysis see Ferguson 2002), or Eastern European families clinging under trains in the chunnel. The castaway tale was revived in the drama of Elián González, the Cuban child who in 1998 washed up on the shores not of Tahiti, but of Florida, and became a cause celebre among Cuban Americans. It was not Polynesians but Floridians – Republicans! – who decided he was a reincarnation of the Baby Jesus and had been helped ashore by dolphins. Today's outlaws and pirates are the *coyotes* or *polleros* cruising borders all over the planet. Death and rescue tales are back, reaching us not from the Sahara but from the Arizona Desert, like the story in summer 2000 of the infant miraculously rescued from the arms of its dead mother, a young Salvadoreña trying to cross into the U.S. It was not passing Bedouins who saved the baby but the Border Patrol, whose usual role is hunting down such people. Captivity narratives surface today in Beverley Hills where domestic workers from Asia tell of indentured servitude and forced confinement, or from sweatshops and brothels in San Francisco and New York. The suffocating nightmare of the slave ship resurged in 1999 in the port of San Francisco where eighteen Chinese laborers emerged mad with suffering from a cargo container in the depths of a freighter where seven companions had died. The following spring England was shaken by the story of forty-three other Chinese men who perished from carbon monoxide poisoning in the back of a truck smuggling them in from the Netherlands. In April of 2001, reports of white on black lynchings reappeared, not from the annals of the Alabama, but from the southern coast of Spain. At the same time U.S. newspapers waxed smug about the 'rescue' of the 'Lost Boys of Sudan', some 12,000 orphaned Dinka survivors of the civil war in Sudan, a handful of whom were brought from refugee camps to communities in the U.S. where, it was obvious, they were going to be no less lost.[2] The boys were indeed rescued from slavery, discovered to have made a comeback in parts of Africa due to falling commodity prices and the collapse of traditional agriculture. In Abidjan, London's *Daily Telegraph* reported, that girls cost five pounds. The reporter deemed it a 'spectacle from the nineteenth century'. In the autumn of of 2001 Europe discovered itself host to thousands of captive female sex slaves, many of them Russian and East European. In turn abolitionism has dusted itself off and come down from the shelf led, as it was 150 years ago, by the London Antislavery Society.[3]

This is surely not what we expected to be doing at the turn of the new millenium.

In the 1990s the metropole's borders became theatres, and as with the death and survival literature of the past, the dramas appearing in our newspapers every day are doing the work of staging the new planetary order, a newly mutating imperial order, creating its subjects, creating us as its subjects (as I too am doing in this chapter). In one important way, this contemporary recycling of the seventeenth and eighteenth-century travel archive turns the old one inside out, for its prevailing focus is not the living but the dead. The earlier genres – captivity tales, shipwrecks, castaways and the like – were usually produced by the survivors themselves, those who, providentially (a key term), lived to tell the tale. By definition there was always a happy ending that affirmed the viability of an emergent metropolitan global, and often imperial, subject. Today's recyclings are chiefly about nonsurvivors. Driven by a different desire, these stories perform dramas not of departure and return, but of denial and exclusion. Now, and how well we know it after September 11, it seems to be death dramas that grip and resonate, though many success stories could be told.[4] In a key of pain and guilt, does the metropole in this literature contemplate itself as a kind of fortress sustained by violent exclusion and assailed by desperate people no less deserving than ourselves? Is it displaying to itself its intensifying legitimation crisis? Or is the effect rather to remind those on the inside of the fortress how lucky they are and how deeply the world is divided between 'us' and 'them'? Either way, the dramas of death and despair stage an alternative register to the dehumanised economist narratives of globalisation that occupy the news and business pages. They underwrote the sense of hubris that seemed to lie just behind the shock and disbelief at the attack on the fortress September 11. Part of the shock was the familiarity of the scene, already imagined multiply by Hollywood.

Late twentieth-century mobility has been driven by processes of decolonisation set in motion after the Second World War, but also by imperatives and possibilities created by technological advance, the communications revolution, and above all the new and ruthless phase of empire, neoliberalism or late capitalism if one prefers, that we are now living. This was not as obvious in the early 1990s as it was at the end. In the early 1990s the academic talk on globalisation had an outright utopian character among scholars across the ideological spectrum. In one early anthology (Featherstone 1990) the authors spoke of a new 'cosmopolitan ideal' of a 'dream of a secular ecumene', 'the crystallization of the entire world as a single place' and the 'emergence of a global human condition' (Robertson 1990); a 'world culture' that is an 'organization of diversity' (Hannerz 1990). 'Humankind', said Ulf Hannerz in that heady

moment, 'has finally bid farewell to the world which could with some credibility be seen as a cultural mosaic'. Today it is hard not to hear in these joyous phrases a revised, eternally innocent, imperial narrative, and a failure on the part of metropolitan scholars to seek correctives to the inevitable blindness of privilege. (The acerbic John Kenneth Galbraith was clearer: 'Globalisation', he said, 'is not a serious concept. We North Americans invented it to disguise our program of economic intervention in other countries').

The Flow Metaphor

Early on, the metropolitan discourse of globalisation established its preferred metaphor, a metaphor of mobility and innocence that is still very much with us. The metaphor is *flow*. The image is of a planet traversed by continuous, multidirectional, commensurate flows of people, goods, money, information, languages, ideas, arts, images. If one is in the 'local' the idea is to find ways to tap into the flow, through an assembly plant, say, or a cash crop, a tourist attraction, a workforce sent abroad, or by a satellite dish, a boom box, a downloaded CD. But, thinking through mobility, the asphyxiated Chinese workers were not flowing in the back of the truck. The Rio Bravo was flowing but not the young men who drowned trying to cross it. As the work of Teresa Caldeira (2001) reminds us, the wealthy do not flow either. At home they retreat increasingly behind the walls of gated, guarded communities; abroad they are walled up in resort enclaves designed to give the illusion of place. (Even the Pope, in a statement issued on International Tourism day in 2001, condemned the proliferation of affluent resorts cut off from the societies around them [*New York Times* 20 June 2001].) Given the naturalness that the metaphor has acquired, it is perhaps worth spelling out more analytically some of the confusions and evasions that follow from it, if only because that metaphor is surely worth preserving for some purposes:

1. The flow metaphor does not distinguish between one kind of movement and another – between the migration of domestic labourers from the Philippines to the Middle East and the travels of sex tourists from Europe or Japan to Thailand or Cuba. Tourists, as tourists, must return to their countries of origin, while transplanted workers often must not because home depends on their earnings. (The Philippines is one of a number of countries, including most of Central America, in which remittances from workers abroad are the chief source of external revenue.)

2. 'Flow' bypasses the question of directionality. 'Dallas' is seen in South Africa but South Africa's fascinating multiracial, multilingual soap operas do not reach North America. Half of Mexico's hydroelectric power flows out of Chiapas, where much of the resident population has no electricity. Money, I am told, now changes hands 100 times more often than goods do, but that flow in the end also has a direction. In early 2001 Kofi Annan announced that when all forms of exchange were taken into account, there was a net 'flow' the previous year of $450 billion from the poor countries to the rich ones, three quarters of it to the U.S. (To put this into perspective, the entire U.S. foreign aid budget in 2000 was a paltry $22 billion, a fraction of what Argentina alone paid the U.S. in debt servicing. Debt service payments to rich countries have lately been taking up fully half of Ecuador's national budget – hence the outward 'flow' of 4 percent of Ecuador's population in two years.)

3. 'Flow' naturalises. It makes it easy to ignore the state policies, transnational arrangements, and structured institutions that create these possibilities and impossibilities of movement – notably our legitimate villains, the World Bank and IMF, but also the kleptocratic national business classes empowered in the name of the free market. The spread of Hollywood films across the planet is not a natural dispersion of culture. It is a business proposition aimed, as a business matter, at stamping out national cinemas, and authorised by trade deals imposed by rich countries on poor ones. The result so far has been that cinema has shrunk. Fewer films are being made and distributed, many fewer people in the world have access to cinema at all, because local movie houses have disappeared. So much for the new ecumene.

4. 'Flow' obliterates human agency and intentionality – it is an intransitive verb. This is very handy. To depict money as flowing obscures the fact that it *is sent* and is received. People who 'flow' are people who have *decided* to go or return, who have been *sent* or *sent for* by others as part of a considered strategy. By eliminating agency, flow takes the existential dimensions of human movement off the table, from excruciating choices forced upon people to the emancipatory possibilities to which mobility gives rise.

5. 'Flow' perversely suggests a natural, gravity-driven process that will automatically reach a tranquil horizontal equilibrium – so the market is imagined as a leveler, as inherently democratising. But, as critique of the late 1990s underscored, the world of unfettered neoliberalism seems to have no gravity. Its forces have proven to be resolutely vertical, and top and bottom seem to recede before our eyes as wealth concentrates in some places and immiseration proliferates in others. In 1999 workers in Mexico were calculated to have one seventh the earn-

ing power they had in 1970, and their wages were half what they were in 1980. At least a third of the 100 million *mexicanos* possesses virtually nothing at all; people are shorter on average than they were thirty years ago. The rich countries have experienced verticalisation too. We hear it over and over: the bottom 40 percent of U.S. households now control 0.2 percent of the national wealth while the top 10 percent controls 71 percent. It is difficult not to see in the attack on the twin towers an assault on this verticality.

'Flow' exemplifies the official, legitimating language of globalisation. It is not a value neutral term, but a positively valenced term (contrast 'drain') used, detached from any ethical dimension. Language with no top or bottom, as when doubled working hours, child labour, reduced food intake, infanticide or scavenging dumps and dumpsters (as recommended by the Oregon Welfare Department) become 'coping strategies' (see González De la Rocha, 2000). Or when any form or degree of jobless immiseration is called the 'informal economy'. Or when any interaction can be described as an 'exchange' regardless of how asymmetrical, unequal or forced it might be. It is surely the task of humanists to denounce such language, to insist on an ecology of public discourse and an ethical component in policy talk. If not us, then who?

The Appearance of Monsters

In imaginative literature, at least the recent Latin American fiction that I have been reading, this newly predatory world is being expressed precisely by the opposite of flow, in narratives of isolated survivors trying to create meaningful spheres of action in claustrophobic indoor spaces to which they have withdrawn from a social world that has become a holocaust, or in terms of violent delinquency, in which the absence of a liveable future means nobody has anything to lose.[5] In vernacular culture it is registered the way it was in predatory stages of earlier empire, by the appearance of monsters. In the 1980s, for example, the diaspora into the U.S. that was underway did not turn up directly in the national imaginary. It registered indirectly, in the drama of the killer bees. These were a species of bee transported from Africa to Brazil as part of a breeding project. The bees acquired their killer label when they turned out to be much more aggressive than the resident species. As the bees began to spread throughout the Americas, their movement was interpreted from the U.S. as a relentless northward invasion. In the 1980s, as the country moved into the largest wave of immigration in its history, the approach of the bees became a national obsession.[6]

In the mid-1990s, in the wake of NAFTA, Mexico and the Caribbean witnessed the appearance of the *chupacabras* or 'goat-suckers'. This was a large winged, bat-like creature about four feet tall that came out at night and attacked the corrals of goats that exist throughout rural regions of Mexico. Humans and other domestic animals were also vulnerable. Newspapers published pictures of corrals strewn with goat corpses and women with neckwounds; drawings of the creature appeared first in the papers and then on t-shirts; the inevitable *corridos* turned up, and the *chupacabras* made a few cameo appearances on the X-Files. The goat-sucker's origins, so the story unfolded, were in a secret laboratory on a U.S. military base in Puerto Rico where the creature was produced by a failed genetic engineering experiment. The *chupacabras* seemed to comment richly on the assault on rural and agricultural life signified by the 1994 NAFTA agreement. Collective landholdings (*ejidos*) were privatised. Subsistence agriculture was told to disappear; goats and corn should be replaced by kiwi fruit or snow peas. Peasants were under enormous pressure to use genetically altered crop strains to compete, and even then it was obvious that U.S. agribusiness was going to suck the blood out of small-scale Mexican farming. Why goats? The monster targeted the non-commodified relations between people and their animals that are at the heart of rural life (in rural Mexico goat *birria* is the standard ritual food at weddings, the locus of social reproduction). By spring of 2001, however, the *chupacabras* looked prophetic of the wholesale holocaust of farm animals in Britain in response to a foot and mouth epidemic caused by the profit-driven transporting of livestock by transnational agribusiness. As with the killer bees, it seems the monster myth got there first.

In rural Peru and Bolivia, the neoliberal era was marked by a resurgence of the *pishtako,* a monster who first appeared among indigenous Andeans in the sixteenth century out of the violence of the Spanish invasion. The *pishtako* put people to sleep with magical powders, and then sucked the fat out of their bodies so that they wasted away. Not surprisingly the *pishtako* was sometimes envisioned wearing a sackcloth tunic reminiscent of Spanish friars. In the late 1980s, while the killer bees pressed northward, the *pishtako* made a series of appearances in the Andes in response to the depredations of neoliberalism (Wachtel 1994). This time it was seeking human fat for export to the U.S. to lubricate machines – cars, planes, computers. Traffickers were also understood to be selling human flesh to fancy restaurants in Lima. Anthropologists reported a widespread panic in 1987 when a story circulated that an army of five thousand *pishtakos* wearing lab coats had been sent to Ayacucho province in Peru to collect human fat to be sold to pay off the national debt. Andeans were not out of the loop. The image captured with impressive exactitude the nature of the forces bearing down upon them. Read-

ers tempted to think of the *pishtako* in overly mythical terms, might want to ponder its relation to the metropolitan practice of liposuction. Why not sell American fat to pay off Peru's debt? But American fat *is* Peru's debt, the ripped off resources converted into cheap food and northern hyper-consumption.[7]

Around the same time the *pishtako* was abroad in the Andes, in neighborhoods of Lima rumors spread about the *sacaojos* ('ojos'=eyes), predators who kidnapped children to steal their eyes for export, returning them blind. This was just one of a huge range of stories of organ theft which since the 1980s have become powerfully meaningful in places where the integrity and continuity of communities and identities have been threatened. By the mid-1990s these stories had become widespread enough that the United States Information Agency set up a website to disclaim them. The most common seems to be the tale of the stolen kidney. In its most common version, a man in a bar is seduced by an attractive woman with whom he goes to a hotel, awaking next day to find he has been drugged and one of his kidneys removed for sale in Europe or the U.S. The story has many variants, but its frequency and distribution has been astonishing. Again from a place of fear and vulnerability the story registers the permutations of the global order quite precisely, particularly new forms of industrial production which assemble things out of parts made anywhere in the world. Third-world bodies become manufacturers of parts to be exported and inserted into sick but wealthy first-world bodies. Communities are fragmented – pieces of themselves have had to be sold abroad and are lodged in the belly of the beast. American versions of the story, which have spread among truckers, for example, likewise seem to register newly unprotected bodies/identities. A 'legitimate' international market in organs does exist (is it legitimate for a poor person to finance a child's education by selling a kidney?). But this is only part of the reason the organ theft story has such reach in the world today. Its resonance is also psychic and symbolic.

The resurgence of monsters and dismemberment is not a third-world phenomenon. In the U.S. it has taken place in film and television, most notably in the hugely successful program 'X-Files', whose ninth and last television season ended in 2002. Most of the horrors mentioned above made appearances on the program, which drew heavily on referents harking back to the cold war, including 1950s fears of nuclear contamination and invasion from outer space. The updating of these referents in the 1990s reflected and created a first-world subject of the new-world order, one that likewise saw itself at the mercy of unknown and possibly state-sponsored predatory forces.

Like the recycling of death and survival literature, the resurgence of monsters and dismemberment perhaps signals processes of what one

might call 'demodernisation' dished up by the fake protagonist, globalisation. Many note the Dickensian quality of the resurgence of child labor. Supposedly postcolonial countries are finding themselves recolonised by the former masters as international finance organisms force them to privatise their resources. Zambia's copper industry is today back in the hands of the company that owned it in colonial times, a sale forced upon it by international lenders who controlled balance of payments support. In New Guinea, the press tells us, the Dayaks have returned to headhunting in the context of an invading lumber industry bringing ecological destruction and an immigrant labor pool. The western U.S., the *New York Times* reported (May 2001), is reacquiring the characteristics of a frontier. While Euro-Americans migrate out, the Native American population grows, the land reverts to an uncultivated state, and the buffalo makes a comeback – decolonisation in the form not of modernisation but something more like its reversal. The erosion of national and international health-care systems has brought tuberculosis back. Hypermobility means that the place you are most likely to catch it is on an airplane. The spread of AIDS invokes the earlier depredations of smallpox in the Americas, especially in the calculated indifference of official power.

Demodernisation

Health care is just one of a range of modern apparatuses which, in the imaginary of modernity, took the form of a *grid* blanketing national territories, intended to reach all citizens. Electricity was perhaps the modern grid par excellence, along with rail and road transportation, telegraph, telephone and television, education, electoral and judicial systems. When grids fail, that is, then the trunk lines are not maintained, these formations become *nodal*,[8] that is, *non-inclusive*. The territories between nodes can be bypassed. So cell phones replace unsustained national phone systems, and it can become easier in highland Peru to call Florence or Bombay than the next village over – provided you have a cell phone. In many countries the state's inability or refusal to maintain the transportation grid means farmers have no way to get produce to market, and their products are replaced by imports from abroad which arrive easily through a centre to centre nodal system. Zambia, an agricultural country, imports corn, unbelievable as it seems, from the U.S. and South Africa because the demise of passable roads – a state responsibility – means Zambian farmers cannot sell what they grow to anyone at all. Educational grids suffer similar fates. In 1991 the Zambian government spent $60 a year on each primary school pupil; in 2000 it was $15, and 20 percent fewer children were enrolled. Rich countries are hardly immune to the effects resulting from the

destruction of those regulatory, redistributive and custodial functions that states and international apparatuses used to perform. The corporate aggression that drives agricultural prices down in Zambia does the same within the U.S., making all but large-scale farmers superfluous.[9] My home country, Canada, has become a first-class international business predator abroad, but its rural areas are being colonized by German and Swiss farmers after free-market governments suspended ecological controls and rules on foreign ownership. Forms of tenant farming (which nineteenth-century immigrants came to escape) have turned up.

What I am identifying here are both processes of demodernisation and stories of demodernisation. The stories point to the creation on a global scale of subjects for whom the expectation of modernity (Ferguson 1999) exists as a thing of the past. This is an irreparable loss for the mature and a failure of futurity for the young. Since its January 1994 uprising Mexico's Zapatista movement has insistently refused that loss. In the spring of 1999 the Zapatistas reaffirmed the expectation of modernity through an experiment in mobility erected, precisely, on architecture of the grid. Hemmed in and harassed in Chiapas by the Mexican army, the Zapatista movement invoked its citizens' claim to the national space by launching a *consulta ciudadana*, a citizens' consultation. Delegations of one man and one woman, members of the popular movement (not the guerrilla army), would travel to each of Mexico's 2,500 electoral districts where they would spend a week meeting with citizens groups, students, officials, anyone open to dialogue with them. A call went out for local host committees to establish themselves, organise the visits, and raise the money. Miraculously, they did. The *consulta* was to culminate in a national plebiscite on a set of Zapatista demands for citizenship, self-determination, and a cessation of state violence. So it was that in March of 1999, five thousand adults, plus another thousand or so children, virtually all indigenous Mexicans many of whom spoke no Spanish at all, set out on a collective journey not from margin to center, as Mexico's state-based optic would require, but from one place in the nation to *everywhere else*, in a grid reproducing the national electoral grid. It was a powerful intervention in a national imaginary already in the process of reinventing itself. Space does not allow here for an account of the dramatic encounters the *consulta* occasioned, though if it did, the registers for the telling would range from the marvelous to the grotesque. Here were the have-nots seeing for the first time all that the haves actually have, yet physically sickened by their polluted milieu and their alien ways; mayors, impresarios, workers sitting down for the first time with indigenous people they had been taught to see as subhuman and dangerous, or not to see at all, listening to their languages for the first time, struggling to relate.[10] The Zapatistas' gesture was modern in its demand

for liberty, equality and fraternity but dramatically postmodern in interrupting modernity's colonial form which holds indigenous peoples in a symbolic space of radical otherness and economic, political and social marginality. The favoured term 'hybridity' is not particularly illuminating of the gesture.[11]

The Zapatistas' experiment in mobility and citizenship, like their writings, asserted the interpretive and political powers of the marginalised. In a different response neoliberalism's metropolitan critics have introduced a vocabulary of immiseration, suffering, despair, vulnerability, entrapment, a language that seeks to be more factually and ethically grounded. Other scholars, with the Zapatistas, warn against substituting the ungrounded language of flow with an ethically grounded language of despair. To opt for despair is to acquiesce to the whole scenario, even as one denounces it, from a position of privilege.[12] J. K. Gibson-Graham, the collective author of *The End of Capitalism (as we knew it)* (1996) argue against accounts of globalisation, laudatory or critical, rendered in 'a language and an image of noncontradiction'. In particular they caution against explanations that give capitalism an interpretive monopoly so that 'everything comes to mean the same thing'. Such accounts, as we know, will seem coherent and plausible but will remain oblivious to a set of things which, Gibson-Graham argue, cannot be subsumed into the narrative of neoliberalism or late capitalism: the continuing co-existence of capitalist and noncapitalist modes of production (especially households and self-employment), the workings of disharmonies, unintended consequences, formations Spivak would call 'dysfunctional for capitalism', and processes of emancipation such as that of women, or Zapatismo (a movement profoundly shaped by women).

Or perhaps, as Gibson-Graham say, such things can be subsumed into a narrative of despair if the interpreter – we – chooses to do so. A dystopic narrative will be plausible, and will lead to paralysis. But, they argue, intellectuals are accountable for creating the world as well as for describing it. Their interventions, in other words, have consequences. Their work includes identifying in the existing world the elements of the worlds they would like to come into being. Gibson-Graham outline a practice, often counter-intuitive for critical intellectuals, of choosing to seek to tell the story otherwise, attending to disharmonies, unintended consequences, emancipatory processes, however trivial they might seem. The apparent triviality may itself be an effect of the workings of the dominant narrative in the analyst.

For example (my example, not theirs), in the imaginary of globalisation there is a tendency to see the global consumer order as a grid – a planetary blanket of Starbucks, Nikes and McDonald's. But this imagined picture is radically untrue, a fact that becomes massively apparent the

minute one leaves affluent neighbourhoods. Consumption, and the ability to consume, is heavily nodal. Markets have no need to be inclusive – it does not matter who is doing the consuming as long as enough of it is going on (indeed if consumption is concentrated, overhead goes down). The economic polarisation produced by neoliberalism means that the world is now full of people, places, whole regions and countries which, far from being integrated into a planetary Walmart, are and know themselves to be, entirely dispensable with respect to what is seen as the global economic and political order, to be nonparticipants in any of the futures that order invites people to imagine for themselves. This is particularly true of agricultural societies, whose lifeways are being decimated everywhere.[13] The neoliberal order creates not necessarily conditions of its own demise (those are probably ecological), but certainly conditions it cannot make sense of: vast sectors of organised humanity who have only the tiniest access to either cash or consumption, and whose task is to make liveable, meaningful lives by other means. By what means do people in the marginal places of the post-progress world – inhabitants of Jamaica Kincaid's 'small places', delinked rural areas or the huge improvised subsistence neighbourhoods that ring many cities – seek to make life viable and worth living? What succeeds and what does not? (Why do the analyses of the new world order elide the role of drugs in making devalued lives liveable?) If people lack even the prospect of economic security, a job or of building and supporting a family, what alternative sense of futurity can be found or created (Balliger 2000)? And if none, what forms of substance and transcendence can one achieve in the present?[14]

Why the Virgin of Zapopan went to Los Angeles

Lifeways geared to ecological and human balance and continuity are, again to use Spivak's (1999) term, 'not functional for [late] capitalism', which operates by a kind of roving flexibility: the assembly plant is here today, gone tomorrow. Predatory capitalism is hostile to cosmos in the sense of an integrative universe where meaning is anchored in practice and place. Such formations require and produce continuity and interconnectedness. They 'get it together'. So it is that in the presence of capitalism's disaggregating momentum, formations that produce continuity and interconnectedness persist and find new ways to install themselves. Alongside stories of organ theft we have stories where new mobilities and access to information are used to reassemble bodies and recover stolen body parts, ancestral remains, commodified sacred objects. Recently the brain of Ishii, the famed last member of a California indigenous people,

was sought out and recovered from a storeroom of the Smithsonian Institute (Clifford 1997, 2000). The bones of the native Greenlanders that Franz Boas brought to New York a century ago were recovered in 1993 by their descendants for reburial (Harper 2000). By 1998 such processes had become common enough for the U.S. Congress to pass a Repatriations Act. In these processes of reassembling, getting it together, the things recouped are perhaps less significant than the acts of recouping them, which affirm the power to seek wholeness or fullness in a place. Of course, as Gibson-Graham would remind us, we interpreters have the power to decide that such processes are insignificant, but we are accountable for that choice and for the world it implies. (In the last year or two, academic conversation has recycled the term 'romantic' as an epithet for dismissing any analysis affirming resistance, hope or transformative possibilities. This gesture, a clear example of 'making everything mean the same thing', implicitly endorses a narrative of despair and paralysis as 'realistic').

Apparently, getting it together is what brought the Virgin of Zapopan to Los Angeles. Around 1995 the Virgin multiplied herself again, this time in response to calls from followers in California, whom she now visits annually. This third self, significantly for my purposes, is called *la viajera*, the traveller. So now there are three of her, *la original, la peregrina, la viajera*. Her power of mobility and *desdoblamiento* today bring her into the orbit of diasporic community. In this context her strategy of self-doubling echoes the new forms of identity, belonging and citizenship being worked out by mobile workforces and social movements all over the planet. As most readers will know, it is common now for *pueblos* in Mexico and Central America to have full-fledged satellite communities in the U.S. from which people, commodities, money, and cultural practices are sent continuously back and forth. As Roger Rouse's pioneering study (Rouse 1991) showed, part of Redwood City, California is a suburb of Apatzingán, Michoacán. Mayan ethnographer Victor Montejo reports that there are Tzotzuhil-speaking villages in Florida, and apartment buildings reorganised according to Mesoamerican socio-spatial relations. The Mixteco of Oaxaca now have a transnational network extending from Puerto Escondido to Anchorage, and Fresno to New Jersey. Every June in the airport in San José, California Mexicana Airlines takes unaccompanied children by the dozens to spend summers with relatives in *ranchos* and *pueblos*. Towns and villages reschedule and redesign local *fiestas* to accommodate their migrant populations (a pattern that, incidentally, re-emphasises religious calendars over national holidays). In short, great effort, creativity, and commitment are going into making and sustaining these connections to place – to keeping it together. The myth of the immigrant eager to leave origins behind still exists, but it coexists alongside

this other immigrant story whose project is sustaining the place of origin, often through processes of self-duplication like those of the Virgin of Zapopan. Working abroad to sustain home often implies dual citizenship in both the literal sense (more and more countries are allowing it) and the existential sense of a kind of doubling of the self into parallel identities in one place and the other. This can be both a fragmenting and an empowering experience.

In economic terms, you could say that with the demise of the mechanisms that used to redistribute wealth from north to south – national development programs, protection of local markets, international aid – émigré workers are redistributing it 'by hand' (the International Development Bank says Latin American workers send $20 billion a year home from the U.S.). This function was recognised by Bush the Younger when, following the disastrous earthquakes in El Salvador in 2001, he gave permission for 150,000 undocumented Salvadorans to remain in the U.S. earning money to send back to help their families recover. Though the economic motivations are obvious, Gibson-Graham would tell us to look at the ways this doubling, this mobilisation of the here to sustain the there, this project of keeping it together is in other respects, again to use Spivak's term, not functional for capitalism. It does not obey the dictates of consumerism or acquisitive individualism or the self-maximising individual. In important respects it is life by other means. Fears of nostalgia should not prevent us from attending to the mechanisms people are using to get it together and keep it together in the face of the intensified disaggregations that are functional for capitalism. The current hero of this story, and not just in the metropole, but in places like highland Guatemala too, is the cell phone. But the mobile virgins are important too because they can show up to offset the monsters.

The inability of neoliberalism to create belonging, collectivity and a believable sense of futurity produces, among other things, crises of existence and meaning that are being sorted through by the nonconsumers and consumers of the world alike, in ways neoliberal ideology neither predicts nor controls. The roving virgins are its symptoms and its inscrutable agents.

Notes

1. I am indebted to colleagues at the Centro de Investigación y Estudios Superiores de Antropología Social (CIESAS-Occidente) in Guadalajara, Mexico for conversations and suggestions that have enriched this work, and for the privilege of a sabbatical year among them. For consultations on the Virgin de Zapopan I am particularly thankful to Gabriel Torres, María de la O Castellanos and Renée de la Torre. For thoughts and analyses on globalisation, immiseration and their exis-

tential dimensions, I thank Mercedes González de la Rocha and Rossana Reguillo. This text was completed under the auspices of a fellowship at the Center for Advanced Study in the Behavioral Sciences at Stanford University, 2000–2001, where I benefited from stimulating discussions with James Ferguson, Liisa Malki and Jean Lave. I also thank James Clifford, Renato Rosaldo, Jesus Martin-Barbero, and colleagues in the Border Studies seminar at the University of Wisconsin, the Women's Studies center at Rutgers University and the Department of Spanish at New York University for their suggestions and the opportunity to present this work.

2. The echoes were of Voltaire's *L'Iroquois*, or Pocahontas in London; the label was borrowed from Peter Pan. The rescue operations in the Sudan, carried out by international Christian charities, have been sharply criticised for exacerbating the problems they are trying to solve (see for example *The New York Times*, Editorial page 27 April 2001). The money paid to purchase enslaved Dinka in order to set them free has increased incentives for the government-sponsored militias who are primarily responsible for Dinka slavery in the Sudan.

3. The London-based Antislavery International reports that by its definition some 27 million people today are enslaved; the transatlantic slave trade is estimated to have transported 15 million individuals over 150 years. In the U.S., estimates that some 100,000 girls and women were being trafficked into the country yearly in the sex trade led Congress to pass a Trafficking and Violence Victims Protection Act in 2000. The mail-order bride business has also revived in the U.S., and today involves large numbers of Russian women seeking a way out of hopeless circumstances.

4. The exception seems mainly to be children, who in the contemporary archive do seem to appear as survivors. The rest seem to be corpses.

5. At the same time, metropolitan literatures have become diasporic. Contemporary French and English fiction are dominated by ex-colonial writers writing for metropolitan audiences about non-metropolitan places and times. To a great degree it is a literature of storytelling.

6. When the bees actually arrived in the early to mid-1990s, as the story played out, they did what immigrants to the U.S. have always been supposed to do. They interbred with the local bees, producing new strains resistant to mites that were destroying the resident population. As of this writing, the most recent killer bee story in the U.S. press (September 2001) was about the misidentification of an apparently aggressive colony in Connecticut as 'Africanised' when they were really homegrown 'European' bees. Michael Moore, in his film *Bowling for Colombine*, associates the bees with the emergence of a contemporary culture of fear in the U.S.

7. In July 2001 Mexico was rocked by news of the capture of 'La Rana', 'the frog', a notorious hit man employed by one of the country's most powerful narco cartels. Unbeknownst to police he had been in custody for some time in a Tijuana jail. Plastic surgery and the removal of forty pounds of fat by liposuction had made him unrecognizable.

8. Bruno Latour mentions the idea of trunk lines and the effects of their severing in *We have Never Been Modern* (1993). Ferguson discusses nodality in *Expectations of Modernity* (1999).

9. Half the potato farmers in the U.S. were forced out of business between 1995 and 2000, and the picture is about the same for U.S. producers of other crops from soybeans to pigs and cranberries.

10. It is important to recognise the sheer originality of the act: from a position of utmost marginality and subalternity it made a utopian claim on citizenship, setting in motion a process that with the collaboration of the privileged required all to experience the historical limitations imposed on citizenship by colonial modernity. One must recognise also the courage it took to embark on this journey in a world unknown but known to be dangerous. It was a remarkable episode in the search for what Mignolo calls a 'politics of cultural transformation' (Mignolo 2000: 159).

11. Exactly two years later, drawing on lessons of the *consulta ciudadana*, the Zapatistas made a second march that seemed to revert from the geography of the secular, national grid, to a geography of pilgrimage and the state geography of margins and centre. They converged on Mexico City, intent on addressing the national congress and demanding approval of peace accords which had been on the table for years. One of the biggest crowds in the history of the city converged on the *Zocalo* (the central plaza) to welcome them. But the centre retained its powers of repudiation. The Zapatista delegation addressed a congress whose majority absented itself; the peace accords were approved in a watered-down version that did not grant the self-determination they had demanded; the status of the movement, as of this writing, is in limbo.

12. Gayatri Spivak makes a related point when she rejects the discourse that creates the third world as the place where wrongs occur, and assigns the first world the task of righting wrongs (Presidential Lecture at Stanford University, March 2001).

13. The 70,000 inhabitants of the valley of Tambogrande in northern Peru, for example, find that their $110 million a year crops of mango and limes is entirely dispensable in the eyes of the Manhattan Minerals Corporation who wants to turn their land into an open-faced mine that would employ at the most five hundred of them. Ironically, the fruit-growing enterprise, for whose survival they are now fighting, was itself made possible fifty years ago by a World Bank irrigation project. Neither Manhattan Minerals nor President Fujimori who approved the mine presented a proposal for the tens of thousands who would be economically displaced by the mine (Lima: *Noticias Aliadas* 38: 13, 16 April 2001). Some theorists are using the category of the 'abject' to describe these huge sectors of organised humanity – 'abject' in its etymological sense of being expelled, thrown out or down (see for instance, Ferguson 1999). Doubts about the connotations of the term have kept me from using it.

14. Here the written sources are ethnographers. Ferguson 1999 discusses the emergence in Zambian urban migrant culture of styles that cannot be analysed as expressions of an underlying code. Anthropologist Robin Balliger (2000), working in Trinidad studies youth culture and the globalised music scene from a related point of view. Music and dance, and a whole set of practices linked to them, turn out to be the mechanisms for creating a meaningful, nearly cashless, communal cosmos.

Bibliography

Balliger, Robin. 2000. *Noisy Spaces: Popular Music Consumption, Social Fragmentation and the Cultural Politics of Globalisation in Trinidad.* PhD dissertation, Department of Cultural and Social Anthropology, Stanford University.

Caldeira, Teresa. 2001. *City of Walls: Crime, Segregation and Citizenship in São Paulo.* Berkeley: University of California Press.

Clifford, James. 1997. *Routes: Travel and Translation in the Late Twentieth Century.* Cambridge: Harvard University Press.

———. 2000. 'History, Anthropology and the Future of Native California'. Faculty Research Lecture, University of California Santa Cruz, October 2000.

Featherstone, Mike, ed. 1990. *Global Culture: Nationalism, Globalisation and Modernity.* London: Sage.

Ferguson, James. 1999. *Expectations of Modernity: Myths and Meanings of Urban Life on the Zambian Copperbelt.* Berkeley: University of California Press.

———. 2002. 'Of Mimicry and Membership: Africans and the "New World Society"', *Cultural Anthropology* 17, 4: 551–69.

Gibson-Graham, J. K. 1996. *The End of Capitalism (as we knew it): A Feminist Critique of Political Economy.* Oxford: Blackwell.

Gonzalez De la Rocha, Mercedes. 2000. *Private Adjustments: Household Responses to the Erosion of Work.* UN Bureau for Development Policy, Conference Paper Series.

Hannerz, Ulf. 1990. 'Cosmopolitans and Locals in World Culture', in: *Global Culture: Nationalism, Globalisation and Modernity*, ed. Mike Featherstone. London: Sage.

Harper, Ken. 2000. *Give me my Father's Body: The Life of Minik, the New York Eskimo.* South Royalton, VT: Steerforth Press.

Latour, Bruno. 1993. *We Have Never Been Modern*, translated by Catherine Porter. Cambridge: Harvard University Press [English translation of *Nous n'avons jamais été modernes* (1991)].

Lynas, Mark. 2000. 'Letter from Zambia', *The Nation*, 14 February 2000.

Mignolo, Walter. 2000. *Local Histories/Global Designs.* Princeton, NJ: Princeton University Press.

Ochoa, Fr. Angel S., O.F.M. 1961. *Breve historia de Nuestra Señora de Zapopan.* Zapopan: Jal.

Robertson, Roland. 1990. 'Mapping the Global Condition: Globalisation as the Central Concept', in: *Global Culture: Nationalism, Globalization and Modernity*, edited by Mike Featherstone. London: Sage.

Rouse, Roger, 1991. 'Mexican Migration and the Social Space of Postmodernism', *Diaspora* 1, 1: 8–23.

Spivak, Gayatri. 1999. *Critique of Postcolonial Reason.* New York, NY: Harvard University Press.

———. 2000. Presidential Lecture, Stanford University, March 2000.

Wachtel, Nathan. 1994. *Gods and Vampires: Return to Chipaya.* Chicago: The University of Chicago Press.

Notes on Contributors

Jens Andermann is Senior Lecturer in Latin American Studies at Birkbeck College, University of London, and has previously taught at the Universities of Constance, Berlin and Bielefeld. He is a co-editor of the *Journal of Latin American Cultural Studies* and the author of *Mapas de poder: una arqueología literaria del espacio argentino* (Rosario 2000). *The Optic of the State: Visuality, Material Culture, and Nation-State Formation in Argentina and Brazil, 1870–1900* is forthcoming from Pittsburgh University Press.

Gordon Brotherston is Professor in the Division of Literatures, Cultures and Languages at Stanford University and Research Professor at the Department of Literature at the University of Essex. His publications include studies of Latin American narrative and poetry and of native American literatures and cultures (*La América indígena en su literatura*, México (DF): Fondo de cultura economica 1997).

Claudio Canaparo is Reader of Latin American Studies at the University of Exeter. He has published *El artificio como cuestión* (Buenos Aires 1998), *The Manufacture of an Author* (Exeter 2000), *Imaginación, mapas, escritura* (Buenos Aires 2000) and *El perlonghear* (Buenos Aires 2001). Currently he is completing *Ciencia y escritura*, due to be published in 2004.

Magali M. Carrera is Chancellor Professor of Art History at the University of Massachusetts, Dartmouth. She is the author of several publications on the art and culture of eighteenth-century Mexico, including *Imagining Identity in New Spain: Race, Lineage, and the Colonial Body in Portraiture and Casta Paintings* (University of Texas Press, 2003). Current research interests include the visual culture of maps and their relation to the nation-building discourses of nineteenth-century Mexico.

Alvaro Fernández Bravo is Adjunct Professor of Literature at the Universidad de San Andrés, Argentina, and a researcher at CONICET. He is the author of *Literatura y frontera: procesos de territorialización en las culturas argentina y chilena en el siglo XIX* (1999), and has edited and published books and articles on issues of nationalism, exhibitions and the formation of cultural patrimonies in Latin America.

Florencia Garramuño is Associate Professor of Brazilian Literature at Universidad de Buenos Aires and Professor of Latin American Literature at Universidad de San Andrés, Argentina. She is the author of *Genealogías Culturales: Argentina, Brasil y Uruguay en la novela contemporánea, 1980–1990* (Rosario 1997) and has edited and published several books and articles on Brazilian and Latin American literature.

Andrea Giunta is Associate Professor of Contemporary Latin American Art History at Universidad de Buenos Aires, Argentina. She has been Visiting Professor at Duke University and a Research Fellow of the John Paul Getty Foundation. Among her publications are *Cultura y política en los años '60* (Buenos Aires 1997), *Goeritz/Romero Brest: Correspondencias* (Buenos Aires 2000) and *Vanguardia, internacionalismo y política: arte argentino en los años sesenta* (Buenos Aires 2001).

Beatriz González Stephan occupies the Lee Hage Jamail Chair of Latin American Literature at Rice University (Houston). Previously she taught literary theory and Latin American literature of the nineteenth century at Universidad Simón Bolívar. From 1993 to 2001 she has directed the critical journal *Estudios*. In 1987 her book *La historiografía literaria del liberalismo hispanoamericano del siglo XIX* was awarded the prize for best essay from the Casa de las Américas. Other publications include *La Duda del Escorpión* (1992), *Crítica y descolonización: el sujeto colonial en la cultura latinoamericana* (with Lucia Costigan, 1992), *Cultura y Tercer Mundo* (1996); *Escribir la historia literaria: capital simbólico y monumento cultural* (2001), *Fundaciones: canon, historia y cultura nacional* (2002) and *The Body Politic: Writing the Nation in the Nineteenth-Century Venezuela* (forthcoming).

Hendrik Kraay is Associate Professor of History and Political Science at the University of Calgary. He is the author of *Race, State, and Armed Forces in Independence-Era Brazil: Bahia, 1790s–1840s* (Stanford University Press, 2001) and has edited *Afro-Brazilian Culture and Politics: Bahia, 1790s–1990s*. *Muero con Mi Patria: Perspectives on the Paraguayan War* (co-edited with Thomas L. Whigham) is forthcoming from University of Nebraska Press. He is currently working on civic rituals and monuments in nineteenth-century Salvador and Rio de Janeiro.

Graciela Montaldo is Profesora titular at the Universidad Simón Bolívar, Caracas, Venezuela. Among her publications are *De pronto, el campo. Literatura argentina y tradición rural* (Rosario 1993), *La sensibilidad amenazada. Fin de Siglo y modernismo* (Buenos Aires 1995), *Ficciones culturales y fábulas de identidad en América Latina* (Rosario 1999),

Teoría crítica, Teoría cultural (Caracas 2001). Together with Beatriz González Stephan, Javier Lasarte y María Julia Daroqui she has co-edited *Esplendores y miserias del Siglo XIX. Cultura y Sociedad en América Latina* (Caracas 1995) and with Gabriela Nouzeilles, *The Argentina Reader* (Durham 2002). She has been visiting professor at Duke University, the University of Maryland, the University of Chicago and the University of California, Davis.

Andrea Noble is Senior Lecturer at the University of Durham, and the author of *Tina Modotti: Image, Photography, Texture* (2000) and co-editor of *Phototextualities: Intersections of Photography and Narrative* (2003), both published by the University of New Mexico Press. She has published widely on issues of Mexican photography and film in journals including *Women: a Cultural Review*, *History of Photography*, *Screen*, *Framework* and *Tessarae*. Currently she is completing her book *Mexican National Cinema*.

Gabriela Nouzeilles is Associate Professor for Spanish and Portuguese at the University of Princeton. She is the author of *Ficciones somáticas: Naturalismo, nacionalismo y políticas médicas del cuerpo* (Rosario 2000) and has co-edited, together with Graciela Montaldo, *The Argentina Reader* (Durham 2002). Between 2000 and 2003 she has been editorial coordinator of the critical journal *Nepantla: Views from South*.

Trinidad Pérez is completing a PhD in art history at the Universidad San Fancisco de Quito, Ecuador. She has researched and published widely on the work of Ecuadorean painter Camilo Egas.

Mary Louise Pratt is Silver Professor of Spanish and Portuguese and Comparative Literature at New York University. She is the author of *Toward a Speech Act Theory of Literary Discourse* (Bloomington 1978) and *Imperial Eyes: Travel Writing and Transculturation* (London, New York 1992), and many essays on Latin American literature and culture, colonialism, and discourse analysis. Her co-authored volumes include *Women, Politics and Culture in Latin America* (Berkeley 1990) and *Linguistics for Students of Literature* (New York, London 1980).

William Rowe is Anniversary Professor of Poetics at Birkbeck College, London. His book *Memory and Modernity: Popular Culture in Latin America* (London, 1991) has been translated into several languages. Among his most recent critical publications are *Ensayos arguedianos* (Lima 1996), *Hacia una poética radical: ensayos de hermenéutica cultural* (Rosario, Lima 1996) and *Poets of Contemporary Latin America: History and the Inner Life* (Oxford, 2000).

Index